From Margaret an
Christ

LAKE DISTRICT
LIFE AND TRADITIONS

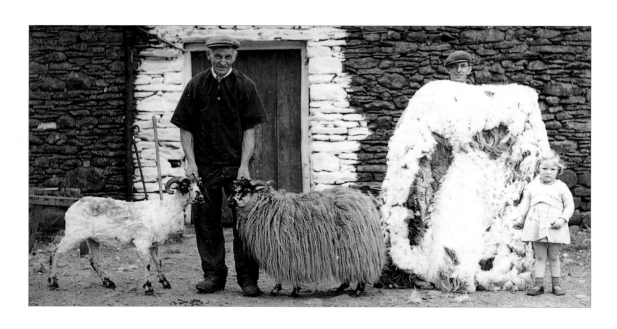

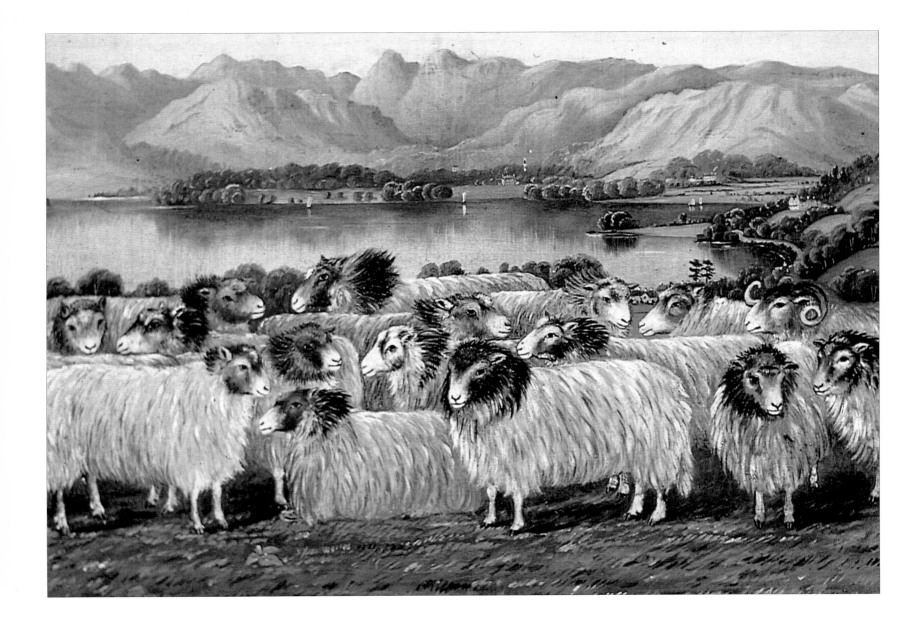

THE
LAKE DISTRICT
LIFE AND TRADITIONS

WILLIAM ROLLINSON

WEIDENFELD & NICOLSON

LONDON

First published in 1996 by
George Weidenfeld & Nicolson Limited
The Orion Publishing Group
Orion House
3 Upper St Martin's Lane
London WC2H 9EA

This book is based upon
Life and Tradition in the Lake District by William Rollinson
published by J M Dent & Sons Ltd in 1974
and the Dalesman Publishing Company, 1981 and 1987.

Front jacket photograph
Ploughing on the high fells in the 1940s

Back jacket photograph
Isaac Cookson, shepherd

Photograph on half title page
Fleece from Rough Fell sheep

Photograph opposite title page
Sheep by Taylor Longmire

Contents page photograph
Horse and plough on high ground

For

David and Christine Carter

Special thanks are due to Margaret Buntin
who allowed me to quote from her late brother's work;
to Irvine Hunt for permission to reproduce Norman
Nicholson's *Weather Ear*, to David Kirk, George Bott,
and Ron Smith, to the editor of *Country Origins*; and
to Christine Denmead, who read the proofs with
her usual thoroughness.

Conversions

Due to the complexities of quoted text and spoken text
there are no conversions of either measurement or
money in the book. The tables on page 160 give a
translation into today's decimal currency which may
help give a better appreciation of the sums quoted.

Edited, designed and typeset by Playne Books
Trefin Pembrokeshire
Editor Gill Davies
Design David Playne
Design assistant Craig John

Acknowledgements

The author and publishers would like to thank the
following institutions and photographers for permisssion
to reproduce illustrations and for supplying photographs:

A & J Photographic
Abbot Hall Gallery and Museum, Kendal
(Hardman Collection)
Barrow Public Library
Cumbria Record Office:
Barrow in Furness, Carlisle and Kendal
Kendal Public Library
Martin Lewthwaite
National Monuments Record
The National Trust
W R Mitchell
Ian Robertson
William Rollinson
Ruskin Museum, Coniston
Raymond Sankey
Brian Sherwen
Stott Park Bobbin Mill
Mrs A E Smith
Mrs J H Smith
Tullie House Museum
and Art Gallery, Carlisle (Mary C Fair Collection)
The Westmorland Gazette
Harry Wiper
Line drawings by Craig John
Map by Alan G Hodgkiss

Printed in Italy

Contents

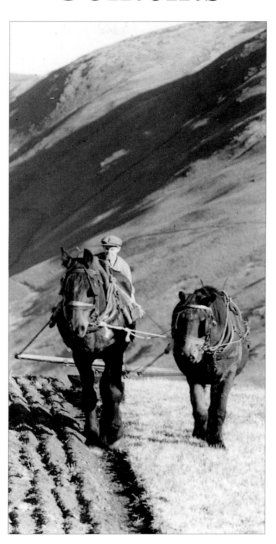

INTRODUCTION
6

THE WAY WE WERE
8

FARMS AND FARM BUILDINGS
22

HEARTH AND HOME
32

PATIENTS AND POTIONS
38

CUSTOMS AND TRADITIONS
45

REGATTAS, FAIRS AND ENTERTAINMENT
57

WAKES, FUNERALS AND GRAVE MATTERS
72

THE SCALES OF JUSTICE
78

TRAVELLING ABOUT
80

ANIMAL MEDICINE
AND VETERINARY MAGIC
93

COCKFIGHTING AND FOX HUNTING
100

SHEEP ON THE FELLS
109

OOR MAK O' TOAK – LAKELAND DIALECT
118

WEATHER LORE
121

WORKING THE LAND
126

STRAIGHT FROM THE WOOD
135

YAN ON TWA AND TWA ON YAN
STONE WALLS
145

QUARRIES AND MINES
150

GLOSSARY
156

BIBLIOGRAPHY
157

INDEX
158

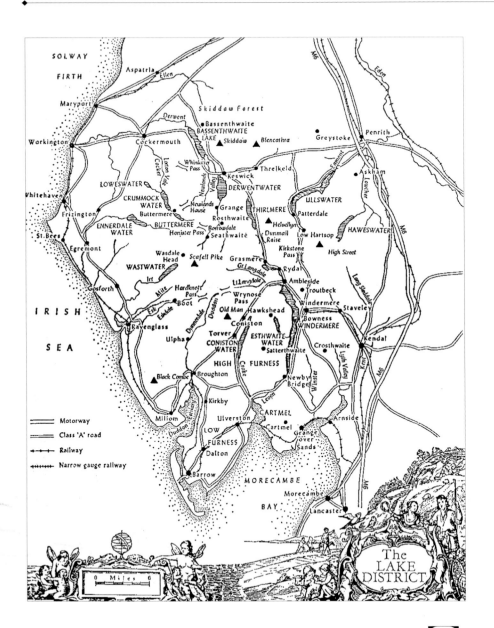

The
LAKE
DISTRICT

Motorway
Class 'A' road
Railway
Narrow gauge railway

0 Miles 6

INTRODUCTION

Like many areas of upland Britain – the Highlands of Scotland, the Yorkshire Dales, Wales, and the Pennines – the Lake District was once a remote, isolated region where innovations and changes were greeted with suspicion and hostility. Within this mountain fastness, folk lore and tradition died hard; the pace of life was governed by the farming calendar, by seed-time and harvest, by lambing and clipping. The turnpike roads of the eighteenth century followed by the railways in the nineteenth eroded this isolation and the motorways of the twentieth century have brought new settlers and commuters, new ideas and an affluence which has accelerated the decline of an age–old folk culture.

Yet these changes, though great in magnitude, have not completely eradicated that former way of life. For all the attempts by schools to stamp it out, the Cumbrian dialect still crackles on market days in Penrith, Cockermouth, Wigton, Ulverston and other market towns; there are still those who prefer to rely on ancient but well-tried and tested folk cures rather than resort to some pharmaceutical preparation, and stories are still told by folk who remember as children having their chests rubbed with the fat from the

Christmas goose and then being sewn into a brown paper jacket which was not removed until the spring. Rushbearings are still celebrated, pace eggs still bowled against one another at Easter, and shepherds continue to reclaim their lost sheep at Shepherds' Meets as they have done for centuries. There are those craftsmen who can still build a length of drystone wall, weave an oak swill basket or rive a clog of greenslate as their fathers, grandfathers and great-grandfathers did before them. Rum butter is still made in Cumbrian kitchens and served up at Christenings and, whatever the Meteorological Office in distant Bracknell might decree, the Cumbrian dalesman is more inclined to trust the signs and portents of good and bad weather on his own fellside.

This book is an attempt to chronicle the folklife and traditions of the Lake District, and in doing so, I have not confined my area of study merely to the central fells but have adopted Norman Nicholson's concept of 'Greater Lakeland'. It is, in part, the story of a 'world we have lost' but also a world in which the echoes of a former way of life are still to be found.

William Rollinson, Ulverston, Cumbria, 1996

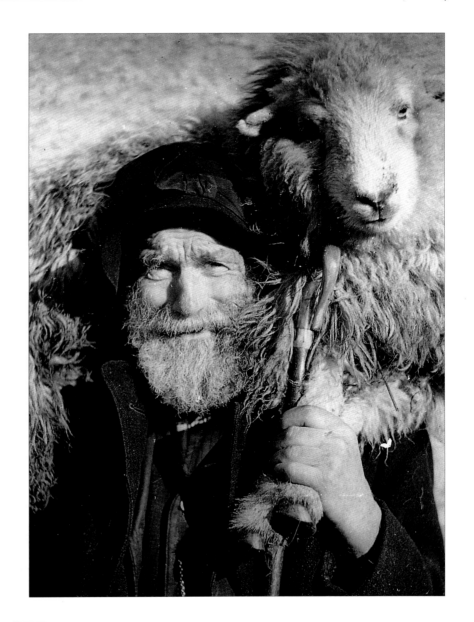

The Way We Were

'The refinement and general condition of a people are in nothing more apparent than in the kinds and qualities of their food, and their methods of preparing it.'

Rev. J. Hodgson, 'Westmorland As It Was', 1822.

1910: A packman displays his goods. This would have been a regular visit, as he called with ribbons, pins, needles and thread to sell.

The Lake District is an area of very high rainfall, clouds, steep slopes, and thin stony soils. While wheat and barley ripened in the milder drier climate of the coastal plain, within the fells the harsher conditions meant that oats became the traditional crop and the dominant bread grain used in the baking of clap or haver bread, a form of unleaven crisp bread which would keep for many months. Celia Fiennes, an indefatigable traveller, observed the making of clap bread in the Kendal area in 1698:

They mix their flour with water so soft as to rowle it
in their hands into a ball, and then they have a board
made round and something hollow in the middle
riseing by degrees all round to the edge a little
higher, but so little as one would take it to be only a
board warp'd, this is to cast out the cake thinn and
so they clap it round and drive it to the edge in a due
proportion till drove as thinn as paper, and still they
clap it and drive it round, and then they have a plaite
of iron same size as their clap board and so shove
off the cake on it and so set it on coales and bake it.
If their iron plaite is smooth and they take care their
coales or embers are not too hot but just to make it
look yellow it will bake and be as crisp and pleasant
to eat as any thing you can imagine.

Haver or Clap Bread
Mix 1lb of fine oatmeal with lukewarm water
and a nut of lard. Add a pinch of salt, mix to a
firm consistency and roll or clap very thin.
Bake until golden brown on a hot plate or
similar implement.

This type of flat oatbread was made throughout Atlantic Europe, from Scandinavia through Ireland to the Basque country.

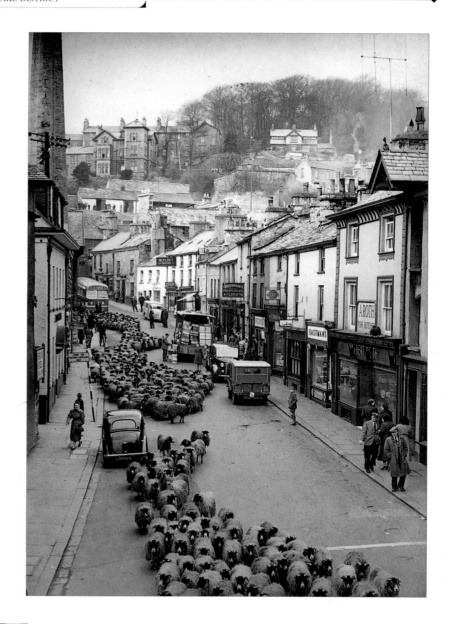

*More sheep than traffic
in All Hallows Lane,
Kendal, in the 1950s.*

Norse: havre = oats

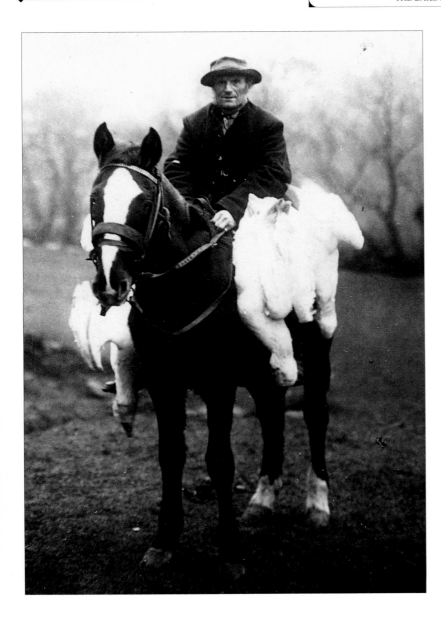

Taking geese to market.

Tatie-Pot

Properly cooked, Herdwick mutton can, quite literally, be a royal feast. It was served at the Coronation banquet of Queen Elizabeth II in 1953 and more recently when she visited High Yewdale Farm, near Coniston. But to savour it to the full it is best in tatie-pot. No 'Merry Neet' or hunt supper would be complete without this most traditional dish. Consisting of Herdwick mutton, black pudding, onions, and topped with crisp brown potatoes, and accompanied by pickled onions and a *l'aal bit o' red cabbish*, the Lancashire hot-pot pales into insignificance. . . .

Recipe

Take ¹/₂lb of neck or breast
of Herdwick lamb
2 large onions
2 large carrots
8 oz of black pudding
Seasoning
Potatoes to cover

Method

Cut the meat into small pieces and place in a roasting tin.
Add the sliced onion and carrots and the slices of black pudding.
Season. Cover with slices of potato.
Brush the potato with oil to help them brown.
Cook in a moderate oven, 400°F or 200 °C, for about two hours.
Add water, if necessary, during the cooking.

Clap bread remained an essential part of the Lakeland diet until the mid-nineteenth century. Oatmeal was also used in other ways; hasty pudding or 'poddish' was a porridge made of oatmeal and water and was usually eaten with butter, milk and treacle. A variation was 'whey sops'. . .

whey according to quantity and . . . a mixture of milk and some oatmeal . . . brought to boiling point on the fire. Then [add] a few breadcrumbs and some caraway seeds. Boil slowly for an hour or so, then add treacle to taste just before taking off the fire and serve up.

Alternatively, oatmeal could be made into 'crowdy', a form of soup in which the stock from boiling meat was poured over the meal and eaten. Oatmeal formed the basis of both morning and evening meals. In 1852 William Dickinson wrote about Westmorland:

. . . a great quantity of oats is ground into meal and this with milk, bread and sometimes cheese constitutes the breakfast and the supper of the chief part of the farm households in this county.

Occasionally, disastrous harvests produced a scarcity of all kinds of grain; in 1799, 1800 and 1816, to avert hunger and eke out the available flour stocks, turnip bread was made. This recipe was used in south Cumbria in the early nineteenth century:

Take off the skin from your Turnips, and boil them till soft; bruise them well and press out the Juice; add an equal weight of Wheat Flour and Knead them up with a sufficient Quantity of Salt and bake them.

From the Neolithic period to the Agricultural Revolution of the eighteenth century, the annual

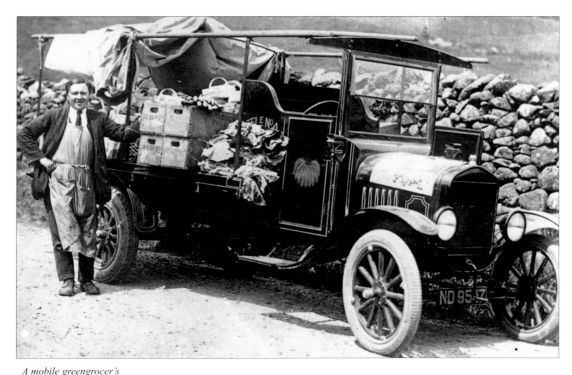

A mobile greengrocer's shop or delivery van was 'the norm' in rural and suburban areas in Great Britain until the impact of widespread car ownership and the birth of the supermarket in the 1960s.
This photograph was taken in South West Cumberland in about 1920.

Rancid Irish butter was mixed with tar and sheep salve and used to water proof fleeces.

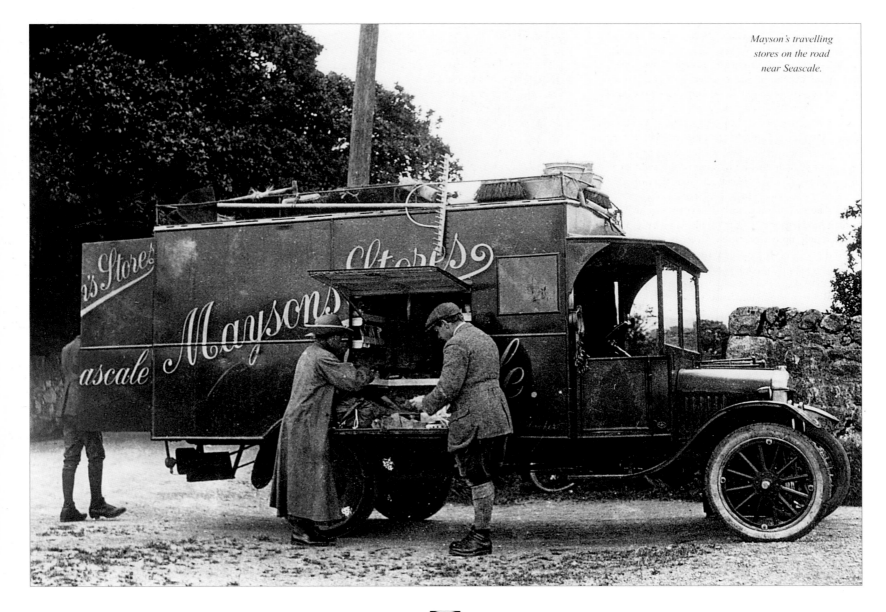

*Mayson's travelling
stores on the road
near Seascale.*

autumn slaughter of animals was an essential ritual which took its place in the farming calendar along with seedtime and harvest. Without the necessary fodder crops to sustain all the animals throughout the winter, Martinmas became the time when beef and mutton were preserved for family use during the approaching winter; much of this was either pickled in brine, 'larded' in melted fat, or dried in peat smoke of the huge kitchen chimneys. This latter method was preferred in the Cumbrian dales – indeed, it was said of the Cumbrian yeoman that he considered a well-stocked chimney to be the most elegant furniture with which he could adorn his house! In 1787 James Clarke claimed that he had seen the carcasses of seven sheep hanging by their hind legs in one Borrowdale chimney and this was certainly no exaggeration. Even as late as 1822 smoked beef was preferred to fresh meat in spite of the fact that it cost twice as much. Usually a 'collop' or slice of meat was boiled on Sunday morning and eaten hot for dinner but after that it was served cold at subsequent meals.

Vegetables and fish

The very nature of the diet – dried mutton and beef and oatmeal – meant that there was a lack of vitamins and the frequent internal ailments and 'agues' were probably a direct consequence of this deficiency. Without a knowledge of vitamins, Cumbrian housewives nevertheless prepared 'herb' or 'Easterledge' pudding in the spring. This consisted of the leaves of bistort, called locally *Easterledges*, a handful of groats or barley, young nettles, the leaves of the Great Bell flower, one or two blackcurrant leaves and a few blades of chives boiled in a linen bag together with the meat. Eaten with veal, it was regarded as a delicacy, and in addition it was said to *clear tha' blood!* A traditional recipe for herb pudding from Caldbeck includes 1½lbs of bistort, 1lb of nettles, ½ a cup of barley, a

bunch of chopped chives and a leaf of blackcurrant boiled in a bag for 2½ hours. Before serving it was customary to add a knob of butter and a beaten egg.

Few vegetables enlivened the seventeenth and eighteenth century diet; apart from onions and pickled red cabbage, garden vegetables are noticeably absent. Even potatoes were not in common use until after 1730. However, Sir Frederick Eden, wrote in 1797:

Potatoes . . . chopped and boiled together with a small quantity of meat cut into very small pieces . . . then formed into a hash with pepper, salt, onions, etc . . . by sailors [is] called lobscouse.

Lobscouse stems from the Norse 'lapskaus' meaning a hash or stew and is one of thousands of dialect words introduced by Norse-Irish settlers.

On festive occasions, especially at Christmas, pies made of minced mutton mixed with fruit and sugar enlivened a jaded palate. Prodigious quantities were eaten. It is recorded that in the 1830s some seven hundred to a thousand sheep were slaughtered in the town and neighbourhood of Kendal every Christmas Eve to provide the meat for these 'mince pies'.

Fish did not feature prominently in the diet of Lakelanders, although there is the oft-told story of the Kendal apprentices who objected strongly to being fed on salmon more often than three times a week – but as the same tale is told in Newcastle on Tyne, Worcester, Gloucester and other towns on the Severn it is probably apocryphal. Salmon was, of course, caught in the Lake District. Visitors to Townend at Troutbeck, the home of the Browne family from 1623 to 1943, will see an enormous 'lester' or salmon spear which is still preserved there. (Norse *lyster* = a fish spear.)

One fish, however, was regarded as a great delicacy: Alpine trout, commonly called 'char', was taken mainly from Coniston and Windermere lakes in the seventeenth and eighteenth centuries. The Rydal Hall papers are full of references to char pies and potted

char. Indeed, one writer claims that Sir Daniel Fleming made the char *'an instrument of social diplomacy, whereby he sweetened (or savoured) his intercourse with politicians and friends at court'*. Many of these pies were enormous; in 1673 Sir Daniel despatched two pies to the Earl of Carlisle which weighed *'near twelve stone'*!

By the eighteenth century, potted char seem to have replaced the pies but the fish still found a favoured place as Mrs Holme revealed in her recipe which was used at the the Rydal Hall table in 1749:

Alpine Trout

I generally put 2 oz of black pepper to 1 oz of mace and 1 oz of cloves, 1 oz Jamacoe pepper finely bet and mix'd as y'u use it of the finest Seasoning will be gone first. Have y'u Seasoning mix'd so when y'u find the Seasoning leave the salt add more and not much more. Salt, then Spice. If Conistone fish after they are gutted and wip'd sprinkle them w'th Salt for an hour or more. Wipe them clean and Season them well. Lay them in the pot y'u intend to bake them in and if they can ly all night, it will be better as they are large fish. Cover them well with clarified butter, and when you pott them throw a little good spice on the bottom of the Pot and among the Fish. Let them drain well, and don't cover them with butter till Quite cold. If Conistone fish, and large, 9 will fill half a Guinea Pot one layer.

In the nineteenth century potted char remained popular, despite the number of char declining due to overfishing. Special earthenware char-dishes were created, many having a picture of the fish incorporated into the design round the sides. Such dishes are now rare and consequently fetch high prices in antique shops.

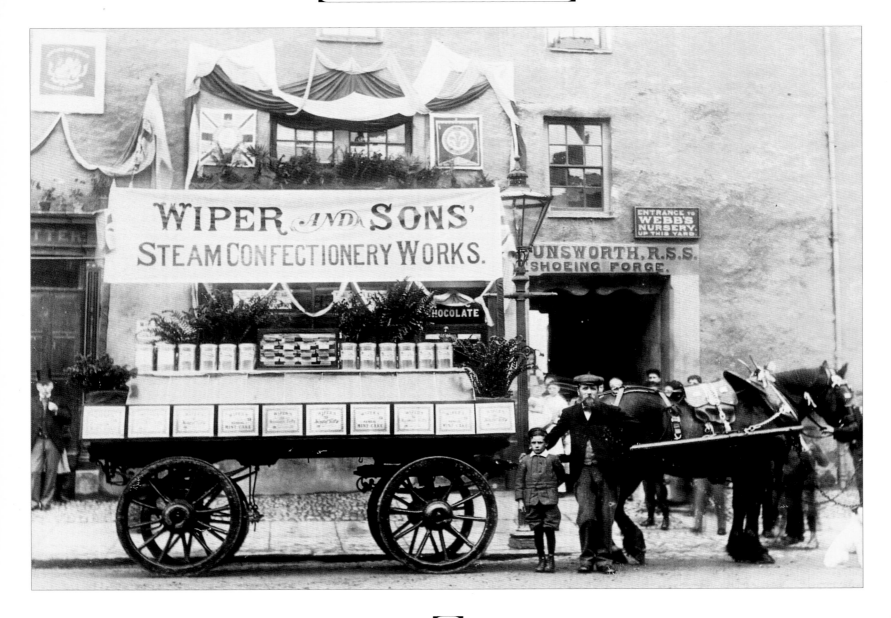

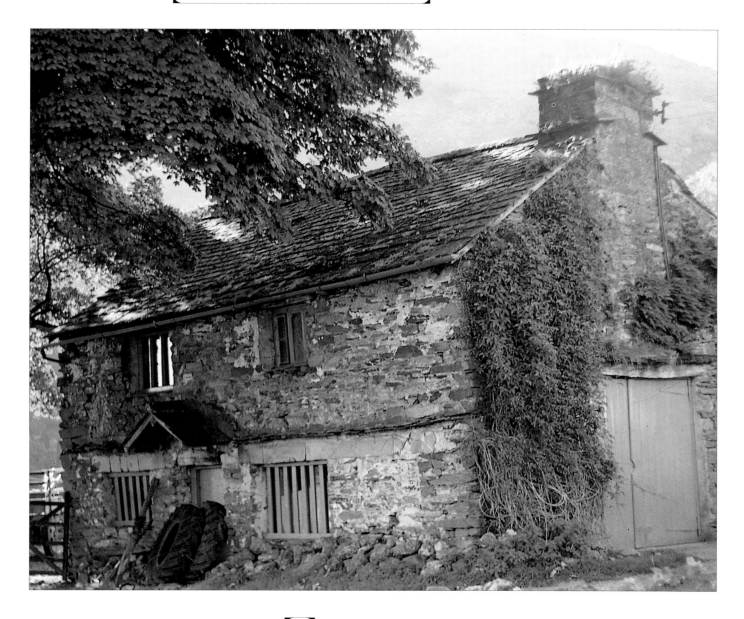

Kendal Mint Cake ready for a procession: Joseph Wiper's float decorated for Queen Victoria's Golden Jubilee in 1887.

An old farmhouse at High Yewdale near Coniston built in the late seventeenth or early eighteenth century. Its inhabitants lived at a time when self-sufficiency was a way of life, when the diet was based upon the farm produce and clothes were made from their own sheep's wool.
The farm is no longer inhabited and has been converted into a garage.

The delights of drinking

Almost all Cumbrian farms brewed their own ale, which accompanied every meal but on special occasions ale possets were made, especially on what were known as 'Powsowdy Nights'. Usually served in basins, these ale possets were made by boiling ale and rum with bread, and seasoning it with spices, nutmeg and sugar. The bread was removed and eaten as a kind of dessert. In West Cumbria there was a variation known as 'Lamplugh Pudding' which consisted of biscuit soaked in hot ale with seasoning and spirits.

'Penny-fairs' dedicated to the delights of drinking were often held in rural communities. Here James Clarke describes such a fair in St John's Vale in 1787:

On the Sunday before Easter all the inhabitants of the parish, old and young, men and women, repair to [the] alehouse after evening prayer: they then collect a penny from each person, male or female, but not promiscuously, as the women pay separately: this money is spent in liquor, and at one of these meetings . . . amounted to three pounds so that there must have been 720 persons present.

Frequently this home-brewed ale was highly intoxicating – and not just for humans. The story of the Barngates Inn near Hawkshead underlines the potency of the local brew. A barrel of beer had burst in the inn yard and a duck, which had imbibed too freely, fell down senseless. The frugal landlady, assuming the bird to be a dead duck, plucked the creature ready for the pot but fortunately it revived and waddled out into the yard, uttering intoxicated quacking noises. It is said that, in a fit of remorse, the landlady knitted a woolly vest for the bereft bird – and thereafter the inn changed its name to The Drunken Duck.

The more affluent members of society were not always content with beer; many indulged in stronger beverages – sometimes with unhappy consequences as shown in an entry in the diary of William Fleming, a wealthy Pennington yeoman farmer in May 1810:

Last night I drank two or three glasses of spirit and water with Mr Shaw when I let him my fields – and today find myself much disordered. . . . The spirit dealers certainly adulterate their liquor with something unwholesome and of deleterious quality. My head and joints are so distracted that I hope I shall have the recollection and the resolution in future to take not more than a single glass of such pernicious beverage. . . . Home brewed ale is the most wholesome liquor.

However, William Fleming's hangover was nothing compared to the dire results of a Hawkshead wager in 1689. It appears that two young men, William Braithwaite and William Stamper, made a bet with a third, Bernard Swainson, that if the said Bernard *'could drinke nyne noggins of brandy'* then they would pay for the liquor but if Bernard failed then he himself must pay for whatever he managed to consume. The Parish register chronicles the events:

. . . now this Bernard drunke of those nyne noggins of brandy quickly; and shortly after that fell downe upon the floore: and was straightway carried to his bed where hee layed two and twenty hours: dureinge which tyme hee could never speke, noe, nor never did know any body though many Came to See him and Soe he dyed*

Not all drinks were alcoholic; in the eighteenth century during the hay harvest, the women consumed a pleasant and sharp beverage called 'whey-whig' which was made by infusing mint or sage into buttermilk whey.

*A noggin was between a quarter and a third of a pint.

Walking the geese to market.

By the end of the century a new drink, tea, began to challenge whey-whig and even home-brewed ale. The story is told of an old lady who received a pound of tea from her son, then residing in London. Not being *au fait* with the newfangled method of brewing *the cup that cheers*, she promptly filled her clay pipe and smoked it, declaring tea to be much better than the best Virginia! A similarly unverified tale is related of another daleswoman who, on receiving a present of tea, immediately made a somewhat unusual herb pudding! The introduction of this apparently harmless brew was not always greeted with enthusiasm; condemned by some as simply *chatter watter*, others saw it as nothing less than a blow to the moral fibre of the region:

A correspondent says that in the neighbourhood of Greystoke, during the late harvest, added to an increase of wages, the female reapers had regularly their tea every afternoon, and the men toast and ale. How different is this from the beef-steak breakfasts of old! How degenerate is the present age and how debilitated may the next be!

The Cumberland Pacquet 23 October 1792

Food and folk culture

In most rural societies, food and folk culture are inseparable, and the Lake District was no exception. Many foods were inextricably linked with the calendar. Sadly, with the possible exception of pancakes on Shrove Tuesday, few of these customs now survive. Several customs were associated with Lent; on Collop Monday, the Monday preceding Lent, the remaining collops or slices of smoked meat were eaten before the Lenten fast. The fifth Sunday in Lent was known as Carling Sunday when carlings or brown peas, soaked overnight and fried in butter, was the accepted delicacy. And it was considered almost profane if Fig Sue was not part of the meal on Good Friday.

William Fleming, when he was writing of Low Furness in 1805, recalled:

It has been an immemorial Custom in this Corner of England, on Good Friday, to eat a kind of Porridge, called here Fig Sewe, made of Figs cut in Quarters, with Wheaten Bread cut into small Square Pieces and boiled in Ale or Beer seasoned with Sugar, Treacle and nutmeg; this is much relished by most People and eaten to Dinner before salt of Fresh Fish.

Although no longer as popular as it once was, Fig Sue is still cooked by the discerning few.

Fig Sue
A traditional recipe used in the 1970s by Mrs Story of Dendron
Soak 1/2lb of dried figs overnight.
Drain and simmer in a little water until tender and the water is absorbed.
Add 1 pint of beer, 4 tablespoons of sugar, a knob of butter and a slice of bread, diced.
Simmer all this together for another few minutes and serve hot.

Ritual delicacies: the funeral arvel

From the dawn of human history, food and drink have been associated with rituals surrounding birth and death and several of these customs survived in the Lake District till within living memory. The Cumbrian tradition of serving mourners at the graveside with arvel bread is ancient, but one which was respected until at least the 1930s. Opinions differ as to the origin of the word 'arvel', some arguing that it is derived from the Norse word *arve*, meaning to inherit, others

claiming that it is an ancient Scandinavian word for funeral, but about the bread there is little divergence of opinion. Small buns, always made from wheat flour, were distributed to each of the mourners attending the interment and these were taken home to be eaten, symbolising a token gift from the departed. Occasionally arvel cheese was distributed in the same manner. At the funeral of George Browne of Troutbeck in 1702 an arvel cheese weighing 78 pounds and costing the not inconsiderable sum of 14s. 7 1/2d was given to the mourners. Sometimes these gatherings served to cheer the survivors rather than to express grief for the departed. At Dalton the mourners retired to a public house where they sat in groups of four and were served with two quarts of arvel ale and arvel bread to be eaten at home. The funeral of a prominent and respected member of the community called for a lavish spread:

At the funeral of Benjamin Browne of Troutbeck in 1748 258 people sat down to a meal which consisted of: 14 dozen Wiggs (tea-cakes or buns with caraway seeds) and 16 dozen of bread

	£	s	d
Cakes, 6 dozen at 2d		12	0
Beef a Quartr.		15	6
Veal a side		4	6
Two sheep . . . at 6s apiece		12	0
Malt, a load (for brewing)	1	7	0
Wine, white and red 2 gallon		17	6

Pace eggs

Easter, of course, was associated with *pace* or *pasche* eggs – hard-boiled eggs coloured with redwood dye, alum, or onion skins. Skilled practitioners would write their names in molten candle wax on the shell before dyeing and this would then appear in white on the finished egg. When the Wordsworths were living at

Pace Egging Song.

Arranged by J. A. MacAlister, Barrow.

Rydal Mount their pace eggs were decorated by their gardener, and several of his efforts may still be seen in the Dove Cottage Museum in Grasmere.

Traditionally, children met at some appointed place – the Castle Moat in Penrith, Castle Hill at Kendal, the Hoad Hill in Ulverston – and bowled the eggs against one another until the shells cracked, like some giant conker game. As well as rolling eggs, they were sometimes 'dumped'; pace eggs sporting the owners' initials were placed in large bowl and gently shaken. Periodically, cracked eggs were removed until finally one remaining pristine egg was declared the winner.

Linked to pace egging was the pace egg mummers' play, particularly associated with Satterthwaite in High Furness. In common with many similar plays, the characters include Lord Nelson, King George, Tosspot and Bessy Brownbags, and the seemingly nonsensical plot has its roots in history, though it is difficult to date precisely. Once in danger of dying out, the mummers play has been revived by the Furness Morris Men and

The Furness Morris Men perform the ancient pace egg play.

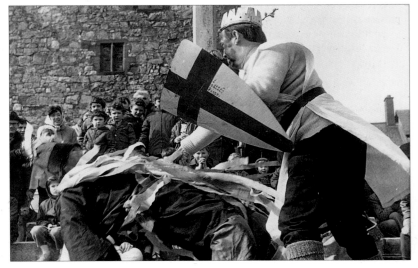

performances may be seen annually in towns, villages and hamlets throughout South Cumbria.

Birth, the Groaning Cheese and Rum Butter

The birth of a child afforded yet another happy occasion for feasting and, once again, traditional foods were consumed. William Fleming, the Pennington diarist, records a strange custom in 1818:

The Wife of a Farmer of mine was brought to Bed a few days ago and Preparations had been made previous to the expected Event. As soon as the good Woman was delivered, some Ale was put on the Fire with Spices to warm and a Cheese (better than Common) and a large loaf of fine Bread. The accoucheur, [a male midwife] cut a slice or two of the Cheese, then cross cut them into Pieces about the size of a Finger and Shook them in his Shirt lap; these were distributed among the unmarried Women to lay under their Pillows at Night to dream of. This cheese is called the Groaning Cheese of which all present ate heartily and drank the warm Ale mixed with Rum or Brandy after which the married Women leapt over a Besom or Birch Broom and she who did not clear the Broom was pronounced the next for the straw.

Following the confinement, it was customary for the married women to hold an 'old wives' do' to celebrate the mother's safe deliverance. Those *laited* (invited) usually brought gifts of a pound of butter, a pound of sugar or a shilling and it was traditional to dine on sweet or rum butter, that most characteristic of Cumbrian dishes. Made from butter, soft brown sugar, rum and nutmeg, this delicacy was fed to the mother in the belief that she would recover from her confinement more rapidly. It is still a feature of Cumbrian Christenings when the sweetmeat is served in fine china rum-butter bowls which are often family heirlooms, passed from one generation to another.

An Ancient Cartmel Recipe for Rum Butter

Melt together $^1/_2$lb of butter and 1lb of soft brown sugar but do not let it boil. Add a little grated nutmeg. Beat it up well and then add one tablespoonful of rum. When it is beginning to cool, put it in a dish or basin. Serve on crackers.

Another curious custom connected with these 'old wives' gatherings' was 'stealing the rum butter'. Writing in the 1870s, John Richardson described this feat of derring-do:

A number of young men of the neighbourhood . . . waited outside the house until the table was spread and the women all seated round it, when two or three of the boldest youths rushed in and seized, or attempted to seize, the basin and carry it off to [their] companions; but, as many of the old wives were prepared to make a desperate fight for it, it was frequently no easy matter to secure the prize, and get out again; and it often happened that some silly pilgarlick was glad to escape minus his coat-tails, or some more important part of his habiliments. When they succeeded in getting the basin of sweet-butter, a basket of oat bread was handed out to them, and they went away to some neighbour's house to eat it, after which each put a few coppers into the empty basin and returned it to the owners.

In some areas, as well as rum butter, the company might also be regaled with 'buttered sops', a dish which has sadly fallen out of favour. Joseph Budworth, described its preparation in 1792:

Upon the day of celebrating the ceremony, all the matrons in the neighbourhood assemble at the joyful house, and each brings as a present to the good woman in the straw either one pound of sugar, one pound of butter, or sixpennyworth of wheaten bread. The bread is cut in thin slices and placed in rows one above the other in a large kettle of 20 or 30 gallons. The butter and sugar are dissolved in a separate one, and then poured upon the bread, where it continues until it has boiled for some space and the bread is perfectly saturated with the mixture. It is then taken out and served up by way of a dessert.

As for the new-born child, its head was immediately washed with rum and from this arose the custom of *weshin't barn's heead*, an excuse for the proud father and his cronies to make merry!

Kendal Mint Cake

Search through the iron rations of Arctic and Antarctic explorers, lone Round-the-World yatchsmen, long distance walkers, Alpine and Himalayan mountaineers and inevitably you will find Kendal Mint Cake, that high-energy glucose confection which has earned the approbation of generations of Lakeland fell walkers as well as those exploring further afield. Hillary and Tenzing in 1953 found time to stand on the summit of the world and break open – not a bottle of Moët et Chandon – but a bar of Kendal Mint Cake!

Yet the famous cake has no long tradition; the Wiper family of Kendal claims that Joseph Wiper developed mint cake in 1869 by accident when he was boiling sugar in his Kendal sweet shop. Certainly a fortunate accident not only for the Wiper family but also for Kendal, a town which might well consider changing its ancient civic motto 'Wool is my Bread' to 'Mint Cake is my Sustenance'!

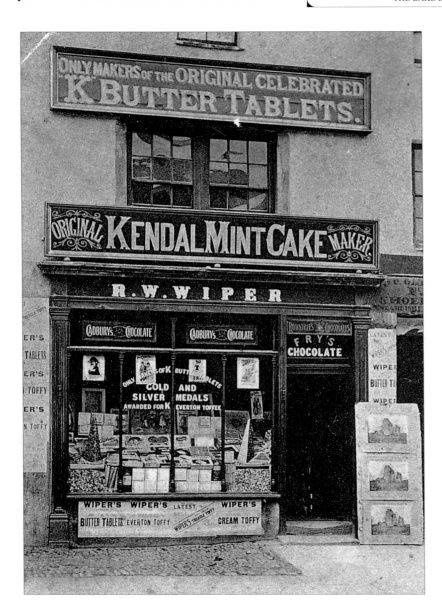

Wiper's Mint Cake Shop before 1910. Kendal Mint Cake, supposedly invented by accident, is a highly concentrated source of energy and was taken on Sir Ernest Shackleton's Antarctic expedition in 1914-17.

Folk Dress

Self-suffficiency was a guiding principle in the way dalefolk clothed themselves and cloth was woven from the Lakeland wool. To avoid the expense of dyeing, wool from black and white sheep was spun together to form a grey yarn which in turn produced 'hodden grey' or 'self grey' cloth, a common colour for waistcoats and coats – and the origin of John Peel's *coat so grey*. James Clarke in 1787 describes John Bristow, an old dalesman from the Greystoke area, who wore clothes made from the wool of his own sheep either dyed by a neighbour *or what is called Skiddaw-grey, viz. black and white wool mixed*. That Clarke mentions this at all suggests that by the late eighteenth century the practice was becoming the exception rather than the rule.

The knitting of hosiery was a common activity and in the guttering gloom of tallow candles and rushlights, men, women and children knitted stockings; any spare minutes were occupied in this way. Indeed, Joseph Budworth, writing of the Kendal area, noted that *'both men and women were knitting stockings as they drove their peat carts into town'*.

This cottage industry certainly helped to supplement the meagre income of many farmsteads. In 1801 2,400 pairs of stockings was the average weekly supply to Kendal market, most of these coming from east Westmorland, particularly Ravenstonedale and Orton. Even as late as 1868, six elderly knitters in Orton produced seventy-two pairs of stockings a month for a Kendal firm. In order to increase the life of newly-knitted stockings, thrifty housewives adopted a simple but effective technique – the heels and soles of the stockings were smeared with molten pitch and then immediately drawn through the ashes of a peat fire so forming a flexible layer which resisted the formation of holes.

The village of Dent, then just over the Westmorland border in Yorkshire, was famous for its 'terrible knit-

ters' and girls from the Lake District were sent there to learn the craft. Betty Yewdale and her sister Sally went from Great Langdale to Dent in the late eighteenth century when they were merely seven and five years old. In old age, Betty related her harsh experiences to Sarah Hutchinson, William Wordsworth's sister-in-law:

We went to a Skeul about a mile off – ther
was a Maister an Mistress – they laarnt us our
lessons, yan apiece – an then we o' knit as
hard as we cud drive, strivin, which cud knit
t'hardest, yan against anudder – We hed our
Darracks [day's work] set afore we come fra'
heam in t'mornin'; an' if we deedn't git them
dunn we warrant to gang [go] to our dinners –
They hed o' macks o' contrivances to larn us to
knit swift – T'maister wad wind 3 or 4 clues
togedder for 3 or 4 bairns to knit off – that at
knittest slawest raffled tudder's yarn, and than
she gat weel thumped.

Harden cloth, a very coarse material made from hemp or flax, was generally used in the making of shirts or sarks. Notorious for their uncomfortable chaffing of the wearer's skin, these sarks were often soaked in water and beaten with a 'battling stick' before being worn. Alternatively, they might be given to a farm servant to wear for a couple of weeks in order to 'break in' the garment as William Dickinson pointed out in 1876:

A carlin sark, new, was rumplement* gear,[*coarse]
To wear next a maisterman's skin
So he lent it to t'sarvent to beetle and wear
By way of a brekkin in.

By the beginning of the nineteenth century, harden cloth had been superseded and John Gough remarked in 1812 that few women knew the art of spinning flax.

Clogs

Most dalesfolk– men and women, yeoman and hired hand – wore wooden-soled clogs. This raather cumbersome footwear sacrificed elegance to expediency for, it was argued '. . .it would be impossible to wade through wet and dirt of a farmyard in winter without these guards' Moreover, the wooden soles provided good insulation from the damp conditions underfoot.

The making of the alder soles and leather uppers was a skilled occupation and 'cloggers' in towns like Keswick, Kendal, Ulverston and Cockermouth were kept busy. The wooden soles were shod with iron 'corkers' or 'caulkers' to prevent excessive wear and ladies' clogs usually had brass clasps. In the slate quarries and copper and lead mines of the fells, clogs were infinitely better than boots which took a long time to dry out when wet. Clogs were lined with soft straw for warmth and miners and quarrymen wore footless stockings so that if they got their feet wet, they merely tipped out the wet straw and relined the clogs with dry, which they always carried for that purpose.

Pedlars

In the eighteenth and nineteenth centuries, many isolated farmsteads and remote dales were visited by pedlars, known locally as 'Scotchmen' irrespective of their nationality. These itinerant tradesmen carried printed cotton cloth, calicoes, pins, buttons, tapes and braids and they always found a warm welcome awaiting them. By the twentieth century the 'Scotchmen' carried pattern books rather than bales of cloth. Tom Fletcher Buntin recalls such visits to his parents' farm in Great Langdale at the beginning of the century:

A Mr Huggon used to travel with patterns of materials from a firm in Kendal called Graham's. He carried his patterns in two packs all neatly packed in two black pieces of oilcloth; each was about 2 feet by 1 foot, fastened with a strap and carried over his shoulders. . . . He would come in and spread his patterns out on the table and mother would order what she required. He carried all sorts of patterns – tweeds, linens, cottons and flannels. The materials you ordered would come later on and we used to pick the parcel up at Chapel Stile. Then mother would go to work making clothes for us.

In the eighteenth century, as well as Scotchmen, itinerant tailors visited remote areas once or twice yearly to make up the 'hodden grey' into clothes. These craftsmen were usually paid between 10d and 1 shilling per day but board and lodging had to be found for them as they often remained with the family for a week or more until the new wardrobe was completed.

By the nineteenth century 'the rust of poverty and ignorance', as one writer put it, had begun to wear off. Improved communications brought new ideas and fashions; this, in turn, meant the decline of age-old traditions both in food and dress. When Ulverston, Kendal and Whitehaven mirrored London fashions and mantua-makers, tailors and milliners had premises there, the need for self-sufficiency declined. As Thomas West commented in 1774: Within the memory of man every family manufactured their own wearing apparel; at present, few wear anything that is not imported And John Gough in 1812 announced:

The yarn hose and coarse druggets of former times
have been supplanted by the manufactures of the
West of England, Yorkshire, Manchester and
Nottingham; so great is the aversion to home-spun
dress at present, that the poor buy a new kind of
second-hand finery from dealers in old clothes.

The age of mass-produced fashion had dawned – and with it died an honourable tradition of folk dress.

Farms and Buildings

Farmhouses

In many parts of England the period from 1570 to 1640 saw a building revolution when the old timber-framed cruck farmhouses were pulled down and rebuilt again in stone. In the remote fastness of the Lakeland fells, however, this Great Rebuilding, as it has been called, was almost a century later than in the more fortunate areas of the country.

The reasons for this backwardness are not difficult to find; until the seventeenth century the Lake District fells afforded a harsh uncompromising environment of small subsistence farms where capital for improvements and rebuilding was hard to find. By the second half of that century, the troublesome Scottish border question had been resolved and the border counties

began to enjoy a period of peace, stability and prosperity based on the woollen industry. By this time, too, the so-called 'statesmen', small, fiercely independent free-holders or customary tenants, had emerged as a powerful social group and these yeoman farmers used their new-found wealth to initiate an unprecedented period of rebuilding, the results of which we can see on the present landscape.

Before 1640 many of the farmhouses in the Lake District were built around a cruck frame rather like the skeleton of an upturned wooden boat. Pairs of naturally – curved oak crucks or 'siles', pegged together at the apex, were raised and these supported a ridge beam and a series of rough-hewn rafters and on this framework the roof was fixed. The low drystone walls, which often hid the crucks from the outside,

carried no load. Few, if any, farmhouses built in this way remain entirely unaltered, though some still retain their crucks but these are impossible to detect from the exterior of the building. However, although the farmhouses have either been pulled down or considerably altered, several examples of cruck-built barns survive and these give a valuable insight into this essentially mediaeval method of construction.

From the mid-seventeenth century, domestic architecture in the Lake District began to change; timber-framed houses were no longer built and load-bearing masonry was universally adopted. Building materials were those which could be obtained locally and closely reflect the underlying solid geology. In parts of Low Furness, West Cumbria and the Eden Valley, rust-red sandstones provide good freestone; in

Typical Lakeland three-bay farm house

The Statesman plan

Photograph of Yew Tree Farm, Coniston, showing the famous spinning gallery.

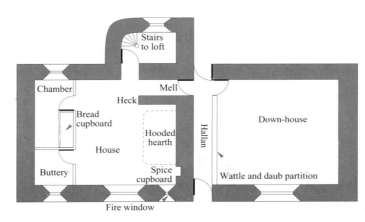

Drawings by Craig John based on Professor R W Brunskill's work.

Cartmel, much of the Furness peninsula and the Kendal area, silver-grey limestones were used, while along the Cumbrian coast, rounded seashore 'cobbles' were readily available, giving a mottled appearance to those sturdily-built homesteads which defy the westerly gales. Within the heart of the fell country the grey, blue and sea-green slates and the rough, craggy volcanic tuffs and agglomerates were used in the absence of other more easily-worked freestones.

Down-house and fire-house

From this time, too, a common plan emerged which has been called the 'statesman plan' after the intrepid yeoman farmers who adopted it. One of the characteristic features was a cross-passage or 'hallan' which ran from the front of the house to the back, effectively dividing the building into two sections, one part being the 'down-house' or service area, the other being the 'fire-house' or simply the 'house', the living accommodation. Of course, there were variations to this plan depending on the wealth and status of the family but on the whole the basic pattern is a common one.

The front door of the farm leading into the hallan passage was often low – 'bend or bump' was a very practical piece of advice! An oak beam, four or five inches high and known as the threshwood or sole-foot, was let into the floor and secured at the walls on either side of the door so, as well as ducking one's head it was also necessary to pick up one's feet. The threshwood was designed to stop rainwater seeping into the hallan but it also appears to have had a mystical significance for charms such as crossed straws or a horse-shoe were frequently fastened here to prevent the intrusion of unwelcome spirits into the house. Having successfully negotiated the threshwood, the visitors found themselves in a dark hallan passage about four feet wide; this formed a convenient storage place for sacks of grain on the eve of market day and

A deer's foot and a horse shoe –
talismen hung on a byre door at
Askham to deter unwelcome spirits.

here, too, pigs would be hung up after slaughter. Above the door there was invariably a shelf holding various carpentry tools, nails and small agricultural items such as sickles. Usually the wall on the side of the hallan which divided it from the fire-house was made of stone whereas the opposite wall was merely a clam-staff-and-daub partition.

At the far end of the hallan passage were three doors: one, immediately opposite the threshwood, opened out into the farmyard; another allowed access down a few steps to the down-house, hence the name. This was the working part of the farmhouse and here the brewing, baking and washing were undertaken. The 'elding', the wood or peat fuel for the fire, was also stored here and in a loft above, the 'haver' or oatmeal was kept in huge oak arks or kists. Opposite the

down-house door, on the other side of the hallan, the third door opened into a 'mell' passage about six feet long which led into the living quarters.

The fire-house was the farm's main living room; often it was floored with pebbles from a nearby beck, sometimes merely with beaten earth, though in areas where slate could be easily obtained, flagged floors were common. The hearth occupied most of the stone wall which partitioned the hallan from the fire-house; the hearth-stone was slightly raised above the level of the floor and on it burned the fire, the fuel being kept in place by a pair of iron fire dogs. Over the fire rose the huge funnel-like canopy or hood which extended out into the room about seven feet above the floor and gradually narrowed into a flue in the loft above. This chimney hood was constructed either of stone or lath

View from the loft of the hood over the fireplace
at High Birk Howe in Little Langdale

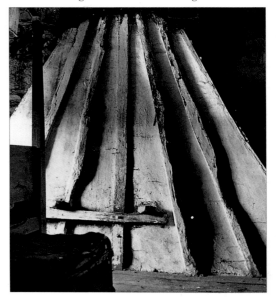

and plaster but in some instances wickerwork, daubed both inside and out with cow dung or clay, was used. Only one example, at Cropple Howe Farm, Eskdale, now remains. Inside the chimney hood the carcasses of sheep were hung to smoke in the 'reek' from the peat fire. Clearly the area around the fire was the warmest cosiest place on a winter's night but there was one major hazard – in wet weather a black sooty liquid called 'hallan drop' fell down the chimney onto the heads of those sitting below. John Gough, writing in the nineteenth century, argued that this was why fell farmers wore their hats when sitting by the fire!

Within the chimney breast, from the back wall to the hood, two beams projected and on these was placed a long beam known as the rannel-balk or randle-tree. This beam was not fixed, so it could be rolled back and forth and the cooking utensils which hung from it by chains, could be positioned on the fire. Adjustable iron pot hangers known as ratten-crooks or racken-crooks were often used in place of chains and by raising or lowering the pot on the fire, the cooking temperature could be controlled. Along one side of the fire was the sconce, a fixed wooden bench under which a small quantity of elding for the morning's fire was stored, while on the opposite side of the fire stood the long oak settle, its back often elaborately carved and the seat serving as a clothes chest. On one side of the fire was a small spice cupboard let into the depth of the stone wall in which spices and salt were kept dry. The door of the cupboard usually bore the initials of the farmer and his wife as well as a significant date, either the year in which they were married or the date that the house was built.

Generally, the fire-house was lighted by two small oak-mullioned windows in the front together with a small fire-window which allowed light to fall directly onto the hearth; many of these were subsequently blocked up to avoid the window tax. Above the fire-window a recess shelf known as the catmallison sometimes contained the family Bible. Beneath the mullioned window stood the long, heavy oak table which, because of its size, often had to be constructed in the fire-house, the timber being passed in through the windows before the mullions were set in place. Around this table the family and any farm servants ate communally; traditionally the men sat with their backs to the windows and the women sat opposite on benches so that they could fetch and carry the food to the table. The head of the family sat at the head of the table and at Townend, Troutbeck, generations of Browne family feet have almost worn away the footrest crossbar at this point.

One other piece of furniture dominated the fire-house – the carved oak breadcupboard or court cupboard which usually occupied a position opposite the hearth. This was a fixture rather than a movable piece of furniture for it formed part of a partition wall which divided the chamber and the buttery from the fire-house. In these elaborately-carved cupboards, which frequently bore the initials of the farmer and his wife, the unleaven haver bread was stored. On either side of the bread cupboard, doors led through the clam-staff-and-daub partition, one into the chamber or best bedroom, the other into the buttery or pantry, which whenever possible was located, on the cooler north side of the farmhouse.

Access to the loft was by by a flight of stone or oak stairs leading from the fire-house and here the children and farm servants slept. The loft was open to the rafters and in spite of 'mossing' the cracks in the slates, during the winter months sleepers might find themselves covered in snow the following morning, a point made by John Richardson in 1876:

A fierce wind fra t'north 'at whissel't and rwoart,
An' dreav t'snow i' blinndin' cloods dancin' afwore't,
Fra t'fells into t'valleys, doon whurlin' it went.

It fand ivvery crack, ivvery crevice an' rent,
Through t'mortarless wo's; in auld hooses, it's sed,
Fwok waken't to finnd theirsels snown up i'bed.

The loft was sparsely furnished. One nineteenth-century writer disapprovingly recorded that:

. . . a rope was stretched across this nocturnal
receptacle of the family, upon which coats, gowns
and other articles of apparal, both male and female,
hung promiscuously.

By the early nineteenth century propriety demanded that such communal sleeping arrangements should be abandoned and most of the lofts were ceiled and divided into bedrooms by the addition of wooden partitions.

This, then, was the basic 'statesman' plan which evolved during the later part of the seventeenth and the early part of the eighteenth centuries. Naturally, there were variations to this pattern; in some areas the byre and the farmhouse were under one roof, forming a long rectangular unit with a cross passage giving access on one side to byre and on the other side to the house – such as at Wall End in Deepdale. It could be argued that this plan reflected the ancient long-house design of earlier centuries but an alternative explanation might be found in folklore for in some areas it was firmly believed that the smell of cattle and other animals would prevent diseases – a situation which almost certainly arose when humans and animals were living in close proximity under one roof-tree!

Undoubtedly these seventeenth and eighteenth century farmhouses are a response to the harsh uncompromising environment of the fells; the thick stone walls and heavy slated roofs defied the strong winds and driving rain and the hallan and mell passages ensured a relatively draught-free snugness around the hearth. James Clarke, the Penrith surveyor

and author, commenting on recent changes in building styles in 1787, wisely noted:

> . . . *though I am willing to believe that modern fashions may have given more elegance to buildings, yet I am far from thinking that they have proved better in general for excluding either the wintry winds or the heats of Summer.*

But change was inevitable; in the eighteenth century, perhaps under the influence of new urban styles, utility was sacrificed to fashion and many farms were modified so that a door entered directly into the fire-house, perhaps protected by a newly-erected porch. At Townend, Troutbeck, a new entrance was made, the former hallan was converted into a long narrow pantry, and the down-house made into a kitchen. Similarly, the great hooded chimney canopies were removed and cast-iron ranges were installed; many of the carved bread cupboards which once graced Lakeland fire-houses found their way into provincial salerooms and now stand, somewhat incongruously, in the twentieth-century living rooms of 'off-comers', assuming a new value as antiques.

Yet, despite alterations and modifications, there are many farmhouses which, by their appearance and plan, indicate their origin. Glencoyne Farm, overlooking Ullswater, provides a good example. Built by the Howard family in or around 1629, it originally conformed to the statesman plan but in 1700, perhaps because of an increase in the size of the family, a pantry and kitchen were added at the rear and the original down-house was converted into a parlour. The two large cylindrical chimneys, common in Cumbrian farms, are notable features at Glencoyne. One piece of folklore suggests that by building in this shape the Devil is denied any corners around which to hide but a more pragmatic explanation suggests that, in the absence of good freestone, the local slates and

Drawings by Craig John based on Professor R W Brunskill's work.

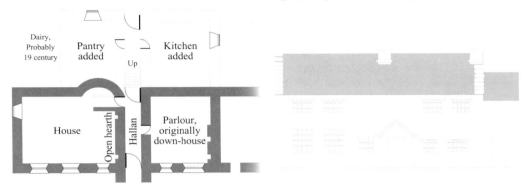

Plan and front elevation of Glencoyne Farm, showing the additions made in 1700.

A white roughcast exterior at a Caldbeck farm about 1900.

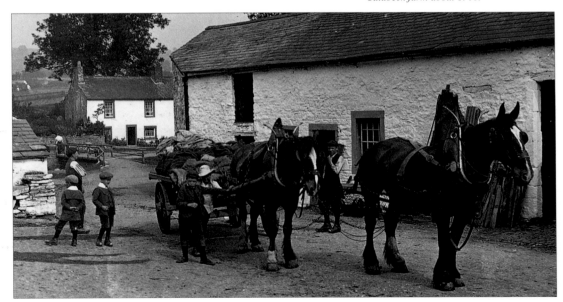

Cumbrian farms, are notable features at Glencoyne. One piece of folklore suggests that by building in this shape the Devil is denied any corners around which to hide but a more pragmatic explanation suggests that, in the absence of good freestone, the local slates and shales lent themselves to this shape rather than to the square corners of more conventional chimneys.

Like so many Lakeland farmhouses, Glencoyne has a white, roughcast exterior; the reason is practical rather than aesthetic for roughcasting was a method of weatherproofing the external walls. Barns and byres do not require this treatment and therefore they stand in contrast to the farmhouses themselves. Wordsworth, in his *Guide to the Lakes* roundly condemned the practice of whitewashing farmhouses, arguing that:

. . . five or six white houses, scattered over a valley, by their obtrusiveness, dot the surface, and divide it into triangles, or other mathematical figures, haunting the eye, and disturbing that repose which might otherwise be perfect

Few would agree with him today, and it is just as well he cannot see the blushing pinks and apple greens which adorn the walls of some Cumbrian farms.

Sir Hugh Walpole used Derwent Farm at Grange-in-Borrowdale as the setting for the Christmas feast in his novel *Rogue Herries*:

In Peel's house the hallan opened straight into the 'down-house'. This was in his case the great common room of the family, the place of tonight's Christmas feast . . . The floor tonight was cleared for the dancing, but at the opposite end trestle tables were ranged for the feasting . . . In other parts of the room were big standard holders for rush lights. All these tonight were brilliantly lit and blew in great gusts in the wind . . . Many were already dancing. It was a scene of brilliant colour with the blazing fire, the red berries of the holly glowing in every corner, old Johnny Shoestring in bright blue breeches and with silver buckles to his shoes perched on a high stool fiddling for his life, the brass gleaming, faces shining, the stamp of the shoon, the screaming of the fiddle, the clap-clap of the hands as the turns were made in the dance – and beyond the heat and the light the dark form of the valley lying in breathless stillness, its face stroked by the fall of lingering reluctant snow.

Many Lakeland farms were completely reconstructed during the period 1640 to 1750 but others were only partly rebuilt. In the case of those farmhouses which were grafted onto pele towers, those massively-built refuges against Scottish raiders during the border troubles, the towers still remain and are often used as extra storage space – as at Kentmere Hall, Wraysholme Tower, Cartmel, and the remote Yewbarrow Hall in Kentmere. At Cowmire Hall in the Winster Valley, the sixteenth-century tower has been incorporated into the domestic building.

Farm Buildings

By the middle of the seventeenth century the cruck building of farmhouses ceased. There are virtually no unaltered examples of such houses but several barns built in the same manner do remain. Stickle Barn near Broughton Mills and the barn at Wall End, Great Langdale, have soaring skeletal boat-like structures.

Cruck-built barns are found outside the Lake District but the so-called 'bank barns' or ramp-entrance barns are almost entirely confined to Cumbria and parts of the Yorkshire Dales. Built on a natural or artificial slope, bank barns have an entrance

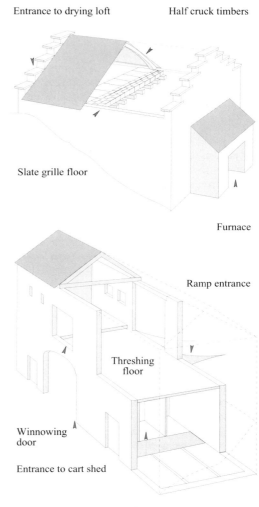

Entrance to drying loft Half cruck timbers

Slate grille floor

Furnace

Ramp entrance

Threshing floor

Winnowing door

Entrance to cart shed

Bryes

A corn drying kiln at Low Hartsop and a typical Lakeland bank barn.

Drawings by Craig John based on Professor R W Brunskill's work.

and Ellinor Browne in 1666, is a splendid example.

Although the origins of this building pattern are obscure, it is intriguing to find that such barns are also found in Western Norway, Switzerland and Pennsylvania. Many bank barns had a threshing area on the upper floor where corn was threshed and 'deeted' in an ingenious way prior to the invention of the threshing machine. Opposite the massive ramp-entrance doors was a smaller winnowing door which, when opened, allowed a strong through-draught of air. After flailing, the grain was tossed from a 'weyt' or shallow dish made of sheepskin into the draught and the lighter chaff was carried away while the heavier grain fell to the floor.

The short and frequently wet growing season in the fells meant that cereal crops often had to be harvested damp or not at all. Corn-drying kilns were therefore once relatively common buildings in farming communities and were probably used jointly by the inhabitants. Low Hartsop near Patterdale has a fine example, believed to date from the sixteenth or early seventeenth century. This small, square-shaped building is constructed on a steep hillside, the entrance to the furnace being on the downside while the door into the drying chamber or loft is located on the higher side of the slope. The floor of the drying chamber is formed of slates set edgeways, with spaces between each slab to allow warm air from the fire below to circulate. The damp grain was spread on a horsehair blanket stretched over the slate grille.

Lakeland's much-photographed 'spinning galleries' have been the subject of recent investigation. Often created when the roof was carried beyond the wall, these wooden galleries provided useful storage space under the eaves; unfortunately the term 'spinning' gallery is misleading since it gives the impression that the spinning of wool was the only activity undertaken. Undoubtedly, on fine warm summer evenings the thrifty Lakeland housewives made max-

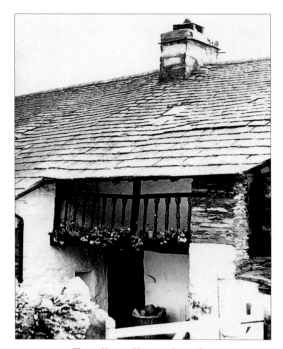

Thorn House, Harstop, has a fine 'spinning gallery'. Undoubtedly serving many purposes, the name derives from summer activities when yarn was spun and cloth hung to dry here.

imum use of daylight, and yarn was spun by distaff and wheel and, later, the cloth was hung after finishing. But the galleries had additional uses. They gave access to the upper floor and here, too, peat fuel might be stored as well as various articles of farm equipment. Although there are exceptions, many galleries face north; a theory recently advanced suggests that in several cases the wool room or barn for the storage of fleeces often lay behind the galleries and below were

the sheep pens. At 'clipping time' the fleeces would be thrown up to a helper on the gallery who would stack them in the adjacent wool room. Clipping was a notoriously long and sweaty business and was best done in the shade – which of course was possible if the pens and the galleries were located on the north side of the barn.

In some instances the galleries are part of the farmhouse as at Hodge Hill and Pool Bank in the Winster Valley. Elsewhere the galleries form part of an outbuilding as at Yew Tree Farm, Coniston, perhaps the most photogenic of the 'spinning galleries'.

Dated stones

The limestones and sandstones which form a broken ring around the high fell country provided a good source of freestone and dated lintel stones are frequently found in these areas. However, the hard volcanic rocks of central Lakeland were not satisfactory and therefore stone for dated lintels often had to be imported – or the date of the farm might be carved into a spice or breadcupboard door. The bank barn at Townend Farm, Troutbeck, has a window lintel which bears the date 1666 – but this has been fashioned from a balk of oak timber.

Evidence from dated stones has to be treated with a degree of caution for sometimes stones from earlier buildings have been set into later constructions. South End Farm on Walney Island has no fewer than three, each retrieved after coast erosion had destroyed earlier farms! Similarly, the stone at Townend, Troutbeck, bearing the initials GB and the date 1626 has been re-set into a part of the house which is later than that date. At Crakeplace Hall in the West Cumbrian parish of Dean, a sandstone block carries the date 1612 and announces that *'Christopher Crakeplace built the same when he was servant to Baron Altham'* but it has been re-sited in a later porch.

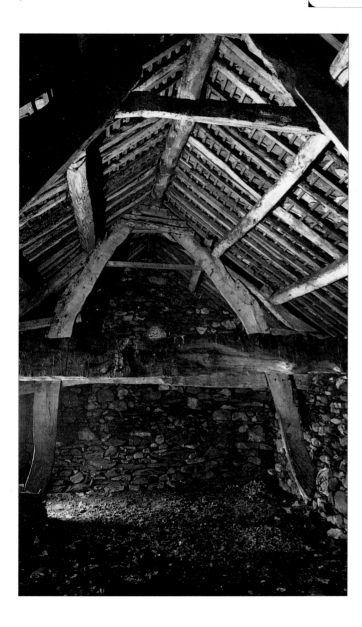

Stickle Barn near Broughton Mills (left) and the barn at Wall End, Great Langdale (right) have soaring skeletal structures, which resemble an upturned boat and are excellent examples of building around a cruck frame.

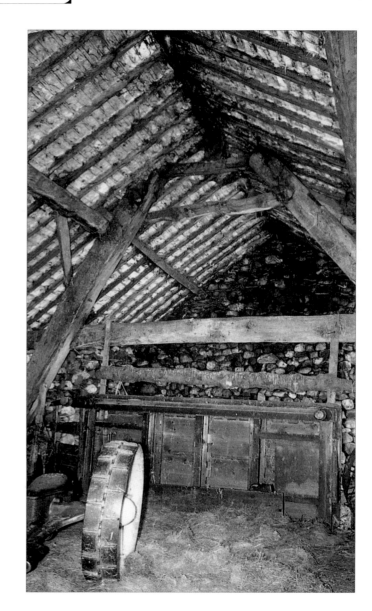

Sixteenth-century dated stones are not as common as those in the following centuries which makes the inscription on the small Elizabethan manor house, Hewthwaite Hall, near Cockermouth, all the more interesting. Arguably the finest carved and painted lintel stone in Cumbria, it bears the legend:

John Swynbun esquire and Elisabeth his wyfe
Did mak coste of this work in the dais of ther lyf
Ano Dom 1581 Ano Reg 23

A somewhat more cryptic inscription, in rhyme, is set into the wall of what had once been a penny ale house at Hutton Moor End near Threlkeld. It records:

This Building's Age
These Letter Show
MDCCX1X
Though Many Gaze
Yet Few Will Know

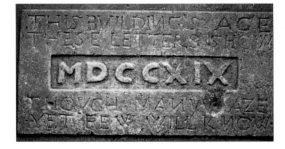

Some dated stones indicate the occupation of the owner of the house or building; at Randle How, Eskdale Green, once an important centre on the pack-horse route from Broughton to Cockermouth, the lintel of a cottage indicates that the original owner was a blacksmith and the hammer, horseshoe and pincers of his craft are shown here together with the initials IN and the date 1679. These are the initials of John

Nicholson, the seventeenth century blacksmith who carried out his trade here. The same symbols and the date 1697 appear on a similar stone set into the wall of a building at Oxen Park in the Furness Fells.

JN (John Nicholson) was the village blacksmith at Randle How, Eskdale Green, in 1679.

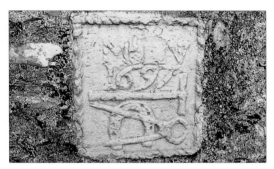

At Oxen Park, High Furness, the blacksmith's insignia is built into a wall.

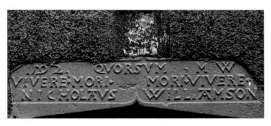

A lintel stone with the date carved in relief at Millbeck, near Keswick.

A Puzzling Portal

A door lintel in the village of Shap bears the strange inscription

Tho. Cooper A.M. 5815

Was Thomas Cooper a Master of Arts (Artium Magister) of either Oxford or Cambridge? Or perhaps the letters stand for Anno Mundi, an obscure reference to the seventeenth-century Bishop Ussher who computed the year in which the world was created by God. The good Bishop arrived at the conclusion that the year in question was 4004 BC; therefore to determine the date of the lintel it is necessary to subtract 4004 from 5815 – leaving 1811.

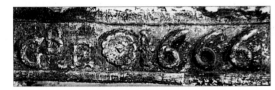

The barn at Townend, Troutbeck, has a dated window lintel carved in oak.

1738 inscribed into a date stone at a barn in Far Easedale, near Grasmere.

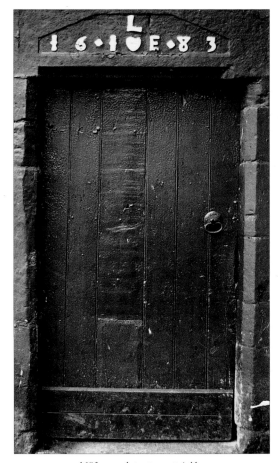

1683 on a date stone at Askham

By the eighteenth century the practice of carving dated lintel stones had declined; the technique of carving dates in relief gave way to a new method of inscribing letters *into* the stone. This art of rustic lettering continued into the nineteenth century but never achieved the popularity of the seventeenth century.

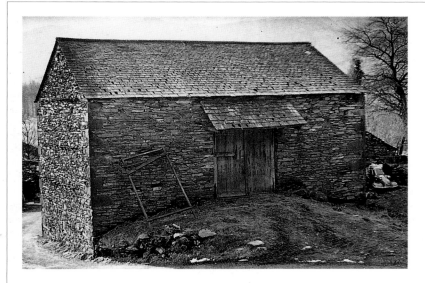

A bank barn at Holme Ground, Tilberthwaite, near Coniston.

Farm Buildings and Lakeland Weather

. . . the rain and cloud of the Lake Country are all-powerful and on the buildings, the farms, and the outbuildings . . . the weather has set the imprint of its wild centuries of storm. The farmhouse characteristic of the district is nowadays, and has been for the past two or three centuries, built of stone, probably quarried within a few hundred yards from the site or, in the case of the older buildings, brought from the nearest stream bed. The walls are at least two feet thick, with an outer and inner facing of good-sized slabs and a filling of smaller stones. The slabs are inclined so that they dip outwards and thus any rain that might drive into the wall drains away, and in all the older houses, built with dry walls owing to the scarcity of lime for mortar, as an additional precaution against wet the outer walls were covered with a layer of plaster, generally white. . . . These thick stone walls keep the houses warm in winter and so pleasantly cool in summer that to enter one from the heat of the dusty roads is like stepping into the coolness and shadow of a cave, while all sorts of intriguing cupboards are tucked away in the thickness of the wall, cupboards with carved oak doors, black with age, and bearing sometimes the initials of the farmer and his dame who built them a stone house, on a site as old as their 'fore-elders', when the Scots ceased troubling long ago'.

Miss E.M.Ward, *Days in Lakeland*, 1929

Hearth and Home

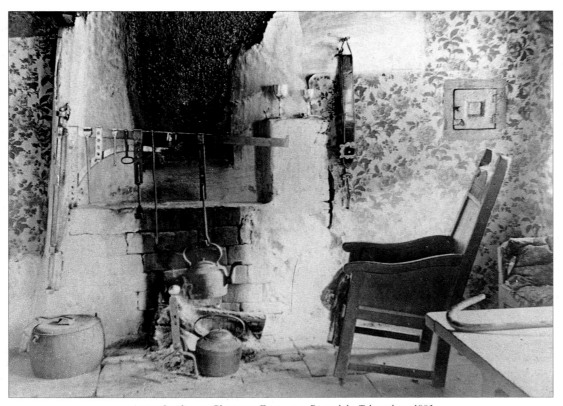

A cosy fireplace at Glencoyne Farm, near Patterdale. Taken about 1903,
this photograph shows an open fire complete with fire crane,
rattencrooks and fire-dog, and a spice cupboard.

Along the Atlantic seabord of Europe, in areas of damp and often cold climates, the hearth was not only necessary for the warmth, comfort and well being of the family, but also essential for the preparation of food. Not surprisingly, then, the terms 'hearth' and 'home' became synonymous and in countries such as Ireland, Scotland, Wales, the Isle of Man, Iceland, and parts of Scandinavia there were long-standing customs associated with the careful tending of the fire.

In the Lake District, even in the nineteenth century, there was a well developed hearth cult, a tradition that hearth fires must be kept burning in remote farmsteads. In 1864 Dr A C Gibson claimed that hearth fires in Parkamoor and Lawson Park, two isolated farms high above Coniston Water, had not been extinguished for centuries, and it was a common boast that farmers had fires originally lit by their grandfathers. It might be argued that it was easier to maintain a slow-burning peat fire than to repeatedly re-kindle a fire using a flourice (iron striker), flint and tinder but it has to be acknowledged that this hearth cult underlines the almost mystical significance of the fire which came to symbolise the spirit of the house.

In many old Lakeland farmhouses, under the great chimney smoke hood, the hearth was paved and usually raised a few inches above the level of the floor. This arrangement seems to have been suitable for the burning of peat and wood such as tree roots and ash tops which will burn with a minimum of draught.

Fire furnishings

In the nineteenth century when coal became more commonly available, hob grates and cast-iron ranges – the Agas of their day – replaced many open hearths. The rannel-balk and the hanging chains were superseded by iron fire-cranes which swung across the fire. From these were suspended adjustable pot-hangers,

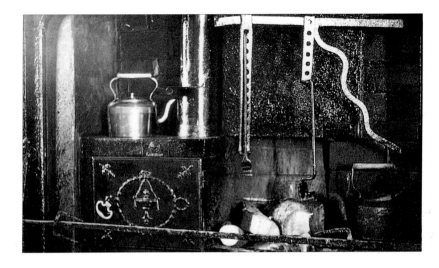

The kitchen range on the left is the eighteenth-century cast iron range in the down-house at Townend, Troutbeck.

A cottage fireplace in Ambleside in 1841 (detail from an original painting by W Collingwood in the Ruskin Museum at Coniston).

known as rattencrooks. Most of the hearthside equipment was made of iron. A schedule of goods belonging to the late Mrs Elizabeth Sharpe of Troutbeck in 1802 contains a special section devoted to 'iron furniture' which included:

two pairs of Tongs, one Fireshovel, one Fire poaker (sic), one Box smoothing Iron, two heaters and Iron stand, one Fire Crane and crooks, one copper kettle and cover, one pr. of snuffers and one corkscrew.

Before the introduction of cast-iron ranges, one of the most common pieces of equipment was the iron fire-dog; a pair of these prevented the fuel rolling into the room and, in addition, they lifted the logs slightly from the hearth so allowing them to burn evenly. Some hearths boasted a cooking spit on which large joints of meat could be roasted in front of the fire – a fine example is still preserved at Townend, Troutbeck. In smaller, less affluent farmhouses meat was boiled in large iron pots. Toast-dogs, however, were univer-

sal in Lakeland farms. No two are alike but essentially they consist of a tripod to which was fastened an iron bar, sometimes adjustable in height, fitted with spikes or prongs onto which food was fixed for toasting before the fire.

Among the most versatile of fireside cooking implements was a bow-handled frying pan which was suspended from a rattencrook; collops or slices of meat could be cooked in the usual way but, if an iron ring two or three inches deep was placed inside the pan to increase the depth and a lid was popped on the top, the pan could be used for baking wheat bread. A variation on this piece of equipment was the kail pot or pot-oven, a small cast-iron cauldron and lid which could be used to boil meat. If placed on a peat fire on its three short legs and then covered completely with glowing peats, it, too, could be used to bake pies, cakes and wheat bread.

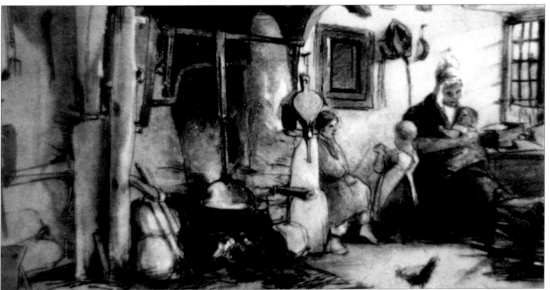

Haver bread

Although wheat bread was occasionally baked, within the damp fell country oats was the staple bread grain and the unleaven haver bread – from the Old Norse word 'havre' meaning oats – would keep for many months. The alternative name 'clap bread' describes the manner in which the meal and water dough was clapped or beaten on a wooden board until it was paper thin. The equipment used in the baking of haver bread was simple but effective – usually there was a circular iron girdle about 26 inches (660 cm) in diameter; this was either set on a brandiron or brandreth, an iron tripod, and placed over the fire or, if it had a bow handle, it was suspended from the rat-tencrook. The thin oat cake was gently slid from the board to the girdle and cooked until golden brown. In some farms, large 'bakstones' consisting of a slate slab and a fire box below were located in the down-house but few examples now remain.

The baking of haver bread often occupied a full day and sufficient was baked to satisfy the needs of the family for one or two months. The bread was stored in the carved oak cupboard which formed such a prominent part of the fire-house. Sadly, the once-traditional haver bread is now no more than a gastro-nomic curiosity; by the end of the nineteenth century cheap wheat arrived from the New World and long-established eating habits changed forever.

Some farmhouses had ovens built into the wall next to the fireplace; usually constructed of handmade bricks, they were circular in plan and corbelled. The door was about a foot square and to bake in such an oven required lighting a fire to heat the interior after which the fire was removed and replaced by the food. Then the door was closed until the baking process had been completed. The introduction of cast-iron ranges meant that these primitive ovens were obsolete and most were destroyed though one or two still survive.

One of the best is at the detached down-house at Brotherilkeld Farm in Eskdale.

The fire-house was generally furnished in a simple manner; as well as the built-in bread cupboard, sconce and huge oak table already described, there were often one or two chairs fashioned from hollow tree stumps. In the houses of more affluent dalesmen solid oak chairs with intricately carved backs and sides were common. By the eighteenth century 'thrown' chairs, in which the balusters were thrown or turned on a lathe, made an appearance and quickly became prized possessions. Bedsteads, too, were elaborately carved and often bore the initials of the farmer and his wife. Some of the finest examples are to be seen at Townend, Troutbeck, where the Browne family frequently carved their own furniture.

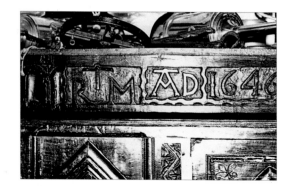

This bread cupboard, intricately carved in 1646, was originally made for Ashlack Hall, High Furness but was later moved to a farm in the Lickle valley.

Until the late eighteenth century most tableware was either turned in wood or fashioned in pewter. As late as 1811 the diarist William Fleming was able to record of his own parish in Furness:

In this parish, within my remembrance, the most opulent families generally used trenchers made of plane tree, and on holidays or when they feasted their friends or neighbours, pewter plates and dishes were sometimes used on the table, wooden piggins or cups were in general use for milk or beer.

Piggins, about the size of a large breakfast cup, were made of short staves with one stave left longer than the rest to serve as a handle.

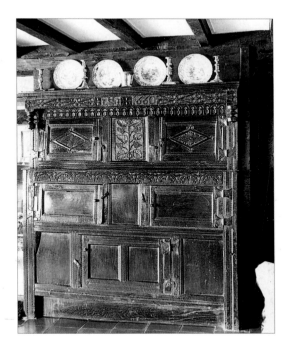

This beautiful carved oak bread cupboard, dated 1660, is at Lanehead in Patterdale.

Lighting

Until the nineteenth century when paraffin lamps became common in wealthy homes, most Cumbrian farms were lit by rushlights and tallow candles. The candles were made by repeatedly dipping the wicks into molten tallow – a smelly and laborious business. By the eighteenth century most farms possessed tin candle moulds which speeded up the process considerably. Rushlights were the cheapest form of illumination and almost every farm made its own. The basic materials were rushes *(Juncus conglomeratus)* and bacon or mutton fat. The rushes, known as sieves, were cut in late summer or early autumn when they were tall and plump. Back in the farmhouse they were carefully peeled, leaving a thin strip of green rind to support the white spongy pith. Nothing was wasted and the peelings were made into besoms or woven into small mats or 'bears' which served as a floor covering. After dry-

ing, the sieves were passed through hot fat – mutton fat was preferred since the resulting rushlights gave a clear constant light which did not sputter or smoke but bacon fat was also used. Clearly, rushlights were very fragile and they, and the tallow candles, were kept in a cylindrical tin 'candle bark' which could be fixed to the wall, the hinged lid having the added advantage that it prevented mice and rats making a meal of the contents.
. . .

The secret of burning rushlights lay in fixing them in a holder at an angle of forty-five degrees – if too vertical the light burned dimly; if too horizontal it burned too quickly and dripped. The crudest form of holder was merely an iron bar fixed at one end into a wooden base and at the other end slightly split to form a V shape into which the rushlight was wedged at the appropriate angle. More sophisticated holders operated on the pincer principle, one arm being held by a counterweight or spring to hold the pincers together

and so grip the rush. Other holders combined pincers for rushlights and sockets for tallow candles; the variety and ingenuity of such implements is enormous for they were not mass produced but made by hand, probably by local blacksmiths. Some farms had 'standarts', adjustable candle and rushlight holders which stood on the floor. One writer in 1822 describes them:

> . . . a light, upright pole, fixed in a log of wood, and perforated with holes up one side, in which a piece of iron, bent at right angles and furnished with a socket for holding tallow candles, and a kind of pincers for rushes, was moved upwards and downwards as convenient.

In the more affluent households a much-prized grandfather clock made by one of the famous Cumbrian clockmakers – Jonas Barber of Winster or John Braithwaite or Samuel Burton of Hawkshead – would hold pride of place in the fire-house. Occasionally there would be a small loom on which the womenfolk wove cloth for the family and, by the late eighteenth century, the spinning wheel had become common – though it was relatively late arriving in some Lakeland dales and the ancient method of spinning by distaff lasted in some places until the nineteenth century.

Most of the carding, teasing and spinning of wool would have been carried out during the long winter evening by the dim light of candles and rushlights but the Brownes of Troutbeck, and no doubt other families, had a simple but effective method of increasing their candle power – a glass globe was filled with water and placed in front of a candle; the light rays passing through the globe were concentrated on the other side.

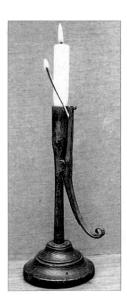
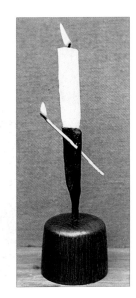

Most Cumbrian farms were lit by rushlights and tallow candles. Even in the wealthier homes paraffin lamps did not became commonplace until the nineteenth century.

*Far left
Candle and rushlight holder, Borrowdale.*

*Left
Candle and rushlight holder, Hawkshead.*

*Right
A tinder box and candle holder with a flourice (striker) and flint.*

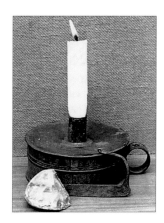

Down-House and Buttery

Most of the heavy domestic work such as washing, brewing and pickling was undertaken in the down-house. The main items of equipment were the set-pot for washing clothes and the bakstone, used as an alternative to the girdle when large quantities of haver bread were baked. In a loft above, the huge oak kists or arks held the oatmeal and barley, and here, too, the malt mill, a quern-like instrument, would be found. In addition there was a wide variety of of utensils and implements used in the preparation of food – the great mash vat for brewing, the souse tub which held the brine or sour whey for pickling, the scummer, a long-handled spoon for skimming the salt meat boiling in the cauldron, the cockle pan – all would be bewildering to the modern cook and these items are generally now seen only in folk museums.

Nineteenth-century butter churn

Although dairying was never as important in the Lake District as it was in some parts of the Yorkshire Dales, most farmsteads made butter and cheese for household use, although occasionally one or two farms also produced cheese for sale in markets. At Borwick Ground, Hawkshead, an 1818 sales book lists thirteen items of cheese, ranging from 10lbs to 12lbs, each of which were sold at $5^1/_2$ pennies and $6^3/_4$ pennies per pound. . . .

Wang cheese

Blue or skim-milk cheese was commonly found on Lakeland tables; this was known as wang cheese because it was so tough that it was possible to make wangs or leather shoe laces from it – or so the story goes . . . The Whillimoor area of West Cumbria was famous for its Whillimoor Wang which, when sold in Carlisle market was described as 'lank and lean but cheap and clean' – a slogan which was commendably honest.

Cheeses were pressed wherever the cheese press could conveniently be located and often this meant under some tree near to the farmhouse. The curd was wrapped in a linen cloth, placed in a cheese rim, a circular wooden frame of coopered staves, and a heavy stone suspended from the tree was lowered onto it to press out the water and form a solid cheese. In the nineteenth century presses operated by screw threads were introduced which in some ways were more efficient but they also required more attention since the screw had to be constantly tightened as the curd shrank. Wang cheese, however, was not pressed; the

curd was kneaded, placed in muslin bags, soaked in brine and then hung up to air-dry.

Cattle were often milked in the fields and the milk brought to the dairy in wooden pails supported by a wooden yoke or in a 'back-can', a tin container shaped like a rucksack. After the milk had settled the cream was skimmed off and allowed to ripen before it was churned. The usual butter churn was either a simple 'up and down' churn or a box churn but by the nineteenth century the oval coopered churn had begun to supersede the earlier models, as pointed out by William Close, the Furness apothecary, in the early nineteenth century:

. . . an oblong [or] square box closed by a cover and furnished in the inside with a winged agitator which is turned round on a horizontal axle by a winch or handle on the outside, and performs the operation of churning by dashing through the cream. The square churns are put together with nails and commonly made by joiners; but there is an oval kind made by coopers and hooped with iron, which begins now to obtain the preference over the others as tight in the joints and likely to be more durable.

Experienced butter makers could tell by the noise within the churn the exact stage the process had reached. When the butter had formed, the buttermilk was allowed to drain away, cold water was then used to wash the butter and then salt was added to form brine. Finally the butter was 'worked' to extract any remaining water before being divided into portions using 'Scotch hands' made of box wood.

The churning of butter was a notoriously fickle activity, often dependent on weather conditions, consequently the whole operation was steeped in superstition and folklore. It was firmly believed – even in the nineteenth century – that cattle could be bewitched (see page 95) in which case the cream

would not turn to butter. Fortunately several remedies were available: a naturally-holed dobby stone hung over the heads of the cattle would ward off the evil eye (see page 49). Alternatively, a twig of rowan could be used to stir the cream and, if all else failed, a garland of rowan leaves around the churn was a sure antidote to witchcraft. It is mildly disappointing, then, to discover that there was a scientific explanation for the difficulties experienced in churning butter – it largely depended on the butterfat content of the milk which, in turn, depended on the type and condition of the pasture on which the cows grazed.

Today a little butter and cheese is still made on Lakeland farms but the bulk of the surplus milk and

The Dairy, c. 1906

'I used to help with the milking
when the men were very busy in the fields.
I used to bring the cows in out of the fields
and fasten them up and then get on with it.
I used to love the sound of the milk in the
buckets. I was lucky, I never got knocked
over but I did have one put its foot in my pail.
After we'd finished I took the milk indoors
and into the dairy where it was put through a
strainer into bowls. The milk stood there for
three meals as we called it, morning, night
and morning again, then the cream was taken
off the first lot and a fresh lot was stood in its
place and that's how it went all year round.
The cream was put into deep creampots and
kept for a week and then churned and made
into butter – we only kept what we wanted
for our own use, the rest went to the
grocers in Penrith.'

Mrs Isabella Cooke *A Hired Lass in Westmorland*

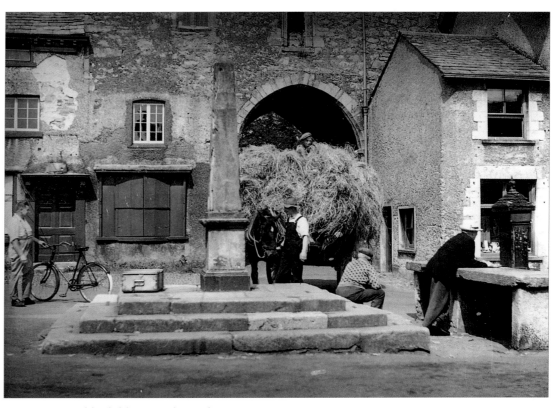

Farm and family life continued to revolve around the seasons. Here hay is still being carted through the medieval gatehouse in Cartmel in the 1950s.

cream from farms near the holiday centres of Windermere, Ambleside, and Keswick finds its way to the great processing plants where – one assumes – the risk of witchcraft is slight.

It is too easy to romanticise the life of a Cumbrian dalesman a hundred and fifty years ago; it should be remembered that 'making ends meet' was frequently a struggle, that life expectancy was short, that the standards of living and comfort were far from what would now be deemed adequate. Yet, in the dark and sometimes draughty fire-house, the most comfortable warm refuge was the hearth which, despite the smoke and the hallan drop, remained the focus of family life. Around the glow of the peat fire and the glimmerings of the rushlights, the traditions and folk tales of the Lakeland hills and dales were transmitted orally from one generation to the next.

Patients and Potions

In an age of antibiotics and anaesthetics, x-rays and fibre optic surgery, it is difficult to appreciate the dangers to life and health which our ancestors accepted as the norm. A difficult child-birth often resulted in the death of both mother and child; an infected cut could bring septicaemia, amputation and death; a badly set broken limb might mean laming and maiming for life. Such were the life-threatening hazards and, in the absence of doctors, the key philosophy in remote areas was self-sufficiency. It was essential to be able to treat the family, and the farm animals, with age-old remedies, passed down from one generation to another and often recorded in family 'commonplace books'. Although by the late nineteenth century most of the dales had a resident doctor, there were those who continued to rely on the herbal medicines and cures used by their grandfathers and great-grandfathers. Such 'hedgerow medicine' was a mixture of medically effective remedies and superstitious nonsense – white magic – but in some cases these primitive cures have survived into the twentieth century.

Fractured limbs, were, of course, commonplace in farming communities and the sufferer would frequently be treated by the local 'bone-setter' who had acquired certain skills, not only in the setting of limbs, but also in the manipulation of dislocated joints. Such men and women were valued members of society for they could treat not only human patients but animals as

well! Most bone setters used comfrey or 'knitbone', the beaten roots of the plant being spread on leather and laid on the afflicted limb to ease the pain. However, success was not always guaranteed and in difficult cases these amateur osteopaths were helpless.

The account books of Sir Daniel Fleming of Rydal Hall give a graphic insight into the problems of broken limbs, in this case the femur of his son, William:

1658 Aug.10			
Given unto George Brown of Troutbeck, a bone setter, when Will was hurt	£0	2	6
Aug. 11			
Given unto William Story of Seadgwicke near Sighser [Sizergh] bone setter – for looking at Will's thigh	£0	7	6
Nov. 12			
Given unto John Rawlings, a bone setter, for Will	£0	10	0

Sadly, the treatment was not successful and William Fleming remained lame for the rest of his life.

Charms and semi-religious magic played no small part in folk medicine; most areas could boast a 'wise man' (or woman) to whom the sick resorted in cases of haemorrhage, ague, jaundice or toothache. Usually texts from the scriptures were written on scraps of

paper and either buried in the ground or hidden in hollow trees. For toothache the charm had to be expedited by a mysterious pinch of the left ear of the sufferer! Clearly, these 'cures' were psychosomatic and it would be unwise to entirely dismiss their potency:

To stop bleeding in Man or Beast at any Distance, first you must have some Drops of ye blood upon a Linen Ragg and wrap a Little Roman Vitrioll upon this Ragg put it under your oxter [armpit] and say these words thrice into yrself 'There was a Man Born in Bethlehem of Judea Whose name was Called Christ – Baptised in the River Jordan in the Watter of the flood and the Child was meak and good and as the watter stood So I desire thee the Blood of Such a person or Beast to stand in their Bodie, in the name of the father son and Holy Ghost Amen'. Then Look into the Ragg and at that moment the Blood stopeth the Blew powder is Turned into Blood by sympathy.

An eighteenth-century formula used to stop a haemorrhage at Bull Close Farm, Skelwith Bridge, near Ambleside

A surgeon's handbill

ROBERT CHARNOCK, Surgeon, Apothecary, and Practitioner of MIDWIFERY, Begs leave to inform the Public, that he has opened a Shop for the retail of Drugs and Medical Compounds, at BOOTLE; and hopes to merit encouragement, by a careful and assiduous attention, to the welfare of his patients. G. Ashburner, Printer.

Gradually, the pseudo-religious element in folk
medicine declined but many of the remedies retained
their curious mystical character. Elizabeth Birkett's
late seventeenth-century commonplace book contains
a wealth of such strange remedies and potions. For *'the
falling sickness'* the sufferer was subjected to a brew
comprising the dried and powdered intestines of three
goslings in *'a draught of ale without Hops'*. *'Stone and
gravel'* was cured by a dose of warm white wine to
which had been added the powdered roots of nettles.
For a headache, the brow of the afflicted person was
soothed with an infusion of marigold flowers and dis-
tilled water, after which it was recommended that the
patient be allowed to sleep *'if he can'*.

To stop a nose-bleed she recommends taking . . .
*the blood of the patient and therewith write on his
brow these words 'consummatum est'.*

But perhaps her most bizarre remedy was for a fit of
the ague:

Take a spider and lye it quick [alive] in a cloth and
hang it about the party's neck, they not knowing
about it, and take it away when the fitt is over.

Toothache, whooping cough and warts

Until the twentieth century, excruciatingly painful
toothache must have been one of the most feared
afflictions. But those living in the Hawkshead area
were fortunate for it was widely believed that if suffer-
ers made a tooth stopping from the wood of the stump
of the local ancient gibbet or gallows, they would be
soon cured. In some areas it was believed that to
improve the teeth of a child it was wise to rub them . . .

. . . with the brains of an Hen
or let a Horse breathe into the Child's Mouth
twice a day, which may prevent convulsive fits.

Whooping cough seems to have been a common
ailment and there are many curious cures. Passing the
sufferer under the belly of a donkey was thought to be
effective but at Skelwith Bridge the potency was
increased by riding the patient across the bridge with
his face to the animal's tail! Elsewhere, mouse pie or a
mouse hung round the neck was believed to have the
desired effect, as was taking the person into 'an under-
ground excavation'.*The English Lakes Visitor and
Keswick Guardian*, 2 February 1878 reported that:

*An old fisherman, formerly well-known at the Forge,
Keswick, once caught a fish, which he put into the
mouth of a child suffering from whooping cough. He
then replaced it in the* [river] *Greta. He affirmed that
the fish, after being placed in the mouth of the child
and returned to the river, gave the complaint to the
rest of its kind, as was evident from the fact that they
came to the top to cough.*

It is clear that such superstitions did exist in
Cumberland and continued to surround whooping
cough well into the twentieth century. In the 1930s
children were 'treated' by being taken on a trip in an

aircraft. The less fortunate were taken to the local gas
works, stood by a retort and told to breathe deeply!
And I certainly recall following a tar machine, getting
clarted from head to toe with tar – but it cured my
whooping cough!

Cures for warts feature prominently in folk medi-
cine. Wart 'charmers' who visited the hiring fairs, were
much patronised as were those who would 'buy' warts
from the sufferer. A black slug rubbed on the wart and
then impaled on a thorn hedge was regarded as a sure
cure as was stealing a piece of meat from the butcher,
rubbing it on the wart and then burying it in the ground.
Others believed that two straws knotted together, put in
a linen bag and then dropped at the cross roads would
be effective. This was an anti-social remedy as the poor
inquisitive soul who opened the bag would certainly
acquire the wart! Rubbing the wart with a variety of
substances – apples, the milk from dandelion stems,
the fleshy leaves of House Leek *(Sempervivum tecto-
rum)*, tying a horse hair round the wart, even licking it
first thing in the morning – all these are remedies wide-
ly used today, despite the fact that they are evidently
psychosomatic rather than medicinal.

The King's evil

Perhaps the most widely-known psychosomatic reme-
dy concerned the tubercular affliction of the skin
known as *'the King's evil'* or scrofula. During the sev-
enteenth and eighteenth centuries it was widely held
that a touch from the reigning monarch would cure the
patient, hence the name.

The superstition had a long history: Edward the
Confessor certainly *'touched for the Evil'* and the last
monarch to do so was Queen Anne. After the
Restoration it became very popular and Charles II
touched 92,107 people between 1660 and 1682 – a
figure which included a number of Cumbrians. Many
parish account books record sums of money given to

parishioners to enable them to travel to London to be 'touched'. One of the earliest appears in the Crosthwaite (Westmorland) registers:

1629 14th Feby.

Given to John Rig of Staveley who hath the King's Evil to go up to be cured thereof 1s 0d

And the Grasmere Parish Records declare that:

We the Rector and Churchwardens of the Parish of Grasmere in the County of Westmorland do hereby certify that David Harrison of the sd Parish aged about ffourteen years, is afflicted as wee are credibly informed with the disease commonly [called] the King's Evill; and (to the best of our knowledge) hath not heretofore been touched by His Majesty for ye sd Decease. In testimony whereof wee have hereunto set our hands & seals
The ffourth day of ffeb:
Ano Do: 1684
Henry ffleming, Rector
John Benson and Jon Mallinson, Churchwardens
Registered by John Braithwaite, Curate

The ailment affected the highest and the lowest in society. The Fleming accounts record the following :

1669 October 2nd *Given unto my brother Roger towards his charges in going unto London to get the King's Touch for the Evil £10 0s 0d*

The practice of 'touching for the Evil' continued for an incredible length of time – from the eleventh century to the eighteenth. If it was not effective in some degree, why did it remain popular? Was it purely psychosomatic – or were there other factors?

Many eighteenth and nineteenth-century remedies relied for their potency on wines and spirits. In 1784 the Hawkshead Parish accounts record the expenditure of 1s 6d *'for one gill of Brandy and one quart of ale for Sarah Usher to stop the ague'.* In alleviating the ague, did this remedy also produce certain side effects? Spirits were not only used medicinally but also as the basis for various rubs and embrocations; William Fisher endorsed this strange prescription as being *'a perfect remedy for the whooping cough'*:

Infuse 2 Cloves of Garlic in a quarter of a pint (ale measure) of Rum for twenty four hours; rub the back and the soles of the feet of the person afflicted for three or four successive nights at Bed time; at the same time abstaining from all animal food.

Despite the peculiar method of application, this remedy was no doubt preferable to being passed under the belly of a donkey – and probably more effective!

Most of these folk medicines required ingredients which were readily obtainable in Lake District communities: flowers, plants, onions, garlic, honey, bees wax – even gunpowder!

For a burn or scald William Fleming in 1813 recommended using an . . .

. . . equal weight of coarse brown sugar and onions. Shred [and] beat them together in a mortar to a pulp which lay on the part affected and it will give immediate ease and take away the inflammation. In violent cases this poltice must be renewed once a day.

In the same year, William Fisher, suggested an alternative treatment for burns:

Take one pound of fresh sheep's suet; shred small and render nicly [sic] then boil in it Eight or nine heads of Garlic for half an hour then strain it and add to it two Ounces of bees wax and one pint of Linseed Oil so let them just mingle well together over the Fire as not to boil them; put into pots for use.

The eighteenth-century commonplace book of John Hall of Leasgill, near Heversham, mainly contains cures for sick animals but occasionally a 'human' remedy is recorded such as this one:

A plaster for Worms for a young Child

. . . take 1 head of Garlic, 1 sprig [of] rue, 1 thimble full of Gunpowder, 1 halfpenny worth of bitter alice [aloes]; heat well in a mortar, mix it with honey and spread it on leather or coarse cloth, lay it on the breast for 24 hours or according to the strength of the patient let it not get lower than the breast.

He also advocates as a cure for typhus fever a tablespoon of yeast in a gill of warm porter repeated every six hours until the fever subsides.

Elsewhere, sufferers from toothache who could not avail themselves of the stump of the Hawkshead gibbet could try this *'sovereign remedy'* – *camphor, ether and laudanum in equal quantities applied to the troublesome molar.*

At Seathwaite in Borrowdale graphite or Black Lead was mined in the eighteenth and nineteenth centuries.This unusual ingredient featured in local cures and as much as would lie on a sixpenny piece taken in

white wine or ale was regarded as a cure for *'the cholick* [and] *it easeth the pain of stone and strangury'*.

Goose grease seems to have been widely used as an embrocation; usually the fat from the Christmas goose was carefully bottled and later rubbed on the chests of children who were then sewn into brown paper waist-coats which were not removed until the spring. There are those alive today who can vouch for the efficacy of this treatment – though it probably did little to foster their social lives.

Even in the eighteenth and nineteenth centuries, men and women who professed a degree of medical knowledge were much called upon though most did not confine their attention purely to medicine. John Walton of Patterdale exercised his skills as a drystone waller, joiner and tinsmith – but he also enjoyed an enviable reputation as a tooth-puller! Similarly, Samuel Relph, vicar of Sebergham, appears to have been the parish doctor as well as the local clergyman, for in one volume of the parish registers he recorded his remedy for lameness:

Take the yoke of a new-laid egg let it be beaten with a spoon . . . add three ounces of pure water, agitating the mixture continually that the egg and water may be well incorporated apply this to the part, cold or milk-warm by a Gentle Friction for a few minutes 3 or 4 times a day.

Taking the waters

Around the perimeter of the Lake District were a number of spas or wells which were thought to possess healing properties. Although none rivalled the fame of Buxton, Bath, Harrogate or Cheltenham, nevertheless they attracted their own clientele. Gutterby, south of Bootle, was much visited in the eighteenth century and by 1777 Shap Wells had *'been found serviceable in scorbutic disorders'*. At Witherslack the farm name

Some twentieth-century Cumbrian folk cures
(known to have been used in the first half of the century)

For Chest Complaints
Smear mustard between two sheets of brown paper and tie around the chest
or . . . Rub with warmed pit candles
(in the iron mining district of West Cumbria)
or . . . Rub with Goose Grease.
For Chapped Hands *(kinns)*
Rub with warmed mutton fat
For Boils
Rub with castor oil or use a bran poultice
or . . . Fresh cow dung wrapped in clean muslin and bandaged over
For Barber's Rash
Pulp up wild rhubarb and rub on the face
For Styes on the eye
Rub with a gold wedding ring
For sore throats
A slice of bacon fat around the neck held in place by a woollen stocking
For chilblains
Half an onion dipped in sugar and rubbed on the affected place
For croup and coughs
Cut up a swede, cover with brown sugar. Leave overnight, then drink the juice
For sleeplessness
A pillow filled with balm (herb)
For spots in Spring
Blackthorn flowers, brewed

'Spa House' serves to remind us that this tiny settlement became a health resort for a short period while the water from the Holy Well at the base of Humphrey Head was *'celebrated for its curative properties in*

gout, bilious and cutaneous complaints'. Indeed, it was visited regularly by the Fleming family from Rydal Hall and in particular by the lead miners from Alston who believed that water would cure a variety of occupational ailments. Such was the power of the belief that even in the twenties and early thirties water from the well was sent in milk churns to Morecambe where it readily found a market on the Promenade!

Arguably the most famous of all Lake District spas was in the heart of the fells at Manesty in Borrowdale. Even in 1740 the salt spring there was visited by a procession of hopeful invalids who were convinced that *in Dropsical, Cachochymic, catchectic disorders; foulness of the Stomach, slipperyness of the Bowels from Relaxations, or much Mucus, some icteritious* [jaundiced] *disorders, it is of service to several.*

James Clarke, the eighteenth-century surveyor and author, claimed that the spring was:

a never-failing cure for cutaneous eruptions in man or beast by washing only. I attended it several years (but not of late) on account of rheumatic pains in my left shoulder about mid-summer, five or six years successively. It so cured me that I have not had the slightest touch of it these twelve years past.

Cures: toads, eels, leeches, moss and cobwebs

One wonders if Mr Clarke tried other cures for his affliction, for they were legion: an eel's skin wrapped around an arm or a leg was a powerful charm against rheumatism; a draught of comfrey tea was another, as was a living toad carried somewhere on the person, though a lump of brimstone, a potato, or a nutmeg might have been equally effective and less trouble-some. Alternatively, bee stings were supposed to have a remedial effect and many people still endorse this painful remedy – but perhaps on balance, and in view of the somewhat strange methods of application, Mr

Clarke was wise to stick to the medicinal salt water of the Manesty spring.

Blood letting, that old and much trusted remedy for all manner of ailments, was commonly applied. Sir Daniel Fleming in 1663 records the expenditure of one pound *'to Mr. Kenp for blooding me and other phisick'* but by the nineteenth century medicinal leeches had largely replaced the knife. In 1810 William Fleming complained that he had paid *'Half a Crown for the Bites of four Leeches'* but conceded that he had gained some relief after they had been *'set to bite on the back Part of my Neck and these Places allowed to bleed freely for 7 hours'*.

In some instances folk cures had an element of sound – indeed, advanced – medical practice. During the First World War, hundreds of Cumbrian children gathered sphagnum moss which, when dried, was used as a wound dressing on the Western Front since it is more absorbent than cotton wool and has antiseptic properties. Long before the discovery of penicillin, moulds were used in Lakeland not only for wounds and boils but also for infected or 'septic' throats, the patient being instructed to eat mouldy apples or cheese. Wounds and skin disorders were often treated with honey, a technique now applied to those who are allergic to antibiotics. And shepherds and farmers who accidentally cut their fingers when working still resort to a spider's web to stem the bleeding instead of applying the twentieth-century version, a sticking plaster.

Evidence suggests that in the coastal communities of North Lancashire and around the shores of Morecambe Bay, cod liver oil was used to treat rheumatism as early as the eighteenth century. Cod from the Bay were caught and gutted and the entrails left in a bucket until the oil rose to the surface; this was then bottled and taken internally for colds, chills and rheumatism. By chance, in the 1770s this remedy came to the notice of doctors at the Manchester Infirmary who tried it on chronic rheumatic patients with such success that some sixty gallons of cod liver oil were sent to the Infirmary every year. In cases where rickets was confused with rheumatism the results were even more spectacular since the oil is an antidote to that crippling complaint.

By the end of the eighteenth century the seeds of scientific medicine were beginning to blossom. As early as 1799, merely a year after Jenner had published the results of his experiments, vaccination against smallpox was introduced into the Furness area of Lakeland by a Dalton apothecary, Dr William Close. His experiments bore fruit and by the early nineteenth century the practice had spread to other parts. William Fleming of Pennington recorded in his diary in 1818:

In spite of the Vaccine Inocculation the Small Pox rages in Ulverston with deadly Violence and spreads fast among the Children there but I do not hear of any being infected who have been cut for the Cow Pox; however, its Efficacy in preventing the Small Pox will most likely now be put to the Test and many Doubts removed.

Indeed many doubts were removed, including those of Fleming himself who had his own children *'cut for the Cow Pox'*. Cholera, however, was another matter; medical knowledge was virtually powerless against the relentless spread of this killer disease and often drastic measures were taken to contain it. An entry in William Fisher's diary conveys the panic which broke out in a small agricultural community on the shores of Barrow Channel when cholera was detected in 1834:

Oct. Elizabeth the wife of Nickles Fisher of Little Mill Stile begun in the Cholera on the night of the 7 and died on the 8 her Grand Daughter residing with her begun on the 12 and died on the 13 Nicholas Fisher husband of the above Elizabeth Fisher begun on the 14 and died on the 15 a daughter took it a few days after but she recovered again it threw the country in to such an alarm it was thought nessary [sic] to prevent its further spreading to burn every article in the House the Clock alone was saved and it had the desired effect. I write this Dec 22 and there has not been another case the loss will be mad [sic] up by the Parish.

Travelling treatments

By the eighteenth and early nineteenth centuries, many Lake District towns were visited by travelling physicians, dentists and opticians who would ply their arts in a rented shop for a few days before moving on to the next town. Their stock in trade, as well as the manner in which they solicited custom, strikes the modern reader as curious. Mr J Davis of Glasgow, an itinerant optician, carried a wide variety of telescopes, landscape glasses, barometers, sextants, compasses, *'improved spectacles'* and *'A Large Assortment of Birds' Eyes'*!

Mr Telzifair, surgeon dentist, offered the public his:

New mode of constructing artificial teeth [which] *effectually supersedes the usual injurious and insecure fastenings by ligatures, wire, hoop and spiral springs*

Meanwhile a rival, Mr Summers, claimed to be:

The only Person in the Kingdom who can extract a Tooth even in the most decayed State, without Pain to the Patient.

Those who doubted Mr Summers' professional abilities could always wait for the next hiring fair where invariably there was a tooth-puller who would extract one's molars in the open air in front of a large crowd – but always accompanied by a small brass band which would strike up at the critical moment to disguise any distress signals the patient was making.

However, as well as these worthy and reputable gentlemen who visited the towns of Ulverston, Kendal, Penrith, and Keswick, there were other less

qualified individuals who can only be described as mountebanks or quacks. In many cases these characters were just as colourful as their remedies and potions: Sam Fitton, styling himself *'The Herb Planet Doctor'*, supposedly practised in the Keswick area in the seventeenth century and was a firm believer in the combined powers of herbs and the Heavenly Bodies. In the eighteenth century, James Mossop, or *'Pill Jim'*, travelled widely through the Lake District pedalling a somewhat potent herb beer which bore the sinister name *'Black Drop'* but which was much prized. Another nineteenth century itinerant physician, known only by the name *'Jackio'*, believed to be of Romany extraction, would perform minor surgical operation in a herb-strewn caravan. And ladies were not excluded from this select band – a woman charlatan calling herself *'The Mother Superior'* dispensed remedies such as toothache drops, baby tantrum powder, a nostrum called *'Green Fire'*, and *'Virgin Water'*, guaranteed to preserve that state in the imbiber!

The very fact that quacks like these continued to operate well into the nineteenth century indicated the conservative nature of rural Cumbrians and strong

Mr Ross assures the public that he does practise midwifery.

Crooks and Rattencrooks . . .

Eighteenth-century dales folk were aware of charms which would not only protect them from sickness but also would safeguard personal property. Christopher Birkett's commonplace book gives an example of a curse used in Troutbeck but sadly, the Latin couplet which forms the crucial element of the spell is difficult to decipher. However, below it is written:

If one have his house broken and Goods taken, and knowes not with whom, let him cut a peece of paper in the like form above marked, write those words thereon as above written, wrap up the Paper and prick several holes into it with a needle or pin, bind it about with threed and hang it in the rattencrook (fire crane), but so that it does not burn. And it may come to discover the Thiefe by being pricked in his Flesh.

Perhaps the curse will work if the victims add their own incantation? But first, find your rattencrook. . . .

Jack of all Trades?

Even in the twentieth century, many Cumbrians prided themselves on an ability to turn their hands to a variety of crafts and trades. In his book *Betty Wilson's Cumberland Tyals* [Tales], Tom Farrall recalls a signboard hanging from an oak tree near to a West Cumberland smithy which announced:

*Henry Dodd, a true born Quaker,
Bi trade a joiner, trunk an' clyas box-maker;
Can Mak a plew, a pair o' wheels –
in truth fit up car
As weel as enny udder man – at least varra nar!
Kills swine in winter, draws teeth frae coo er cob -
Aw thees he's match ta duah – or enny udder job.*

belief in the powers of herbal medicine and hedgerow cures. Even today this is not quite dead; there are many who prefer to put their trust in ancient cures rather than to seek help in some pharmaceutical preparation.

Travelling dentists and opticians rented temporary accommodation to sell their skills and stock in trade.

Cumbrian Cures

Ague

Secretly hang a live spider in a cloth around the patient's neck.

Toothache and tooth decay
Pinch sufferer on the left ear.
Stop the tooth with wood from the stump of the ancient gibbet or gallows at Hawkshead.
Rub a child's teeth with the brains of a hen.
Let a horse breathe into the child's mouth twice a day - which may prevent convulsive fits.

Whooping cough
Pass the patient under the belly of a donkey. . . .
Even better, ride the patient across Skelwith Bridge with his or her face to the donkey's tail.
Eat mouse pie or hang a mouse around the neck.
Go into an underground excavation or cave.
Take a trip in an aircraft.
Breathe in fumes from the local gas works.
Follow the road-tarring machine.

Nosebleeds
Write *consummatum est* on the brows of patients with their own blood.

Falling sickness
Consume the dried powdered intestines of three goslings mixed in a draught of ale without hops.

Headache
Soothe the brow with an infusion of marigold flowers and distilled water.

Wounds, boils or septic throats
Apply or eat (as applicable)
mouldy apples or mouldy cheese.

Warts
Rub a black slug on wart and then impale slug on a thorn hedge.
Steal a piece of meat from the butcher, rub this on wart and then bury the meat in the ground.
Knot together two straws, place them in a linen bag and deposit bag at the cross roads. The wart will be transferred to whomsoever finds and opens the bag.
Rub the wart with Apples.
Rub the wart with 'Milk' from dandelion stems
Rub the wart with House leek (*Sempervivum*) leaves.
Tie a horse hair around wart.

Lick wart first thing in the morning.

Rheumatism
Wrap an eel's skin around limb.
Arrange to be stung by bees.
Soak cod entrails in a bucket and drink the oil that rises to the surface – but it is easier to buy commercial cod liver oil!

Carry a live toad about your person – or carry a nutmeg or a potato.

Wounds
Dress with dried spagnum moss or with spiders' webs.
Treat with honey.

'Stone and gravel'
Take a dose of powdered nettle roots mixed into warm white wine.

General treatments
Apply leeches.
Write out extracts from the Bible and hide these in hollow trees or bury them in the ground.

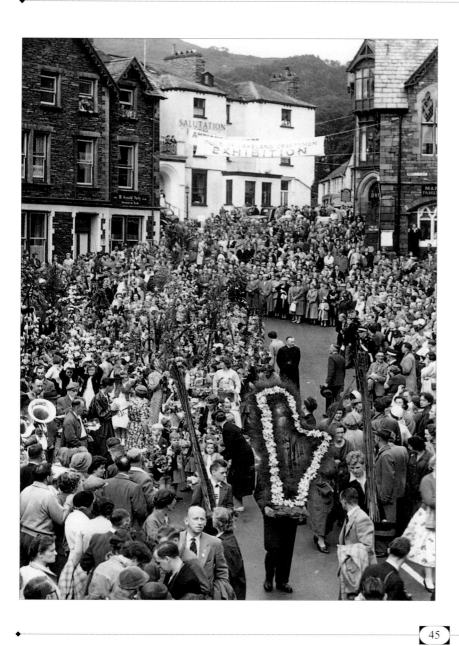

Rush-bearing celebrations at Ambleside

Customs and traditions

Not surprisingly, folk customs and traditions die hardest in remote upland areas such as the Cumbrian mountains. In several instances these traditions are shared in common with Norway and the 'Celtic fringe', perhaps a legacy from the Norse settlers who colonised the Hebrides, western Scotland, parts of Ireland and the Isle of Man. In other cases the customs seem to be confined to the Lake District but one thing is certain – they all appear to have their origins far back in history, though many are no longer maintained.

Wedding Customs

If the church was not too distant, the bride and groom often walked to the ceremony, preceded by the village fiddler – a custom which is still respected in parts of Norway. During the service it was customary – and still is in certain Lakeland villages – for the local boys to *'snecken oop yat'*, that is to tie a rope across the church porch which was unfastened only when the bridegroom had 'shelled out', or distributed small change amongst the young tearaways. Immediately after, a race took place on foot or on horseback to the bridal house where the winner received a riband from the bride. Such boisterous activity sometimes ended in tears, as the *Westmorland Gazette* reported in November, 1825:

In remote country villages, the customs of our forefathers are retained for a longer period than where society is called more polished, and where custom must bow to fashion. At weddings where parties are in a condition to appear mounted, it is usual for the bridesmaid and other maids, the bridegroom and the rest of the men, to run for the ribbon. A certain house is named as the winning post, and he or she who first arrives there is declared the victor, and is afterwards celebrated

in the village annals. A scene of this kind was on foot, on Monday last. About eight in the morning, a party consisting of ten horses, eight men and three women, proceeded to Musgrave Church, and about half an hour after, nine of the horses were seen with their riders dashing for the village of Warcop. At the bottom of the village there is a low bridge, and a shallow muddy rivulet well impregnated with decomposed matter. At the turn of this bridge Miss R. led the van, about to rush into the arms of victory, to reach the goal and win the prize. But how fleeting are human prospects, how uncertain our hopes, how rapidly is the cup of pleasure or happiness dashed from the lip. Ere she had gained the 'key stane o' the brig', away went the horse, away went the saddle, and away went Miss R., in three different directions; the horse scampered up the village, the saddle lay quietly on the bridge, and Miss R. alighted softly in the centre of the muddy river, a disconsolate duck or darling with all her honours blighted. Her swain looked piteously on, half inclined to kiss away the mud from her sweet bespattered face. Her new leghorn [bonnet], with all its gay and gallant white flowing insignia was ruined – her dark drab riding habit spoiled forever; but fortunately she rose, 'unhurt amidst the crush of matter', (though not like Venus from the sea) with only a slight scratch on the arm, was hurried to the house of the village milliner to repair damages, and was soon in a position to proceed again, no doubt at a more sober pace, and long to remember a Westmorland Wedding.

Inevitably, wedding festivities were costly affairs but 'Bidden Weddings', whereby the guests paid for their own entertainment and made a contribution to the happy couple, were not uncommon as Jollie noted in 1811:

The Bidden Wedding, as it is provincially called, was very common a few years ago, and is not yet quite obsolete. In that case, the bridegroom and a few friends ride about the villages, for several miles round, bidding, or inviting, their neighbours to come to the wedding on the day appointed. The wedding is likewise advertised in the county newspaper, with a general invitation, and enumerating the various rural sports to be exhibited on the occasion, such as horse races, foot races, leaping, wrestling, etc. for suitable prizes. This generally brings together a great concourse of people, who, after enjoying the sports of the day, make a contribution to the newly-married couple. This sometimes amounts to a considerable sum, and is found very useful to the wedded pair in setting them forward in the world.

A Public Bridal

The following advertisement appeared in the *Cumberland Pacquet* newspaper in June, 1803:

Jonathan and Grace Musgrave propose having a Public Bridal, at Low Lorton Bridge End, near Cockermouth, on Thursday, the 16th of June, 1803; when they will be glad to see their Friends, and all who may please to favour them with their Company; for whose Amusement there will be various Races, for Prizes of different Kinds; and amongst others, a Saddle and Bridle; and a Silver-tipt Hunting Horn, for Hounds to run for – There will also be Leaping, Wrestling, Etc., Etc.
Commodious Rooms are likewise engaged for Dancing Parties, in the evening.

Come, haste to the Bridal!
to Joys we invite you,
Which, help'd by the Season,
to please you can't fail;

*But should Love, Mirth, and Spring
strive in vain to delight You,
You've still the mild Comforts
of Lorton's sweet Vale.
To the Bridal then come,
taste the Sweets of our Valley.
Your visit, good Cheer and
Kind Welcome shall hail;
Round the Standard of
Old English Custom we'll rally,
And be blest in Love, Friendship,
and Lorton's sweet vale*

Such weddings were often advertised by printed handbills in the manner of a fair or theatrical performance. In 1807 Joseph Rawlings and Mary Dixon of High Lorton were married in such a fashion and the printed public invitation extended a welcome to:

*Friends, Acquaintances and others . . .
who were assured that
. . . every effort will be used to accommodate the
company, and to render the day agreeable.
The prizes included
one saddle to be run for, and two bridles to be
trotted for, by horses; two belts to be wrestled for,
two hats to be run for, gloves to be leaped for, and
a tankard to be shot for, by men.
The celebrations ended with a
Pantomime Exhibition ... to be performed by
Actors of the first Distinction*

After this the guests were invited to make their monetary contribution to the happiness of the newly-weds on a pewter plate held on the bride's knee.

Leaping contests, wrestling, as well as foot races – in which women participated equally with men were all accepted as an integral part of these rustic wedding celebrations, as was the bizarre custom of breaking the wedding cake over the head of the bride. Although not as traumatic as it might at first appear since the bridecake was not the elaborate iced centre piece of today's receptions but rather a thin currant cake, it was, nevertheless, eagerly anticipated since it was believed that the number of pieces into which the cake broke would indicate the number of children the couple would produce. The bride's head was covered with a white cloth and the groom, standing behind her, broke the cake over his wife's head and the fragments were then distributed amongst the guests. A similar custom prevailed in Ireland where fragments of the cake were placed under pillows so that sleepers would dream of their future partners.

The celebrations often ended with the time-honoured tradition of throwing the stocking which, according to one early nineteenth century authority, J Hodgson, in 1822 was:

*. . . a custom which refinement has proscribed as
indelicate, though it offered no offence to the
decorum of the rude simplicity of the people
amongst whom it prevailed. While the new married
couple sat upright in bed, with the curtains open
only at the foot, the young men attempted to hit the
bridegroom and the young women the bride, by
throwing the bride's stockings over their shoulders.
Those who were successful in the attempt went
away assured that their marriage was near.*

Later, delicate sensibilities in Victorian times recast this tradition into the anodyne throwing of the bride's bouquet. In High Furness, wedding festivities regularly continued into the early hours when so-called 'friends' fired shots over the couple's roof.

'Troublesome Wives and Frolicsome Women'

Although divorce and separation were almost unheard of in rural Lakeland communities, occasionally whispers of discord are recorded. The diarist, William Fleming, gives an example in 1812 of a situation which Hardy was later to record in Wessex and Hugh Walpole in Cumbria – the sale of a wife.

It seems that an unfaithful wife and her lover were pursued from Furness to Whitehaven by the somewhat aggrieved husband. The erring and unrepentant lady was unwilling to return home and was therefore led by a halter round her neck to the market place in Whitehaven and auctioned, whereupon she was bought by her lover *'for something less than one shilling'*. Whether or not it was a bargain, Fleming does not record!

Similarly, the following transaction is reported in the pages of the Annual Register for the year 1832. Joseph and Mary Anne Thompson had been married for three years but connubial bliss escaped them; a mutual separation was agreed on and on Saturday, April 7th, Joseph Thompson arranged for the Carlisle bellman to announce the sale of his wife in the market place. Having placed Mary Anne on an oak chair with a straw halter around her neck, Joseph addressed the assembled crowd:

*Gentlemen, I have to offer to your notice my wife,
Mary Anne Thompson, otherwise Williams, whom I
mean to sell to the highest and fairest bidder.
Gentlemen, it is her wish as well as mine to part
forever. She has been to me only a born serpent. I
took her for my comfort and the good of my home;
but she became my tormentor, a domestic curse, a
night invasion, and a daily devil. Gentlemen, I speak
truth from my heart when I say – May God deliver
us from troublesome wives and frolicsome women!
Avoid them as you would a mad dog, a roaring lion,*

a loaded pistol, cholera morbus, Mount Etna, or any other pestilential thing in nature.

Now I have shown you the dark side of my wife, and told you of her faults and failings, I will introduce the bright and sunny side of her, and explain her qualifications and goodness.

She can read novels and milk cows; she can laugh and weep with the same ease that you could take a glass of ale when thirsty. . . . She can make butter and scold the maid; she can sing Moore's melodies, and plait her frills and caps; she cannot make rum, gin or whisky, but is a good judge of the quality from long experience in tasting them. I therefore offer her with all her perfections and imperfections for the sum of fifty shillings.

After waiting about an hour, a bargain was struck when one Henry Mears agreed to take the lady for twenty shillings and a Newfoundland dog. Evidently, the parting was amicable; Mears and Mary Anne left in one direction, Thompson and the dog in another.

Stang Riding

Like so many Cumbrian dialect words, *stang* is derived from Old Norse, and means a pole or plank; stang riding was a method by which a community publicly shamed a supposed guilty person for an alleged impropriety. Generally performed by proxy, it was usually reserved for adultery by men or women, although it was sometimes used as a punishment for wife-beating and, if some authorities are to be believed, for husband-beating as well! The character nominated by the community to impersonate the guilty party was carried through the village or dale on a plank, followed by a noisy shouting mob. Stops were made at each door when the stang rider explained his appearance in ribald doggerel rhyme and of course the final stop was made outside the house of the supposed

culprit before the mob adjourned to the ale house, no doubt to reflect upon the success of their rough justice.

Barring-Out

The annual schoolboy riot of 'barring-out' the master from his school would today be termed a 'sit-in'. The custom survived in Cumbria until at least the end of the last century and the object seems to have been to persuade the master to grant longer holidays. Most 'barrings-out' were amicable and doting parents usually gave sums of money to their rioting offspring. Sir Daniel Fleming of Rydal regularly rewarded his sons in this way 'at their barring-out' which generally took place between 7th and 15th December and was clearly in anticipation of the Christmas holidays. However, such ceremonies could become protracted affairs; at St Bees, the school charter restricted the rebellion to *'a day and a night, and the next day until one-o-clock in ye afternoon'*.

John Bolton, writing in the nineteenth century of his Furness schooldays, remembered with affection the schoolmaster who:

. . . quietly submitted to have a little dirty water thrown over him when he attempted to storm our barricade, being always forced to retreat, it was not with frowns and threatenings for another time, but with a good-natured smile at his defeat.

Elsewhere, however, the same degree of amicability was not forthcoming. In December 1887 the Dalston School Board received this request from the schoolmaster:

I would ask the sanction of the Board for the closing of the school for the vacation on the evening of Thursday, the 20th. If we open on the Friday we shall most likely have a poor attendance. My

principal reason for asking is that we shall be better able to put a stop to the old barbarous custom of Barring out. Some of the children might possibly be persuaded to make the attempt on Friday, and in such a case I should feel it my duty to inflict an amount of castigation on offenders such as neither they nor myself would relish.

Clearly a case of discretion being the better part of valour – and his request was granted.

Rowans, Dobbie stones and Beltane fires

Rituals involving inanimate objects such as trees, rocks and plants form an integral part of folk life and almost certainly have their origins in the pre-agricultural phase of human history. Superstitions associated with trees remained in the Lake District until the beginning of the present century; one of the most widely observed was the carrying of rowan branches to the Beltane 'bone-fires' which were lighted on the eve of May Day. So-called because bones were originally used as fuel, this midsummer ceremony was clearly derived from pagan fire festivals and it was believed that the rowan would protect the bearer from 'the evil eye'. Travelling through Cumberland in the late eighteenth century, Thomas Pennant noted that

. . . till of late years the superstition of the Beltain was kept up in these parts [around Keswick], and in this rural sacrifice it was customary for the performers to bring with them the boughs of the mountain ash.

Even in the middle of the last century, rowan was placed in keyholes or hung above doors to prevent witchcraft and it was widely held that a rowan twig placed in the cream during churning would make the butter come. The ancient couplet:

*With rowan tree well fenced about
We're safe from evil*

emphasises the magical properties of this tree – but why should this be so? Our Irish-Norse ancestors venerated the mountain ash as the sacred tree of Thor and perhaps these settlers introduced the superstition in the ninth and tenth centuries, but Professor E Estyn Evans has developed the theory that the origins of the beliefs might be traced back to the prehistoric period. In Ireland, he argues, the rowan, holly, elder, and whitethorn were all imbued with supernatural powers because these plants all became common in Neolithic times as weeds of cultivation, associated with early agricultural activity. Consequently, they became symbols of the farming year, their blossoms heralding the spring and the red berries being a token of the promise of rebirth after the harvest.

Other trees were associated with superstitious beliefs; in some areas, sprigs of yew were traditionally dropped on a coffin as it was lowered into the ground, and the bringing of May blossoms into a house would be followed be ill-luck or the news of a death in the family – a belief still current today. At Brough, near Kirkby Stephen, the curious custom of Carrying the Holly Tree was common until the mid nineteenth century. According to one authority

The ceremony consisted of a number of young
men and boys procuring a holly . . . the twig
ends of all the branches were lopped off, and on
the stumps were tied a number of torches
dipped in candle fat; these on the twelfth night
after Christmas Day were lit up, and the
illuminated ensign was carried all over town,
preceded by a band of music . . . each publican
offered as much ale or other drink as he could
afford to the party that would by show of force
land the blackened emblem on his premises

after the torches had burned themselves out. . . .
The ceremony always seemed to end in a few
free fights, with blackened faces, and any
amount of drunkenness.

The Westmorland Note Book Volume 1, 1888–1889

In Ireland and the Isle of Man, the tradition of decorating trees close to springs with coloured rags has long been respected and, of course, the Derbyshire well dressings still continue. In the Lake District a similar custom survived at least until 1894 when, on Maundy Thursday, oak trees growing near to springs or fountains at Satterthwaite and Hawkshead Hill were bedecked with coloured rags and fragments of broken crockery.

Stones and rocks were also regarded as potent charms. Naturally-holed stones, known as 'dobbie stones', were traditionally regarded as powerful talismen against bewitching, and these were usually hung above the heads of cattle in the byre. The 'dobbie stone' still kept at Bleaze Hall, Old Hutton, is a well-worn axe hammer, probably dating from the Neolithic period. Elsewhere, strangely eroded rocks often assumed a mystical significance; in 1801, William Fleming recorded a limestone boulder at Great Urswick which served as a powerful fertility symbol:

About 100 yards to the West of Urswick Church in
Furness in a Field called Kirkflat, adjoining to the
Highway, stands a rough piece of unhewn
Limestone which the inhabitants of Urswick were
accustomed to dress as a Figure of Priapus on
Midsummer Day, besmearing it with Sheep Salve,
Tar and Butter, and covering it with Rags of various
Dyes, the Head ornamented with Flowers.

The boulder is still there, though now incorporated into a stone wall, its powers of fecundity apparently no longer needed. . . .

Rushbearings

The strewing of rushes on church floors is probably one of the most ancient rituals in the Christian Church, perhaps even derived from the pagan Roman festival of Floralia. Once widespread throughout England, by the eighteenth century the custom had lapsed in all but a few places in the north, and today in Cumbria it is celebrated only at Warcop, Musgrave, Ambleside, Grasmere and Urswick. Now largely a flower festival, the rushbearing once served a practical purpose for, in pre-Reformation times and, indeed, even up to the eighteenth century, the floors of most churches were beaten earth and burials were undertaken within the naves. Interments continued at Grasmere Church until 1823 and, because of the the resulting sinking of the floors, the benches had to be constantly relocated. The renewal of 'sieves' or sweet-smelling rushes, then, was as much a necessity as a ritual.

*Carrying a 'burden'
at a rushbearing.*

Extract from *The Rushbearing*

Ballad written by Mr Edward Button (sometime schoolmaster of Grasmere)

The Church of good S. Oswald
Possessed in days of yore,
For the hardy race who worshipped there,
A rugged earthen floor.

As we may well imagine,
This floor so damp and cold,
Gave influenza to the young –
Rheumatics to the old.

And so to make things pleasant,
And save the doctor's fees
They strewed the Church with rushes dry,
And thus got warmth and ease.

In some churches near to the coast – for example on Walney Island and at Dalton – marram grass from the sand dunes replaced rushes, and no doubt kneeling on this sharp, spiky grass was a penance in itself! Elsewhere, the annual strewing of the rushes was undertaken in high summer when the rushes were fully grown and the two main harvests, wool and hay, had been safely gathered in. It was considered a 'boon service' for the church and therefore the parishioners expected no reward. However, as early as 1680 the Grasmere Churchwardens' accounts show:

For Ale bestowed on those who brought rushes
and repaired the Church. 1s.

Four years later the amount spent on ale had increased to two shillings and in 1685 it had reached the prodigious sum of five shillings and six pence but from then on – perhaps under pressure from more temperate parishioners, the amount remained con-

Rushbearing depicted in
a painting by
Frank Bramley, R. A.
in 1905.

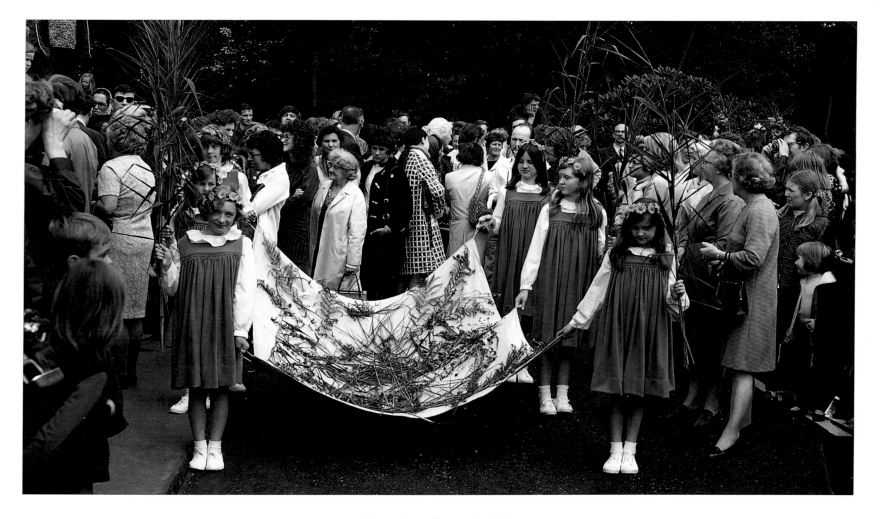

Rushbearing at Grasmere in 1972

THE RUSHBEARING

Rushbearing March

The traditional Grasmere and Ambleside Rushbearing March *was played by fiddler Jimmy Dawson who lead the procession at Grasmere for forty-six years.*

stant at two shillings and six pence until 1774. In 1819 the Churchwardens' accounts record for the first time the expenditure of three shillings and nine pence for 'Rushbearers' Gingerbread' for it seems that by this time the bearers were mostly children who received, as their reward, a piece of 'rushbearers' cake'. Apart from a lapse of thirteen years in the mid nineteenth century, the gingerbread tradition has continued to the present and it is still baked and sold in the small shop – once the village school – in the corner of the churchyard.

James Clarke, who witnessed the Grasmere Rushbearing in the late eighteenth century, says:
I happened once to be at Grasmere, at what they call a 'Rushbearing'. This is an ancient custom, formerly pretty universal here, but now generally disused. About the end of September,* a number of young women and girls (generally the whole parish) go together to the tops of the hills to gather rushes. These they carry to the church, headed by one of the smartest girls in the company. She who leads the procession is styled the Queen, and carries in her hand a large garland, and the rest usually have nosegays. The Queen then goes and places her garland upon the pulpit, where it remains till after the next Sunday, the rest then strew their rushes upon the bottom of the pews, and at the church door they are met by a fiddler who plays before them to the public house, where the evening is spent in all kinds of rustic merriment. . . .'
* Clarke is mistaken about the month.
Before 1845 the Grasmere ceremony was held on the Saturday nearest to St Oswald's Day, 5th August.

There can be no doubt that by the beginning of the nineteenth century, the Grasmere Rushbearing had become an excuse for merrymaking and drinking, as one writer rather crustily records in 1827:

The church door was open, and I discovered that the villagers were strewing the floors with fresh rushes. I learned from the old clerk, George Mackereth, that, according to the annual custom, the rushbearing procession would be in the evening. . . . During the whole of this day I observed the children busily employed in preparing garlands of such wild flowers as the beautiful valley produces, for the evening procession, which commenced at nine, in the following order: The children (chiefly girls), holding their garlands, paraded through the village, preceded by the Union Band. They then entered the church, where the three largest garlands were placed on the altar, and the remaining ones in various parts of the place. In the procession I observed the 'Opium Eater', Mr Barber, an opulent gentleman resident in the neighbourhood, Mr and Mrs Wordsworth, Miss Wordsworth, and Miss Dora Wordsworth. Wordsworth is the chief supporter of these rustic ceremonies. The procession over, the party adjourned to the ballroom, a hayloft at my worthy friend, Mr Bell's [now the Red Lion], where the country lads and lasses tripped it merrily and heavily. They called the amusement dancing. I called it thumping, for he who made the most noise seemed to be esteemed the best dancer; and on the present occasion, I think Mr Pooley, the schoolmaster, bore away the palm. Amongst the gentlemen dancers was one Dan Birkett. He introduced himself to me by seizing my coat collar and saying: 'I am old Dan Birkett, of Wythburn, 66 years old, not a better jigger in Westmorland.' No, thought I, nor a greater toss-pot. On my relating this to an old man present, he told me not to judge the Westmorland manners by Dan's, 'for', said he, 'you see, sir, he's a statesman, and has been to Lunnon [London], and so takes liberties.'

'A Pedestrian', *Hone's Year Book* 1827

The Grasmere church floor was paved in 1840 and carpeted in 1844 at an expense of eleven shillings and four pence, yet the tradition continued until the present with few changes. The report in *The Times* over seventy years ago could well apply to the 1990s:

Saturday morning had been 'nobbut glishy', the sun appearing for a few moments, to be swiftly hidden by scudding grey clouds that brought heavy showers; but after a drenching torrent at 4 the wind shifted a little to the north, and half an hour later there was an azure sky, the whole valley lay smiling in the sunlight, and every Grasmere child was standing on the low, flag-topped wall that surrounds the churchyard, their happy faces beaming down through the rushes and flowers of their 'bearings' on the throng of parents and visitors in the roadway below. Beneath the trees opposite a pretty group appeared – the six elder girls at the village school, dressed in simple frocks of green and white, their hats wreathed with stag's horn moss, carrying a big home-spun linen sheet decorated with flowers and filled with rushes. The three bells rang out their quaint intervals from the old tower, the village band in a neighbouring garden did bravely and soon struck up the strain of the Rushbearers' March – so ineradicably associated with the rushbearing – played in 1781 by Jimmy Dawson, the fiddler who led the procession for 46 years. Away they go, 'barns' [children] and bearings like a summer flower bed waving in the wind, for as in Wordsworth's day the bearing 'o'er tops the head of the proud bearer.' Headed by the band, and the banner of St. Oswald, they pass the lych-gate and the gingerbread shop . . . a rather confused procession, without the studied orderliness of an Italian village ceremonial. . . .

The Times 12 August, 1921

An Early Nineteenth Century Ambleside Rushbearing

In 1898 Canon H.D.Rawnsley recorded the recollections of Miss Hannah Nicholson, then aged 85. With her sister Margaret, she lived at the Old Post Office in the Market Place in Ambleside, and vividly recalled the rushbearings of her early childhood:

In my young days we met at the Village Cross on the Saturday nearest St Anne's Day, at 6 o'clock in the evening. Old Tommy Houghton, the clogger, came; he was a very clever jigger, best dancer hereabout; he was a kind of clerk and village constable. . . . He it was who marshalled us. Everyone who chose came – young and old; and all who carried burdens received a good big cake of gingerbread, made by Old Mickey the baker. . . . Folk came from miles around to see the procession, and Wordsworth never missed; he and the Rydal party would sit in our little room to see the procession start . . . we all met – a hundred or more – and then an old man played on his fiddle or his pipe, and off we went round the village, up street and down street, to the same old tune. We only knew one tune in those days – *The Hunt is Up* – and so up the hill to the old chapel. There we put our burdens into the corners of the big square pews . . . and came back to the Cross for our gingerbread. . . . We became refined in later days, and then we had a band – the Steamer Band [from the Windermere steam boats] – and my mother, who collected for the gingerbread, had to collect an additional sovereign for the band

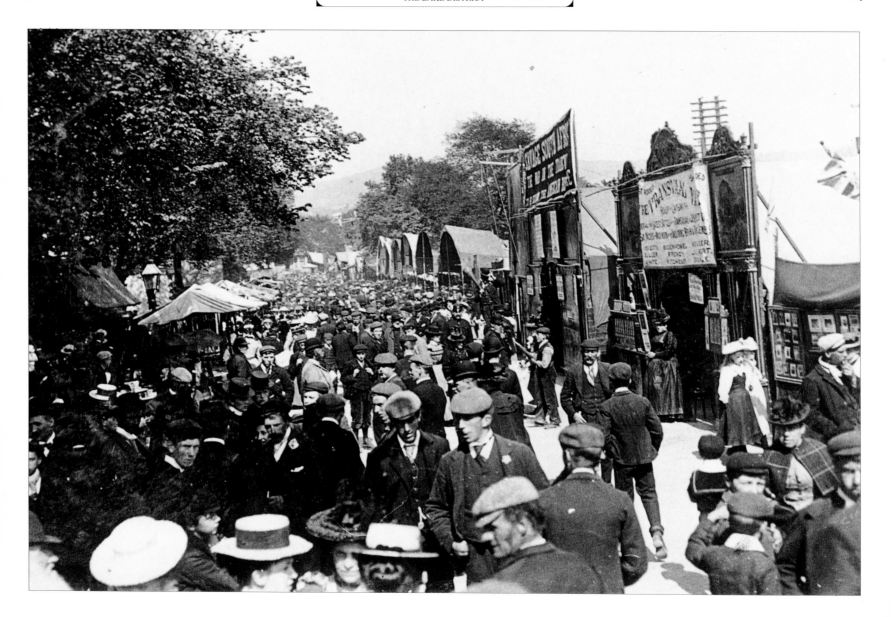

Fortunately, rushbearings are still a part of the folk life in five parishes in Cumbria but, sadly, many of the traditions which would have been respected barely a hundred years ago have been lost. Few now remember the riotous 'barring outs', 'bidden weddings' have long since been forgotten as have the magical properties of the rowan; in an age of mass media and satellite images our traditional customs are part of the 'world we have lost' – and our culture is poorer for it.

Hiring Fair in Kendal in 1899. Scenes from the Transvaal War are displayed in the booth on the right.

An annual cattle fair and horse show in Ulverston in the early nineteenth century was also the venue for the hiring of labour and servants.

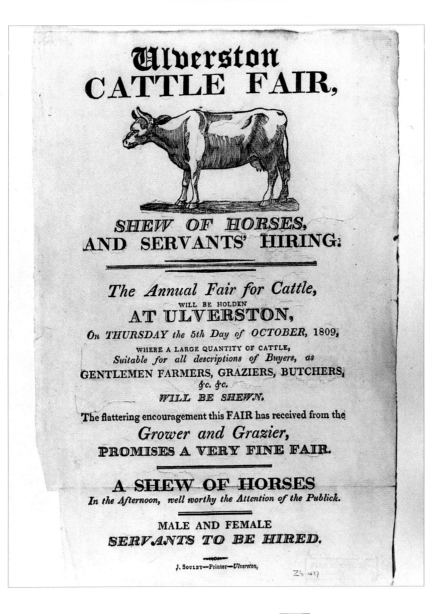

Grasmere Gingerbread

1 lb (450 gms) plain flour
11/2 cups milk
4 tabsp syrup (rounded)
4ozs (115 gms) butter
2 teasp. bicarbonate of soda
2 teasp. baking powder
6 teasp. ground ginger,
6ozs (170 gms.) white sugar

This is how it was formerly made by old Mrs Beetham, and distributed to the children who took part in the Rushbearing ceremony.

1
Melt sugar, margarine, milk and syrup, but do not boil.
2
Add baking powder and bicarbonate of soda and stir well.
3
Pour onto sieved flour and ginger and beat.
4
Put-into a fairly large baking tin and bake in a Warm Oven for about 45 minutes or until golden brown.

The Hirings

Of all the country fairs, the twice-yearly hiring fairs were the most anxiously awaited. Held at Whitsun and Martinmas, the most important were those at Cockermouth, Kendal, Keswick, Carlisle, Penrith and Ulverston. Those farm-hands and servants not 'stopping on' for a further six months, offered themselves for hire in the open market place. A straw stuck in a hat or from the corner of the mouth indicated that a labourer was for hire and on completion of negotiations between master and man, hands were struck and the hired hand received a shilling as 'arles' or 'earnest money' as a token of a binding agreement. Melvyn Bragg's novel *The Hired Man* opens with a vivid and evocative account of such a hiring in Cockermouth at the end of the last century. Women were hired in the same way: Mrs Isabella Cooke describes her hiring in Penrith in 1906:

When I was 16½ I said I was going to get a job, so my parents agreed and wanted me to go into gentleman's service. I said I wanted to go where there were animals so on Whitsun Tuesday I went on the carrier's trap from the village [Great Strickland] to Penrith, 11 miles away. My father said I'd to ask for £10 for the 6 months.
Well, I went and stood on a certain street in Penrith [Burrowgate] and the bosses and mistresses did likewise. I was walking slowly along and a horrible scruffy-looking man came along and said 'Are you for hire?' I didn't speak, kept on walking and a woman came up and said 'Are you engaged?' I said 'No' . . . she said how much money did I want. I said £10 for the half year and she said could I milk. I said 'No' so she said 'I'll give you nine and learn you to milk', so that was all settled and she

gave me a shilling, what they called yearls. It was a fastening fee and I was to go on the Thursday and this was Tuesday . . . I walked there on the Thursday and took what clothes I wanted to put me on until my mother could get the rest together. She bought material and made up all my underclothes and pinafores and coarse aprons, etc and when she got them all ready the farm lad took a horse and cart and we went and collected my box – it was 6½ miles.
I stayed there for two years – they were nice folks and sure looked after you. I was only allowed out on a Sunday after I'd finished and that was in time to go to church at 6.30pm and had to be back in by 9pm. If I was a few minutes late she was outside looking for me.

'A Hired Lass in Westmorland'
Cumberland and Westmorland Herald, n.d.

'Ist Thee for Hiring, Lass?'
An Ulverston Hiring in 1907

In this extract from a tape recording made in April 1995, Mrs Rose Ashton in her 102nd year describes her hiring in Ulverston at the age of fourteen:

There wasn't much work for us when we were young girls. We left school at fourteen and as there was no work for us, we got our heads together, me and my friend, and we said we'll go to the Hiring Fair and get hired. Our mothers couldn't afford the ten pence so we walked the 8 miles from Barra [Barrow] to Ulverston and we had to be there for ten o'clock when the hiring started.
We walked up and down King Street, up and down, and then a farmer come up to us and said 'Ist thee for hiring lass?' and we said 'Yes. What will you give us?' 'Well, I'll give thee five pounds'. 'Oh, no! Not five pounds for six months!' So we left him and

off we go up King Street again. Walked a bit farther and come across another farmer. 'Ist thee for hiring, lass?' 'Yes. And what will you give me?' 'I'll give thee five pounds ten'. 'Won't you give us any more?' 'No'. 'Oh, well, the hiring isn't over till twelve. We'll walk up and down a bit.'
Another fella come to us 'Ist thee for hiring, lass?' 'Yes. What will you give us?' 'I'll give thee six pounds ten shillings', 'Right! We'll take you!' Then he gave us a silver shilling. Now that silver shilling, once you take that silver shilling, you're bound to go. If you don't go, they claim the six pounds ten off your mother so therefore you've got to go. So we went to Longridge [near Preston] and we done the six months for six pounds ten shillings each.

Christmas came and we had a lovely dinner, very nice, and the lady came to me and she said 'Have you finished, Rose?' And I said, 'Yes Madam. I've washed up and all's nice and tidy in the kitchen.' 'Oh, well' she said 'You see that ball of string there?' I said 'Yes'. She said 'Will you go down to the paddock?' I said 'The paddock?' Now the paddock was the outside toilet in a field. There was no toilet paper in those days – they made their own with the weekly newspapers. So she said 'Well, I want you to go down to the paddock and make some. There's the needle and there's the cord and you thread it up' she said 'And back of the door you'll see a nail and you can hang it on there'. So I sat there and I think I shed a bucket of tears. Christmas Day and I'm thinking of my mother and sisters all enjoying themselves and here I am sitting on this toilet threading toilet papers. . . .
At half past four she came to me and said 'Have you finished, Rose?' and I said 'Yes'. So she said 'Well, come and have some tea now'. I had me tea and I went to bed; broke my heart, it did and I thought 'If that's me Christmas Day, I've had it . . . !'

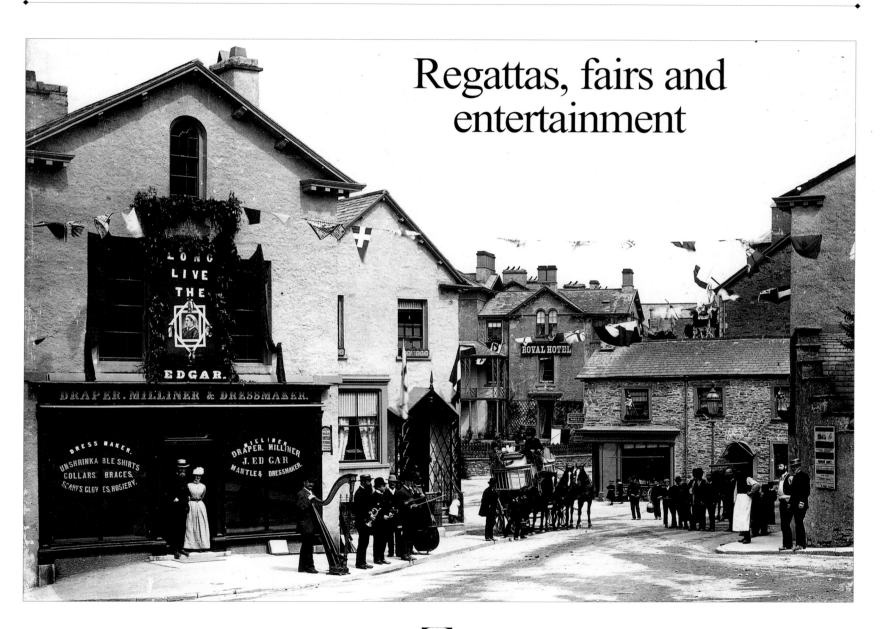

Regattas, fairs and entertainment

In the late summer of 1779 the first Bassenthwaite Regatta was held, an event which established a fashion amongst gentry and visitors alike. A large crowd lined the shores of the lake to witness a variety of entertainments. The main attraction was 'the swimming sweepstake'. Several horses were towed on a raft into the lake; the raft was then allowed to sink, obliging the animals to swim for the shore – wagers being placed on the first horse home and dry! Two years later, not to be outdone by the unquestionable success of the Bassenthwaite Regatta, a colourful eccentric character, Joseph Pocklington, who owned 'Pocklington's Island' in Derwentwater, decided to organise a Keswick Regatta, the *pièce de resistance* of which was to be a mock sea battle on the lake:

> Pocklington's Island (late Vicar's Island) will be
> attacked with a formidable Fleet; when a stout
> resistance is expected to be made . . . and it is
> thought that the circling Mountains will bear a
> Part in this Tremendous Uproar.
>
> *The Cumberland Pacquet,* 21 August 1781

In fact, as so often happens, it was the weather that 'bore a part' and the whole enterprise was washed out. The following year, however, the sun shone and the Regatta was judged a huge success, especially the 'sea battle', an early example of 'war games'. . . .

About 4 o'clock preparations were made for the attack on Pocklington's Island; the fleet retired behind Friar Crag to prepare for action, previous to which a flag of truce was sent to the governor [Pocklington], with a summons to surrender upon honourable terms; a defiance was sent, upon which the fleet appeared advancing with great spirit before the batteries, when, after forming in a curved line, a terrible cannonade began on both sides, accompanied with a dreadful discharge of

[Previous page]
Musicians in Bowness
prepare to give a spirited
performance to celebrate
Queen Victoria's
Diamond Jubilee in 1897.

Amongst the various
amusements, rowing and
running matches were to
be entered by both men
and women, with a ball at
the Salutation Inn,
Ambleside to complete the
entertainment.
The first Windermere
regatta was held in 1775.

WINANDERMERE REGATTA.

WINANDERMERE REGATTA,
Will take Place at the Ferry House,
On Wednesday the 25th July, 1810,
WHEN THE FOLLOWING

MATCHES,
WILL BE SAILED FOR.

1. Mr. Bolton's Schooner, the VICTORY.
 Mr. Wilson's Schooner, the ENDEAVOUR.
 Mr. Pedder's Schooner, the EXPERIMENT.
 To start at eleven o'Clock.
2. Mr. Pedder's Schooner, ROVER.
 Mr. Wilson's Cutter, ELIZA.
 Mr. Wilson's Latine Sailed Vessel, PALAFOX.
3. Mr. William Jernett's, LIVERPOOLIAN.
 Mr. Smith's, KITTY.

ROWING MATCHES.

1. Mr. Francis Astley's Wherry, MARY.
 Mr. Wilson's Wherry, SWIFT.
2. A Prize of one Guinea, to the best Fishing Boat on the Lake.
3. A Prize of one Guinea, to the best Boat kept by an Innkeeper.
4. A Gown to be rowed for by Women.
5. A Prize of two Guineas, for the best Boat on the Lake; Wherries excepted.

RUNNING.

1. One Guinea to the best Runner, distance two Miles.
2. A Gown to be run for by Women, distance one Mile.
3. A Hat to the best Runner, (Man or Woman) blindfolded, distance one hundred Yards.

LEAPING.
One Guinea to the best Leaper.

WRESTLING.
One Guinea to the best Wrestler.

A Variety of other Amusements will take place.
Dinner on the Table at four o'Clock.

There will be a BALL at the Salutation Inn, Ambleside, on Thursday the 26th.

JOHN WILSON, Esq. of Elleray, Steward.

musquetry, which continued a considerable time, occasioning the most tremendous roar that can be conceived, which was frequently echoed back from hill to hill in a variety of sound.

The Cumberland Pacquet, 10 September 1782

The euphoria produced by such unabashed showmanship prompted one writer, Mr Clarke, to proclaim:

Had the poet who described the battle of the Gods seen a Regatta-day at Keswick it would have very much enriched his muse for that subject.

By contrast, the Windermere Regatta held at the Ferry, was, with one or two exceptions, a more decorous affair, involving sailing and rowing matches, as well as leaping running and wrestling competitions. In 1810 two regattas were held, one on 25th July, the other on 27th August. Miss Ellen Weeton, a governess employed by the Pedder family at Dove's Nest, overlooking the lake, attended both; she was amused by the first but shocked and horrified by the second. Writing to her aunt she recalled:

The first held at ferry house, near the island, I was much pleased with. There was one footrace in the water; several stakes were, at certain distances, driven into the ground where the water was about three feet deep; several holes were made, purposely that the runner plunging in, might tumble and get a ducking. It was laughable indeed, for there was no danger. The second Regatta was expected to have been more splendid still, in consequence of which Mr Pedder invited a number of friends. We were sadly disappointed; it was one of the most blackguard things ever conducted. After a rowing match or two, which began the entertainment, there followed a foot race by four men. Two of them ran without shirts; one had breeches on, the others only drawers, very thin calico, without gallace [braces]. Expecting they would burst or come off, the ladies

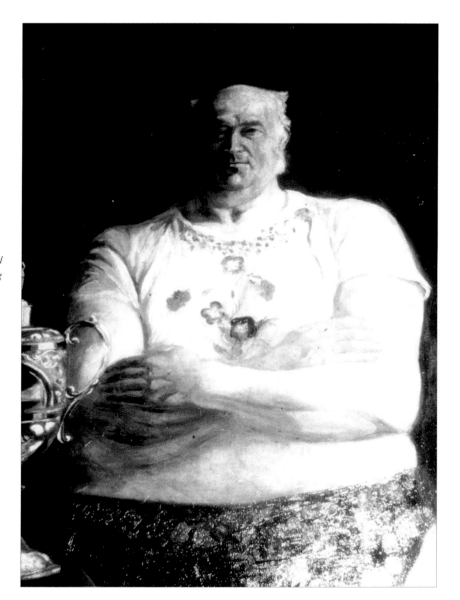

George Steadman retired in 1900, aged 54, having won the Heavyweight Championship at Grasmere 17 times.

durst not view the race, but turned away from the sight. And well it was they did, for during the race, and with the exertion of running, the drawers did actually burst and the man cried out as he run – 'O Lord! O Lord! I cannot keep my tackle in, G-d d-n it! I cannot keep my tackle in!' The ladies, disgusted, every one left the ground; there were many of Fashion and rank; amongst others Lady Diana Fleming, and her daughter, Lady Fleming, and the Bishop of Landaff's daughters; several carriages, barouches, curricles, but all trooped off . . . it was a gross insult to every woman there, and there was a much greater number assembled on that day, than there was on the previous Regatta; of elegant, well-bred women, I mean.

Ellen Weeton *Miss Weeton's Journal of a Governess*

Professor Wilson's 'Radiant Procession'
The Windermere Regatta of 1825

The weather was as Elysian as the scenery. There were brilliant cavalcades through the woods in the mornings and delicious boatings on the lake by moonlight; and the last day 'the Admiral of the Lake' [Professor Wilson] presided over one of the most splendid regattas that ever enlivened Windermere. Perhaps there were not fewer than fifty barges following, in the Professor's radiant procession, when it appeared at the point of Storrs to admit into the place of honour the vessel that carried kind and happy Mr Bolton and his guests. The three Bards of the Lakes (Wordsworth, Southey* and Wilson) led the cheers that hailed Scott and Canning; the music and sunshine, flags, streamers and gay dresses, the merry hum of voices and the rapid splashing of innumerable oars made up a dazzling mixture of sensations as the flotilla wound its way among the richly-foliated islands and along bays and promontories peopled with enthusiastic spectators.

Life of Scott by J G Lockhart

* There is some disagreement about Southey's presence; some authorities suggest that he was ill at home in Keswick at this time.

A High Furrness Sports Day is celebrated with a tug of war at Satterthwaite in about 1895.

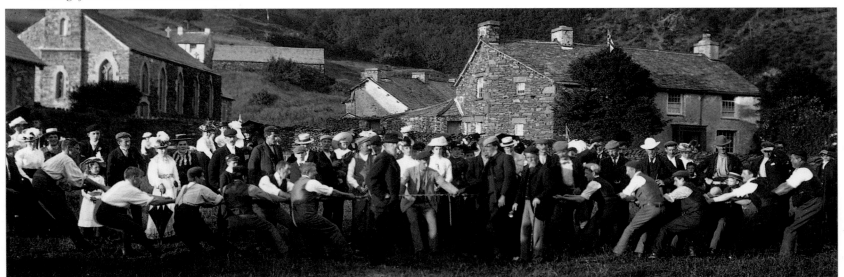

The absence of statutory holidays meant that country fairs were eagerly anticipated as opportunities for merry-making. Some of these fairs such as the Appleby Horse Fair and the Egremont Crab Fair are still held, but others have lapsed. Rosley Fair near Wigton was once one of the liveliest in Cumbria, attracting people from a wide area:

Here the white labours of the loom proclaim
The weaver's skill, and thrifty housewife's fame.
There heaps of ginger-bread their charms display,
And shine refulgent in the face of day,
. . .Gauze, ribbon, lace in gay profusion lie
Hats, caps, and cloaks to catch the female eye.
Brooms, baskets, beehives and bright Burslem-ware
Shall not remain unsung in Roslay-fair.

'Roslay-Hill Fair' in *Miscellaneous Poems* by Ewan Clark 1779.

Sadly, the advent of agricultural auction marts spelled the death knell for Rosley and other country fairs and today the Hope and Anchor Inn stands isolated in the middle of the former fair ground which once resounded with the noise and bustle of horse-dealers, cheap-jacks, mountebanks, tooth-pullers and wart-charmers.

Even the tiny village of Ravenglass on the coast once had its fair. A charter, originally dated 1209, conferred the right to hold the fair on the festival of St James the Apostle and by the beginning of the eighteenth century the event extended over three days. At its height, people were attracted from Ennerdale, Wigton, Kendal, and Wasdale – and the boys of St Bees School claimed a day's holiday for the event, though this was suppressed. By the beginning of the nineteenth century the fair was in decline and by mid-century had become a pale shadow of its former self, being merely a sports meeting, the 'St Jam Races' with trotting contests on the foreshore, blind wheelbarrow races and wrestling matches.

Contenders at the World Championship
'gurning' contest can compete with
or without their dentures.

By contrast, the Egremont Crab Fair is still held on the third Saturday in September. Retaining some of its rumbustious character, the spectators are showered with crab apples – hence the name – from lorries and trailers. But the highlight of the fair is the World Championship gurning contest. *'Gurning through a braffin'* – grinning or grimacing through a horse collar – has long been a favourite Cumbrian pastime, once popular at all country fairs. Considerable effort and much practise, with and without dentures, goes into these competitions and there is a much-told story of the man who was merely expressing encourage-ment when a friend was competing – and suddenly found himself the new World Champion.

Grasmere Sports

Grasmere Sports, always held on the third Thursday in August, is acknowledged as one of the most important fixtures in the Lake District sporting calendar. It seems to have had its origin in the wrestling contests which took place in a field next to the Red Lion Inn on the evening of the rushbearing ceremony but in 1852, when the first official records began, other events such as the Guides' Race, and the hound trails were introduced. Later, the sports were transferred to the present site, east of the village. Here thousands of visitors and locals gather to watch the wrestling, sprinting and hound trailing.

But for many, the highlight of the day is the gruelling Guides' Race to the summit of Butter Crag, over drystone walls and minor crags, through bracken-infested slopes and ankle-wrenching scree.

Once regarded as the most testing of mountain events, the race has now been challenged by a new sport and a new group of folk heroes. Fell running, in which the competitor pits himself against the clock, calls for a degree of stamina, courage and confidence which few outdoor activities demand. Jos Naylor, MBE, a Wasdale farmer, has established a national and international reputation in this masochistic sport. His record of 72 Lakeland peaks, each over 2,000 feet, in 23 hours and 11 minutes, will be hard to beat.

Tekin' Hod
Cumberland and Westmorland Wrestling

The long 'dog days' of high summer, when the hay harvest was safely in and the sheep newly clipped and *smitted*, was traditionally the period when most Cumbrian shows and sporting activities were held.

Today some of these events, such as Grasmere Sports and the Rydal Show, attract thousands of visitors and tourists but to appreciate fully the delights of the country shows it is necessary to seek out the smaller local gatherings in places like Ennerdale, Eskdale or Ings. Here is the true Cumbria rather than the somewhat commercialised events staged for the benefit of the tourist industry. The proceedings are conducted in a more relaxed atmosphere; there is usually a chance for a *l'aal crack* with neighbours and the finer points of hound trailing and wrestling are discussed in the clipped crackle of the Cumbrian tongue, unintelligible to southerners and 'off-comers' but bearing a remarkable similarity to the Scandinavian languages from which most of the dialect words are derived.

Far removed from the 'grunt and groan' sessions formerly seen on ITV, *wruslin* is an essential element in Cumbria's folk culture, as much a part of things as rum butter and tatie-pot! The skill depends not so much on brute strength as on balance and agility as the two contenders *tek hod*. Clasping hands behind each other's backs, they begin a seemingly drunken waltz as they size one another up; suddenly there is a flurry of legs, the tempo increases as one man is caught off balance so that a part of his anatomy, other than his feet, touches the ground – and the bout is over. Similarly, if a competitor loses his hold, he forfeits the bout. If the rules of the contest are a mystery to the uninitiated, then the terms used – hypeing, haming, cross-buttocking, hankering the heel – might well be another language but to many Cumbrians they are as familiar as their own dialect.

This typical native form of physical combat has its own traditional dress: a sleeveless vest, 'long johns' and velvet trunks – often elaborately and beautifully embroidered by mothers, wives and girl friends practising an age-old folk art. Indeed, there are regular contests for the most sartorially elegant wrestlers. Coincidentally, the same costume is worn in Iceland

The traditional velvet trunks are often richly embroidered by wrestlers' loved ones.

where *glima*, a remarkably similar form of wrestling, is almost a national sport. In glima bouts the contestant wear leather belts; each man grips his opponent's waistbelt at the left hip and, as in Lakeland wrestling, the contest hinges on balance, skill and concentration, while the moves – the hitch, the outside click, the cross-buttock, the back heel – are almost identical to the Cumbrian manoeuvres. Although Cumberland and Westmorland wrestlers do not wear belts when competing, the traditional prize was usually a leather belt which the champion proudly wore to church on the Sunday following his victory, to the admiration of the ladies and annoyance of the gentlemen. Such similarities between the two forms of wrestling might well indicate a common origin; did the Norsemen who colonised both Iceland and Cumbria introduce this unusual form of unarmed combat?

There is no doubt that the sport has an ancient history. In 1256 William of Gospatrick had his shin broken by David de Brugings in a wrestling bout, and in 1581 Richard Muncaster mentions it, but the great days occurred in the eighteenth and nineteenth centuries. In 1785 a match took place on the frozen surface of Windermere near to Rawlinson's Nab; the

contestants wore clogs, additional entertainment was provided by the Kendal Town Band and an ox-roasting formed part of the catering arrangements.

By the mid-nineteenth century, the wrestling had acquired a very wide popularity: the rings at Melmerby and Langwathby in eastern Cumberland, Carlisle in the north, Greystoke in the Ullswater area and Windermere Ferry and Flan How in the southern Lake District all attracted both competitors and spectators from inside and outside Cumbrian boundaries. In 1851 at Flan How, Robert Atkinson of Sleagill, Westmorland, met William Jackson of Kinneyside, Cumberland, for the Championship of England. The contest, for a purse of £300, attracted one of the largest crowds ever to witness the sport and a conservative estimate suggests that some 10,000 spectators arrived from towns and villages throughout Cumbria as well as from as far away as London, Liverpool and Manchester. Atkinson won, by three falls to one.

Any pantheon of *wruslin* heroes must surely include such names as 'Belted Will' Richardson of Caldbeck, John Woodall of Gosforth, Tommy Longmire of Troutbeck, the Reverend Abraham Brown – no doubt inspired by Jacob's wrestling bout with the Angel in the Book of Genesis – and Professor John Wilson of Elleray, alias 'Christopher North', the writer.

Although John Wilson did not compete in the prize ring, he was acknowledged as an excellent wrestler. One opponent described him as *'a verra bad un to beat'*; this was none other than that old reprobate Will Ritson, who kept the inn at Wasdale Head. In his younger days, Will had been a noted wrestler and although he managed to throw Wilson twice out of three falls, the *'girt yeller-haired Professor'* later had his revenge at *the louping* – he jumped twelve yards in three jumps, with enormous stones clenched in each hand! Wilson's avid enthusiasm for wrestling is attested by one of his articles in *Blackwood's Magazine*; in December 1823 he wrote of:

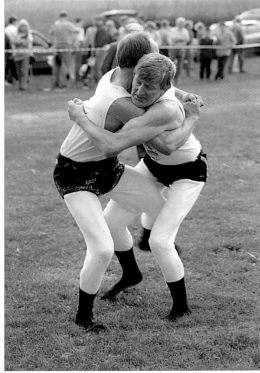

Still a popular sport today, Cumberland and Westmorland wrestling has a long history and may well have been introduced to the area by Norsemen.

Eager baying hounds wait to be slipped by their owners at Wasdale.

The trail hounds leap over a gate in hot pursuit of the aniseed trail.

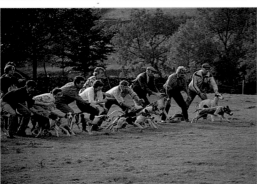

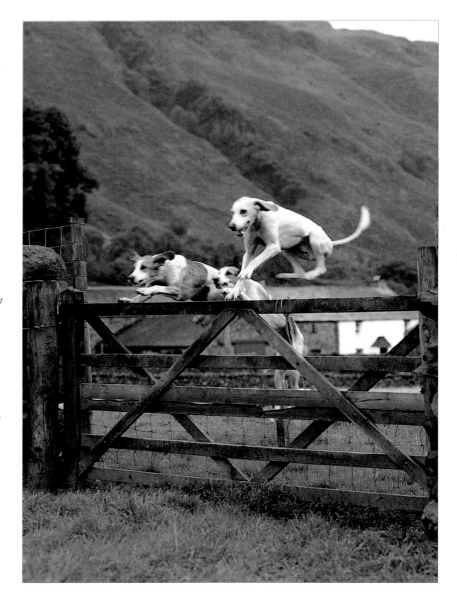

Windermere
REGATTA,
TO BE HELD
AT THE LOW WOOD INN,
On Thursday, the 23rd September, 1830.

The Stewards propose that the following arrangement of Sports be adopted :

A TRAIL HUNT *will commence at* 9 o'clock.—First Dog £1. second, 10s.

TEN O'CLOCK.

Rowing Match for Skiffs, single handed.

First Prize, £1.—Second (if more than two) 10s.

HALF-PAST TEN.

MATCH with FISHERMEN'S BOATS, double-handed, each to be rowed by the Men who have regularly fished in them, short Oars only.—First Prize, £1.—Second, 15s.—Third, 10s.—Fourth (if five Boats contend) 5s.

ELEVEN O'CLOCK.

ROWING MATCH

For Wherries, double-handed.

First Prize, £3.—Second Prize (if three Boats) £1.

HALF-PAST ELEVEN.

MATCH for PLEASURE BOATS single-handed.—First, £1—Second, 10s. Third (if more than three) 5s.

TWELVE O'CLOCK.

Match for Boys under 16 years of age,

In Skiffs, double-handed.—First prize 10s.—Second (if more than two) 5s.

Private Matches among Gentlemen Amateurs, and other amusements, will take place at this time.

ONE O'CLOCK.

It is requested that all SAILING BOATS rendezvous in the Bay at Low Wood, and form a Sailing Match for a NEW SUIT OF COLOURS.

TWO O'CLOCK.

A GRAND PROCESSION,

To be formed of all the Boats, to follow in succession—the Sail Boats to take the lead.

THREE O'CLOCK.

Grand Wrestling Matches.

All names to be entered at a quarter before three.—First prize, £6 and a handsome BELT.—Second Prize, £2.—Two falls out of three to decide the last contest.

A Cold Collation will be ready at this hour for Ladies and Gentlemen, at the Low Wood Inn.

A FOOT RACE

Will take place immediately before the wrestling.—First prize, 15s.—Second, 5s.

All disputes to be settled by the Stewards, or those appointed by them.

A SPLENDID EXHIBITION OF

VAUXHALL FIRE WORKS

Will take place (at dark) in the evening.

Stewards,

Professor WILSON,	I. L. BEETHOLME, Esq.
JAMES BRANKER, Esq.	ROBT. PARTRIDGE, Esq.

A Ball will take place on Friday evening, at the Low Wood Inn ; dancing to commence at nine o'clock.

T. Richardson, Printer, Kendal.

. . . the intense and passionate interest taken by the whole northern population in this most rural and muscular amusement. For weeks before the great Carlisle annual contest, nothing else is talked of on road, field, flood, foot or horse-back; we fear it is thought of in church, which we regret and condemn; and in every little comfortable 'public' [house] within a circle of thirty miles' diameter, the home brewed quivers in the glasses on the oaken tables to knuckles smiting the board in corroboration of the claims to the championship of a Graham, a Cass, a Laughlen, Solid Yaik, a Wilson, or a Wightman.

Another less likely enthusiast was Charles Dickens; after observing the sport at Windermere he wrote in *Household Words*

They strip to their drawers and flannel vests, shake hands in a token of amity and then, while exerting every muscle to the utmost, these fine fellows never exhibit a trace of savageness or animosity.

Yet of all the heroic figures celebrate in the annals of wrestling, none can equal George Steadman of Asby, near Appleby. In 1900 at the age of fifty-four, he decided to quit the ring having won the Heavyweight Championship at Grasmere on no fewer than seventeen occasions. This gentle giant, with his portly figure and mutton-chop whiskers, gave the appearance of an avuncular cleric as he posed for photographs amid a veritable Aladdin's Cave of silver cups, teapots, trophies, medals and belts.

In an age of kung-fu and kendo, the art of Cumberland and Westmorland wrestling is still alive and well, and during the winter months a new generation of Cumbrian children is taught the finer points of the sport in delightfully-named 'wrestling academies'. Perhaps it requires only the attention of a tele-

£6 and a handsome belt was offered as the first prize for the Grand Wrestling Matches at Windermere Regatta.

vision mogul to elevate this most skilful of all the rural sports to the position it once held.

The legend of the Troutbeck Champion Wrestler

One of the earliest wrestling legends concerns Hugh Hird, the Troutbeck Giant. Sometime in the reign of Edward VI or perhaps Henry IV, Hugh is said to have visited London and participated in wrestling matches before the king. His prowess and skills won the day and attracted royal approval. Curious to know the secret of Hugh's success, the king inquired about his diet. *'Thick poddish an' milk that a mouse might walk on dry-shod, to my breakfast, and the sunny side of a wether* [sheep] *to my dinner when I can get it'* was the response. Whereupon the king ordered a sheep to be roasted and the young giant immediately consumed it. As a reward for gaining the wrestling championship, Hugh was given the house in Troutbeck where he lived, the adjacent land from which he could cut peat, and the wood from Troutbeck Park.

The Poor Man's Fox Hunting

If one sport may be said to challenge wrestling for the affection and loyalty of Cumbrians, it must surely be hound trailing. Although sometimes described as 'the poor man's fox hunting', even the most ardent anti-bloodsports supporter could scarcely object to an activity which has no quarry. Rarely seen outside Cumbria, hound trailing has no long history yet it has become one of the most characteristic sporting events in the Lake District social calendar and, arguably, it has replaced cock fighting in its popular appeal. Today the hound trails are supported by much the same cross-section of the community which once attended the cock mains.

The hounds follow a trail laid by rags soaked in aniseed and oil over fell and dale, mountain and

moorland for several miles. Of course, the unscheduled appearance of a fox or even a rabbit can cause something of a diversion and there is at least one recorded instance of a hound finishing amongst the leaders with a rabbit clenched in its mouth – but such instances are rare. Before the founding of the Hound Trailing Association in 1906, the sport was open to all kinds of roguery. Stories are told of identical hounds being switched half way round the trail, of false trails being laid, and – my favourite – of one wily old fellsman who trained his hound to follow the smell of bacon fat above everything else, smeared his boots with bacon and then departed from the official trail by taking a short cut down the fellside, ensuring that his hound came in first.

Now, such deception would be impossible; the laying of a trail is carefully monitored, each hound is marked before the 'slip' with a dye in a position known beforehand only to the judges, and the race of ten miles for senior hounds must be accomplished within strict maximum and minimum limits.

Trail hounds are *not* fox hounds and the two must not be confused. Bred more for speed than stamina, trail hounds are both lighter and faster than those bred for fox hunting. Average speeds of twenty miles per hour over scree, crag, becks and bracken are not uncommon in their avid pursuit of the aniseed trail. On damp cool days speeds are faster than in warm weather since the hounds are less inclined to stop to drink. Part of the mystique which surrounds hound trailing is concerned with the way the animals are fed. Cosseted and pampered like the fighting gamecocks of an earlier age, their diet is often a closely-guarded secret since it is believed that herein lies the formula for success. Similarly, a champion hound will be trained to respond to a particular shout, whistle, call or

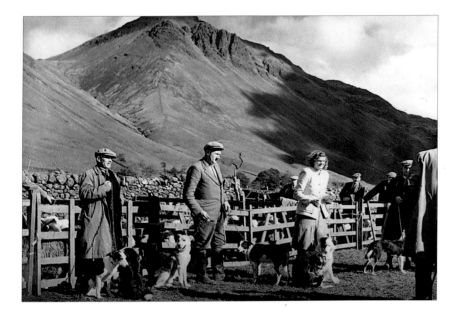

Sheepdog trials at Wasdale Head

signal as anyone who has seen the finish of a trail will recall. As soon as the hounds are within earshot, the owners break into a cacophony of yells and screams to encourage or cajole their animals to make for the finishing line. The sight and sound of an excited line of howling owners at the end of a trail, matched only by the eager baying hounds before they are 'slipped' to begin the race, must be experienced to be believed. Winning the hound trail at one of the big Lakeland shows or sporting events brings great prestige and it seems that, like wrestling, this most Cumbrian of sports will continue for many years to come.

Beatrix Potter at the Grasmere Sports Hound Trail

About nineteen dogs were thrown off, but two young hounds turned back at once, puzzling about the meadow. The spectators of the tarred wall received them with execrations and shouts of 'any price agin yon doug!' Rattler won, a lean black and white hound from Ambleside. . . . Rattler's victory appeared popular, Mr. Wilkinson danced on the box, slapping his thigh . . . indeed, Mr. Wilkinson raced so alarmingly on his own account with a wagonette that we began to wonder whether he was, to quote aunt Booth's expressive phrase 'boozy', the lower orders were so extensively, but the weather was some excuse.

Beatrix Potter's Journal in 1895

Auld Wives' Hakes and Merry Neets

Until the late nineteenth century the difficulties of travel and the isolation of many of the inner valleys of the Lake District meant that opportunities for social contact were limited so farmers' wives eagerly seized any

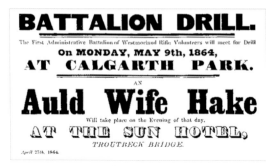

An Auld Wive's Hake was a grand opportunity to catch up with the local gossip.

opportunity to get together for a cup of tea and a chance to catch up with the local gossip. An 'Auld Wives' Hake' was one such occasion. At Troutbeck the *hake* was usually held on Old Christmas Eve (January 4) at the Mortal Man Inn but elsewhere it coincided with events which occupied the menfolk. The annual festivities at Christmas, clipping time and harvest, when a *kern supper* took place, were the highlights of the social calendar but other less regular events also afforded an excuse for a *merry night*.

When a new house or barn was built, a 'timber raising' was held and all those neighbours who had helped construct the roof were rewarded with a supper and a 'carding do', a card party, in the newly-completed building. Similarly, when a new tenant entered his farm, a 'boon ploughing' would be arranged and his neighbours would bring their ploughs and teams and give him a day's work, to be followed by a 'tatie-pot supper', cards for the elderly, and dancing in the barn for the youngsters which, according to the diarist, William Fleming, *'has more inducement than the most extravagant wages he could have offered'*.

The most popular card games in the early nineteenth century were 'three card lant', whist, and the unsophisticated 'brag' and 'nap', the prizes being usually a goose, a leg of mutton or sometimes a whole sheep. But there were many who were simply content to spend the *'merry neet'* listening to the music, watching the dancing, consuming ale possets and the appropriately-named 'humming grog' or merely enjoying a *lile crack* (gossip) with their neighbours.

The dances at these *merry neets* were often a mixture of modern and traditional; the latter included the Cumberland Square Eight, the Long Eight, the Ninepins Reel and the Circassian Circle, all of which resembled in some degree Scottish country dances, a point which did not escape John Keats when he witnessed a dance at Ireby in 1818:

They kickit and jumpit with mettle extraordinary, and whiskit and friskit, and toe'd it and go'd it, twirled it and whirled it, and stamped it and sweated it, tatooing the floor like mad. The difference between out country dances and these Scottish figures is about the same as leisurely stirring a cup o' tea and beating up a batter pudding.

Although these rustic dances could not compare favourably with the elegant assemblies in London, Bath and Cheltenham, nevertheless it was considered to be a social asset to be able to participate in the dancing. Consequently the sons and daughters of yeoman farmers were taught the necessary skills in the Assembly Rooms of Ulverston, Ambleside, Keswick and elsewhere. No doubt the task was difficult and smacked of silk purses and sows' ears as this description of a dancing class in Bowness in 1802 suggests:

We went up a flight of stone stairs to a large room where we were not a little amused by the essay of the lads and girls of Bowness – a more awkward

squad can scarcely be imagined – and the rough and brawling voice of the Master promised but an ill omen for the graces and manners of his pupils. However, let me not undervalue praiseworthy and innocent endeavour in the Parents to educate the minds and assist the sympathy and graces his little ones – and worthy of commendation.

Unfortunately, the behaviour of the adults did not always provide a role model for their offspring. In 1811 F Jollie described a 'dancing party' which would not have been out of place in a Wild West saloon!

In their dances, which are jigs and reels, they attend to exertion and agility, more than ease and grace. . . Indeed these dancing parties often exhibit scenes very indelicate and unpleasant to the peaceful spectator. No order is observed, and the anxiety for dancing is great; one couple can only dance their jig at the same time, and perhaps half a dozen couple [sic] stand on the floor waiting for their turns; the young men busied in paying addresses to their partners, and probably half intoxicated, forget who ought to dance next; a dispute arises; the fiddler offers mediation in vain; nay the interference of an angel would have been spurned at; blood and fury! it must be decided by a fight, which immediately ensues. During these combats the whole assembly is in an uproar; the weaker part of the company, as well as the minstrels, get upon the benches, or stand up in corners, while the rest support the combatants, and deal blows pretty freely among each other; even the ladies will not infrequently fight like Amazons in support of their brothers, sweethearts, of friends. At length the fight is over, and the bloody-nosed pugilists, and unfeathered nymphs, retire to wash, and readjust their tattered garments; fresh company comes in – all is quiet, and the dance goes on as before.

In small print below the heading are listed some 96 dances – a full evening lay ahead. Those participating and listed against the quadrilles and reels appear to be pupils since they are invited to the recommencement of the school two years hence. The dancing began with 'a March by the small Class' and included a Broad Sword Hornpipe, a Garland Dance and a Spanish Gauracha with 'Castinetts'.

Mr. LISHMAN'S BALL,

IN MR. YEWDALE'S LARGE ROOM, KESWICK,

On Friday Evening, March 29th, 1822.

Part First.

To COMMENCE with a March by the small Class.
Scotch Steps... Misses E. Richardson and Thompson.
Reel.... Three Sets.... Fifth Class.
Single Dance... Misses J. Bowe and M. Douthwaite.
Allemande... Misses James, Dixon, and Master Wren.
Hornpipe... Masters W. Edmondson & G. Williamson.
Kilkenny's Reel.... Two Sets.
High Dance... Misses Edmundson and Robson.
Quadrilles... La Coquette and La Poule.... Fourth Class.
Scotch Steps... Misses Rookin and Clarke.
Medley Reel... By Four Ladies and Gentlemen.
High Dance... Misses Williamson and M. Richardson.
Irish Dance... Eight Ladies... Tall Class.
Scotch Steps... Misses Douthwaite and Bowe.
Irish Dance... Three Ladies and Gentlemen... First Set.
Hornpipe... Two Masters Williamson.
Solo, with Garlands... Misses Hoggarth and Benson.
Arbours... Two Sets... by Four.
High Dance... Misses Tolson and Clarke.
Figure... Misses Thompson and J. Bowe, Masters W. Edmondson and G. Williamson.
Figure... Five Ladies and Gentlemen.
Hornpipe... Master Banks and Dover.
Quadrilles... La Fauche and the Flying Roy... by Twelve.
Scotch Dance... Misses Gill and A. Dixon.
Garland Strespey, with Adagio and Air... Misses Benson, Douglas, Richardson, Dent, M. Plasket, and J. Ashburner.
Hornpipe... Masters Greenip and Birkett.
Allemande... Misses Airey, Gibson, Ashburner, Plasket, and Cockbain.
High Dance... Misses Greenip and J. Hewetson.
Reel o'Bogie... Three Sets... First Set.
French Steps... Miss Dixon.
Figure... Misses Clarke, Rookin, E. Richardson, and M. Douthwaite.
Hornpipe... Masters Browngg and Fisher.
Figure... Four Ladies and Gentlemen.
Scotch Steps... Miss Vickers.
Waltz Trio... Misses Browngg and Douglas, and Master Guy.
Hornpipe... Masters J. Dover and Wren.
Garland Strespey with Adagio and Air... Misses Hoggarth, Walker, Browngg, and Tuer.
High Dance... Misses M. Plasket and James.
Steps, Single Time... Masters Cartmel, Ashburner, and Clarke.
Allemande... Misses Tolson and M. Plasket, and Master Edmundson.
The Grove Dance... Misses J. Bowe, M. Douthwaite, E. Richardson, and Clarke.
Irish Reel... Two Sets... Second Class.
High Dance... Misses Richardson and Dent.
Reel o'Bogie... Three Sets... Less Class.
Solo Garland... Misses Airey, Gibson, and Ashburner.
Hornpipe... Master Fleming.
Scotch Dance, in Two Parts... Miss Walker and Master Bowerbank.

French and German Waltzing... Ladies.
Reel Four... Misses Greenip and James, Masters Dover and Dixon.
High Dance... Miss Walker.
Scotch Reel... Two Sets... Least Class.
High Dance... Miss Douglas.
First Contra Dance.
Second do. do.
Garland Dance... Twelve Ladies... Queen, Miss Thompson.

Part Second.

Arbours... Miss and Master Clarke.
Hornpipe... Master J. Browngg.
High Dance... Misses J. Ashburner and Browngg.
Quadrilles... La Chase and Le Terpsichore... Eight Ladies.
Hornpipe... Masters Ashburner and Guy.
High Dance... Misses Hewetson and A. Plasket.
Walts, Trio... Misses Hoggarth and Benson, and Master Airey.
Hornpipe... Masters Bell and Robson.
The Pavilion... by Eight.
Steps... Single Time... Masters J. Dover, Wren, and Edmundson.
Juvenile Dance... by Sixteen.
Highland Steps, with Garlands... Three Ladies.
Quadrille, Four... Misses Walker and Browngg, and Master Dixon and Airey.
Hornpipe... Masters Cartmel and Bowerbank.
Medley Reel... Eight Ladies.
Quadrilles... La Chase and Le Terpsichore... Second Class.
Hornpipe... Masters Clarke and Edmundson.
Irish Reel... Two Sets... First Set.
Madame Sachi's Dance... Misses Tuer and Plasket.
Spanish Gauracha, with Castinetts... Miss Hoggarth.
Garland Strathspey with Adagio and Air... Six Ladies, Tall Class.
Hornpipe... Master Airey.
Reel Three... Two Sets... Least Class.
Allemande... Five.
High Dance... Misses Ashburner and Cockbain.
Quadrilles... La Coquette and La Poule... Third Class.
Steps, Single Time... Masters Bell and Browngg.
Madame Sachi's Dance... Misses Airey and Gibson.
Medley Dance... by Four.
Long Irish Reel... by Six.
Waterloo Dance... Miss Hoggarth.
Irish Figure... by Six.
Hornpipe... Master Dixon.
Third Contra Dance.
Fourth do. do.
Solo Garlands... Three Ladies.
Broad Sword Hornpipe... Masters Guy, Bowerbank, Robson, and Airey.
Bower Dance... Five Ladies.
To CONCLUDE with a March.

Doors to be opened at half past 5, and the Ball to begin at 6 o'Clock.

Tickets to be had of J. Lishman, at Mr. J. Rookin's, Innkeeper.

☞ J. L. begs leave respectfully to inform his Friends, that he purposes recommencing his School in 1824, and hopes for a Continuance of their Favours.

BAILEY, PRINTER, COCKERMOUTH

A varied evening of entertainment includes Shakespeare, a laughable farce and a comic song.

Music for *merry neets* was usually provided by a fiddle – most dales could boast at least one fiddler – and a tin whistle, though later the melodeon became popular. In some areas 'unconventional' instruments were employed – one of the most bizarre being a metal coffee pot with holes punched in the side which apparently emitted a sound not unlike a piccolo. In the Millom area, when there was a lack of musical accompaniment, the winnowing machine was pressed into service to beat out the rhythm for dancing.

The popularity of these dances remained through-out the early decades of this century, little changed since Keats's day.

Here the Vicar of Patterdale, W P Morris, describes the warmth and spirit of the village 'hop' in 1903

The floor is polished and made up-to-date and slippery with bits or scrapings of wax candles, and if the room gets very dusty by midnight, the M.C. or deputy produces a jug of water and profusely sprinkles the floor. The dancers go through the old-fashioned tripping of the light fantastic toe with great enthusiasm. If the atmosphere of the room gets very close, the young men at once take off their coats and 'go' with gusto. To strangers it is a wonderful sight to see them swing round in the six reel, long eight, square eight, valse, varso vienna, schottische, polka etc.

Although the ubiquitous discos and amplified sounds of heavy metal bands have made inroads in places like Kendal, Keswick and Ambleside, village dances, whist drives and socials are still held, especially in winter but sadly, and unaccountably, the term *merry neet*, once synonymous with Cumbrian folk culture, has been replaced by the Celtic word *ceilidh*.

The Theatre

Although some distance from centres of theatre life, the Lake District nevertheless had a tradition of 'folk theatre' which had deep roots. Mummer's plays were traditional at Christmas and Easter and in the fifteenth and sixteenth centuries Kendal craftsmen performed 'mystery plays'. But after the Restoration, 'legitimate' theatre began to develop. In the Westmorland Troutbeck the tradition seems to have been particularly strong; in the seventeenth century a band of players from the village regularly performed at Christmas before Sir Daniel Fleming at Rydal Hall and his account books record such items as:

1661 Dec. 27. Given to Troutbeck players for acting here 'The Fair Maid of the West' 10s 0d

1668 Dec. 28. Given to Troutbeck players being little boys 5s 0d

It seems probable that these players performed 'play-jiggs', short dramas in verse specially written for them by local 'rymers'. The best known of these was Thomas Hoggart, the village carpenter (whose nephew was William Hogarth, the satirical artist.) What he lacked in learning 'Ald Tom' Hoggart made up for in enthusiasm and he produced such epics as *The Destruction of Troy* and *The Lascivious Queen*, both performed in the open air. The latter play was acted out on a specially constructed stage near to Troutbeck Church on St James's Day, 1693 but *The Destruction of Troy* was a more ambitious spectacular which involved a wooden horse – built by Hoggart himself and from which men emerged at the critical moment – Hector dragged by the heels of Diomede, the flight of Aeneas and the burning of the city. Doubtless this untutored Cumbrian carpenter had the panache of a Cecil B de Mille!

Even after Tom Hoggart's death in or about 1709, his plays continued to be performed. Writing in 1780, Adam Walker recalled how, in his childhood, he had played a fairy in Hoggart's *Destruction of Troy*. The performance took place in the open air at Bowness and was intended as a tribute to the playwright:

I myself have had the honour to bear a part in one of his [Hoggart's] plays. . . . This play was called 'The Destruction of Troy'. It was written in metre, much in the same manner as Lope de Vega, or in the ancient French drama; the unities were not too strictly observed, for the siege of ten years was all represented; every hero was present in the piece, so that the Dramatis Personae consisted of every lad of genius in the whole parish . . . I remember not what Fairies had to do with all this; but as I happened to be about three feet high at the time . . . I personated one of these tiny beings. The stage was a fabrication of boards placed about six feet high, on strong poles; the Green Room was partitioned off with the same materials; its ceiling was the azure canopy of heaven; and the boxes, pit and gallery were the green slope of a fine hill. . . . Despise not, reader, this humble state of the provincial drama . . . there were more spectators, for three days together, than the three theatres in London will hold, and . . . you never saw an audience half so well pleased.

The Troutbeck thespians continued to perform in the second half of the eighteenth century; indeed, on Christmas Eve 1786, they were confident enough to give a performance of *Hamlet* in the Jolly Dragoon Inn. By this time, however, travelling players were entertaining rustic audiences in barns and make-shift 'theatres' in various parts of the district. As early as 1722 Benjamin Brown of Troutbeck visited the 'thea-

Various members of the Hall, Hamilton, Melville and Bowman families dominate the casts of 'Charles II' and 'The Hen-Pecked Husband' in Kendal in 1826.

tre' in Kendal and five years later he records spending the prodigious sum of 4s 6½d in *'Kendal at playhouse'*. Almost certainly this theatre was no more than a barn or stable hastily converted so that the 'barnstormers' could perform on a temporary stage in front of an audience seated on bales of hay. The fire risk was considerable and in 1775 the Reverend Edward Jackson, Vicar of Colton, recorded in his diary *'Fire in the Playhouse'* – the barn belonging to the White Hart Inn, Ulverston.

Joseph Budworth visited one of these travelling companies in Keswick in 1792 and has left a lively description of the the 'theatre' and the performance:

In the evening we went to see The Merchant of Venice in an unroofed house. The sky was visible through niches of boards laid across the upper beams. The walls were decorated, or rather hid, with cast-off scenes, which shewed in many places a rough, unplastered wall. . . . Between the acts a boy, seated upon an old rush chair, struck up a scrape on a fiddle. . . . The house was as full as it could possibly cram, and my friend counted but thirty-six shillings' worth of spectators in the pit, at eighteen pence a head, including a young child that squealed a second to the Crowdero of the house. Perhaps, as the actors were so near to the audience, it was frightened by Shylock's terrific look. Whilst I remained, not even the 'Hush a be babby' of its mother had any effect.

Another traveller, J Mawman, passing through Penrith in 1805, noted a barn with 'Theatre' inscribed in large letters over one entrance, 'Stage' over another, and 'Entrance' over a third, where the manager sat anxiously awaiting an audience that did not materialise.

Gradually, however, permanent theatres began to replace the barns and stables. One of the earliest was

A Mr Saxoni regularly trod the boards – or rather the tight ropes – of Cumbrian theatres; his playbill grandly indicates that he will 'exert himself in a peculiar Manner by a novel display of Activity on the Tight Rope'. He then repeated the performance with a boy tied to each foot! Despite the applause referred to and the extension of the run for one more, 'Positively the last', night, Mr Saxoni explains in small print below the list of wonders to be performed that he is 'inclined to discontinue this profession' and offers for sale 'his hydraulic and other curious Apparatus'.

opened in 1736 in Whitehaven, then one of England's most important ports. In Kendal, a theatre was opened in the north-east corner of the Market Place in 1758 – later it was converted into shops and in 1843 it became the Working Mens' Institute, an inscription it still proudly bears despite now being occupied by an estate agent. The curtain rose on another theatre in 1790 in the Woolpack Yard – capable of holding between six and seven hundred people, it rejoiced in the name The Theatre Royal. In 1828, behind the Shakespeare Inn in Highgate, the New Theatre, opened its doors. Sadly, because of considerable opposition from the religious community of the town, it survived for a mere five or six years. The building has recently been restored so now something of its original elegant Georgian facade can be appreciated. Ulverston, described by one writer as *'a pocket edition of the metropolis, mimicking its dissipations and copying its manners'*, opened its first purpose-built theatre in 1796 and this rapidly became the focus of social life in the area. William Fleming was an inveterate though highly critical patron; in his usual acerbic manner he records in his diary a visit to the theatre on 22 November 1800:

This evening went to the theatre in Ulverston where was represented *The Tragedy of Barnwell*. Two or three of the actors tolerable, but the others miserably supported. A lady in the boxes (Mrs. B. . . .) was the only person I saw affected so much as to shed a tear, and from certain circumstances in her behaviour this evening, I am induced to suspect brandy rather than the sympathetic proofs of sensibility.

The taste of theatre-going Cumbrians was, to say the least, catholic. In 1854 a Kendal audience watched scenes from such tear-jerkers as *The Outlaw of Sicily*, *A Murderer's Grove* and *Richard III* but a

Three years after appearing before the Royal Family at Windsor, the two twin Irish Giants, nearly eight feet tall, are on show in Kendal for six days.

footnote to the playbill cheerfully announces that *'parties desirous of dancing betwixt each part will be allowed if they choose'.*

'Spectaculars' were great crowd-pullers. *The Real Phantasmagoria (from 28 Haymarket, London)* toured Lakeland's theatres during the early nineteenth

century with hair-raising representations of *'Louis XVI which changes to a skeleton, Lord Nelson, Paswan Oglou, The Turkish Rebel, the Bleeding Nun from 'The Monk', and a striking likeness of His Majesty etc. etc.'* But for those who feared that they would be shocked by such a programme, the playbill reassures the public that *'the audience may rely on the utmost decorum during the whole Performance'.*

Lord Nelson popped up again in February 1806, this time in the Theatre Royal in Whitehaven when, according to the advertisement

...will be presented Shakespeare's Celebrated Comedy of the Merchant of Venice ... followed by singing and dancing and concluding with a panoramic of an exact representation of the grand and ever memorable Battle of Trafalgar, during which Miss Quantrille will recite, in the personage of Britannia, a monody on the death of the ever-to-be-lamented hero of the Nile and Trafalgar. The termination will be a striking likeness as large as life of the Immortal Hero ascending from the sea and rising on a cloud supported by angels.

Another firm favourite was the melodrama *The Pilot or A Storm at Sea* which flooded the stage with water to the delight of the audience – and the consternation of the theatre management!

Characteristically, these northern audiences demanded – and received – value for their money. On 3 November 1804 the patrons of the Ulverston theatre sat through a performance of a tragedy, King Henry II or The Fall of the Fair Rosamond, a comic dialogue, Sawney and Bonaparte, a favourite comic song by Mr Dunning entitled The Lord Mayor's Show, another song by Mrs Darley, called The Shelter'd Bird and the evening's entertainment concluded with a musical farce The Irishman in London

or The Happy African Boxes were 3s, the Pit was 2s and the Gallery was 1s. However, all was not sweetness and light; one Richard Cousen, a mariner, of Bouth in High Furness, confessed in a 'submission' or printed public apology, dated 21 November 1806 that 'being in liquor' he ...

... did on Thursday Evening the twentieth November Instant, throw a certain Glass Bottle out of the Gallery of the Theatre at Ulverston, to the imminent danger of the Audience and Performers for which offence I have been apprehended and ordered to be prosecuted but on account of my general good Character, at the Instance of Mr. Buttler, the Manager (whose pardon and that of the Public at large, I humbly solicit), I have been set at Liberty. Now I do hereby promise never again to be guilty of such an offence.

The age of audience participation had arrived

In an age of mass entertainment, videos, cable and satellite television, some have argued that the days of live theatre in our provincial towns are numbered but despite severe funding cut-backs there are some encouraging signs. The theatre at Rosehill near Whitehaven, continues to be an important cultural centre in West Cumbria; the remarkable Theatre in the Forest at Grizedale offers not only theatrical performances but music, lectures and poetry evenings; the new Brewery Theatre in Kendal and the small, intimate Old Laundry Theatre in Bowness provide lively programmes. And at Keswick the legendary though now immobile 'Blue Box', despite leaks in the roof and the noise of sheep in the adjacent field, delights and entertains visitors and locals alike just a few hundred yards from where Joseph Budworth attended the performance of *The Merchant of Venice* in 1792 – and long may it continue.

A production of Macbeth in 1808 included singing and speaking witches and two apparitions: one of an armed head and one of a crowned head. This was to be followed by a song decrying Napoleon Bonaparte, a vision of Britannia, a hornpipe, a comic song and, finally, a musical farce – a very full all-round evening's entertainment.

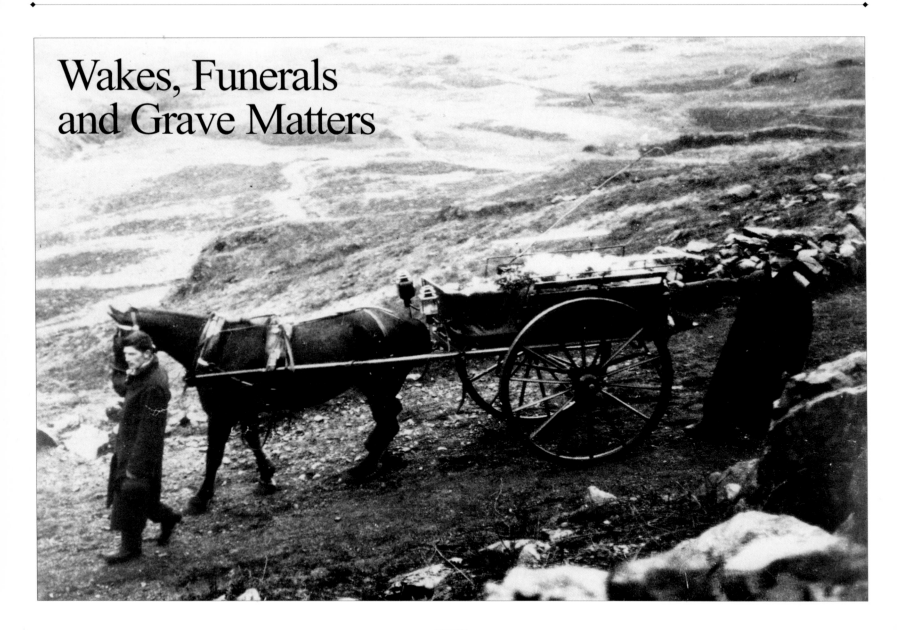

Wakes, Funerals
and Grave Matters

In all societies, folk lore, superstition and death are inseparably linked and there are many Cumbrian customs and traditions associated with death and burial. One of the strongest and one which lasted until the nineteenth century, was the curious belief that a dying person could not pass away peacefully if he or she was lying on a bed containing pigeon feathers. In the event, when death was imminent, the patient was often removed from the bed and placed on the floor where, it was believed, the soul could depart in peace. Such uncouth handling may well have hastened the arrival of the Grim Reaper, thereby adding credibility to the superstition! A similar belief prevailed also in Ireland.

After the death, it was deemed necessary to 'tell the bees' of the bereavement and a special messenger was sent to the hive to address the bees and drape the skep with black ribbon. It appears that although the custom was followed in other areas, including Scandinavia, Ireland and various parts of Britain, it survived longer in Cumbria than elsewhere. Certainly there are people alive today who have 'told the bees' in the 1930s and 1940s. The origin of the tradition is difficult to trace. Perhaps it stems from a belief that if the bees were not told, they, too, would die or go away. In 1986 W Dodd remembered that when the tenant, Henry Wilson, died at Greenways, Edenhall:

. . . his widow draped the hives with crêpe, told the bees that their master was dead and bid them to the funeral. After the funeral she took each hive a portion of the funeral repast.

Ireland has long had a tradition of lively wakes and in Norway a custom not dissimilar was respected; a famous illustration by N Astrud entitled *Likdansen* shows the corpse with a lighted candle at his head, the bible under his chin – and a boisterous dance in progress! In Cumbria there does not seem to have

A Writer of Epitaphs

As well as the author and producer of 'play-jiggs', Tom Hoggart (see page 68) was often asked to compose epitaphs.
Three of his best-known efforts are:

◆

For William Bell, a Sexton
Passengers, if thou wod tell
Who lies here, 'tis William Bell;
He was sexton, long together,
Then one Bell did ring another.

◆

For William Johnson, a Cobbler:
Here's Johnson, the cobbler,
by death stricken dead,
He poorly lived, poorly dyed,
was poorly buried;
For a pipe of tobacco was all his wife spent
On his funeral, so to the kirk-yard they went,
And made his interment
in a great shower of rain;
It had been no matter
if we'd there left the twain.

◆

For a Woman
Here lies a woman
No man can deny it,
She died in peace although she lived unquiet;
her husband prays if e'er this way you walk
You would tread softly – if she wake she'll talk.

[Facing page]
The funeral cortège of Tommy Dobson, the famous huntsman, on Hardknott Pass, 1910.

been the same nonchalant atmosphere at wakes but the tradition of watching the body until the day of the funeral was customary:

Between the death and the interment, which is from two to three days, the neighbours watch the corpse alternately – the old people during the day till bedtime, and the young people afterwards till morning. Bread, cheese, and ale with pipes and tobacco are provided for those who attend the corpse. The friends of the deceased, as well as the neighbours for several miles round are generally invited to the funeral, who are served with bread, cheese, ale drams, pipes and tobacco. After the burial, a select party of friends and neighbours are again invited to supper.

F Jollie *Sketch of Cumberland Manners and Customs*, 1811.

Visitors arriving to express condolences were expected to undergo the gruesome ordeal of touching the body, a tradition which arose from the ancient superstition which claimed that if the murderer touched the body of his victim, the corpse would bleed. Consequently, mourners had to endure this test to show publicly that they were not responsible for the deceased's demise.

The corpse was carried from the farmstead to the church along jealously-guarded corpse ways which were frequently the source of friction in dales communities. In Troutbeck, Windermere, there are records of fences being removed to allow a funeral cortège to use a long-established route through certain fields to the church. Any departure from this route would have been regarded as an ill-omen. An unfounded belief developed that if a corpse passed over private land, a right of way would be created. John Richardson, writing in 1876, emphasises the potency of this tradition:

There was a general belief, which has partly come down to our own times, which in some degree accounts for the scrupulous exactness with which they kept upon these old-established paths. It is a vulgar error of course, but there are old people yet living who will tell you that if a corpse on its way to church, is carried by a fresh way across the fields, that way becomes a public road for all time, not to be stopped up by anything short of an act of parliament, if by that.

The belief clearly was an ancient one; this 'corpse permit', allowing a body to be carried over private ground, was signed and witnessed in 1689:

These may certify to all it may concern that I Joseph Sunton of Tockhow in clayfe in the County Palatine of Lancashire, yeoman, did ask leave and license of Bernard Benson of Tockhow, James Braithwaite of Loanthwaite and George Braithwaite of Loanthwaite, Thomas Dove of Birkhow and Edward Hird of Outyeat all in the County of Lancaster, yeomen, to carry the corpse of Jane Benson my Mother in Law, late of Tockhow afforsaid, widow deceased, through their several closes hereafter and herin named that is to say through Bernard Benson's close called Ridding, and through James Braithwaite's close called Farrfield woodboardyeat [?], and through George Braithwaite's close called Langfield and through Edward Hird's close called Birkrow field or the loan thereto adjoining, the said corpse being carried from Tockhow afforsaid to Grasmere Church the twentieth day of December last past before the date hereof. And I do believe that I had no right to go that way but by permission of asking leave. As witnessed my hand this twenty eighth Day of March . . .
Anno. Dom 1689.
Joseph Sumpton

In some areas it was usual for singers to head funeral processions, chanting hymns and psalms. The following is an extract from a lady's will dated 1704 in which she bequeaths:

Twenty shillings to be distributed by my said
Son in Law to such young men and others who
shall sing Psalms before my Corpse to ye
Church all ye time of my funeral.

Where the church was some distance from the farmstead, the bearers often rested at intervals along the way and the coffin was placed on 'resting stones' which can still be identified is some places such as the ancient track over Burnmoor which led from Wasdale Head to the traditional burial ground at St Catherine's chapel in Eskdale.

As the doleful procession neared the church, the 'passing bell' would, by the number of tolls, indicate the funeral of a man, a woman or a child. The signal varied from dale to dale but at Troutbeck the bell tolled nine times and a pause for a man, six times for a woman and three times for a child. The burial service was usually conducted with due decorum – but not always. The Low Furness diarist, William Fleming, castigates the Vicar of Dalton for his unseemly behaviour in 1805:

He is a disgrace to the gown [being] most
notorious for drunkenness and lying: frequently,
I say, the solemn funeral service is hiccup
through in a way most distressing to the
mourners and this minister of the gospel is
scarcely able to follow the corpse to the
grave without assistance.
What an example to his flock!

William Fleming had little time for clergymen. He wrote this about another Furness vicar:

The Reverend Kelly always will be poor
Whiles there's a Public House so near his door.
Kelly, whose wit as much exceeds his sense
As love of liquor oft exceeds his pence.

Around the graveside, the arvel bread and sometimes arvel cheese (see page 17) was distributed, before the family and invited mourners returned to the farmstead for the funeral feast. William Fleming's comments in 1805 show the degree of class distinction observed at such occasions:

It is a singular custom still followed at Dalton by the
more respectable inhabitants at funerals, to divide
the people who attend the Interment into three
classes. The first class consists of the richest and
nearest relatives who have a warm dinner provided.
The second consisting of the poorest and more
distant relations together with the richer
acquaintances, partake of a cold dinner; and the
third, of the farmers and people of the town who
are not relations or opulent acquaintances
these have bread and cheese.

Stories and legends

In isolated communities the corpse often had to be carried many miles to a distant church on a crude bier or sled or, alternatively, strapped to the back of a pack horse. Several folk legends are associated with these dismal journeys. One much-told story concerns the Coniston area. Before St Andrew's church had the right to bury its dead, bodies had to be transported to Ulverston for burial; it seems that the late Mr Jenkins was making his final journey to that town, carried on a sled. A short distance from Coniston poor Mr Jenkins fell into a beck – and it was some time before the mourners discovered the absence of the principal personage. Fortunately, after a search, he was found

and safely interred in Ulverston churchyard but the beck still bears his name, Jenkins Syke.

Another well-known and equally macabre story is told of the corpse road from Wasdale Head to Eskdale over the lonely, windswept Burnmoor. During the funeral of a young man the packhorse carrying his corpse took fright and galloped off into the mist and was lost. Shortly after, the man's mother died and at her funeral in the snow the same thing occurred. After a prolonged search the mourners found a horse – but it was the one which bore the young man's body; the woman's corpse was never found.

The same corpse road features in yet another lugubrious legend; as the coffin of a woman was being carried over the fell to Boot, it accidentally bumped into a rowan tree and immediately a miracle took place and the dead woman revived and was taken back home to Wasdale. Some time later the woman succumbed a second time and, when approaching the same rowan tree, the widower was heard to call to his son who was leading the horse: *'Tek heed o' yon rowan, lad'!*

A Jacobite Princess?

In the quiet churchyard at Finsthwaite near the southern end of Windermere stands a simple marble cross, erected in 1913 by the Canon C G Townley. It marks the grave of Clementina Johannes Sobieski Douglas of Waterside who was buried here in 1771. It has been suggested that this lady was an illegitimate daughter of Prince Charles Edward Stuart, the Young Pretender, by Clementina Walkinshaw. Admittedly the evidence is slender but the mother of Prince Charles was Princess Maria Clementina, the granddaughter of King John Sobieski of Poland. Moreover, in 1760, Miss Walkinshaw, in a letter to James III's secretary, writes *'. . . before 1745 I lived in London [and] was between then and 1747 undone.'* and goes on the speak of *'an*

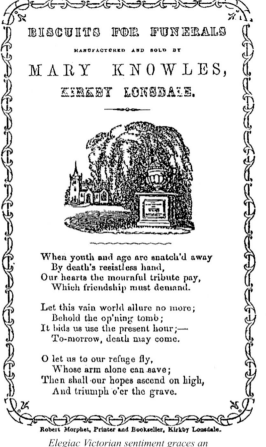

BISCUITS FOR FUNERALS

MANUFACTURED AND SOLD BY

MARY KNOWLES,

KIRKBY LONSDALE.

When youth and age are snatch'd away
By death's resistless hand,
Our hearts the mournful tribute pay,
Which friendship must demand.

Let this vain world allure no more;
Behold the op'ning tomb;
It bids us use the present hour;—
To-morrow, death may come.

O let us to our refuge fly,
Whose arm alone can save;
Then shall our hopes ascend on high,
And triumph o'er the grave.

Robert Morphet, Printer and Bookseller, Kirkby Lonsdale.

Elegiac Victorian sentiment graces an advertisement for funeral biscuits.

obstacle in the way which has done Him [the Prince] *no service, and me great hurt'.*

This was taken by Canon Townley and others to mean the birth of an illegitimate child. Was this daughter brought up in this remote corner of the Lake District in order to conceal her identity from potential enemies? It seems possible – yet she herself made no attempt to hide her illustrious name for she witnessed a will in 1770, so was she really of royal blood? The mystery remains.

Woollen Shrouds

During the reign of Charles II an attempt was made to encourage the woollen cloth industry by requiring burial in woollen shrouds. Under a stature passed in 1679 it was ordered that a fine of £5 be imposed if an affidavit, duly witnessed, signed and sealed, was not delivered within eight days of the burial. Several Lake District churches have these certificates. Hawkshead Church has over two hundred; the one below is preserved near the vestry door:

Paroch: de Hawksd. in Com. Lancs
Wee Agnes Sawrey widdow and Dorothy Tyson
Spinster doe severally make oath yt ye Corps of
Margaret Tyson of Gryzdale in the Parish aboves'd
beeing Buryed the first of April 1696 was not put in
wrapt wound up or Buryed in any shirt sheet shift or
shroud made or mingled with Flax Hemp etc or any
Coffin lined with Cloth etc. or any material but what
is made of sheep wool only According to a late Act
of Parliamt. made for Burying in Woollen. In
witness herof wee the said Agnes Sawrey &
Dorothy Tyson have sett our Hands & Seals.

Capt: et jurat: primus dies(?)	Agnes Sawrey
Aprilis Ano Di 1696	her mark
Myles Sandys	Dorothy Tyson her mark

An Old Wives' Tale Refuted

The old adage that 'Hard Work Never Killed Anyone' seems to be disproved by an ostentatious Victorian gravestone in tiny St Michael's graveyard at Rampside

Two Bowness Gravestones: An Old Soldier and a Freed Slave

Nestling close together at the eastern end of Bowness churchyard are two remarkable graves. Thomas Ullock who died on 19 October 1791 aged seventy-five years, was a former soldier who had fought for King George II and the House of Hanover:

*Poor Tom came here to lie
From battles of
Dettingen and Fontenoy
in 1743 and 1745*

His near neighbour was a freed slave:

*In Memory
of
Rasselas Belfield
A Native of
Abbyssinia
Who departed this life on the
16th Day of January 1822
Aged 32 Years*

*A slave by birth I left my native Land
And found my Freedom on Britanias* [sic] *Strand
Blest Isle! Thou Glory of the Wise and Free!
Thy touch alone unbinds the Chains of Slavery*

Wordsworth in his *Guide to the Lakes* (1810) mentions *'the Abyssinian recess of Rasselas'* but was this thought sparked off by his personal knowledge of this freed slave living barely a few miles away?

in Low Furness. John Dickinson died in January, 1878, aged forty-one years. His grieving mother blamed her daughter in law for his demise as the gravestone clearly illustrates. Although now partly illegible, the inscription reads:

Here lies my tortured son
For comfort of late he had none

Elsewhere in lachrymose Victorian fashion we read:

My Mother she will fret for me
My Mother now I cannot see
Father, Mother, Brothers fret no more
There is a better place for me in store

But the most crushing indictment appears at the base of the memorial:

It was 232 hours in 12 days
That brought poor John to his grave

Epitaphs

Epitaphs often display a dry and unintentional degree of humour. Can one really be certain that the widow meant the epitaph on her husband's grave in Cockermouth churchyard?

Stranger, call this not a place of gloom
To me it is a pleasant spot, my husband's tomb

'The Poet's Corner' in the churchyard at Grasmere where lie William and Mary Wordsworth, their daughter Dora and Hartley Coleridge.

In a Kendal churchyard is a brief but poignant rhyme:

Here lies John Ross
Kicked by a hoss

A noncommittal epitaph is inscribed on the grave of Nicholas Barrow in Cartmel Priory; it simply states:

What sort of man he was, The last day will discover.
Died 30 May, 1802, Aged 85

In St Michael's Church in Workington an understandably resentful epitaph marks the gravestone of Joseph Glendowing who was murdered near Workington on 15 June 1808:

You villains! if this stone you see
Remember that you murdered me!
You bruised my head and pierced my heart
Also my bowels did suffer part

And at High Harrington in West Cumbria this verse marked the grave of a 'free spirit'

Joseph Thompson may here be found
Who would not lie in consecrated ground
Died May 13th, 1745
Aged 63 when he was alive

An Internment Record
– or a Jack-in-the-Box?

John Wilkinson, one of the great figures of the Industrial Revolution, is justifiably famous as an Iron Master and, arguably, the inventor of the world's first iron boat, yet few men have undergone such a complex burial procedure. Although he owned ironworks in Shropshire, Staffordshire and Wales, like so many Cumbrians, he returned to his roots and in 1795 built a large house at Castlehead, near Lindale. Always an iron-obsessed eccentric, he had for many years kept an iron coffin ready to receive his corpse.

When he died in 1808, aged eighty, his body was enclosed in a wooden and lead coffin and transported from Shropshire, across the sands of Morecambe Bay to Castlehead for interment. However, the bearers were overtaken by the incoming tide and had to flee for their lives – leaving John behind in the quicksand! Eventually the coffin was extricated and it finally reached Castlehead but sadly the iron coffin proved too small so John was given a temporary burial in the garden until a larger iron coffin could be made. When this arrived, John was disinterred. Unfortunately solid limestone was encountered before sufficient depth could be achieved so once again John was temporarily reburied until the bed rock could be excavated and he was laid to rest – but not for long.

In 1828 the house was sold and the new owners, not wishing to have the previous owner outside their windows, had Wilkinson exhumed and buried, at dead of night, in the vicinity of Lindale Church. The exact location remains a mystery. Never one for false modesty, the inscription on Wilkinson's iron memorial in the village records:

His different works in various parts of the kingdom are lasting testimony of his unceasing labours. His life was spent in action for the benefit of man and, as he presumed humbly to hope, to the glory of God.

The Scales of Justice

'The animal fair held at Broughton this day was not overstocked with cattle . . . but the number of beggars and their saucieness – especially towards evening – was insupportable, for you must either give them money or bear their abusive language which they were by no means sparing of. They highly merited to be whipped through the towns for I am sure that the most severe flagellation could not exceed what was due to them.'

William Fleming, 1 August 1801

Sheep Stealing.

Five Guineas
REWARD.

Whereas for about twenty years past Sheep and Lambs have been annually stolen from the Mountain Sheep Pastures belonging to the *Black Hall* and *Gaitscale* Estates, at the head of the division of Ulpha, in the Parish of Millom, Cumberland, and the Farmer there has not been able to detect the Thief or Thieves.

Notice is hereby given,

That if any Sheep or Lambs shall in future be stolen from the Flocks belonging to either Estate, any person giving such information to Mr. GEORGE TYSON of Black Hall, as shall lead the Offender or Offenders to conviction, shall receive a reward of Five Guineas.

THE MARKS ARE;

BLACK HALL STOCK.—A red smit stroke down the near side; and both Ears cropped and upper Key bitted.
GAITSCALE STOCK.—A red smit mark over the Shoulder; and some of them also a red pop on the near Hook Bone, as a gathering mark for a particular part of the pasture; and both Ears cropped and under Key bitted.

Last year a Lamb of the Black Hall Stock which had been stolen, returned with one Ear cut off leaving the appearance of a Short Fork.

N. B.—Any communication made to Mr. WILLIAM BLENDALL, Solicitor, Broughton in Furness, will be forwarded to Mr. TYSON.

Black Hall ; 18th August, 1834.

MARY TYSON, PRINTER, KING STREET, ULVERSTON.

Here a reward is being offered for information regarding sheep stealing – a crime that in times of the harshest punishments might have led to transportation or the gallows.

Villiam Fleming, the Pennington diarist, summarised the views of the majority of landed gentry in the early part of the century when he complained so bitterly of the increasing number of beggars and advocated strong action in the August of 1801.

Many nineteenth-century attitudes to the poor and destitute were at best indifferent, at worst, chilling, and conditions described by Dickens in his novels could certainly find parallels in Cumbria. Such uncompromising condemnation fails to appreciate that many of these saucy beggars were men who had been dis-

charged from the army and navy, having fought for their King and Country, and, being without means of support, forced to beg for their livelihood.

Fleming was, for a time, Overseer of the Poor for his parish. His unsympathetic and chauvinistic attitude to unmarried mothers is reflected in his entry for 9 August 1810:

> Took Margaret Brockbank, a young woman belonging to our Parish, to father a child of which she is now big – and likely to be the second bastard she will produce chargeable to us. She named John Murphy, an Irishman, as the father of the child. The House of Correction is a fit place for such a wanton and unthinking woman.

Presumably, since Murphy was not mentioned in Fleming's invective, he was the innocent party.

Children at work

Perhaps one of the most disturbing examples of society's attitude to destitution is demonstrated by the treatment of orphans who were apprenticed to work in Messrs Ainsworth, Catterall and Company's cotton mill at Backbarrow on the River Leven. The 1816 Report of the Select Committee of the House of Commons on the 'State of Children Employed in the Manufactories' makes depressing and horrific reading. The children, mostly parish apprentices from the workhouses of London and Liverpool, were aged from seven to fifteen; they worked in the mill from five o'clock in the morning until eight at night all year through, with half an hour for breakfast and half an hour for dinner.

The lucky ones were marched to Finsthwaite Church, some two miles away, for Sunday morning service and in the afternoon were taught to read the New Testament. The less fortunate were obliged to clean the machines from six in the morning until mid-day, the mill owners no doubt believing that idle hands did the Devil's work.

There were no seats in the mill so the children were forced to stand during their fourteen-hour working day and, not surprisingly, many fell asleep through sheer exhaustion. With the machines unfenced, there were numerous accidents involving crushed fingers and broken limbs.

In all the shameful history of child labour in nineteenth-century Britain, few establishments can have equalled the appalling reputation of the Backbarrow cotton mill, yet hundreds of guests who now dine and stay in the former factory, now a luxury hotel, are blissfully unaware of its notorious past.

Six years before the Select Committee's report was published, a thirteen-year-old girl, who was working in another Furness cotton mill, was so severely kicked by a brutal overseer that she died. After a medical inquest a jury acquitted Postlethwaite, the overseer, of any responsibility for the girl's death and he left the court a free man. Such were the perversities of justice; had he robbed the girl of a few pounds instead of killing her, he would almost certainly have been sent to the gallows.

Society's attitude to property was ambivalent; while many thousands of people were robbed of their commons grazing rights during the during the Enclosure movement of the early nineteenth-century, men, women and children suffered grotesque punishments for the theft of relatively small sums of money or a few worthless trifles.

William Fleming gives one example of a robbery at Grange over Sands in April 1813:

> About 5 o'clock yesterday a daring Robbery was committed near the Grange in Cartmel by 3 men supposed to be Irish who took £22 and his watch from a man named Greenwood returning from market. The villains were persued. and will, I hope be apprehended soon and punished, as they deserve.

And apprehended they were, for next day two of the robbers were captured while the third made a dash for the sands of Morecambe Bay and freedom but was captured by the huntsman and hounds from Dallam Tower – probably the largest quarry they had ever caught! The three men were tried at Lancaster and subsequently hanged.

Did the punishment fit the crime?

The draconian anti-theft laws were no respecters of age. At Cumberland Quarter Sessions held on 3 January 1837, William Barton, aged thirteen, was charged with stealing a piece of hemp rope, for which he was imprisoned in solitary confinement for two weeks. Similarly, James Harkness, aged fifteen, and George Boyle, aged twelve, were both given sentences of two weeks in solitary for the theft of five iron hoops.

But perhaps these boys were fortunate for at the same Quarter Session, Rosanna Thompson, aged twenty, pleaded guilty to stealing three sovereigns and was sentenced to seven years transportation. John Wilson, sixteen, and William Morgan, seventeen, received the same sentence for picking a pocket, while William Young, aged twenty-nine – found guilty of entering a house, stealing a bunch of keys, six pence and a few copper coins – was condemned to fourteen years transportation.

Readers of Robert Hughes's classic book *The Fatal Shore* will be aware of the hellish conditions which awaited those who were unfortunate enough to be transported as convicts. Justice tempered with mercy does not seem to have been a policy much favoured by the Carlisle magistrates.

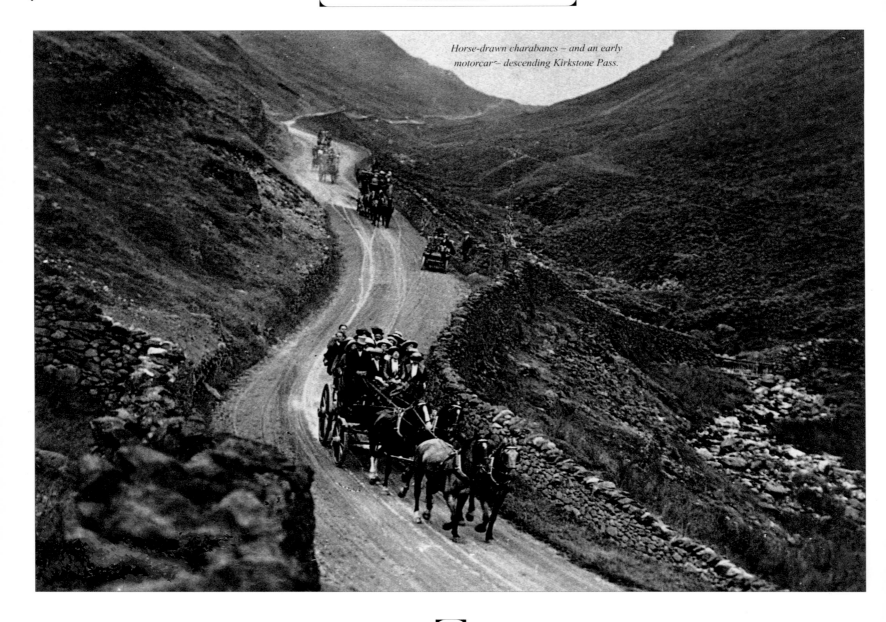

Horse-drawn charabancs – and an early motorcar – descending Kirkstone Pass.

Travelling about

Shanks' Pony and Pack Horses

In the eighteenth and early nineteenth centuries those who could rode on horseback – albeit on turf 'sonk' saddles (see page 129) – those who could not used shanks' pony. William, Mary and Dorothy Wordsworth thought nothing of walking, in all weathers, from Grasmere over Dunmail Raise, along the shores of Thirlmere to Keswick to visit the Coleridge family and Coleridge himself made a prodigious nine-day journey on foot through Cumbria's mountains and moorlands in 1802. But such exploits are as nothing compared to the feats of that redoubtable lady Mary (Mally) Messenger who walked from Keswick to London and back on three separate occasions. When she died in 1856, at the age of ninety-three, the *Derwentwater Record* noted:

Several times during the last century she performed the journey between her native place, Keswick, and London on foot, and on one occasion brought a stand table over her shoulder, an achievement which she frequently spoke of in her later years when speaking in disparagement of the effeminacy of modern manners and fashions.

In 1886 this was the recommended clothing to wear for a visit to the Lake District.

In the eighteenth century many roads within the fells were were little better than stream beds and travelling on foot or on horseback could result in injury, as William Gell acknowledged in his journal in 1797. He and a group of companions had set out to walk from Borrowdale over Honister Pass to Buttermere:

ASKEW'S

KESWICK *and* BORROWDALE
❧ COACH. ❧

Leave Grange.	Leave Keswick Market-place
9 0	10 15
12 45	2 15
5 0	6 15

The drive between Keswick and Borrowdale, along the margin of Lake Derwentwater, is one of the prettiest in the Lake District. The Bowder Stone (supposed to be the largest piece of detached rock in the world), is within 15 minutes' walk of Grange.

FARE - 9d.

W. ASKEW, Proprietor.

. . . along one of the blindest roads we could have chosen . . . [which] became so rugged that any attention to the scenery of the country must have been attended by a stumble over some pointed slate of which the way is composed. A few trifling slips gave us warning of what we had to expect without care, and we afterwards heard that a guide from Keswick had broken his leg there about a year before we visited the spot. A short time before we arrived at the top of the fell the road became nothing more than a morass, and it is curious to relate that a dispute ensued whether a loose line of stones was intended for a road or the bed of a torrent at the time when a considerable fall of rain, or the dissolution of winter snows produces frequent floods in this mountainous region.

In 1730 Benjamin Browne, the High Constable of Kendal Ward, undertook a survey of the roads of his area and the results are typical of the condition of roads in the Lake District at that time; all the roads surveyed are described as *'bad', 'narrow', or 'covered with ye hedges'*. The Garburn Road, connecting Troutbeck with Kentmere, was said to be

. . . soe much out of repair and in decay, that a great part of it is not passable for either man or Horse to travel through the said ways without danger of being bogged in moss or lamed among the stones.

The same road has changed little since that time; it remains unsurfaced and badly eroded by the fellside streams, affording an excellent example of what eighteenth-century roads were like.

Clearly such roads were impossible for wheeled vehicles but were, with care, accessible to pack horses and by the 1770s pack-horse trains traversed the fells linking Whitehaven, Ulverston, Hawkshead, Penrith, Cockermouth and Cartmel with Kendal which rapidly became the most important pack-horse centre between Wigan and Scotland. From the cobbled yards and streets of this grey Westmorland market town clattered and jingled the weekly trains to Barnard Castle, York, London and elsewhere and it is estimated that about 230 pack-horses were regularly entering and leaving Kendal each week about this time, a clear measure of its importance. These pack-horse trains long remained a feature of Cumbrian rural life; even as late as 1868 Gibson recalled that:

. . . there are many of the old inhabitants of Langdale who remember gangs of pack-horses on the way from Kendal to Whitehaven over Hardknott and Wrynose, one especially, led by a sagacious old black stallion; their master and only attendant rode a pony and had a habit of taking his ease at . . . several inns along the route, following and overtaking the horses between his stopping places and riding on to the next, where he would rest and drink until they had plodded patiently past, when, at his own good time, he would follow and repeat the process.

It is believed that this was the last route to be used regularly by pack-horses.

Turnpikes

The system of improved or turnpike toll roads began in 1663 but, not surprisingly, was slow to reach Cumbria.

The first turnpikes were made in the Whitehaven area in 1739 and they were followed by the Kendal to Kirkby Lonsdale road, and later by the route through Kendal to Eamont Bridge. By 1800 there were fifteen turnpike roads in Cumbria linking Kendal with Ulverston, Bowness, Ambleside, Cockermouth, Keswick and Appleby.

The effects of such improvements were immediate. Carriers' wagons were introduced in 1753 and, for those who could afford them, stage coaches rejoicing

Cross-sands guide stone at Cartmel

in such fanciful names as *The Flying Machine* (1763), *The Royal Pilot* (1815) and *The True Briton* (1817) made seemingly incredible journeys at average speeds of between five and six miles per hour. As always, there were those who remained sceptical of such enterprises and, we are told:

Some learned doctors warned people from travelling by the wild and whirling vehicle, as the rate at which it went would bring upon them all manner of strange disorders, chief among which was apoplexy.

The good doctors need not have worried unduly, however, for the introduction of stage coaches barely touched the lives of the vast majority of dalesfolk,

and most Lakeland valleys remained remote and isolated from such innovations. Writing in 1872, James Stockdale remarked that

> . . . there was not, until some little time before the end of the last century, a four-wheeled carriage of any kind in the whole of the parish of Cartmel, excepting at Holker Hall and Bigland Hall.

And in 1801 Dorothy Wordsworth, living at Dove Cottage on the Ambleside to Keswick turnpike road, considered it sufficiently noteworthy to record in her journal *'Today a chaise passed'*, for most people travelled on foot or on horseback.

Over 'The Sands'

One of the main routeways into the southern Lake District was the cross-sands road over the wide and watery expanse of Morecambe Bay at low tide. Surely one of the most unusual roads in the kingdom, this constantly-changing road was used by locals and visitors alike, and many of the early tourists gained their first glimpse of the Cumbrian mountains reflected in the wet sands of the Bay.

The route has a long history; probably used in the Bronze Age, it continued to be one of the most important thoroughfares into Cumbria in the mediaeval period. The Priors of Conishead and Cartmel priories appointed guides to lead travellers over the treacherous Leven and Kent Sands respectively but the dangers of the crossing did not discourage that audacious Scot, Robert Bruce, who in 1322 on one of his sorties across the Border, crossed the Sands and made a surprise attack on Lancaster. Four years later, the Abbot of Furness petitioned King Edward II to allow him to have his own coroner in Furness because, he argued, so many people had been drowned crossing the Sands to attend Coroners' Courts in Lancaster! Following the

dissolution of the monasteries, the Duchy of Lancaster took the responsibility for appointing and paying the guides and the service continued – but not without criticism. John Wesley crossed the Sands in 1759 on one of his missionary trips to West Cumberland and complained in his journal of . . .

> . . . a generation of liars who detain all strangers as long as they can, either for their own gain, or their neighbours. I can advise no stranger to go this way: he may go round by Kendal and Keswick, often in less time, always with less expense, and for less trial of his patience.

However, Wesley's prejudices were not shared by locals who continued to use the route to and from Lancaster. Wordsworth often used the road; indeed, it was in the middle of Morecambe Bay, seeing a group of agitated travellers coming towards him, he learned the momentous news from France *'Robespierre is dead!'* Later, referring to the Bay, he confided to the poet, Felicia Hemans (best known for the dramatic line 'The boy stood on the burning deck') that '. . . *the Lake scenery . . . is never seen to such advantage as after the passage of . . . its magnificent barrier.'*

In 1781 a public coach service commenced running across the Sands; it was a diligence or light coach carrying three passengers and the driver, and it operated from Lancaster every Monday, Wednesday and Friday, returning from Ulverston on Tuesdays, Thursdays and Saturdays; timing, of course, dependent on the tides. The proprietors of the venture assured the travelling public that

> . . . they have procured a sober and careful driver who is well acquainted with the Sands, and humbly hope their plan will meet with due encouragement as this is the most cheap, safe and expeditious method of crossing the Sands.

Yet, despite the proprietors' optimism and the 'brobbing' or marking with small branches the changing route across the Kent and Leven by the guide, the cross-sands route road was not without its dangers, especially in mist and fog, and there are horrifying tales of coaches going round in circles until the tide finally engulfed them. The combination of the rapid tidal flow together with the presence of quicksands frequently proved fatal. The registers of Cartmel Priory from the late sixteenth century until 1880 record no fewer than 141 victims who had *'drowned on the sands'*, and at the west end of the nave there is a gravestone bearing the following inscription:

> *Here lies the body of Robert Harrison Son of Thomas and Margaret Harrison who was drowned on Lancaster Sands the 13th day of January 1782 in the 24th Year of his Age*

and below . . .

> *Also here lies Margaret Harrison who was Drowned January the [indistinct] 1783 near the same place where her son was Drowned AE 48*

The catalogue of fatalities is both long and depressing: October 1803, two men were overtaken by the tide – one drowned, the other managed to swim ashore. In August 1814 two post chaise drivers were drowned and in September 1821 the driver of a chaise and his passenger both lost their lives. In June 1846, nine people who had been to the Ulverston Whitsuntide Fair, and who were all in the same cart, were drowned but the cart was subsequently salvaged. Eleven years later, in 1857, seven young men going to Lancaster Fair perished in a similar accident – ironically, the cart in which they were travelling was the same one involved in the 1846 tragedy.

In 1820 a plan was advanced to build a series of wooden refuge towers in the Bay where, in an emergency, travellers could ascend and, like St Simeon

Stylites, sit tight, at least until the waves had receded; apparently only one such platform was erected.

In spite of the fatalities, generations of Cumbrians used this route southwards to Lancaster, largely because it was considerably shorter than the journey around the the Bay; using the 1818 turnpike via Levens Bridge, the distance between Ulverston and Lancaster was thirty-five miles whereas the Sands route was a mere twenty-two miles, and of course, by using the fords across the Duddon and Esk estuaries, the Sands road was the shortest route south for west Cumbrians.

Many preferred the sands road for another reason – in summer the clouds of dust raised by carriages and carts on the land roads could be unpleasant but there was no such problem on the sands. Undoubtedly, the early tourists magnified the dangers of the cross-sands route, probably enjoying a slight frisson in the same way they did when exaggerating the steepness of the Cumbrian mountains but one local writer in 1810 dismissed this as nonsense and declared

'. . . in fine weather, along with the attending guides, there is no more danger in a journey across the estuaries than in any other road.'

The route remained popular even when the first railways began to be built; indeed, nostalgia for coaching in general was not uncommon and one Lancaster newspaper in the 1840s looked back with affection to the 'good old days' of reliable coaches because the mail train from Preston had taken three hours and ten minutes to make the twenty-two mile journey when ice on the rails prevented the wheels of the locomotive from gripping – a familiar refrain even today.

A regular cross-bay coach service continued right up until the completion in 1857 of the Ulverston to Lancaster railway line. Today the route is increasing in popularity once more and thousands of walkers – and the occasional Royal party in horse-drawn vehicles – trek across the Sands with the official guide who is still appointed by the Duchy of Lancaster.

Mrs Radcliffe Crosses the Bay, 1795

We took the early part of the tide, and entered these vast and desolate plains before the sea had entirely left them, or the morning mists were sufficiently dissipated to allow a view of distant objects; but the grand sweep of the coast could be faintly traced, on the left, and a vast waste of sand stretching far below it, with mingled streaks of grey water, that heightened its dreary aspect. . . . The body of the sea, on the right, was still involved, and the distant mountains on our left, that crown the bay, were . . . viewless; but it was sublimely interesting to watch the heavy vapour begin to move, then rolling in lengthening volumes over the scene, and, as they gradually dissipated, discovering through their veil the various objects they had concealed – fishermen, with carts and nets stealing along the margin of the tide, little boats putting off from the shore, and, the view still enlarging as the vapours expanded, the main sea itself softening into the horizon, with here and there a dim sail moving in the hazy distance. The wide desolation of the sands . . . was animated only by some horsemen riding remotely in groups towards Lancaster, along the winding edge of the water, and by a muscle [sic] *fisher in his cart trying to ford the channel we were approaching.*

Observations during a Tour to the Lakes
Anne Radcliffe, 1795.

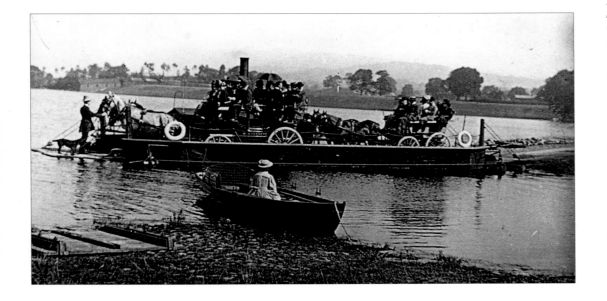

The Windermere steam ferry about the time of the First World War with two of Rigg's Windermere /Coniston coaches on board.

Tourist Traffic

As road improvements continued, so traffic within the Lake District increased and local coach services commenced operation. In 1822 Mr Banks, a Keswick tanner, began to run a daily coach from Keswick to Cockermouth over Whinlatter Pass, and two years later another intrepid gentleman, Jack Cawx, penetrated the depths of Borrowdale in a chaise, the first to be seen in the valley. However, the road was so bad that he almost overturned his vehicle on Grange Bridge.

Inevitably, with more wheeled vehicles, road accidents began to occur. In 1840 Wordsworth and his son John narrowly escaped injury on a journey along the Whitehaven-Grasmere turnpike; two to three miles from Keswick their one-horse gig was hit by the approaching mail coach and the horse, the gig, the two Wordsworths and part of a drystone wall were flung into a field. Years later the coach driver, David Johnson, relating their story of how he had *'spilt the Wadsworths'*, confessed that he had: *Nivver heard a body's tongue sweer* [swear] *gladlier, though, for I thowt we'd kilt the poit.*

By the middle of the nineteenth century tourists were flocking into the Lake District in their thousands and transport facilities expanded accordingly. This trend is reflected in the returns of the Ambleside Turnpike Trust for 1855 when 21,480 carriages passed and repassed Troutbeck Bridge between Ambleside and Windermere, and a further 15,240 paid the toll on the Grasmere to Keswick section where, a mere fifty-four years previously, the passing of a single chaise was a noteworthy event. The opening of the Kendal to Windermere railway line in 1847 encouraged the development of tourist coaches; in 1851 Black's *Picturesque Guide to the English Lakes* announced:

On the arrival of the trains, coaches leave the station at Windermere for Ambleside and Keswick and the mail proceeds by this route to Cockermouth and thence by railway to Whitehaven. Coaches also run daily between Windermere and the towns of Hawkshead and Coniston.

Among the private concerns operating these coaches was Richard Rigg of the Windermere Hotel, whose name became synonymous with coaching in the Lake District. His Royal Mail coaches, pulled by three horses and driven by scarlet-coated, white-top-hatted drivers, became one of the most familiar parts of the Lakeland scene until the 1920s when the regular coach service was superseded by the buses of the Lake District Road Traffic Company. The introduction of surfaced roads was a factor in the decline of some coach services. Although a Keswick-Honister Pass-Buttermere coach successfully ran from the 1860s, when the road was surfaced in 1934 it was discovered that horses could not restrain a coach on a gradient of one in four and so the service was withdrawn.

Coaching was essentially for the tourists and dalesfolk continued to rely on horses, gigs and traps even as late as the 1920s. However, in some areas a semi-public service of waggonettes was established before the First World War; in Borrowdale a waggonette ran from the Scafell Hotel to Keswick on 'quarry pay Saturday'. Those not able to afford the 3s 6d fare could travel into Keswick with Ned White the postman in his dog-cart but that usually necessitated an overnight stay. In 1896 a two-horse waggonette connected Patterdale with Penrith and this was later expanded to a four-horse charabanc which left Patterdale at 7.15 am and reached Penrith at 10.00 am, returning at 3.30 pm and arriving back in Patterdale at 7pm.

Descending steeply from Newlands Hause.

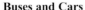

*Poster for an early
nineteenth-century cross-
sands coach.*

*A bus excursion
in Wasdale.*

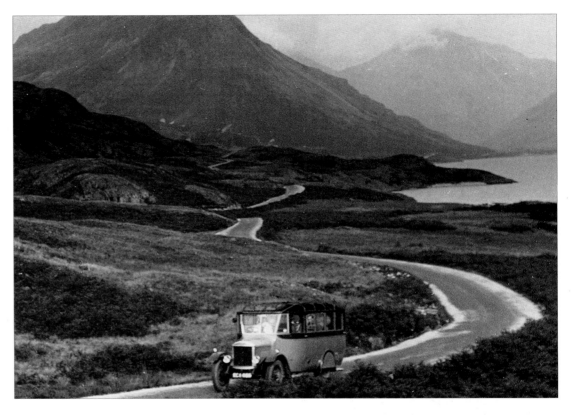

Buses and Cars

The Lake District Road Traffic Company began to operate a modest motor service between Bowness, Windermere, Ambleside and Grasmere in 1904 and by 1915 the Ullswater (Royal Mail) Motor Service was running twice-daily between Penrith and Patterdale. In Borrowdale Mr John Woodend ran a chain-driven Daimler car service between Seatoller and Keswick before 1914 but this ceased during the period of the First World War, and in 1920 Mr W F Askew inge-

niously attached a Ford chassis to the body of an old horse-drawn waggonette – a successful fusion of the old and new. At about the same time Mr Woodend brought into service a fourteen-seater vehicle.

By 1928 the road along Borrowdale had been improved and widened and there were no fewer than five services in operation in the valley. Elsewhere, the same pattern was repeated. In 1923 James and Fred Airey ran an eight-seater car between Ambleside, Hawkshead and the Windermere Ferry which proved so popular that the following year a fourteen-seater bus

was introduced which, in turn, was followed in 1933 by two larger vehicles.

In the 1920s the Lake District Road Traffic Company ran their so called 'Yellow Peril' buses – solid-tyred, chain-driven Thorneycroft coaches – from Windermere to Keswick and from Ambleside to Coniston at a maximum speed of twelve miles per hour, slow by today's standards but then considered to be recklessly speedy.

Public transport within the Lake District has declined in the last two decades; some communities

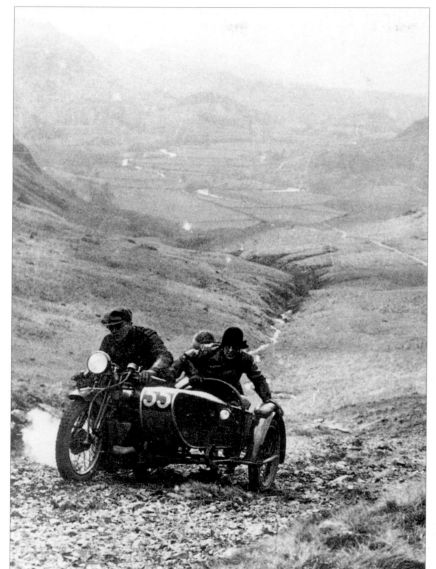

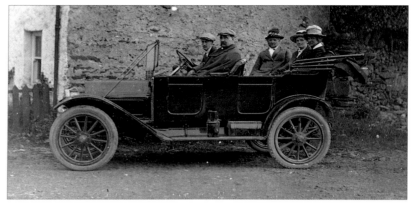

Motorbike and sidecar on the unsurfaced Hardknott Pass

Luxury travel by automobile, South Cumberland about 1920.

1915: The Ullswater Royal Mail motor coach made a twice daily run between Penrith and Patterdale.

find themselves without a service, others have a service restricted to summer or school terms. Away from the main roads, some private operators such as the Mountain Coat Company run minibuses on routes which larger companies found unprofitable, and it is once again possible to 'ride the Mail', not in one of Rigg's horse-drawn coaches, but in special Post Office vehicles designed to carry both post and passengers between Penrith and Patterdale and Martindale, from Ulverston to Grizedale, and from Broughton to Cockley Beck at the head of Dunnerdale.

And the age of horse carriages is not quite dead for visitors can be transported in summer between Ambleside and the steamer pier at Waterhead in waggonettes, recalling a more leisurely age when traffic jams and parking problems were unheard of.

The 'Rash Assault'

Although the railway from Carlisle to Maryport was opened in 1845 and the following year the Lancaster to Carlisle line over the wilds of Shap Fell was inaugurated, no railway threatened the mountain fastness of the Lake District until 1847. In that year two lines were built which, despite anguished protests, reached out to the very foothills of the mountains. In April 1847, the Cockermouth to Workington railway was opened and, in the same month, the Kendal to Windermere line reached Birthwaite, then a tiny hamlet above Bowness on Windermere. Many people expressed serious doubts about this new mode of transport: *'No reasonable man would allow himself to be dragged through the air at the alarming rate of twenty miles per hour,'* trumpeted one antagonist but others fretted about the possible social impact of the railways.

Wordsworth, having by then shrugged off his mantle of the young radical and assumed the cloak of the arch-conservative, vehemently expressed his opposition to the 'rash assault' of the Kendal to Windermere line in a celebrated letter to *The Morning Post* in 1844:

The directors of railway companies are always ready to devise and encourage entertainments for tempting the humbler classes to leave their homes. Accordingly, for the profit of shareholders and that of the lower class of Innkeepers, we should have wrestling matches, horse and boat races . . . and pot houses and beer shops would keep pace with these excitements and . . . the injury which would be done to morals, both amongst this influx of strangers and the lower class of inhabitants is obvious.

However, it is worth recalling that William's pragmatism overcame his finer feelings and in a letter to Charles Lloyd he tentatively raised the question of investing a sum of £500 in railway companies . . . !

The original plan for the Kendal-Windermere line was to extend it northwards to Ambleside and over Dunmail Raise to Keswick, and in the 1870s the scheme was resurrected but this time the opposition was led by John Ruskin and Robert Somervell. Ruskin adopted the same high moral tone that Wordsworth had taken some thirty years earlier when he wrote of *'the certainty of the deterioration of the moral character in the inhabitants of every district penetrated by a railway'* and declared that the sole achievement would be to

. . .open taverns and skittle grounds around Grasmere, which will soon, then, be nothing but a pool of drainage, with a beach of broken ginger-beer bottles'.

Constructed in 1875, the Ravenglass to Boot railway line carried iron ore and passengers down Eskdale to the sea.

1847: a viaduct on the Kendal and Windermere Railway

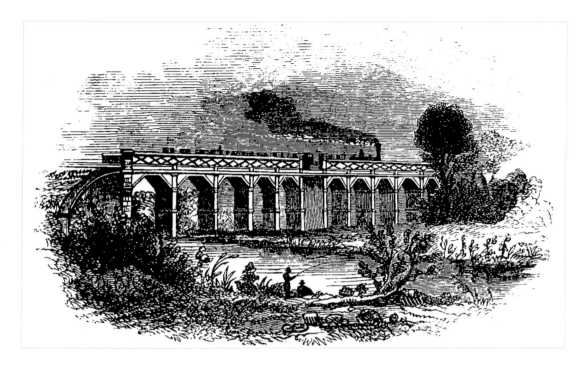

line was opened, a vessel which still proudly carries tourists. Six years later in 1865 the line from Penrith to Keswick was completed, sparking off a thriving tourist industry, and in 1868 the Furness Railway Company extended its network as far as Lakeside at the southern end of Windermere. As well as serving the developing tourist traffic, the line also provided transport for the Backbarrow iron works on the River Leven, the Stott Park bobbin mill, and the gunpowder works at Haverthwaite and Bouth.

Charabanc poster, 1895

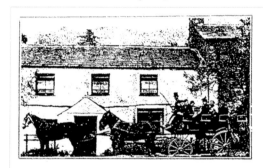

Not all influential literary voices were raised in opposition to railways. Harriet Martineau, then living at The Knoll, Ambleside, saw no evidence

. . . of either moral or economic mischief to the region from the opening of railroads into it. We cannot believe that any inhabitants of the valleys would, if seriously asked, say that his happiness has been impaired by the sight of the parties who arrive by steamboat or railway, carrying their provisions, and sitting down in the churchyard, or under the trees of some knoll, to have their minds opened and their hearts softened by a spectacle of beauty which gives them for a time a new existence . . . – let them come; and the more the better!

And come they did, not merely the artisans and their wives and children on day trips but the affluent *nouveaux riches* who built mock-gothic turreted fantasies on the shores of England's largest lake and helped to create the town of Windermere around the rail head at Birthwaite, arguably just as much a creation of the railways as Crewe or Swindon.

In 1859 another railway line invaded the fells, this time running from Foxfield on the West Cumberland to Furness line, through Broughton almost to the foot of Yewdale Crags at Coniston. Originally intended to facilitate the export of copper from the nearby mines, the line also developed a traffic in slate, timber and tourists and the Coniston Railway Company launched the steamboat *Gondola* on the lake in the same year the

The line's most illustrious passenger was that early commuter Henry W Schneider, the ironmaster. He lived at Belsfield, overlooking Bowness Bay, and each morning, preceded by his butler carrying his breakfast on a silver tray, he would walk down the lawn to his private steam-yacht, the *Esperance*, proceed down the lake to Lakeside where his private railway carriage awaited to take him to his office in Barrow in Furness.

The last line to be built into the fells was the Ravenglass and Eskdale Railway which was opened in 1875 to export the haematite iron ore from the Nab Gill mine above Boot. The mining company closed in 1882 and the railway encountered financial difficulties. In 1915-17 the original three-foot gauge was re-laid as a fifteen-inch gauge and as a miniature railway *L'ile Ratty* assumed a tourist function which it enjoys today, attracting steam railway buffs aged from seven to seventy from all parts of Britain.

Plans for railway lines to Ennerdale and Buttermere were abandoned in the face of pressure from early conservationist groups and attempts to extend the Coniston line to the slate quarries of Little Langdale were similarly defeated. A final 'rash assault' was planned in the late 1920s and early 1930s when a funicular line to the summit of Coniston Old Man was seriously proposed but capital was not forthcoming. Despite his earlier temptations, had he been alive, it is doubtful if Wordsworth would have looked favourably on the line as a financial investment!

The Windermere Ferry

The ferry service across the middle *cubble* or division of Windermere is at least five hundred years old; traditionally it has been the main link between the market towns of Hawkshead and Kendal across the 'largest standing water' in England. Unless the ferry is used, long detours are necessary, but south of Belle Isle, Windermere's largest island, the lake is merely 560

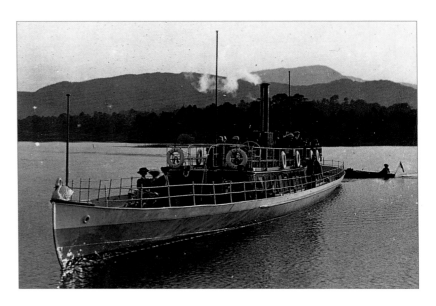

The first 'Swan' at Waterhead, Windermere in about 1895

yards wide, and here the main ferry service has operated since the fifteenth century, though there is evidence to suggest that there may have been a minor ferry between Miller Ground and Belle Grange.

The right to operate the ferry was a prized and jealously guarded privilege which in the seventeenth and eighteenth centuries belonged to the Braithwaite family. Theirs was the responsibility of providing 'the Great Boat' in which men and horses were rowed across the lake. In 1699 Thomas Braithwaite built a new boat and as a result proposed raising the toll, a suggestion which sparked off considerable protest:

> . . . *it hath beene ussed and Accustomed . . .*
> *time beyond the measure of man . . .*
> *for anyone who wished*
> *. . . to pass repass & travell over*
> *Windermer Watter Att the fferry boate*
> *on the King's hyeway there to pay*

only one penny and no more ffor their
soe passing and repassing.

Bowing both to public pressure and the law, Thomas Braithwaite retracted and continued to charge only one penny. Would that public pressure against increases in travel costs had such effect today! By 1830 the toll had increased to 2d for foot passengers, 3 shillings for a post-chaise, 3s 6d for a 'gentleman's chariot', and 4 shillings for a carriage – but no charge was made for return journeys made within the same day. There was no regular timetable; the boat was normally moored on the western Lancashire shore and those approaching from Kendal had to hail the ferryman and Wordsworth recalled in *The Prelude*:

> . . . *shouting amain*
> *A lusty summons to the farther shore*
> *For the old Ferryman . . .*

By 1831, two ferry boats were in use, for Thomas Cloudsdale's lease charges him with the upkeep of *'the Little Boat and the Great Boat'*. Both were powered by sweeps, or long oars but by the nineteenth century, with the increase in the number of vehicles, the man-powered ferry boats became inadequate so in 1870 a steam-powered chain ferry was brought into operation. This could accommodate a coach-and-four, or two coaches if the leaders were detached, and the Hawkshead carriers' carts made the trip across the lake three times each week while Rigg's Coniston coach made a daily journey in summer. *The Westmorland Gazette* noted with satisfaction the improvements to the service and commented that:

. . . the steamer and chains which have taken the
place of the old lumbering row-boat completes the
crossing and return in much less time than the old
boat took to go one way. The men employed are
also prompt and obliging, so much so that they
hurry across the lake on hearing the first intimation
of a passenger.

This first steam ferry remained in service until 1915 when it was replaced by a larger vessel which was used until 1954 when it was replaced by *The Drake*, itself replaced in 1990 by *The Mallard*, the present Windermere ferry.

Ferry Legends

Not surprisingly in five hundred years the ferry has its own stories and legends. The story of *The Fatall Nuptual* is recorded in a poem probably written by Richard Braithwaite of Burneside Hall. It chronicles a disaster which took place on 19 October 1635 when some forty-eight or nine wedding guests, returning from a celebration in Hawkshead, were drowned when the ferry capsized. There is, however, no evidence to suggest that the bride and groom were aboard the doomed vessel and it seems likely they escaped the fate which overwhelmed their friends and relatives. Perhaps one reason for the tragedy was overcrowding; almost fifty people and and eight horses seems an excessive load for a relatively small oar-propelled boat. All the victims were buried at St Martin's church in Bowness.

An equally spine-chilling and much-told legend concerns the ghostly *Crier of Claiffe*, a misguided delinquent who, especially on dark and stormy nights, urgently hailed the ferry from the Westmorland shore. On one occasion a ferryman who answered the summons returned with an empty boat, horror-stricken and dumb and remained in that state until he died some days later, unable to the last to tell of what he had seen. Present passengers aboard *The Mallard* need have no qualms for the legend goes on to tell how the monks of Furness Abbey exorcised this troublesome individual and he supposedly lies buried on Claife Heights.

Steam on the Lakes

The first regular passenger service on Windermere was not a steam boat but a barge which was rowed with long oars, supplemented, when conditions were right, by sails. In 1836 or 1837 James Gibson of Ambleside and Mr White of Newby Bridge offered the public a service which until 1845 was the only one in operation. A complete traverse of the lake was possible. Mr White's boat covered the section between Newby Bridge and the Ferry where the passengers had to transfer to Mr Gibson's boat which then conveyed them to the head of the lake. Prior to the boat leaving Waterhead for the return journey, passengers in Ambleside were alerted to the imminent departure of their vessel by a boy in the Market Place who blew a horn. Although the journey was a leisurely one – it took three and a half hours to complete the full trip of fourteen miles – the fares were relatively cheap for it cost 1 shilling from Ambleside to Bowness, 1s 6d to the Ferry and 3 shillings to Newby Bridge where the service connected with a coach to Lancaster and Ulverston.

In 1845 the first steamship began operating; she was the *Lady of the Lake*, a seventy-six-foot long paddle steamer owned by the Windermere Steam Yacht Company. Wordsworth, predictably, was outraged and, indeed, there was some initial opposition from locals to this new form of transport. In 1846 the Reverend Charles Mackay commented that:

. . . the inhabitants . . . of Bowness, Lowwood,
Ambleside and generally the gentry of the
neighbourhood set their faces against it and would
not use it . . . even for the conveyance of a parcel –
so annoyed were they that their darling lake should
be so disturbed by the evolution of the paddle
or their clear atmosphere contaminated by
the smoke of a funnel.

Not all local opinion was hostile, however, for the painter John Harden of Brathay Hall described the *Lady* as *'a pretty and handsome vessel . . . no eyesore rather an ornamental object'*.

Soon it was appreciated that in the absence of good roads, the service was a great convenience to both residents and visitors alike and in her first short season she carried no fewer than five thousand passengers. Success bred success and in 1846, just over a year after the *Lady of the Lake* was launched, she was joined by a companion vessel the *Lord of the Isles* and for a year or so the two ships established a monopoly in the provision of passenger transport – but this was not to last. In 1849 the Windermere Iron Steam Boat Company set up in competition and its first ship, the *Fire Fly,* was launched, followed in 1851 by the *Dragon Fly*.

Soon competition was cut-throat and the antics of

the two rival companies would have formed an excellent plot for a Gilbert and Sullivan comic opera! In July 1850, the *Lady of the Lake* and the *Fire Fly* were damaged when each attempted to hinder the other. When the Steam Yacht Company offered trips around the lake for a maximum fare of 6d (cabin) and 3d (deck) and included a bottle of beer, the rival Iron Steam Boat Company countered by offering free excursions!

The *Lady* was slower than the *Dragon Fly* which took perverse delight in overtaking its rival with the ship's brass band pointedly playing *The Girl I Left Behind Me*.

Economic disaster was eventually averted and common sense prevailed when in 1858 the two companies amalgamated, forming the Windermere United Yacht Company. Eight years later the united company launched the *Rothay*, the last of the Windermere paddle steamers. By then it was clear that the steamer service was attracting a large numbers of day visitors and holidaymakers. This encouraged the Furness Railway Company to extend its line from Ulverston to Lakeside where a landing stage was incorporated into the station. The line was opened in 1869 and was shortly followed by the launch of a new steamer, the *Swan*.

Two years later the Furness Railway Company assumed control of the Windermere United Steam Boat Company and the ships continued to ply the lake under the ownership of British Rail until 1985 when they were privatised. The new company reverted to the old name, the Windermere Iron Steam Boat Company, although none of its vessels is powered by steam!

Like Windermere, Ullswater still retains a passenger service; in 1859 a paddle steamer, the *Enterprise*, was launched at Pooley Bridge but, sadly, little is known of her. However, in 1877 the Ullswater Steam Navigation Company commissioned their own *Lady of the Lake*, and this was followed in 1899 by the *Raven* which, in the following year, carried Kaiser Wilhelm II on a jaunt round the lake when he was a guest of Lord Lonsdale at Lowther Castle.

Coniston Water also has a long tradition of passenger steam boats. In 1855 Mr James Sladen operated a small steamer from the Waterhead Inn to Nibthwaite and Lake Bank. There were three round trips a day, including Sundays and the fares were 1s 6d first class and 1 shilling second class. Strangely, the enterprise failed to find public support and within weeks of its commencement the service was withdrawn.

This inauspicious beginning did not discourage the Coniston Railway Company from launching the *Gondola* in 1859. This sleek beautiful vessel operated regularly until 1908 when yet another *Lady of the Lake*, a larger more powerful ship, replaced her, though she continued in service intermittently until the Second World War. In 1950 the *Lady* was broken up but the *Gondola* lay half submerged and neglected in the reedbeds of the southern end of the lake until she was resurrected by the National Trust. Craftsmen and apprentices from the Vickers shipbuilding yard in Barrow restored and refurbished her. Now once again she glides majestically and quietly over the surface of the lake.

The 'Gondola' on Coniston Water

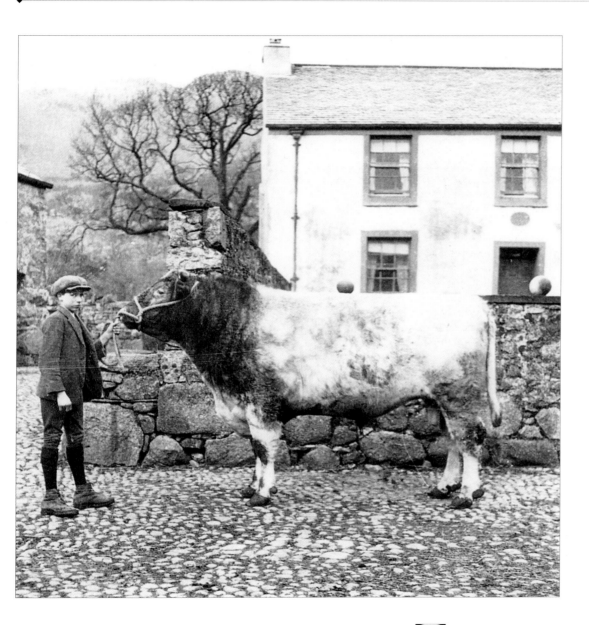

Animal Medicine and Veterinary Magic

A fine bull, Eskdale, 1920s.

The self-sufficiency which characterised so much of rural life in the seventeenth, eighteenth and nineteenth century Lakeland was certainly apparent in the way in which animals were treated when sick and many of the folk remedies applied to humans were applied without discrimination to animals as well! Before the Agricultural Revolution, which in Cumbria was somewhat later than many other areas of Britain, veterinary medicine was unsophisticated – a curious mixture of white magic, blind superstition and well-tried kill-or-cure folk remedies. In the absence of trained and qualified veterinary practitioners, fell farmers had to treat their own stock as best they could. Bleeding, that universal panacea for both man and beast, was much used and anyone who showed any degree of skill was much called upon. Sir Daniel Fleming of Rydal Hall regularly resorted to this treatment for his horses and cattle; typical entries in his account books read:

1657 February 23 Given for the blooding
of Hobson – horse at Ambleside *4d*
1679 Oct. 1 Given to ye Miller of
Ambleside for blooding and giving a
Drinke to my Cowes for ye murrain *1s 0d*

As much as two pints of blood might be extracted from an animal – more if a high-spirited horse was being bled to pacify it. In 1787 John Hall, of Leasgill near Heversham, recommended for a horse with inflamed lungs: '. . . *speedy, large and repeated bleedings . . . first take 3 quarts, next day two quarts, and if no better 1 quart daily.'* One wonders if the poor animal survived such massive bleeding.

The Miller of Ambleside who gave 'a Drink' to Daniel Fleming's cows almost certainly used a drenching-horn; in the days when cow remedies consisted of various powders mixed with water and treacle, it was necessary to mix the ingredients in an animal horn, open the cow's mouth and pour the dose down the animal's throat. Even today many farmers refer to the administering of medicine to animals as 'horning', and occasionally ancient horns can still be found in the dusty recesses of Lakeland byres. In one

Dosing a yearling sheep today – a far cry from eighteenth-century treatments.

farm in Great Langdale, twentieth-century pigs were dosed from an old boot which had the toe cut out – and no doubt it was just as efficient as the cow's horn.

Far more primitive than 'horning' was the 'rowelling' of cattle and horses; this involved the insertion of an irritant between the skin and the flesh of the animal just above the forelegs. Often this consisted of a small leather disc, a wad of setter-grass *(Helleborus foetidus)*, a piece of onion, or a ball of cotton wool, and this was allowed to remain for twenty-four hours. After removal, the wound was kept open for a week or more with a ball of lard and salt in order to allow the 'evil humours' to drain from the animal.

An equally primitive 'cure' was applied to sheep which had contracted a condition known as *sturdy* or *the gid*, a disease which is transmitted by dogs and foxes which have tapeworms. The parasite finds its way from the grass into the sheep and in particular to that section of the brain which controls the sight where the eggs develop into cysts. The afflicted animal becomes blind in one eye, causing it to wander round and round (*sturdy* is derived from the Norman-French word *étourdi* meaning giddy). In the nineteenth and early twentieth centuries, some farmers developed the skill of trepanning their animals; with a sharp knife a section of the skull was removed, exposing the brain, and the small bladder or cyst which was the cause of the problem was removed with a goose quill. Shepherding was definitely not for the squeamish! A curious superstition developed that this operation should be performed only at full moon when, it was argued, the skull was softer than at any other time. Following the trepanning, the incision was usually treated with green salve or a mixture of egg-white and lint-tow, and covered with a tar plaster although some shepherds insisted on placing a silver threepenny or sixpenny piece over the incision before applying the plaster! Within a day or so the victim would be seen grazing with the rest of the flock, hav-

ing made a miraculous recovery and seemingly no worse for its ordeal.

One of the most bizarre treatments was that applied to yearlings and shearling ewes when they lost condition and the fleece deteriorated. It is now believed that this results from a calcium/phosphorus deficiency but in the nineteenth century the cure was simple – the skull of the poor animal was merely thumped hard with the knuckles of the hand, after which the sheep, though no doubt dazed, appeared to make a recovery. It should be noted, however, that this strange ritual took place at the same time as the sheep were wormed and it seems probable that the regaining of condition was more likely to be induced by this rather than by knocking on the animal's skull.

Not all remedies relied on superstition; in the nineteenth century many of the tried-and-tested remedies were probably quite effective. William Fisher, a Low Furness yeoman farmer, recorded several examples in his journal:

A receipt [sic] for a Wound or Bruse in a Hors or Cow

Blue vitterol and verdigrass	each ¼ ounce
Coppras and Broach Allum	each ½ ounce
Salt Peetre	2 ounces

To be Boild in one Quart of Vinegar

A Good Gripe drench for a horse

and will Cure a Cow that is hove or blown by eating Clover which will relive in a ¼ of an hour

1 oz. sweet spirits of Nitre
1 oz. salt of Tartar
1 pint of mild warm Ale

to be repeated about 6 or 8 hours afterwards to prevent a relaps.

Of course, wherever possible, the fell farmer used ingredients which were readily available on his farm or could be easily and cheaply acquired. For example, John Hall in 1787 recommended the use of an ointment *'for strangles'* which consisted of butter and foxglove flowers *'taken in by stamping in a mortar then put them in a pot and stand for a fortnight or longer to rot, then boil them and strain them for use'*. Similarly, ingredients such as bees wax, honey, linseed oil, rainwater, black pepper, saffron, and mustard all played a part in these well-tried remedies. Even the application of dog-fat for the treatment of arthritis and other joint afflictions in horses, was popular. Said to have deeply penetrating effects, the fat was obtained by boiling the carcass of an old dog until the fat could be collected by skimming the surface.

For cows which were 'down' and unable to get up, a sandwich of brown paper and mustard was prepared and applied to the top of the tail – with predictable results, but not all these remedies were as effective. In 1819 William Fleming, the Low Furness farmer, tried out a potent brew of *'chamberley and brimstone'* on an ailing pig with no result so he then resorted to *'some milk which had been poured on Iron Ore and it died immediately'*. . . .

The power of superstition remained unabated until the nineteenth century; in many parts of the Lake District it was strongly believed that diseased and ailing cattle were a direct result of bewitching. Even as late as 1857 it was maintained that several naturally-holed stones, known as *dobbie stones*, hung in a stable or byre would prevent evil spirits bewitching the animals.

Moreover it was believed that ailing cattle had been 'elf-shot' with tiny flint arrows. A cure could be effected if the animal was touched with one of these flints or dosed with water in which the flints had been washed. This accounts for Bishop Nicolson's entry in his diary for 27th June, 1712:

By Cardonoc (Cardurnock) to Bowness (on Solway) where we saw several Elf Arrows, too pretious (for the cure of Elf Shot) to be parted with.

Similar charms and talismen were credited with the powers of warding off evil influences and in particular from preventing cream from churning and the 'flaying' or bewitching of cattle. This spell from Troutbeck appears in the eighteenth-century commonplace book of Christopher Birkett:

If there be chattell that are bewitched, Take some of the hair of every one of them and mix the haire in faire watter, or wet it well . . . lay it under a Tile, set a Trivet [tripod] over the Tile, make a lusty fire, turn your Tile oft upon the haire, and stirr upp the haire ever and anon, after you have done this by the space of a quarter-of-an-hour let the fire alone, and when the ashes are cold, bury them in the ground toward that quarter of heaven where the suspected witch lives.

Unfortunately the commonplace book does not relate the incidence of success of such measures.

If the belief in witchcraft survived until the eighteenth century, so, too, did the barbarous practice of calf immolation – indeed, it did not finally cease until the second half of the nineteenth century. It was believed to be a cure for contagious abortion or brucellosis and as late as 1866 a bull calf was roasted alive in the village of Troutbeck because all the cows there were calving males. If a cow slipped its calf, it was often buried at the entrance to the byre.

The West Cumberland Times in 1876 carried this shocking report:

A farmer living within one hundred miles of Lake Bassenthwaite has been rather unfortunate with respect to some of his cows being addicted to

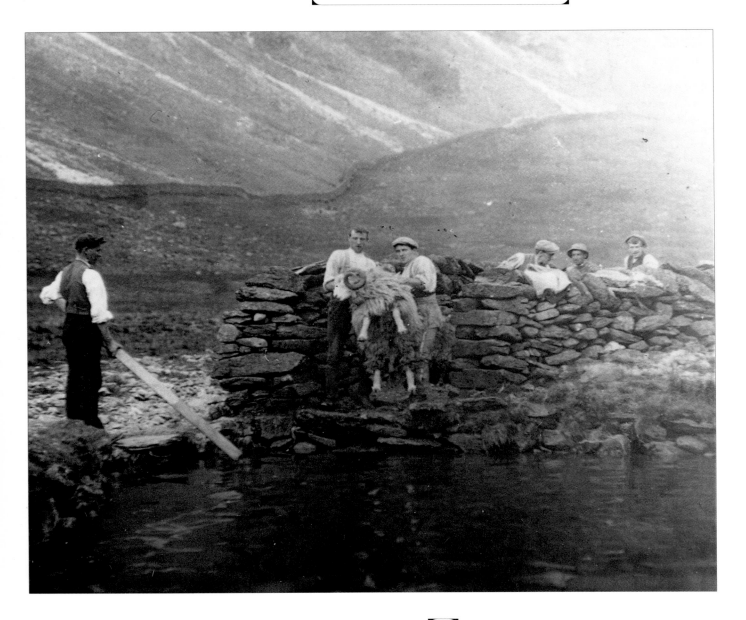

Watched over the wall, a group of men prepare to wash a struggling ram in a 'dub', a deep pool in a river bed.

slipping their calves. Somebody advised him that, in order to prevent a continuance of similar misfortunes, he should bury a calf in sight of its dam. The cruel suggestion, we are credibly informed, was actually carried into effect.

A more humane prevention was to allow a goat to remain with the cattle or, alternatively, to hang bags of salt above the heads of the animals.

Animal diseases, and in particular that affliction known as murrain (foot-and-mouth disease), were much feared; against such disasters, primitive veterinary science was powerless. Murrain could spread with lightening speed, carried not only by animals but by humans and – it is now believed – by birds. *The Complete Cow Doctor* by T. Beaumont (1863) was to be found in many Lake District farmhouses. This volume contained a remedy against murrain which consisted of a draught of myrrh, Epsom Salts, sulphur, antimony and diapente powder mixed with a quart of rue tea but this quasi-medieval potion can have had little effect. In view of the devastation caused by murrain, it is not surprising to discover that superstition played a central role in its supposed treatment.

Among the most persistent beliefs was *needfire*, derived from *neet* or oxen fire and possibly a relic of ancient fire worship; similar superstitions existed in Norway, Sweden and parts of Scotland. Needfire was kindled by friction in some central location after all other fires in the community had been extinguished. Then, in order to produce a 'good reek', straw, green cuttings and other damp fuel was heaped onto the fire, after which the cattle, and other animals, were driven through the smoke. Harriet Martineau in her *Guide to the Lakes* (1855) tells the delightful story of one old dalesman who, when all his cattle had been fumigated by the needfire, subjugated his ailing wife to the same potent charm!

There is much evidence for the use of needfire in

nineteenth-century Lakeland: at Finsthwaite in about 1837, Sawrey in 1845 and again in 1847, Monk Coniston in 1847, the Killington area in 1840 and the Keswick region in 1841 – when the fire was brought from farm to farm over Dunmail Raise from Westmorland – and finally at Troutbeck in 1851, the last recorded use.

In 1840 William Pearson described the needfire at Crosthwaite near Kendal; the fire had been kindled at Killington and passed through Westmorland as far as Skirwith in Cumberland:

The 'smoke' was in the narrow Kirk Lane on Sunday, 15th November, 1840; the fire was composed of damp litter and green wood in order to produce the greatest amount of smoke, and the cattle were driven close to the fire and sometimes driven through it.

By midnight the fire had been transmitted by hand to Howgill. Pearson continues:

Advertisement for Sheep Dipping Apparatus – 1840's

A, The Dipping Tub. B, The Drainer. C, The Inclined Plane.

THE ABOVE SKETCH IS AN ACCURATE DESCRIPTION OF

BIGG'S SHEEP-DIPPING APPARATUS,

[Which obtained prizes at the Meeting of the Highland and Agricultural Society of Scotland, at Berwick-upon-Tweed; at the Yorkshire Agricultural Society's Meetings held at Hull, 1841, and at Richmond, 1844; and also a Silver Medal from the Royal Agricultural Improvement Society of Ireland, at their Meeting, held at Dublin, August, 1844.)

LAMB DIPPING COMPOSITION," which requires NO BOILING, *and may be used with Warm or Cold Water*, for effectually destroying the Tick, Lice, and all other insects injurious to the Flock, preventing the alarming attacks of Fly and Shab, and cleansing and purifying the skin, thereby greatly improving the wool both in quantity and quality, and highly contributing to the general health of the animal.

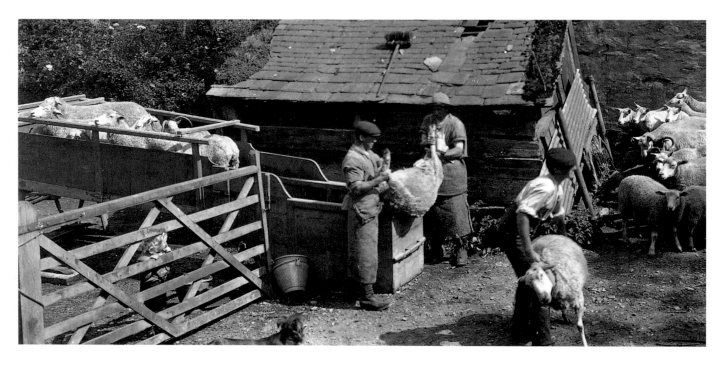

*Sheep dipping in the
1920s at
Mearness Farm, Cartmel.*

Most of the farmers cheerfully complied and as cheerfully forwarded the fire to their neighbours. A few whose idleness outbalanced their superstition, remained in bed.

Undoubtedly such folk-practices have their origins in the mists of antiquity but what is surprising is that they lingered almost to within living memory.

Before sheep dipping became common, flocks had to be 'salved' by hand in order to waterproof the fleece and, it was believed, protect the animals from 'kegs', lice and other parasites. Exactly when the practise was introduced into the Cumbrian fells is not known but Sir Daniel Fleming spent considerable sums annually protecting his sheep in this way. The

Rydal Account Books for 1645 show that the steward at Rydal Hall, Richard Harrison, paid £4 5s 0d for *'greasing ninescore and fifteen days'*, which works out to about 5d per day *'without meat or drinke'* and in April 1661, Sir Daniel records:

Item (paid John Bankes) which hee
had paid to Great John for two days
salving of hoggs with tobacco 1s 0d

The salve used was a mixture of Stockholm tar and rancid butter though occasionally tobacco was added, as at Rydal. In 1698 the salve for the Rydal flock was made up of butter from Hawkshead costing £3 14s 11d and tar brought from Ambleside,

£2 13s 0d while the bill for labour amounted to £4 16s 4d. In the same year the steward noted that the hoggs (yearlings) required 6 gallons of tar and 5 stones and 3 featlets of butter [a featlet = 4 pounds], and the old sheep needed 25 gallons of tar, 16 1/2 stones of butter and 3 stones of tallow to complete the salving. Clearly the process was a costly one.

The practise of salving continued until well into the nineteenth century, and in some parts of the Lake District until 1905 when the Board of Agriculture enforced compulsory dipping in an attempt to eradicate sheep scab. The composition of the salve continued to be tar and rancid butter; in the early nineteenth century the usual mixture was 16 pounds of butter to 4 quarts of tar and this was sufficient to salve between

thirty-five and forty sheep at a cost of 6d per animal. Generally taking place at *t'back end*, the period between mid-October and mid-November, salving was a slow, laborious and smelly job. The 'smearer' divided the fleece along the back of the sheep and then applied the salve to the skin from head to tail with his forefinger, repeating the process many times until the sheep was salved. A skilled 'smearer' could handle ten to twelve animals a day for which he was paid 2d per sheep. Techniques changed somewhat in the second half of the century when the salve was liquified and poured onto the animal's skin from a long-spouted can; this process required two men but more sheep per day could be treated. By the mid-century sheep dipping, using Bigg's patent troughs and dipping composition, had become common. Economics hastened the demise of salving; in 1868 sheep could be dipped for 1½d per head compared to salving at 8d per sheep. Moreover, the wool from dipped sheep brought 1½d to 2d per pound more than the fleeces of salved sheep – a further strong incentive for the practice of dipping. Scientific veterinary medicine, insecticides and chemical dipping compounds have abolished the ancient technique of salving – and with it has gone the odour of sheep smelling pungently of rancid butter! But recent health scares associated with chemical sheep dips have resulted in a re-assessment of the old ways and some farmers are looking back nostalgically to the days of their great grandfathers and *tarry woo'*. . . .

By the late eighteenth century many areas of the Lake District could call on the services of semi-professional horse and cow 'doctors', the forerunner of today's veterinary practitioners. At Crosthwaite, near Kendal, Thomas Harrison kept an account book between 1769 and 1803 which illuminates the activities of these early 'vets'. His income seems to have been largely derived from the sale of 'drinks', pills, and potions to neighbouring farmers but he also made

visits to sick animals when requested. His accounts contain such items as:

1776	**To Jos Taylor**	£	s	d
Jany. 8	to a Cow Drink			8
Feby. 11	Do. 2 Cow Drinks		1	4
March 24	Do. a mustard Drink			6
June 17	Do. plaster			4

He seems to have supplemented his finances by entrepreneurial transactions, for he bought such items as butter and herrings for his customers on a commission basis. In addition, he engaged in curious 'bargaining' such as the agreement he made in 1774 with one John Atkinson whereby Atkinson undertook *'to*

shoe the old mare for two years to come after the first time of her wanting shoeing' in exchange for an old Galloway *'which I got in a swap at Kendall'*.

For those dalesmen who could not afford the skills of Thomas Harrison and his like, there were printed 'self-help' guides which not only described in vivid detail the symptoms of a variety of ailments, but also outlined a number of possible cures. *The Farmer's Jewel* written by *A Person of Thirty Years' experience* and *The New Cow Doctor* by J Cundall, both printed and published by A Soulby in Penrith, were typical of such do-it-yourself handbooks and were as widespread as today's car-maintenance manuals. With these and similar volumes on his mantleshelf, and with a basic knowledge of medicinal properties of plants, the eighteenth and nineteenth-century dalesman felt equipped to care for his animals.

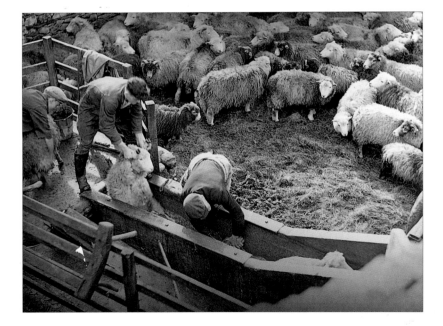

A rather apprehensive flock await their dipping – which was made compulsory in 1905, helping enormously to eradicate scab. Its institution meant the decline of the ancient practice of salving sheep with tar and rancid butter.

Cockfighting and Fox hunting

The traditional appeal and the antiquity of Cumberland and Westmorland wrestling might lead one to assume that this sport has always been the most popular in the Lake District but this is certainly not so. Until it was made illegal in 1835, cockfighting held the dubious honour of attracting the largest number of supporters. No sport was followed with more zeal and enthusiasm. Now regarded with horror and loathing, it was once the sport of kings; both Henry VIII and James I were passionately fond of cockfights.

In the northern counties it was supported by a wide cross-section of society, from the squire, clergyman and schoolmaster to the hired hand and village school lad. It gained the sort of mystique which rugby union football acquired in the late-nineteenth and twentieth centuries. It was firmly believed that cockfighting developed character by providing examples of gameness and pluck and in the eighteenth century most public schoolboys were initiated into its mysteries. Indeed, James Clarke was moved to write in 1787:

When these are the practices inculcated to early youth, we need not wonder at that spirit which has

so often displayed itself to the terror and destruction of all opposers.

Clearly, then, the cockpits of Cumbria corresponded to the playing-fields of Eton! In fact, the link between schools and cockfighting is ancient; during the reign of Henry II it was customary in London for schools to hold Shrovetide cockfights supervised by the schoolmaster and the same tradition continued in Cumbria until the eighteenth century. It was even suggested that '. . . masters and pupils were often more conversant with the points, qualities and colours of cocks than with grammar and arithmetic'.

There is some evidence to suggest that the schoolteacher's meagre salary was supplemented by the *cockpenny* that each pupil provided every Shrovetide. James Clarke claimed that in many cases as much as half the master's salary depended on the cockpennies but the value of this levy seems to have varied. Sir Daniel Fleming annually records the donation of cockpennies to his sons. When they attended the Rydal village school they usually received 6d each:

1665 Feb. 6 Given unto Will, Harry and Daniel for their cockpennies 6d

5ols. worth of Malt.

The Property of Mr. JOHN THOMPSON, of Stainton, Maltman.

WILL BE FOUGHT FOR,

In WELCH MAINS, at the cover'd PIT, in PENRITH.

On Thurſday the 26th, and Friday the 27th, Days of APRIL, 1787.

IN Sixteens, Eights, n Fours, as they may fall in Weight. Cocks of all weights will be taken in, and one ounce & half allowed to Stags, and two ounce to Blenkards ; to Fight in Steel.

The Owner of each Cock to pay 18s. being the value of Half a Load of MALT, and to Fight Win and Draw; to ſhew and weigh the Monday before fighting : Cocks brought in to feed the 17th of April.---The Money for each Day's Main to be paid before the Cocks are ſet down. The Owner of each Cock admitted into the PIT GRATIS.

Feeders { Bowneſs, at the Angel. } PENRITH.
{ Thompſon, at the Duke's Head. }
{ Brownrigg, at the Golden Fleece. }

BELL, PRINT, PENRITH.

f the inc
s practical
one by ma

Mr Bulmer and a prize Eskdale game-cock in about 1926.

Cocks of all weights are invited 'to Fight in Steel' at the covered pit in Penrith in 1787. Cocks are to be 'brought in to feed' some ten days before the event.

The following year they boys received a bonus:
1666 Feb. 26 *Given to the three boyes for cockpennies 2s and to bett 6d – 2s 6d*

When the boys moved to the school in Kendal the cockpennies were increased; Henry was made a captain in 1675. This was the equivalent of being made captain of the First XV now and Sir Daniel, with obvious parental pride, records
1675 Jan. 30 *Sent by John Bankes to my son William 10s, Henry – being a captaine a broad 20s piece in gold and Daniel 5s for cockpennies to the master.*

At Cartmel the 'cockpenny' paid to the village schoolmaster seems to have varied from one shilling to a guinea, depending on the wealth of the parent – an early example of means-testing.

The exact purpose of the cockpennies is uncertain. Some authorities clearly believed it was part of the master's salary while others suggest that it enabled the teachers to provide a prize to be fought for – at Wreay and Bromfield the prize was a silver bell – but there are those who insist that the money was used to provide cocks to fight against those brought by the pupils. Certainly the 'cocking' on these occasions seems to have been festive; Francis Nicholson describes the preparations at Wreay, near Carlisle:

About three weeks previous to the eventful day, the boys assembled and selected as their captains two of their schoolfellows whose parents were willing to bear the expenses incurred in the forthcoming contest. After an early dinner on Shrove Tuesday the two captains, attended by their friends and schoolfellows . . . distinguished by blue and red ribbons, marched in procession from their respective homes to the village green, where each produced three cocks, and the bell was appended to the hat of the victor. . . who had great honours conferred upon him in the presence of all the neighbourhood, who never fail to assemble on these occasions.

Schoolmasters were not the only pillars of society to endorse and encourage cockfighting. The Church was often actively involved in its promotion and in many Lakeland parishes local clergymen were amongst its most vehement supporters. At Burgh-by-

Sands and Bromfield the cockpits were located close to the churches and at the latter cockfighting was carried on after the service on Sundays. At Penrith the pit was located on the south side of the churchyard while at Heversham and Warton, just over the Westmorland border in Lancashire, the cockpits were set between the churches and the ancient grammar schools. Towards the end of the eighteenth century at Urswick-in-Furness, the vicar presided at Shrovetide cockfights and, according to John Bolton:

> . . . might be seen running round the ring, being then a strong and active man, but instead of preaching a sermon or reciting passages of the Scriptures to his unruly parishioners to keep them quiet, he used a more persuasive and irresistible argument – a nice little two-handled cudgel . . .

An early example of muscular Christianity? The sport appealed to all sections of the ecclesiastical hierarchy; there is a tradition that at Rose Castle near Dalston, the official residence of the Bishops of Carlisle, a cockpit existed in the garden. This was scotched in 1908 by the Bishop's chaplain who explained that it was nothing more sinister than a circular sunken garden – perhaps there were some who believed him!

Traces of cockpits can still be detected in some Lakeland villages such as Heversham, Orton and Natland. The best is on the village green at Stainton in Furness. Here, between limestone boulders, a level area has been enclosed by a shallow circular ditch, leaving a platform some seventeen feet in diameter on which the cocks fought. The upcast from the ditch created an enclosing embankment on the outer edge, making a total diameter of 38 feet. Spectators stood on the embankment and the 'feeders' and 'setters' occupied the ditch surrounding the fighting platform.

Not all cockpits were in the open; certainly after 1835 when it was declared illegal, cockfighting con-

tinued behind closed doors but even before that some pits had been constructed inside. Colourful extrovert John Wilson, alias 'Christopher North', had a cockpit constructed under the dining-room floor when his house was built on the shores of Windermere at Elleray. After entertaining his friends to dinner, the table was moved back, the carpet rolled up, the floorboards lifted – and the company enjoyed an evening of 'cocking'. Closed pits – so-called because they were held indoors and an entrance fee charged – were not uncommon and Cowper records such meetings at Skelwith Bridge, Oxen Park, and in an upstairs room at the Brown Cow Inn at Hawkshead.

Fighting cocks were bred solely for combat; most birds ranged from 3lbs 14oz to 5lbs 6oz and they were equipped with spurs, slightly curved steel spikes on a leather band which fitted over the bird's natural spurs. Affluent owners often had silver spurs made for their birds. Fitted with such weaponry, the cocks could inflict fearsome wounds on their opponents. H S Cowper, a staunch apologist for the 'sport', maintained that properly-made spurs, 'fair' spurs, as they were called, either inflicted wounds which were fatal, or clean and quick-healing but evidence for such a claim is scarce. Young cocks were known as *stags* and *stag mains* were popular; the one-eyed veterans of several mains were *blenkards* or *blanchards*. The most popular form of competition was the Welch or Welsh main in which a given number of birds fought often to the death; the surviving half were pitted a second time until only a quarter of the birds remained – and so on until two birds were left and these fought until the weaker succumbed.

A champion fighting cock was a financial asset to be pampered and cared for; one nineteenth-century cockfighter claimed that a single bird had won for him six chairs, a load of meal, a quarter of beef, a watch, and a chest of drawers! Not surprisingly, the attention devoted to the feeding of these birds was

legendary. The exact diet of fighting cocks was usually a closely-guarded secret for it was believed that feeding was the key to success but generally the birds dined on warm fresh milk and 'cock-loaf', a rich bread made from flour, eggs, milk, sugar, currants, barley and either a glass of sherry or port wine. Even today the term 'fed like a fighting cock' is in common use for anyone enjoying gastronomic delicacies.

'Fed Like a Fighting Cock . . .'

The following recipe was used in 1865 – thirty years after cockfighting had been made illegal – by Miles Birkett who worked at the Blackbeck Gunpowder plant, near Bouth.

2 oz cream of Tartar
2 oz candied lemon
1 juice of lemon
Boil in 3 pints of water.
When cool pour into a Bottle

Cock loaf

Wheaten bread without crusts crumbled up, mixed with 3 eggs according to quantity. ½ [lb?] mutton without fat. 1 glass of port wine all mixed up into a paste. . . after a meal of that stuff with two teaspoonsfuls [from the bottle?] With cock-bread when broken up. Between times feed with Barley pratched [sic] in oven till very dry and beard dries off Champion stuff of all the world for feeding.

Cumbria Records Office, Barrow

County cock mains drew large crowds of spectators. At Ulverston, the annual three-day main was held on a raised platform in the town's Assembly Rooms, the last of these extravaganzas being held in

1828 when it was announced that '*A grand main of cocks will be fought at Ulverston on 29th, 30th and 31st of May between the gentlemen of Lancashire and Cumberland. William Woodcock feeder for Lancashire and Addison for Cumberland. A pair of cocks to be in the pit each day at ten o'clock*'.

Ulverston was, at this time, the social centre of Lonsdale North of the Sands, described by one writer as '. . . *a pocket edition of the metropolis, mimicking its dissipations and copying its manners*', so it is not surprising to find that cockfighting was part of the social scene. But not everyone supported the 'sport' and some raised their voices in protest at this ritual slaughter. William Fleming, the Pennington diarist, was one of these and he registered his disgust in 1813:

Thursday, March 11. This morning the annual Assembly of Blacklegs and Blackguards, Gamesters and Pickpockets commenced at Ulverston with brutal Pleasure to observe the Courage and Ferocity of a few poor cocks. The main between the Cumberland and Lancashire Men which commenced this Day was . . . attended by many who paid 6s for Admittance into the Pit. Some Men from Liverpool, Newcastle, Carlisle and other Places at a Distance attended, and there is little Doubt they would be amply recompensed for taking so long Journeys at this Season of the Year and for so laudable a Purpose as Cardplaying and Cockfighting, quarrelling, Drinking, swearing, lying and cheating, injuring their Health and in all Probability losing their Money.

Three days later, as if to justify his convictions concerning the debauchery of cockfighting, he recorded, with some satisfaction:

Sunday, March 14. John Ashburner, one of the Cockfighters, emerged from the Alehouse this Morning, stood at the Top of the Backlane where it joins Church-walk at Ulverston as the People were going to the Church, hallooed and waved his Hat, utering many strange Exclamations and insulting many People, but without being noticed. However, just when the Clergyman had taken his Text and begun his Sermon the same Person entered the Church and smacking the small Door too violently he marched up the middle Aisle till opposite the Pulpit; there waving his Hat he interrupted the Preacher and began to harangue the Audience, but was soon disturbed by the Churchwardens and Dogwhipper and committed to the Black Hole.

John Ashburner's downfall had been prophesied in 1806 when Fleming described a cockfight fought at Dalton between Ashburner and a gentleman named Addison, the stakes being 2 guineas a battle and 10 guineas the Main. Ashburner lost and Fleming wrote: '*Ashburner will be a Beggar if he live 10 years from this Time, or his Intellect will be deranged.*'

Cockfighting, along with bull-baiting (see page 108) and badger-drawing, was proscribed in 1835 but it proved difficult to eradicate entirely and for many years it continued in remote dales. Indeed, some maintain it still continues in the fells despite the heavy penalties. H S Cowper records a delightful story concerning the '*gentlemen of the sod*' in the Hawkshead area who held an illegal main on the northern boundary of their parish, the most northerly in Lancashire. As soon as the police were spotted by the look-outs, the cocks were bagged and the cockfighters fled across the county boundary into Westmorland where the main continued!

Secret cockfight in Westmorland

APRIL: The Cumberland cock-fighting season, which begins at Easter and lasts sometimes a month and sometimes well into the summer, according to the rapidity with which the birds are killed, opened rather disappointingly for breeders last weekend.

West Cumberland owners held five bird mains, in Westmorland, in one of the most secluded and prettiest spots in Lakeland on Saturday.

They left their homes at 3am for a secret meeting place. The birds were as eager for the fray as their owners. They were clipped on the neck and breast, weighed in, and fitted with heavy steel spurs which took the place of the harmless indiarubber tipped ones which had served for many preliminary practice bouts during the last few weeks.

Betting was heavy. When one champion Indian Game fell with the spurs of a little duckwing through his eyes, his backing of over £60 was lost, but he did not live to fight another day. Match followed match and the grass became splashed with blood. There was no interference. The main was a success, and sportsmen dispersed as quietly as they gathered.

A report in the 'North West Evening Mail' in April 1929

The Charcoal Black and the Bonnie Grey

This version of *The Charcoal Black and the Bonnie Grey* is from Walney Island but the ballad was known throughout Cumbria, the place names being changed to suit a particular location.

Come all you cockers far and near
I'll tell of a cockfight when and where,
At Tummerhill I've heard them say
The North Scale lads had a bonnie grey.

Two dozen lads from Biggar came
To Tummerhill to see the game,
They brought along with them that day,
A black to match with the bonnie grey.

They all went in to take a cup,
The cocks they then were soon set up.
For ten guineas aside those cocks did play,
The charcoal black and the bonnie grey.
When these two cocks came on the sods,
The Biggar lads said 'Now, what odds ?',
'No odds, no odds', the rest did say,
'But we'll hold your guineas and beat your grey.'

These cocks had struck but two or three blows,
When the Biggar lads saw they were like to lose,
Which made them all look wan and pale,
And wish they had fought for a gallon of ale.

Now the black cock he has lost their brass,
And the Biggar lads did swear and curse,
And wish they'd never come that day,
To Tummerhill to see the play.

Foxhunting

The Old Fox Trap above Thirlmere

Trees have put a green cover over many things and, not least, a stone-built fox trap below a chaotic fall of screes in the shadow of close-set spruces. I was first told about the trap almost 20 years ago when a man, old then, explained how his father had used it 60 years before. This is no ordinary trap, it is a roughly circular wall about ten feet high with a 'batter', an in-slope, at the top and with a boulder overhanging one side. An old clocker was put in the trap and, supposedly, the fox, scenting it, would jump down from the boulder and be prevented from escaping by the batter. Some of the trap is fallen now, an oak grows at its centre, but enough is left to show the quality of workmanship. . . .

'Country Diary' by Enid J Wilson in *The Guardian*, Dec 1971

The fox trap at Levers Water, Coniston, where the fox 'walked the plank' baited with a goose, and was catapulted into a deep hole with overhanging walls.

During the last decade, foxhunting has become a major issue within the fells; most dalesmen see hunting as the necessary extermination of vermin rather than a sport, and the farmer who has seen his newly-dropped lambs savagely mutilated or his wife whose chickens have had their heads systematically bitten off, will have views equally as strong as those of the Anti-Bloodsports League or members of the National Trust who wish to ban hunting on the Trust's land. Of course, foxhunting in the fells bears little similarity to the colourful social rituals of Leicestershire; few huntsmen sport the 'pink' coat and black hat of the 'squirearchy' and to follow the hounds in the Lake District requires not a well-groomed hunter but a stout pair of well-dubbined boots for fell packs are followed on foot. Whereas foxhunting in the Midland shires is a part of the upper class social scene, in Cumbria it is altogether a more democratic and homely affair – provided, of course, you are not a fox!

Organised foxhunting on any scale dates from the mid-eighteenth century. Before that time farmers and landowners killed not only foxes but ravens, eagles and other vermin as best they could. Records of several parishes in the fells give details of bounties given to those who successfully produced evidence of a 'kill'. At Hawkshead during the early eighteenth century the standard rate was 5s for a fox, 2s 6d for a cub and 4d for a raven if the head was produced. Between 1730 and 1797 some 421 ravens were killed and Wordsworth in his *Guide to the Lakes* recalled seeing:

. . . bunches of unfledged ravens suspended in the churchyard of H[awkshead], for which a reward of so much a head was given to the adventurous destroyers.

At Cartmel, foxes heads were impaled on the church gates like grizzly talismens, and the Crosthwaite parish records mention the following payments:

1752

To Wm. Ware for 1 old Eagle	2s 0d
To Jas. Gateskel for 2 young Eagles	2s 0d

1762

For 2 Eagles and 1 Fox	4s 4d
For Eagles and Foxes	£1 6s 6d

At Keswick in the early eighteenth century fox-cub hunting was tried but soon abandoned as unremunerative – a cub was valued at merely one shilling whereas a full-grown fox earned the hunters three shillings. During the seventeenth and eighteenth centuries it was common practice for young men who killed foxes to visit local landowners displaying the carcass of the victim in the hope of receiving a financial reward for their skills – and usually they were not disappointed. The account books of Sir Daniel Fleming record several such rewards:

1673 May 12
Item, to some Ambleside men
who had killed a spotted fox 6d

1674 May 31
Given to some Ambleside fox killers 6d

Eagles

Although foxes were the most common type of predator, eagles were also classified as vermin to be destroyed, as various parish account books show. Two hundred years ago, eagles were common in the Borrowdale area and George Smith's curious map of the Black Lead Mines, published in 1751, cryptically records in the Buttermere valley *'here eagles build'* with the same awe that mediaeval cartographers indicated *'here be dragons'*! At the of the eighteenth century a long rope was kept in Borrowdale so that men from the valley, and those from neighbouring dales, could be let down the crag faces in order to destroy the eyries. Thomas Gray, visiting Borrowdale in 1769, described how one farmer

. . . was let down in ropes to the shelf of the rock
on which the nest was built, the people above

shouting and hilloaing to frighten the old birds, which flew screaming round, but did not dare to attack him. He brought off the eaglet [for there is rarely more than one] and an addle egg.

Eagles could be very rapacious; not only would they seize lambs but would also take the occasional sheep dog and they have been known to drive sheep over precipices in order to kill them. James Clarke,

A dog fox – just one of many predators, including eagles and ravens, for which a reward was once paid.

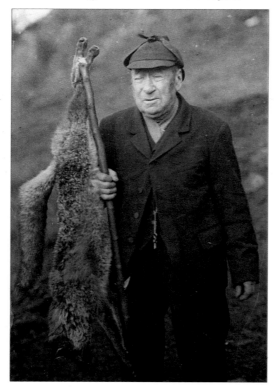

writing in 1787, mentions a single eyrie on Wallow Crag, Haweswater which, when destroyed, contained the remains of thirty-five fish and seven lambs in addition to other prey. The sheer size of some of these birds could be intimidating; Clarke claims that he saw one specimen with a wing span of 6 feet 8 inches and goes on to record how, on one occasion, he tried to shoot one:

. . . it flew about 90 or 100 [yards] when I got near it and fired at him again and so a third time but did not hit it; I had shot No. 4, but durst not attempt it again, for while I was loading my gun the fourth time, it came within six or seven yards of me, so fierce as if to begin an attack, so I left it.

It seems that James Clarke was not only a poor shot but clearly he believed that discretion was the better part of valour!

By the mid-nineteenth century eagles were no longer common and in 1860 the journal *The Field* began to record sightings, a sure sign of decline in numbers. After many years' absence from the Lake District, the eagles are once again back and nesting in the remote, wild eastern fells; the exact location of their eyrie is known to a handful of ornithologists and the birds are closely guarded; even walkers and climbers are steered clear of their mountain fastness – a far cry from the days of the Borrowdale eagle rope and nest raiding.

Foxes

Although eagles could inflict severe damage on a flock, for sheer wanton killing, the fox had no equal. Before they were hunted with hounds, foxes were trapped in vicious steel-jawed spring traps but in the rough fell country ingenious dry-stone walled constructions were used. These foxtraps were basical-

ly bee-hive shaped, with walls overhanging on the inside, the only opening being the hole in the top. To set the trap, a plank – with a goose, a chicken or any other tasty morsel dangling from the end like the clapper in a bell – was balanced on the rim of the structure. The fox, scenting the bait, literally walked the plank towards his goal until his weight overbalanced the plank and tipped him into his stone prison cell from which, because of the overhang, escape was almost impossible. Such traps can never have been very common but there are several located high up amongst the screes of the fells.

In 1943 Thomas Hay drew attention to a fine trap on Great Borne, Ennerdale, long disused and at a height of 1,300 feet, but since then others have come to light. Below Great Howe Crags on the Coniston Old Man range, overlooking Levers Water, is another splendid trap; the walls here stand to a height of about five to six feet and although much of the corbelling has fallen in, there is still a discernible overhang. The whole structure is roughly circular, measuring between ten and twelve feet in diameter. A third

John Peel's Day was celebrated at the Oddfellow's Arms, Caldbeck.

example is tucked away in spruce woods which flank the western side of Thirlmere and almost certainly others await recognition by sharp-eyed fell walkers.

John Peel

To many, fox hunting in the Lake District means only one thing – the John Peel saga, the legend that has become not only part of Lakeland folk lore but equally part of our national heritage. Stories about John Peel abound, some of them true, many apocryphal, but one thing is certain, the ballad which bears his name is sung wherever the English language is spoken. And yet there are some surprising discrepancies.

Peel was born at Park End near Caldbeck, amid the wild, rolling fells *back o' Skidda*, in 1777, not in Troutbeck; moreover, his coat was not 'gay', as some versions have it, but grey – hodden grey, in fact. Described as *'terrible land in t'leg and lish* [agile], *with a fine girt neb* [large nose] *and grey eyes that could see for ivver'*, most portraits show a somewhat sour-faced, square-jawed individual wearing a bat-

tered top hat and holding his *'laal bugle horn'*.

For most people, John Peel is the personification of Lakeland foxhunting, a fact which did not escape the anti-hunting fraternity when they desecrated his grave in Caldbeck churchyard some years ago. However, the fact remains that organised fox packs were operating in the fells long before he was born. 'Squire' Hasell of Dalemain certainly kept foxhounds around the middle of the eighteenth century and another early report of foxhunting comes from the parish of Watermillock in 1759. Apparently, the Bailiff of Gowbarrow received a rate of *'forty quarts of oats'* from each farmer in return for which he kept hounds to suppress foxes but had failed to keep his part of the bargain, consequently a vestry meeting decided to. . .

> Hire men to destroy the Vermint . . . [and] . . . the swiftest fox hounds from the mountainious enoersons [sic] of Keswick etc.

In addition, men were hired *'to attend with guns and every other engine'* to destroy vermin. The hunt was arranged during Whitsun week, 1759, and by all accounts was very successful. James Clarke, who was an eye witness, claims that:

> The sum-total of vermin destroyed were fifteen foxes, seven badgers, twelve wild cats and nine marterns (called here, by way of distinction, Clean Marts) besides a prodigious number of foulmarts, eagles, ravens, gleads, etc.

Fox hounds and huntsmen

Anyone who has seen a Lake District fox pack in action will readily appreciate the difficulties which both men and hounds experience; in the Midlands it is customary to go in search of the fox in some covert

Hounds outfoxed

A FOX had the last laugh when it was chased by a pack of baying hounds from the Ullswater Hunt into the craggy hills of Patterdale.

As it made its escape, 24 of the dogs became crag-fast on St Sunday Crag and Patterdale Mountain Rescue Team had to be called out.

In the fading light it was decided the unusual rescue mission was more suited to daylight and so the dogs were left to spend the night on their rocky perch.

Patterdale team leader Dave Freeborn said: "They were in quite a difficult place to get to and were totally stuck on quite a large ledge. The next morning we sent a climber up to them and when he reached them he was faced with 24 hounds looking at him inquisitively. They were quite calm and quite pleased to see us."

Hunt 'whipper in' Graham Bland was helped up the crag and then with the assistance of four members of the team the dogs were individually passed down the rock face from person to person in a sling.

The 'Westmorland Gazette', 31 March, 1994

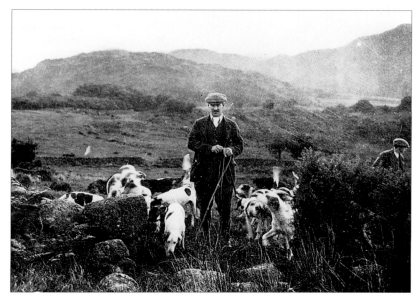

Willie Porter and hounds

about midday, after the social niceties of stirrup cups have been observed, but here in the fells, 'dragging' to locate the scent is an early morning preliminary to the hunt. Once the scent has been picked up the hounds will follow their quarry over bog and bracken, scrub and scree for many miles but the result is not always a 'kill', for the fox's wiles are not merely legendary but very real. They can run effortlessly along the top of a drystone wall, using their brushes for balance in a way hounds cannot; similarly, they have been known to follow stream beds to hide their tracks or run amongst sheep in order to mask their scent. Their stamina is prodigious and they can cover great distances. In March 1818 John Peel's hounds covered fifty miles but one of the most strenuous took place in the mid-nineteenth century when the Blencathra hounds followed a scent from the slopes of Skiddaw, through Portinscale, along the western shores of Derwentwater, up the length of the Borrowdale valley to Sty Head Pass where the fox finally escaped in the dark. The hounds were discovered in Coniston the next morning, having run more than fifty miles over the most rugged land in the Lake District.

If hard-pressed, the fox will go to earth in a *borran*, a pile of loose boulders or scree – and then persistence is the name of the game . . . W Wilson, writing in the 1880s, records the timely escape of a fox from a borran on the Langdale Pikes:

About twelve years ago, a fox escaped from the hunters into an inaccessible crevice of a rock near Stickle Tarn. For three weeks a party of from thirty to seventy Langdale men stayed by him night and day, blasting the rock by day, and placing a stone before the crevice to prevent his escape by night. At last a wet night drove them down the valley, and when some of them returned next morning, the stone placed before the crevice was gone, and so was the fox! Gone! beyond even the reach of John Peel's view halo! The mystery of his escape has never been solved; but the prevailing idea has always been, that 'some Gursmer [Grasmere] chap mud ha' done it!'

Occasionally, terriers would be sent in to winkle out the fox but there was no guarantee which would come off best. In the nineteenth century a vicious instrument known as the 'fox screw' was used to extract the fox; fixed to a pole or stick, this barbarous double-screw pulled out the animal like a cork from a bottle. Fortunately, they have long been outlawed.

Foxes have frequently been known to take refuge

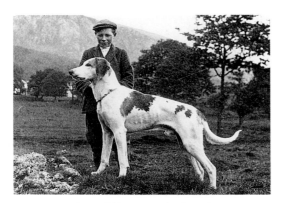

Boy with Trueman, a fine hound.

on a *bink* or ledge so narrow that they cannot be followed. In this case attempts were usually made to dislodge it either by stones or by lowering down a member of the hunt on a rope to knock the animal off its perch. There is a much-told story of one man who was successful in his attempts to remove the fox from the *bink* only to find that he was left dangling at the end of his rope as the fox shot off, hotly pursued by the rest of the hunt!

It has been said, not without reason, that most dalesmen love the hunt better than marriage and this is, perhaps, why it has its own folk heroes, songs and legends. The hounds, the foxes and the men who hunted them were certainly a tough and hardy breed; none more so than eighteenth-century Farmer Dixon. James Clarke related how this indomitable character fell from Blea Water Crag while out hunting on the High Street range. Although he broke no bone, he was badly bruised and completely scalped but such was his devotion to the chase that he was able to give these instructions to the rest of the party before he himself fell down senseless: *'Lads, fox is gane out at t'hee end, lig dogs on an I'll come syun. . . .'*

John Woodcock Graves who wrote the words of *D'ye Ken John Peel* certainly made Peel the best known huntsman in England for, as he reportedly told Peel, *'you'll be sung when we're both run to earth'*. However, there are other famous huntsmen. Also celebrated in song, Joe Bowman led the Ullswater hounds almost continuously from 1879 until 1924 and stories of his exploits are almost as colourful as those told of John Peel. In 1857 Tommy Dobson, a bobbin turner, founded the Eskdale and Ennerdale pack and served it until he died in 1910. His tombstone in the tiny graveyard of St Catherine's chapel in Eskdale bears not only a likeness of his genial features but also the head of a hound and a fox. Even in the early days of organised foxhunting it seems that huntsmen were popular folk-heroes, as the *Carlisle Journal* recorded in 1829:

> . . . the shepherds and others resident at Crosthwaite, Watermillock, Patterdale and Martindale, presented a handsome silver cup to John Taylor Esq., of Baldhow, for his indefatigable exertions in destroying foxes by his excellent pack of hounds. In the course of the last two years these dogs have killed fifty-six foxes.

The spirit and traditions of John Peel, Joe Bowman and Tommy Dobson live on in the present Lakeland packs, the most famous of which are the Coniston, the Mellbreak, the Eskdale and Ennerdale, the Ullswater, the Lonsdale and the Blencathra. The hounds are supported by the subscriptions of the local farmers who feed and house them during the summer months; in the winter, they come together in kennels for the hunting season.

In the past, packs have been kept for the hunting of other animals; terriers were bred for foumart or polecat hunting while in some areas otter hounds were maintained. In Troutbeck, and no doubt in other val-

leys, hare coursing was a popular pastime and harriers were kept for this purpose. But it was the fox which merited the most attention and the foxhunters who were praised in the rousing ballads which still enliven Cumbrian 'hunt suppers' and 'Merry Neets'.

Bull-Baiting

In 1835, along with cockfighting and badger-baiting, another degenerate activity was made illegal – the practice of bull-baiting. Once common in Keswick, Kirkby Stephen and Kendal, where it was outlawed by the Corporation in 1790, bull-baiting was certainly a blood sport which provided a spectacle for the mob. W Wilson described the procedure in Keswick:

> In Keswick a large iron ring was formerly fixed in a stone block in the market place; this was called the bull-ring, and to this the bull, previous to being slaughtered, was fastened by the ring in its nose, and then baited and bitten by savage dogs amid dreadful bellowing, till the poor beast was almost covered with foam and quite exhausted. Great excitement prevailed when a bull was being being baited, and large numbers assembled to witness the sport. On such occasions the market-place at Keswick was crowded, and many, in order to obtain a good view, might be seen sitting on the roofs of the adjoining houses. . . . Beyond the excitement which the exhibitions produced among the spectators, the system was thought to be of great value in improving the quality of the beef, an aged bull being especially tough unless well baited before slaughtering. . . . When the flesh of a bull was exposed for sale, it was the rule in Keswick, and probably elsewhere, to burn candles during the day on the stall on which the meat was exposed for sale, in order that customers might be aware of the quality of the meat sold there.

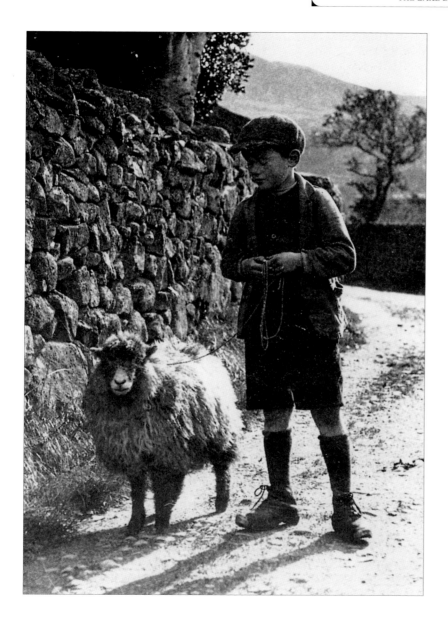

A boy wearing the flat cap, clogs and knee-length trousers so typical of his time, with a hogg or yearling sheep in the 1920s.

Sheep on the Fells

'... the home fells whitened with the shorn sheep let loose scattered over them like daisies.'

Miss Eliza Lynn Linton

Beatrix Potter, that charismatic originator of Peter Rabbit, Benjamin Bunny and other anthropomorphic animals, was a most unlikely fell farmer. Born into an affluent Kensington family, the royalties from her children's books enabled her to buy many farms in the Lake District which, on her death in 1943, she generously left to the National Trust. As Mrs Heelis she became a well known judge of Herdwicks and would appear at local sheep fairs wearing clogs and a battered felt hat. Here she writes an obituary for a much-loved Herdwick ram and, at the same time, demonstrates her knowledge of the breed:

A grand old champion of the fells is dead. Mr. Joseph Cockbain's celebrated Herdwick ram, 'Saddleback Wedgewood', has died on January 14th at Hill Top Farm, Sawrey. The ram was bred at High Row, Threlkeld by Mr. Cockbain; his sire was Mr. Jerry Richardson's 'Gable'. He was lambed in 1923

– he was not very old as Herdwicks go – but he had been failing for six months and his complaint was incurable.

Wedgewood's successes in the ring were past counting. He won 54 firsts and championships. In 1928, he was exhibited eleven times and eleven times he came out champion. And there were giants in those days; Wedgewood; Roamer; Grayknott. Old Roamer is still living; but shrunk into little room.

Wedgewood was the perfect type of a hard big-boned Herdwick tup; with strong clean legs, springy fetlocks, broad scope, fine horns, a grand jacket and mane. He had strength without coarseness.

A noble animal.

It is too early to tell what mark he will leave upon the Herdwick breed. Not all fine rams are as impressive as Gatesgarth Ned, whose line appears again and again in Herdwick pedigrees. Judged by his young stock, Wedgewood will prove to be a successful sire. I am proud to have had the use of him in my flock; though I could have wished that he had survived to go home to Threlkeld.

'As Easy as Yan, Tyan, Tethera . . .'

One of the most fascinating aspect of Cumbrian folk lore concerns the ancient dialect way of counting sheep. These numerals, it is argued, are a direct link with the 'Dark Ages' when Cumbria was part of the great Celtic kingdom of Strathclyde. Although there are differences from dale to dale, there is a striking similarity between the numerals 1, 5, and 10, not only in Cumbrian but in Old Welsh, Cornish and Breton – languages from areas that were also part of the 'Celtic fringe'. Some years ago an enterprising Keswick restaurant was called the 'Yan, Tyan, Tethera' after the Borrowdale sheep scoring numerals 1, 2 and 3. Unfortunately many visitors not acquainted with local traditions thought it was a Chinese restaurant!

Sheep Scoring Numerals, One to Ten

	Coniston	Borrowdale	Eskdale	Old Welsh	Cornish	Breton
1.	**yan**	**yan**	**yaena**	**un**	**un or onan**	**unan**
2.	taen	tyan	taena	dou	deu or dyw	daou
3.	tedderte	tethera	teddera	tri	try or tyr	tri
4.	medderte	methera	meddera	petuar	peswar or pedyr	pevar
5.	**pimp**	**pimp**	**pimp**	**pimp**	**pymp**	**pemp**
6.	haata	sethera	hofa	chwech	whe	chouech
7.	slaata	lethera	lofa	seith	seyth	seiz
8.	lowra	hovera	seckera	whyth	eath	eiz
9.	dowra	dovera	leckera	nau	nau	nao
10.	**dick**	**dick**	**dec**	**dec**	**dek**	**dek**

T Ellwood, *Sheep Scoring Numerals*

The Eskdale Tup Show

Apart from Shepherds' Meets, the tup fairs, where rams or tups were hired out or sold for breeding purposes, provided opportunities for farmers to gather and cast critical and experienced eyes over the livestock and, like the meets, they are also social gatherings. This is a delightful description of the Eskdale Tup Show in the early part of the present century:

The great event of the year was the Eskdale Tup Show, held over fifty years at the 'Woolpack', the last Friday in September, when tups were shown and hired out for the season. The sheep were pure Herdwick, arrived the previous day having walked over the fells from Borrowdale, Wasdale, Coniston, Seathwaite, Bootle and elsewhere. The inn was transformed, furniture stored away, floors were sawdusted, windows were barricaded, bedrooms full to overcrowding, one hardly knew who was sleeping where.

This was a time to celebrate and meet your friends, and they did. Beer at threepence per glass, and spirits at fourpence, soon had them singing in each room, one above the other. Special staff was engaged each year to help, and each knew his own job. The big, hefty butcher, who supplied nine rounds of beef and six hams to be eaten on the day, was chief barman. Pickles were stored in huge crocks. Large squares of apple pasties by the dozen, loaves by the hundred, and all made on the premises. Little Tommy Pharaoh (he was about five feet tall) strutted about the field in a grey topper and fancy waistcoat, cast-offs from Lord Muncaster, just like one of his game-birds. Mr. Inman from Coniston, always sober and dignified, Ned Nelson from Buttermere, looking like one of the prophets, quoting the Bible and stroking his black beard. Mr. Rothery from Wasdale Head with his high choker collar and frock coat looking more like a parson than a flockmaster . . . one old chap with a red beard aired his views in no uncertain manner about 'lasses

now wearing low necks', for fashion had moderated the high neck a little. . . .

Mrs S J Bulman

Herdwick Sheep

Sing, my bonny harmless sheep
That feed upon the mountain steep;
Bleating sweetly as ye go
Through the winter's frost and snow.
Hart and hind and fallow deer
Not be half so useful are:
Frae kings to him that hods the plow
Are all obliged to tarry woo'.

From an old Cumbrian spinning song.

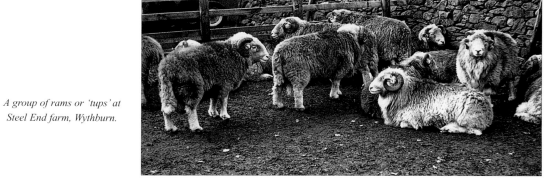

A group of rams or 'tups' at Steel End farm, Wythburn.

Despite its tortuous rhymes, this ancient song makes the valid point that the wealth of the Lake District

Prize tups at Lowick about 1870.

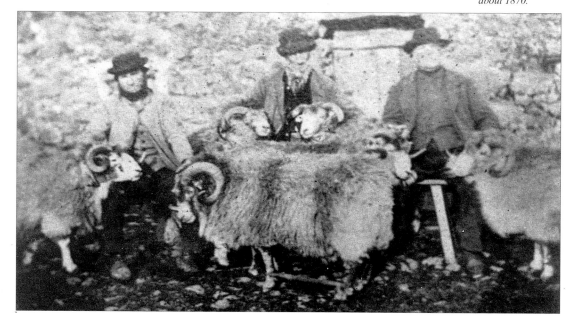

depended on its sheep. If Kendal's civic motto acknowledged that 'Wool is my Bread', then throughout the Lakeland fells 'the Golden Fleece paid for all'.

Traditionally, the sheep most associated with the fells – indeed, the breed best suited to the harsh environment – is the Herdwick. To be strictly accurate, the name refers to the sheep farm but it is now commonly accepted as the name of the breed. Stories concerning the origin of Herdwicks abound; they are almost part of Cumbrian folk lore. Some authorities insist that the breed developed from forty or so animals which swam ashore from the wreck of a Spanish Armada vessel but the fact that the Cistercian monks of Furness Abbey had 'Herdwyk' farms centuries before 1588 surely invalidates this claim. A variation on the shipwreck theme suggests that the vessel was of Viking origin but, again, the evidence is slender. There are striking similarities between the ear or lug marks used in Norway and in the Lake District (see page 113) but this in itself does not prove that the sheep originated in Scandinavia, merely that the owners or their forebears probably came from there. Another theory is that the Herdwick breed developed from the indigenous species which was first domesticated by Bronze Age or Neolithic Cumbrians but this remains to be proved.

The earliest detailed description of Herdwicks is that given by James Clarke in 1787:

There is a kind of sheep in these mountains called Herdwicks which, when properly fed to the highest growth seldom exceed 9 or 10lbs. a quarter. They, contrary to all other sheep I have met with, are seen before a storm, especially of snow, to ascend against the coming blast and to take the stormy side of the mountain, which saves them from being overblown. This valuable instinct was first discovered by the people of Wasdalehead. They, to keep this breed as much as possible in their own village, bound themselves in a bond that no one should sell above 5 ewe or female lambs in one year. But means were found to smuggle more, so that all the shepherds now have either the whole or half breed of them, especially where the mountains are very high, as in Borrowdale, Newlands and Skiddaw, where they have not hay for them in winter. These sheep lie upon the very tops of the mountains in winter as well as in summer. . . . If a calm snow fall, the shepherds take a harrow and drag it over the tallest heath or ling; the snow then falls to the bottom and the sheep feed upon the tops of it and upon the moss which grows upon the stones. . . . Whence this breed first came I cannot learn. The inhabitants of Nether Wasdale say that they were taken from on board a stranded ship. Till within the last few years their number was very small. They grow very little wool, 8 or 9 of them not producing more than a stone, but their wool is pretty good.

Certainly there is some truth in this description but it has also been suggested that during the two centuries since it was first written, it has gained a somewhat undeserved degree of authenticity. To suggest that Herdwicks will, in blizzard conditions, seek the exposed side of a fell rather than the lee side strains credibility and few dalesmen would agree. Paranoiac Keswick museum keeper, cartographer and son of a farmer, Peter Crosthwaite scribbled this censure in the margins of his copy of *Survey of the Lakes* by Clarke:

O, for shame, Mr. Author! Neither the present Generation nor their forefathers before them ever knew Cumbrian Sheep keep the weather side of a mountain in a storm when they could get to the leeward.

Similarly, Clarke's statement that Herdwick wool was 'pretty good' was an exaggeration; most Herdwicks carried a fleece of between 2$1/2$ and 3$1/2$ pounds weight and this was full of *kemps* or hairs, making it very coarse. Yet, despite these reservations, Clarke does make the point that the Herdwick is a hardy breed; it is undoubtedly the breed which can withstand exposure better than any other. Described as *'the breed best standing starvation'*, they are able to nibble a living from the coarsest bent-grass and the toughest heather shoots but more than that, they can withstand burial under snow for up to three to four weeks, providing they can get air, living on their own fat. Sheep cocooned in this way have been known to live on a bizarre diet of moss and their own wool – and survive to give a crop of lambs in the spring. In the harsh winter of 1947 a flock of ninety-seven Herdwicks was buried in fifteen feet of snow, yet only two perished and the rest survived for many years.

Before the Agricultural Revolution, it was necessary to use any fodder available to sustain as many animals as possible through the winter. Often sheep were fed with food-stuffs such as corn-straw, pease-straw, ivy and ash leaves. Under the orders of the Court Baron of the Manor of Windermere in the seventeenth century, it was an offence to 'cutt down or breake any other Men's Ash leaves', clearly indicating that such leaves were harvested for winter fodder. Perhaps the most unusual winter feed was the leaves of the holly bush. In the eighteenth century, and probably earlier, High Furness shepherds hand-fed their flocks in winter with both sprigs of holly and ash, as Thomas West described in 1774:

At the shepherd's call the flock surround the holly-bush and receive the croppings at his hand, which they greedily nibble up and bleat for more. The mutton thus fed has a remarkably fine flavour. A stranger unacquainted with this practice would imagine the holly-bush to have been sacred amongst the fellanders of Furness.

The practice certainly continued until the twentieth century and the late Tom Fletcher Buntin of Great Langdale recalls feeding Herdwicks with holly:

We left the fell gate~open so that they could drop in and as soon as they heard the sound of the axe they would come running down the hill.

A characteristic which James Clarke does not mention is the Herdwick's remarkable ability to stick to its own *heaf*, the area of fell where it was weaned. On the open fells of the Lake District this homing instinct is much appreciated by fell farmers for it means fewer strays. Of course it gives rise to tales of farmers who have sold Herdwicks to distant farms only to find some weeks later the same animals contentedly cropping the grass of their native heaf. But the white-faced coarse-fleeced Herdwicks are not the only sheep on the Lakeland fells; Swaledales, known to dalesmen as *Swaddles*, the curly-fleeced Teeswaters, and Rough Fell breeds are all present. Cross-bred sheep outnumber the Herdwicks for they provide a combination of saleable wool and mutton. But the Herdwick remains the quintessential Lakeland sheep, and for that reason the National Trust continues to encourage the breed.

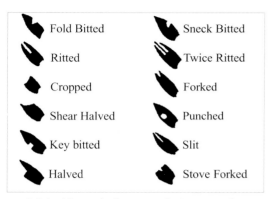

Fold Bitted	Sneck Bitted
Ritted	Twice Ritted
Cropped	Forked
Shear Halved	Punched
Key bitted	Slit
Halved	Stove Forked

Lakeland lug marks denote specific farm ownership.

Hoggets, Gimmers, Twinters and Thrinters. . . .

The distinctive dialect age-names given to sheep and the *lug* or *smit* marks used to indicate ownership are one of the most fascinating aspects of Lake District folk culture. A lamb, either male or female, before shearing is known as a *hogget* or *hogg*, a name to be found in the mediaeval records of Furness Abbey. After its first clipping, the animal becomes a *twinter*, or two-winter and in the following year a *thrinter*. Such age-names are common in Iceland and are found in the famous *Book of the Settlement, the Landnamabok*. Similarly, the name *gimmer*, a yearling ewe, is used in Iceland (*gymbr*) and Norway (*gimbr*) and it may be argued that such dialect words were introduced by the Norse-Irish settlers who colonised this area in the ninth and tenth centuries. Further support for this can be found in the way sheep are marked on the *lugs* or ears. Generations of Cumbrian children had been reprimanded by the threat of a *'clip round t' lug'* and the word is now equated with 'ear' but in fact it is derived from an Old Norse word *lög* meaning 'law'; in other words, the farmer put his lawful ownership mark on

the animal on the most convenient place – the ear. In addition, a *smit* mark was usually daubed on the sheep's flank. Lug marks used in the Lake District are almost identical to those used in Norway, and under Norse law any farmer who cut off the ears of his sheep was liable to prosecution, for if this was done then there was no reliable way of identification since any smit mark would be annually removed at clipping time. Lugless sheep were therefore suspect. A similar rule applied in the Cumbrian fells; no farmer was allowed to crop a sheep on both ears unless he lived on a farm belonging to the Lord of the Manor who, of course, was above suspicion. The lord alone had the right to use a lug mark which removed most of the ears.

The lug marks are owned not by the farmer but by the farm. If a tenant farmer moves on, then the lug marks remain with the farm. Sheep rustling is still a problem in the fells and lug marks are the only certain method of identification, a point which did not escape Parson Sewell, the incumbent of Troutbeck from 1827 until 1869. He was said to have leaned over the pulpit before one Sunday service and inquired of his clerk:

> Hasta seen owt o' twa [two] lile sheep o' mine?
> They're smitten int' ear like thine
> but deeper int' smit.

As well as the lug marks, animals were smitted with *pop* marks on the flank after clipping; often a large letter or a distinctive insignia in red or black was used. Before the advent of chemical dyes, these pop marks were made with haematite iron ore *rudballs*. The 'setting books' for Rydal Hall record the expenditure in June 1693, of 2s *'for three hundred Rudballs for the clipping'*. In the nineteenth century, that incorrigible illicit whisky distiller, Lanty Slee, dug *ruddle* from the Langdale fells near Red Tarn and sold it to his neighbours for *sheep rudding*. Over in Borrowdale, graphite from the mine at Seathwaite was used for smitting.

Most farmers now use a commercial dye but some years ago, in an attempt to cut costs, a group of farmers brought a quantity of cheaper Australian dye – only to find that in the first shower of rain their smit marks were completely washed away.

The permutation of lug and smit marks is enormous and in the nineteenth century a register of marks was required. The first of these *Shepherd's Guides* was compiled in 1817 by a Martindale yeoman farmer, Joseph Walker. Dealing with the Eastern fells, its object was simply *'that everyone might have the power of knowing the owner of stray sheep and so be able to restore to everyman his own'*. So successful was it that soon every area of the Lake District had its own guide. Each farm was represented by two fierce-looking sheep, the one on the right showing the appropriate lug mark, the one the left displaying the smit mark. Several editions of these guides were published and it is still possible to come across a well-thumbed early edition on Lakeland mantle shelves.

In spite of the Herdwick's homing instinct, animals occasionally stray over watersheds and into adjacent dales and so, for centuries, Cumbrian shepherds have held *meets* to sort out the strays and at the same time to enjoy a get-together. Until 1835 one of the most famous was held on the flat summit of High Street, a mountain easily accessible from Mardale, Hartsop, Troutbeck and Kentmere. Here, at the hub of the fells, the shepherds would meet annually to exchange stray sheep and hold a sports meeting. James Clarke visited a meet here in the the 1780s:

> Neighbouring shepherds . . . held festival, during which there were horse racing, wrestling and other such-like country diversions; hither likewise everyone brings the stray sheep he has found during the preceding year, that they may be owned, they also, at this time, frequently amuse themselves with foxhunting.

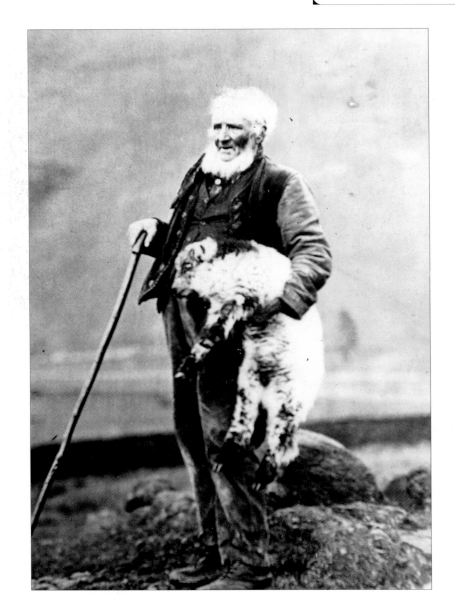

*A nineteenth century fell
farmer with his sheep
tucked under his arm.*

*Clipping Herdwicks at
Tilberthwaite in 1972.*

Meets are still held, though today in less exposed situations than mountain tops. The Walna Scar meet, held in November, has resorted to the more convivial surroundings of a local hostelry – one year at the Newfield Inn, Seathwaite, the next year at the Blacksmith's Arms, Broughton Mills, and the following year at the Church House Inn at Torver. Horse racing has given way to hound trailing but the meet usually ends with a 'merry neet' and a tatie-pot supper – naturally, made with Herdwick mutton.

The Shepherd's Calendar

The age-old cycle of laiting and lambing, dipping and clipping still continues to determine the pattern of farming in the fells as it has done for generations past. It begins in November when the *tups*, the rams, are put to the ewes and the conception of new life begins. The

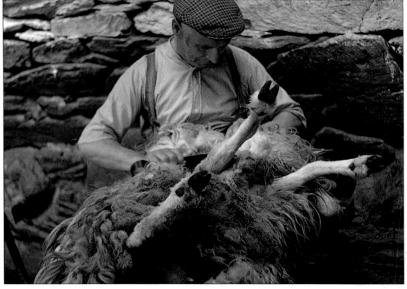

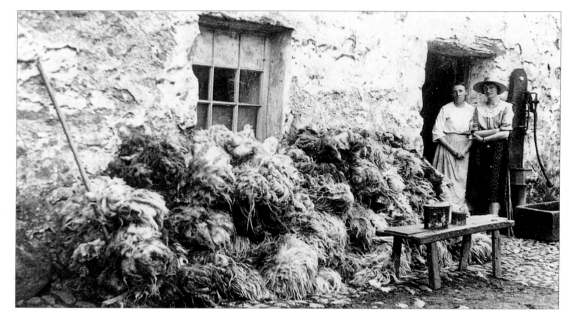

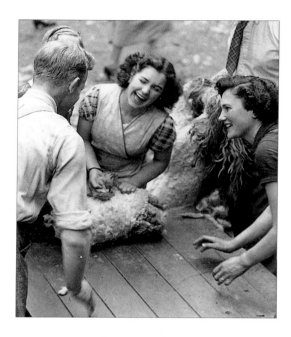

Two women by the pump with a huge pile of fleeces stacked against the wall, Eskdale.

Cheerful faces as fleeces are rolled after the clipping.

timing is crucial for if the tups run with the ewes too soon, then the lambs could be dropped when snow is still on the *intak* field. Usually mid to late November is thought to be the most appropriate time; if a stray tup visits the flock before this, the whole lambing programme could be ruined. At the end of February the flock is dipped and by early March the ewes are brought down to the 'inland' pasture, the best quality land close to the farm, where the lambs are dropped from the middle of April until the middle of May. Work during this time is long and arduous and the farmer must use all his store of veterinary skills and subtle ploys to ensure that as many lambs as possible survive. It might be necessary to persuade a bereaved ewe to suckle a lamb that is not its own. This can be difficult. To encourage the ewe to accept the lamb some farmers resort to dosing the animal with whisky and sprinkling

the lamb with the same spirit! Others believe in an equally effective, though somewhat less-expensive, method; both the ewe and the intended fosterling are smeared with a well-known brand of soap. Sometimes sprinkling a ewe's milk on the lamb's fleece will work. In extremes, a ewe's dead lamb will be skinned and draped over an abandoned lamb in order to persuade the ewe to suckle it. Lambing is not always the idyllic event imagined by the poet or town-dweller.

At the first unfolding of the crosiers of bracken in May, the ewes and lambs are returned to the fell where they remain until early in July when clipping commences. Until the beginning of the present century it

was customary to wash the sheep before shearing in a dub or deep pool. This is no longer done although ancient drystone-wall sheep folds can often be observed near to such pools along the Lakeland becks.

Unlike lambing, clipping has always been one of the most important festivals in the farming year. Essentially a communal activity, it was common for farmers and their hired men to visit each farm in turn. Their combined efforts ensured that the flock was soon clipped and then dancing, drinking and merrymaking went on far into the light nights. Clippers were often served with specially brewed clipping ale, the strength of which encouraged singing – and more drinking. In this traditional clipping song, the company had to obey the commands of the second and third verses to let the drink circulate; if the glass was not drained by the end of the refrain, the penalty was a second round:

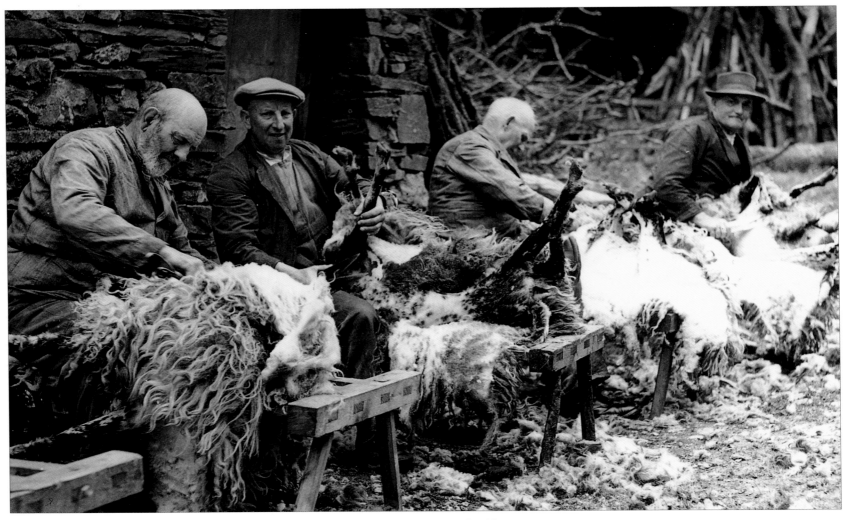

Clipping sheep was a communal and festive activity – hard work but an excuse for making merry. Here sheep are being clipped at Brockstones Farm, Kentmere.

Here's a good health to the man o' this house,
The man o' this house, the man o' this house;
Here's a good health to the man o' this house,
For he is a right honest man.

And he that does this health deny,
Before his face I justify (or just defy);
Right in his face this glass shall fly,
So let this health go round.

Place the canny cup to your chin,
Open your mouth and let licquor run in;
The more you drink the fuller your skin,
So let this health go round.

Hand clipping sheep.

At Rydal Hall in the seventeenth century the flock was clipped by the tenants who were obliged to give a day's boon service but Sir Daniel made sure that there was a generous supply of ale, bread, cheese and tobacco as incentives. The Rydal accounts even show that Sir Daniel appreciated the therapeutic value of music:

1684 June 20 *Given to Renny, fidler, [sic] for playing this day to my clippers 6d*

Mrs E Lynn Linton gives an evocative account of a nineteenth century clipping:

The sheep are . . . dragged out by the boys as they are wanted, and flung on their backs into the lap of a clipper seated on a long kind of settle – 'sheep forms' they are called – who tranquilly tucks the

little pointed head under his arm, and clips away at the under part of the wool, taking care to keep the fleece unbroken; the art being to hold the middle way, and neither to graze the skin by going too close, nor to loosen the fleece by cutting above the welted fibres. All four feet are now tied together, and the beast is hauled round as a solid kind of rug, when its back is sheared in the same way, the fleece hanging down like a bit of carpet or small crib blanket. When the whole is off, the legs are untied, and it is lugged – that is the only word to express it – panting and terrified to the place where the man stands with the ruddle pot . . . where it receives its smear and letter of assignment, and is then dismissed to its huddled group of companions clustered together at the remotest spot in the yard available. The little figures of the boys learning of the men . . . the pretty young house girls, looking so quiet and gentle, dressed in their Sunday best and carrying great jugs of beer – the strongest that can be brewed – laughing and yet shy, as they penetrate into the mass of men and animals in the yard; the cows milking by the byre doors; the purple hills and the calm lake; the home fells whitened with the shorn sheep let loose scattered over them like daisies, but very unhappy yet, not recognised by their lambs. . . these are the incidents which make sheep-shearing a striking thing to see.

Following clipping the newly-smitted sheep return to the *heaf* until August when once again they are dipped against blowfly. In October the fells are raked again and the gimmer ewes are selected for breeding purposes, some being sent for wintering to Walney Island, Sandscale and the Solway Marshes, while the *wethers*, castrated sheep, are sent to be fattened for market. By mid-November the tups are allowed to run once more with the ewes and the ancient farming cycle begins all over again.

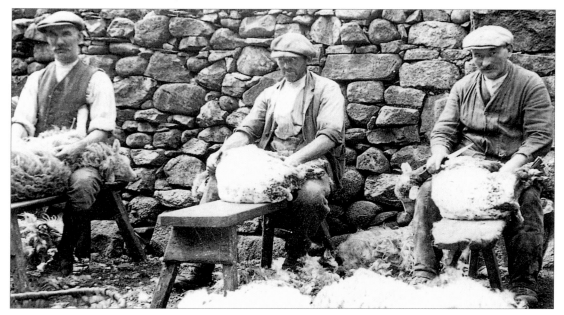

Oor Mak O' Toak

Or a Discourse on Dialect

If one single characteristic may be said to distinguish the Lakelander from his Northumbrian, Yorkshire, Lancastrian and Scottish neighbours, it must be the dialect of the fells. Aptly described by the late Norman Nicholson as a *'clicking, cracking, harshly melodious tune'*, the Lakeland dialect is closely related to the Old Norse spoken by the Norse-Irish colonists who settled here in the ninth and tenth centuries and left their place names – *gills, booths, slacks, becks, fosses* and *thwaites* – scotched on the fells and dales, the mountains and moorlands. Of course, Celtic words, either relics of the original folk speech or introduced by the Norse-Irish from Ireland and the Isle of Man, are present – *ask*, a newt (from the Celtic *asc* = lizard or newt); *dunnock*, a hedge sparrow (from the Celtic *donn* = dusty-coloured); *buckie*, a whelk (from the Manx gaelic buckee); chimla, chimney (from the Manx gaelic *chimlee*), and the much-quoted Celtic sheep-scoring numerals (see page 110) are all examples. But the majority of dialect words are derived from Old Norse.

Canon Sam Taylor in his *Cartmel Priory and People,* 1955, relates the story of Harold Manning of Flookburgh who, when serving with the Royal Navy during the Second World War, was sent to Iceland as a coastguard. He reported that the Icelanders understood his home dialect and that he, in turn, had no difficulty in understanding their terms for fishing and farming equipment. This is not really surprising when one considers that Icelandic is the least-changed of all the Scandinavian languages and is therefore very similar to Old Norse, the language spoken by the Norse-Irish settlers who colonised Cartmel and the rest of the Lake District

The same hypothesis had clearly been appreciated by the Reverend T Ellwood, vicar of Torver, south of Coniston when, in 1895, he published his *Lakeland and Iceland – A Glossary of Words in the Dialect of Cumberland, Westmorland and North Lancashire which seem allied or identical with the Icelandic or Norse*, now once again in print. Here he identifies hundreds of dialect words which he believed were identical to Icelandic Old Norse.

Several years ago, on the first of many visits to Iceland, I took Ellwood's glossary with me and attempted to verify his theory. There is no doubt whatever that there is a very close similarity between the dialect of the Lakeland fells and Icelandic. Here are some of his dialect words and their Icelandic/Old Norse counterparts:

Dialect Icelandic/ Old Norse	meaning translation
angry	painful or inflamed
angr	*pain*
arval	anything connected with heirship or inheritance
arfr	*inheritance*
barn	child
barn	*child*
bang	a blow
bang	*hammering*
bid	to request attendance, applied chiefly to marriages and funerals
bjoða	*invite*
bigg	barley
bygg	*barley*
brant	steep (for example, Brantwood)
brattr	*steep, precipitous*
clap bread	thin (oat) cakes beaten or clapped with the hand
klappa	*to pat*
clegg	horsefly
kleggi	*horsefly*
dub	pool or deep water
dypi	*depth*
elding	fuel
elding	*fuel*
fettle	order, condition
fella	(pronounced 'feddla') *to put into good order*
flit	to remove, as of household goods and chattels
flytja	*to remove*
force	waterfall, e.g. Force Forge, Aira force
foss	*waterfall*
forelders	ancestors, parents
foreldri	*parents*

garth	a garden or small enclosed field
garðr	*a garden or small enclosed field*
gate	thoroughfare, a way, road
gata	*a way, a road*
gaum	sense or forethought
gaumr	*heed, attention, hence gaumless*
gimmer	a ewe lamb
gymbr	*a gimmer or ewe that has not lambed*
gouk	cuckoo
gaukr	*cuckoo*
grave	to dig
grafa	*to dig*
haver	oats
hafrar	*oats*
ken	to know; 'd'ye ken John Peel?'
kenna	*to know*
kist	a chest
kista	*a chest, a box*
kitling	a kitten
kettlingr	*a kitten*
lait or late	to seek
leita	*to seek, to search*
laik or lake	to play as children do
leika	*to play*
mickle	large
mikill	*large*
moudywarp	the mole
moldvarpa	*a mole*
mun	must
mun	*must*
reckling	the weakest member of a litter of pigs or a brood of chickens
reklingr	*outcast*
reek	smoke
reykr	*smoke*
hence	
reykjavik	*The smoky bay;* the steam from nearby hot springs was originally mistaken for smoke.

rive	to tear; a 'slate river' or divider of slates
rifa	*to tear*
seeves	rushes
sef	*a rush*
segg	a hard callous place on the hand
sigg	*thick, hard skin*
spelk	a splinter
spelkr	*a shaving; spelk or swill baskets were woven from oak shavings*
steg	a gander
steggr	*a male bird*
wath	a ford
*vað	
a ford	

It seems clear, then, that the Norse influence on Lakeland dialect was – and still is – considerable. Certainly visitors from Scandinavia can recognise echoes of their own languages in everyday conversations while the tourists from the south of England are often completely perplexed. Even more mystifying are some of the local pronunciations of place names – a veritable minefield for the unwary. . . .

Name	Local Pronunciation
Aspatria	Speeatry
Bassenthwaite	Bassenthat
Crosthwaite	Crossthat
Gilcrux	Gilcruise
Grasmere	Gersma
Hawkshead	Aakseyd
Little Salkeld	Laal Saffel
Penrith	Peerith
Raughton Head	Raffton Heed
Sedbergh	Sebba
Torpenhow	Trepena
Ulpha	Oofer
Ulverston	Oostan
Walney	Wonly

One of the major problems with the recording of dialect is that it is meant to be heard rather than read. Despite the best efforts of dialect writers such as John Stagg, William Dickinson, and A C Gibson, dialect does not sit comfortably on the page, or, as Melvyn Bragg graphically puts it:

'It takes a bit of getting used to on paper; it looks very awkward, as if it has forgotten to take off its walking boots and clomped onto the nice clean page too rudely. It demands to be spoken'.

With that proviso in mind, it is worth quoting one of the best pieces of dialect by A C Gibson (1813-1874). It concerns Betty and Jonathan Yewdale from Hackett in Little Langdale and a *'laal bit o' fratching'* – or a spot of marital disharmony. The narrator is supposed to be a neighbour from a nearby farm at Oxenfell.

Ther' hed been a funeral fray about t'Ho'garth, an' varry nar o't'men fooak about hed geean wi't'till Cunniston [Coniston]. Nixt fooarneeun, Betty Yewdale com' through fray Hackett, an' says she till me, 'Hes yower meeaster [husband] gitten back fray t'funeral?' 'Nay,' says I, 'he hesn't!' 'An'irrn't ye gan ut lait [seek] him?' says Betty. 'Lait him!' sayd I, 'I wodn't lait him if he didn't cu heeam for a week.' 'Why, why!' says she, 'yee ma' due as ye like, but I mun [must] bring mine heeam, an' I will!' An' off she set i't'rooad till Cunniston. On i't'efterneeun, she co' back, driving Jonathan afooer her wi' a lang hazle [hazel] stick – an' he sart'ly was a sairy object. His Sunda' cleeas [clothes] leeuk't as if he'd been sleppi' i' them on t'top of a durty fluer [floor]. T'tye of his neckcloth hed wurk't round till bela t'ya lug, an' t'lang ends on't hung ooer ahint [behind] his shou'der. His hat hed gitten bulged in at t'side, an' t'flipe [hat rim] was cock't up beeath beack an frunt. O'togidder, it wod ha' been a queerly woman body 'at wod ha' teean a fancy till Jonathan that day. Says I till Betty, 'What, ye hev fund him than?' Fund

him!' says she, 'ey I fund him! I kna't what ut lait him! I fund him at t'Black Bull, wi'yower meeaster, an'a lock meear o't'seeam sooart. They wor just gan ut [going to] git the'r dinner, wi'a girt pan o'beef-steeaks set on t'middle o't'teeable. I meead t'frying pan an't'beef-steeaks flee gaily murrily oot o't'duer, an' I set on an'geh them o'sike a blackin' [scolding] as they willn't seeun forgit. Than I hail't Jonathan oot fray amang them; bit when I'd gitten him oot wi'me, I sham't ut be seen on t'rooads wi'him. Dud iver ye see sike a pictur'? 'Why, nay! nit sa offen, indeed,' says I. 'Well,' says Betty, 'as I wodn't be seen i'rooads wi'him, we had to teeak t'fields for't, an' as it wosn't seeaf ut let him climm t'wo's [walls], I meead him creep t'hog-hooals*,' sayd Betty, 'an' when I gat him wi'his heead in an'his legs out, I dud switch him.

*Hogg-holes are rectangular gaps at the base of dry-stone walls which allow sheep to pass from one field to another

Street signs taken in Scandinavia. Each contains one or more Lake District dialect words.

Norway:
gate = street, road.

Norway:
smauet = smout
= a narrow passage.

True Cumbrian – with a helpful translation!

Sweden:
föräldrar = parents;
barnen = children;
leka = to play.

Norway:
children at play.

Norway:
gangway, thoroughfare.

Iceland: hlíð = a slope,
hence Lyth valley.

Sweden:
brant = steep
'The steps are steep . . .'

Norway:
Lapskaus = scouse = a stew.

Norway:
flytting = flit = to remove.
Note removal men!

Weather Lore

John Ruskin with a group of friends on frozen Coniston Water.

'Holiday-makers are almost invariably convinced that the Lake Country is wet. So it is. But it is not nearly as wet as their morbid preoccupation with the weather leads them to conclude. It is no wetter than other well-known holiday districts'.

Miss E M Ward, writing in 1929 in *Days in Lakeland*

Lakeland weather is notorious – but it must be admitted that at the same time it has been much maligned. More than a century earlier than Miss Ward, another apologist, William Wordsworth, observed in his *Guide to the Lakes* that the:

> . . . rain here comes down heartily and is frequently succeeded by clear, bright weather when every brook is vocal and every torrent sonorous. . . . Days of unsettled weather, with partial showers, are very frequent; but the showers, darkening, and brightening as they fly from hill to hill, are not less grateful to the eye than finely interwoven passages of gay and sad music are touching to the ear.

The fell farmer, lacking the Bard's poetic sympathies and fine syntax, probably had his own, no less colourful, way of describing the Cumbrian climate, and, like all those who work on the land, he almost certainly had that innate ability to forecast good and bad weather. Before the advent of radio and television every dalesman knew the essential art of weather forecasting; he knew the signs and portents of frosts and mists, sunshine and storms as well as he knew his own flock or fellside. Even in these days of computer techniques and sophisticated satellite forecasting, many of the traditional weather maxims, handed down from one generation to the next, are locally more accurate than the 'official' forecast, for *'mountains make their own weather.'* For generations, Furness farmers have looked westward at sunset; if the whale-back silhouette of the Isle of Man can be seen, they know well enough that rain will follow within twelve hours or so. And if it can't be seen, it's raining already . . . or so the story goes.

Certain sounds, emanating from various directions, can be a good indicator of impending weather conditions. At Haverigg, near Millom, if the sound of 'Walney Pot', the seething waves between Walney

Island and the south Cumberland shore, can be heard, then stormy conditions are to be expected. Similarly, the sound of waterfalls is regarded as a useful weather indicator. Referring to the River Kent, Fuller, in his edition of Camden's *Britannia*, claimed that:

There be two catadupae or waterfalls; whereof the
northern, sounding clear and loud, foretookeneth
Fair weather; the southern, on the same terms,
presageth Rain.

In the eighteenth century James Clarke noted the same phenomenon at Swarthbeck falls, Ullswater, saying:

. . . these sounds are a barometer of the
neighbourhood. Traditions handed down from father
to son have formed a set of rules by which the
farmer is enabled to predict with tolerable certainty
the weather of the day from the sounds these
cascades emit the preceding evening.

At Keswick, the sounds of Barrow and Lodore falls were regarded as weather portents in exactly the same way. In scientific terms, the intensity of these sounds is determined by the strength and direction of the winds which, in turn, are governed by the position of high and low barometric pressure and the proximity of frontal systems but such meteorological refinements were unknown until the early decades of the present century.

Clouds, too, were closely observed features. One of the oldest of the Lakeland weather maxims is
If Skiddaw wears a cap,
Criffel knows full well o' that. . . .
acknowledging that low cloud almost always affects both sides of the Solway estuary.

That rounded bastion of the fells, Black Combe, thrusting south-westwards into the Irish Sea, is another useful meteorological touchstone; the warm, moisture-ladened air masses rushing in from the Atlantic are forced to rise over this outlier of the Lakeland mountains and the resulting condensation produces 'messenger clouds' which usually foretell rain in the central fells within hours. These lines from *The Ambleside Weather Glass* reflect a similar fascination with clouds, rain and mountains:

When Wansfell wears a cap of cloud,
The road to Brathay will be loud;
When mists come down on Loughrigg Fell,
A drenching day greyheads foretell.

Norman Nicholson (1914-1987), Cumbria's other great poet, lived almost all his life in St George's Terrace in the former industrial town of Millom. In this poem, written in 1954, he eloquently records the sounds by which he could forecast the weather.

Weather Ear
Lying in bed in the dark, I hear the bray
Of the furnace hooter rasping the slates, and say:
'The wind will be in the east,
and frost on the nose, today'.

Or when, in the still, small, conscience hours, I hear
The market clock-bell clacking close to my ear:
'A north-west wind from the fell,
and the sky-light swilled and clear'.

But now when the roofs are sulky as the dead,
With a snuffle and sniff in the gullies,
a drip on the lead:
'No wind at all,
and the street stone-deaf with a cold in the head'.

The same 'greyheads' probably also looked for the characteristic bar and cap of pale cloud on Fairfield and Seat Sandal for these were the harbingers of the Lakeland equivalent of the fierce Helm Wind of the Eden valley, a cold uncomfortable, rheumaticky wind. At Keswick they look for a similar lenticular cloud on Skiddaw and Blencathra, knowing that a biting, blustery east wind will soon be rattling windows in Rosthwaite and stirring the dead leaves in Brandelhow woods. At the head of the dale, 'Borrowdale sop', a famous cloud which forms over Sty Head and Sprinkling tarns, has long been used as a forecasting sign; if the cloud moves south-eastwards in the direction of Great Langdale, rain may be expected within twelve to twenty-four hours, but if it progresses north-eastwards and passes east of the Borrowdale fells, fine weather will prevail.

Sunset, that old stand-by of weather forecasters, has always been regarded as significant. In the Kendal area this contradiction of the well-known 'red sky at night' rhyme was recorded in the nineteenth century:

If the sun in red should set,
The next day surely will be wet.
If the sun should set in grey,
The next will be a rainy day.

Clearly a case of hedging one's bets! Several of these weather maxims concern birds, though some stretch one's credulity. For example, the curious notion that *'if the cock crows on going to bed, it rises with a watery head'* seems somewhat implausible as does *'if the owl calls 't'wet' it will rain next day'*. Another intriguing rhyme runs:

If the cuckoo lights on a bare bow.
Keep your hay and sell your cow.
But if he comes on the blooming May,
Keep your cow and sell your hay

The well-known *'when swallows fly low – for umbrellas go'* could well depend on the fact that in

damp weather the flies and insects remain close to the ground – hence the low flying acrobatics of the swallows. In the Cartmel area the rhyme

If the ice at Martinmas bears a duck
The rest of the winter is slush and muck
. . . may have grain of truth as does
Gull, Gull fly to the sand
There's always bad weather when you're on the land

In the same area, indeed, in communities all around Morecambe Bay, it is believed that the tide influences the weather which accounts for

If it rains with the ebb
You can go to bed.
If it rains with the flow
You can go to the plough

Certain Saints' days and holy days were thought to be very significant. Christmas was quite important as in the improbable *'if the sun shines not on Christmas Day, the apple crop will surely fail'*. And *'a green Christmas makes a fat churchyard'* underlines the suspicion associated with a mild December. More important, however, was Candlemas, on 2 February:

If Cannelmas Day be sunshining and warm
You may mend yer oald mittens and look for a storm

. . . warns one rhyme, while from Witherslack, near Grange over Sands, comes the delightful . . .

If the trush sings 'fore Cannelmas Day
It does nowt after but repent and pray.

The Great Frosts of 1607 and 1894

The past decade has been one of relatively mild winters but the Lake District has experienced some Arctic winters. One such occurred in 1607 when Ullswater

The rain can come down like stair rods.
As a group of visitors entered Borrowdale in 1865, they recorded:

'A fearful storm raging. Nothing but clouds and such awful crags, down which newly-formed mountain torrents are dashing, which rush over the rocks and stones in our path, and look like rapids. . . . The road is so steep and difficult, that our drivers say we must get out and walk . . . Alas for certain white hats!'

Later matters improved and they described:

'An endless assemblage of mountain tops, all covered with a rich sunset haze. We stood long to look at them, while our feet sank in the soft moss, and the little black-faced sheep bleated near us, the only sound that broke the intense stillness.'

'Excursion to Loweswater'
Mary Hodgson and Lydia Hunt

The road is so steep and difficult

and other lakes were frozen. The Watermillock Church Register that year records:

In this year of our Lord God, 1607, was a marvellous great frost which continued from the first day of September until the 15th of February after. Ullswater was frozen over and so continued from the 6th day of December until the 22nd day of February following. So strong that men made a common way up the same from John Barton's door to Fewsdale Wyke. And men of Martindale carried sheep up the same, on at Bartons and off at Sharrowsande. Men went up the same water and over it with horses loaded with corn.
Upon the 6th day of January the young folks of Sowlby went unto the midst of the same water and had a minstrel with them and there danced all after-noon. On Shrove Tuesday, being the 9th of February at Watermillock was a bonfire builded on the ice and matches of shootings shot and a pot with ale drunk thereupon by Edward Willson of Bennethead, Anthony Rumney, Frances Rumney John Castlehow and others.

Although the 'Great Freeze' of 1894-95 was not perhaps as prolonged, it gave rise to much merry-making. Windermere became a continuous sheet of black ice and an estimated two thousand people skated on the frozen surface; two bands took turns to provide the music for waltzes on the ice and people walked, sledged, picnicked and played hockey and curling. Special trains from Manchester, Liverpool and Lancaster brought thousands more and the hotel keepers rejoiced at this unaccustomed influx of winter visitors. Carriages ran on the ice between Belle Isle and Bowness and even an ice yacht, running on glass balls, became a regular sight. And to control the crowds, the police formed an ice patrol. But inevitably the thaw set in and by end of February the ice began to deteriorate – and life in Bowness and Windermere returned to a

Storm clouds over Wasdale Head

more sedate pattern. . . .
Late frosts and sudden storms in April, known as *hogg-squalls* because they often coincide with the return of the hoggs to the heaf, sometimes delay the spring flush of new grass and this has probably given credence to the old adage that *'you should allus* [always] *hev half yer hay left at Cannelmas'* to safe-guard against a late spring.
Lakeland weather is characterised by the sudden-ness with which the local conditions can change; the old Icelandic saying '*If you don't like the weather, just wait a minute'* could well apply to the fells and dales of Cumbria. This, of course, makes conventional weather forecasting difficult. Warm, moist Atlantic air masses moving in from the west can soon turn a bright morn-ing into an afternoon of *'kessened o'er'* skies, and many a haymaking has been rained off after a promis-

ing start. *'Too bright too early'* is a familiar saying in the Lake country. . . . Micro-climate can also be influenced, especially in summer, by local convection currents ascending from the fellsides which can, under certain conditions, produce ominous cloudbanks while away in the south and west the Cumbrian plain and the sands of Morecambe Bay shimmer in sun-shine. Tourists have for many years noted this tenden-cy with understandable exasperation. As one visitor in 1792 moaned:

At a time when the sky is clear, a black cloud will start up instantly from behind a mountain, and if you are not very near a house, ten to one you are wet before you can run a hundred yards.

Similar rapid weather changes can occur on a number of lakes, particularly Bassenthwaite Lake and Derwentwater. Here sudden gusty squalls, known as *'bottom winds'*, can be quite fierce in certain localised areas. One late eighteenth-century observer noted :

One part [of Derwentwater] was agitated violently
without the least apparent cause, while another
was so smooth as to have scarcely moved more
than a ripple upon its surface; a boat with two men
was tossed up and down in a storm in one part,
while a man at no great distance was fishing quiet-
ly with a rod and line from another'.

William Gell, *Tour in the Lakes made in 1797*

One of the common misconceptions about rainfall in the Lake District is that precipitation falls with equal magnitude throughout the area. Nothing could be further from the truth. Admittedly, the central fells have an average of 225 'rain days' each year but rainfall totals vary considerably. The Vale of Lorton below

Crummock Water has about 54 inches per year, Keswick has about 57 inches, Ambleside, 72 inches, Seathwaite in Borrowdale, 129 inches, and Sty Head still holds the record with 250 inches in 1928. The perversity of Lakeland rainfall has often resulted in dramatic flooding. In June 1686, Hawkshead was struck by torrential rain and flooding:

The like of it was never seen in these parts by now
man livinge, for it did throw downe some houses and
mills and took away several briggs . . . the water
wash't upp great trees, stocks, and greate stones a
greate way off and lay'd them on men's ground.

In August 1749, the Vale of St John was devastated by a water spout which caused considerable damage and flooded the dale to a depth of several feet. In fact, late July and August seemed to be a fateful time for

floods; in Keswick the name 'Morlan' of 'Magdalen' floods was given to the frequent inundations which coincided with the saint's feast day, 22 July. On August Bank Holiday 1936, a cloud-burst above Lingmell Gill resulted in a torrent which washed away bridges and footpaths at Wasdale Head and deposited a huge fan of debris into Wastwater. And on 13 August 1966, twelve hours of continuous heavy rain resulted in unparalleled destruction in Borrowdale and Langdale. Accurate prediction of such phenomena is, as yet, impossible but dalesmen continue to keep a weather eye open for the traditional signs which they instinctively know herald changes in the weather of their dale – whatever the Meteorological Office might say.

Even men of the cloth have been known to put their trust firmly in weather lore, and the story is told of the Vicar of Troutbeck, the Reverend Sewell, who, on being requested to offer a prayer for a fine haymaking, is said to have replied:

It's nae use es lang as t'winds in this quarter'!

Summer: Sunshine and clouds, Tarn Hows.

Winter: The white-capped Langdale Pikes

Working the Land

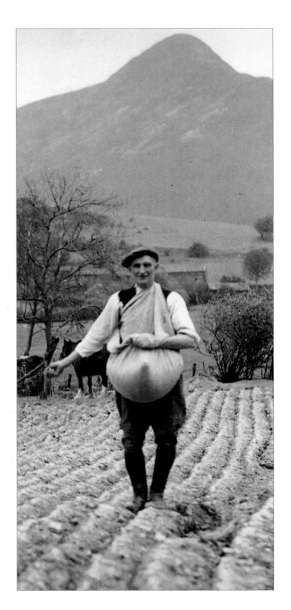

The Agricultural Revolution was relatively late arriving in the fells. Until then, farm implements were both few and primitive. Largely made of wood, their form and function had scarcely changed since mediaeval times.

In the eighteenth century the Cumbrian farmer would have been quite at home with the sickle, flail, harrow, ox-team and plough depicted in illustrations illuminating the fourteenth-century Luttrell psalter.

Ploughing

The transformation of the heavy, cumbersome wooden ox-drawn plough into the light iron, horse-drawn plough of the nineteenth century was an integral part of the transformation of farming. In 1850 William Dickinson was able to recall:

> . . . a venerable plough-wright who used to ridicule his younger brethern 'with their planes and their paint' working several days over 'a bit of a plew', and then it had to be sent to the smith after all! Where he could have cut down the timber, borne it home on his shoulder, and finished his plough the same day without assistance, and no smith required – all being of wood except for the coulter and sock, which would be supplied from the old plough.

Perhaps he had this in mind when, a few years later, he wrote:

> *Now out wid heam-mead roan-tree plue,*
> *Wid ironin' scanty eneuff,*
> *Lait up strea braffins – reap traces enue,*
> *And see 'at they're o' draft preuff.*

James Stockdale repeats a similar story from Cartmel where these clumsy wooden ploughs were made in a single day from suitable trees, and he adds that in order to season the green wood, it was dried out over a fire of gorse and bracken. Such home-made ploughs were extremely inefficient implements, often requiring two oxen and two horses to work them. Usually the horses were harnessed one behind the other in front of two oxen yoked side by side. One man drove the team, another put his weight on the plough beam to prevent the ploughshare from riding over the ground, while a third man guided the plough. If the land being worked was heavy, a fourth man would follow the team armed with a fork, breaking up the clods of earth (see illustration on page 128).

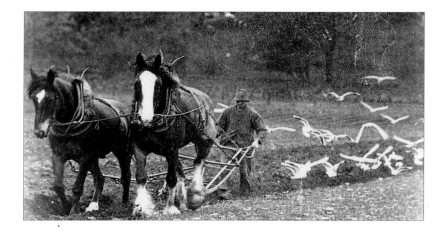

Broadcasting seed on the furrowed ground.

Horse-drawn plough, followed by seagulls.

At the end of the eighteenth century, John Bolton of Storrs Hall on the shores of Windermere, introduced the light iron plough into Westmorland. The prototype was made by Wilkie of Glasgow, and it soon became the model for plough-wrights throughout the Lake District. By 1850 William Dickinson was able to report that:

They are . . . remarkable for neatness of finish, an absence of nick-nackery, and a simplicity and lightness of construction, with strength adapted for the stony soil of the county [Cumberland] and weighing from 12 to 13 stones each.

And of course the main advantage of these ploughs was their efficiency in turning the sod and the fact that they could be operated by one man and a couple of horses, a point celebrated in rhyme by a local poet:

One man can now, with two good mares,
Plow more in good March weather,
Than four horses then, with cows and steers,
Man, lads and all together.

The basic design of the iron plough changed but little over the years. Hundreds were made by such firms as Stalker of Penrith and Harling of Sedgwick, and there are many present-day farmers who will remember being taught to plough with one of these implements and two sturdy Clydesdales. During the Second World War, when food was scarce, plough teams like these were to be seen working land at an altitude which had not grown crops since the Napoleonic Wars.

Although not a plough in the accepted sense, the push-plough or breast-plough was used in the eighteenth and nineteenth centuries to break new ground on steep fellsides. One of the most primitive instruments in agriculture, the push-plough was similar to a spade with a flange or wing at right-angles to the face, acting as a coulter; this was regularly sharpened with a stone. The shaft or pole of the plough was approximately six feet long, terminated by the 'crown' or cross piece which was pushed by the operator's chest or thighs. In difficult or stony ground, a second man was often harnessed to the plough, like an animal, to give extra momentum. Not surprisingly, the use of this primitive implement has been described as *'the most slavish work in husbandry'*. The purpose of the push-plough was to remove the shallow acid turf from the steeply-sloping intake field, and this was allowed to dry before being burned, after which the ashes were spread on the field. During the enclosure of the commons in the eighteenth and nineteenth centuries, thousands of

The Old Plough

Rambling one evening, and pausing as I rambled, through one of the quiet valleys of Cumberland, I saw . . . an old man sitting near me at his cottage door. . . . He did not mark me; he did not even raise his eyes to the setting sun, though he was probably enjoying its light and warmth to the last. Hard by, under a hedge, there lay a broken, worn-out plough, long since thrown aside, and, like the peasant himself quite super-annuated. There now came a sturdy carter with a saw, to cut off the handle of the useless implement. Apparently he wanted the piece of wood for something doing on the farm. He lays one hand upon the plough, and prepares to use the saw with the other. Suddenly the old man is roused; his eye glistens; he calls out authoritatively, 'Leave the old plough alone!'

I understood directly that he had held and guided it in his youth. I noticed that the handle of the plough was still smooth from its frequent contact with the human palm. He had leant on it, and heard the lark sing the while, as to his dull ears it had long ceased to sing. 'Leave the old plough alone!' The words kept ringing in my ears as I walked on. I asked myself what plough, what instrument or what product of any kind . . . will remind me of the labours of my youth.

William Smith, 1808-1872

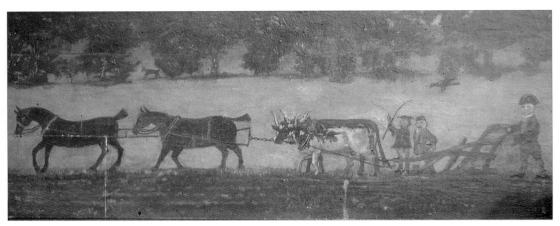

A remarkable oil painting, formerly in The Woolpack Inn at Boot in Eskdale but now privately owned, illustrates the primitive ploughing technique. Painted on wooden boards, the picture is thought to date from the mid-eighteenth century; it shows a proud farmer dressed in his Sunday best with a three-cornered hat on his head, driving a crude wooden plough, assisted by two labourers who control the ox and horse team and keep the plough in the ground.

Breast ploughing has been described as 'the most slavish work in husbandry'.

en sleds. In many ways this was admirable since on steep slopes a sled would remain stable whereas a wheeled vehicle would overturn. Even today it is possible to spot ancient bracken sleds mouldering away in the dark recesses of Lakeland barns. Certainly wheeled vehicles were rare in the fells until the late-eighteenth century. James Clarke makes the possibly exaggerated claim that wheeled vehicles of any kind were unknown in Borrowdale until the 1760s:

> In carrying home their hay (for they make no stacks) they lay it upon their horses in bundles, one on each side . . . the traveller may even see hay carried in this manner through the streets of Keswick. Their manure they carried in the same manner, putting it in wicker baskets; in the same manner they carried the smaller wood for firing, the larger logs they trailed.

That Clarke chooses to mention this anomaly may be a sign that this method of transport was in decline. By the end of the century, when Bailey and Culley were compiling their report on the agriculture of Cumberland, the single horse-drawn cart was in common use. However, the carts to which Bailey and Culley refer were almost certainly crudely-built *'tummel cars'*, constructed entirely of wood with solid clog-wheels made of three pieces of wood fastened together with wooden pins. These wheels were fixed to the axle which turned under the body of the cart. Frequently, and especially on stony ground, the axle and the cart parted company! The crude mechanics produced an unmistakable and unpleasant squeaking:

> The revolving axle-tree of the clog-wheeled carts, scantily greased, making each a most unnatural squeak . . . disagreeable music . . . about as pleasant as that produced by 'the cleaver and marrow bones'.
>
> James Stockdale, 1872

acres of unpromising land were brought into cultivation, for a poor crop of oats could be coaxed from land ploughed in this way. Following the end of the Napoleonic Wars and the subsequent fall in the price of oats, such land was allowed to revert to rough pasture.

Farm Carts

If the introduction of the light iron plough was a manifestation of the Agricultural Revolution in the Lake District, so too was the development of the light wooden farm cart. William Dickinson suggests that before 1750 only affluent yeomen farmers and the larger landowners had carts, for most farm produce such as hay, corn, bracken and peats were transported by wood-

An almost essential accessory, then, was a cow's horn filled with fat which was liberally and regularly applied to the axle-tree to reduce the cacophony.

Harness was equally primitive; braffins or horse collars were generally made by plaiting 'symes' of hay or straw but halters were often made of hemp or plaited 'seeves' or rushes. The major disadvantage was when horses, tethered side by side, became hungry they ate one another's harness. And only the affluent yeomen had leather saddles; most fell farmers and their wives made do with 'sonks' or green sods, girthed on to the horse with hay bands.

Slowly at first, but with increasing speed, the new light wooden carts began to arrive in the Lake District. Wheel-wrights started to construct dished wheels with *naffs* (hubs), spokes and felloes which turned on the axle, not with it. William Close recorded his impressions of these new carts at the beginning of the last century:

The wheels are commonly dished or made a little concave by the receding of the spokes, and run loose upon a wooden axle-tree about 12 inches wider at top than at bottom, where the distance of one to the outside of the other is 4 feet. . . . The dimensions of these carts are as follows: the breadth is 3 feet 6 inches; the inside length is 4 feet 2 inches at bottom and 4 feet 8 inches at top; the depth of the fore end is 14½ inches and 13¼ inches at the other end. The length of the shafts or poles, before the body of the cart is 6 feet. The wheels are commonly 3 feet 10 inches, and sometimes 4 feet high; 2¼ inches broad and generally hooped with 9 or 10 stones of iron. The cost of the whole complete is about £8 18s 0d.

The making of the cartwheel was a highly skilled art, calling for an experienced hand and eye. The naffs, or hubs, were usually of seasoned elm, the felloes, or component parts of the rim, were ash pinned with oak pegs, and the spokes were oak, preferably riven rather than sawn, in order to preserve the strength of the grain. On completion, the wheel would be 'hooped' by a blacksmith on a 'tyring platform'. This involved heating the iron rim in a fire until it was red hot, fitting it over the wooden wheel and immediately dowsing it with water so that the iron contracted and fitted tightly on the felloes.

To complete a pair of cartwheels took four days in the 1930s and cost between £3.10.0 and £4.0.0 a pair. In those days 'built-in obsolescence' was unknown and some of these wheels lasted for forty years or so. Sadly, like so many rural crafts, the wheel-wright's art has declined almost to the point of extinction.

These single horse carts were efficient and also versatile; by using *overings*, additional boards at the two sides and at the front end, the capacity of the cart could

Wheel hooping at Hawkshead. The blacksmith was not only a farrier; he could make and mend all manner of household and agricultural equipment.

be increased. Similarly, by adding *a shelving*, a framework which extended at the rear and the front, the cart could carry an increased load when being used for hay-making. Such carts were common until the 1930s and 1940s when the internal combustion engine began to replace horsepower.

Sickles, leys and harvesting

The sickle is arguably one of the oldest agricultural tools. In Denmark and elsewhere, beautifully fashioned flint sickles were in use in the Neolithic period and the ancient Egyptians harvested both wild and cultivated corn with a primitive form of sickle. In Cumbria the use of the sickle for harvesting lasted until the second half of the nineteenth century – longer than in many other areas, largely because the bands of Irish labourers who came over for the harvest preferred it to the 'ley' or scythe. The implement most commonly used had a blade about 2 feet 6 inches long and this was edged with tiny cutting teeth. The work was arduous and back-breaking; in the early part of the nineteenth century it was estimated that three men could reap, bind and stouk a customary acre of grain in a day for a

wage of four shillings each. Usually the Irish labourers 'followed the harvest', beginning in Low Furness, Cartmel, West Cumbria, and the Eden valley where the harvest was relatively early, and following on into the uplands where, due to environmental factors, the crops ripened somewhat later. The working day was a long one as this early nineteenth century account testifies:

> The day is commonly considered from 5 o'clock in the morning until 8 in the evening, of which an hour and a half [is] consumed in meals and taking refreshments at other times, the whole being served in the following order: cheese, bread and beer before the reapers enter the field in the morning; breakfast about 8 o'clock, beer, sometimes about 10 in the forenoon; dinner at 12; beer about 3 o'clock; cheese, bread and beer about 5 in the afternoon, and supper after leaving the field about half past 8 in the evening; likewise as much beer at other times of the day as the heat of the weather may render necessary.
>
> William Close

Gradually the ley replaced the sickle, a process which was accelerated in the second half of the nineteenth century when it was appreciated that acre for acre crops could be harvested more cheaply with the scythe than with the sickle. The ley used in the Lake District was usually 4 feet 6 inches long and attached to the pole is such a way as to balance the implement was an oakwood *strickle* for sharpening the blade. Each of the four sides of the strickle was pitted with tiny indentations and the whole was smeared with bacon fat, after which it was dusted over with fine quartz sand from the shores of a mountain tarn in order to create an abrasive surface. Later, these home-made sharpeners were replaced by a piece of wood to which emery paper had been attached. . . . Leys may still be seen on fell farms through their use is now largely confined to the cutting of bracken.

Horse-drawn reaping machines were introduced about the middle of the nineteenth century – one of the earliest was at work at Hackthorpe Hall, Lowther, in 1851 – but progress was slow. After cutting, the sheaves were set in stouks which remained in the field, traditionally *'for three Sundays'*, to allow the sap to dry out before it was carted and stacked.

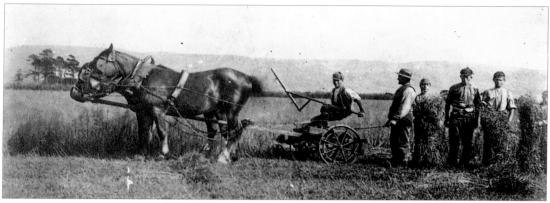

Horse reaping in Cumberland in the 1920s.

Reapers at High Furness in 1890: Much of the harvesting was then done by bands of itinerant Irishmen who preferred using the sickle to the scythe.

Reaping at Langrigg near Boot in 1926.

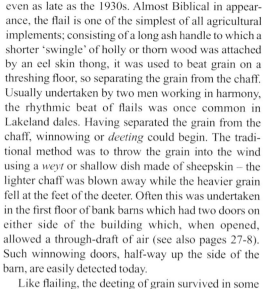

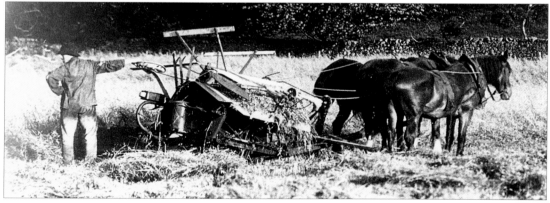

even as late as the 1930s. Almost Biblical in appearance, the flail is one of the simplest of all agricultural implements; consisting of a long ash handle to which a shorter 'swingle' of holly or thorn wood was attached by an eel skin thong, it was used to beat grain on a threshing floor, so separating the grain from the chaff. Usually undertaken by two men working in harmony, the rhythmic beat of flails was once common in Lakeland dales. Having separated the grain from the chaff, winnowing or *deeting* could begin. The traditional method was to throw the grain into the wind using a *weyt* or shallow dish made of sheepskin – the lighter chaff was blown away while the heavier grain fell at the feet of the deeter. Often this was undertaken in the first floor of bank barns which had two doors on either side of the building which, when opened, allowed a through-draft of air (see also pages 27-8). Such winnowing doors, half-way up the side of the barn, are easily detected today.

Like flailing, the deeting of grain survived in some places as a relic and archaic farm practice until the twentieth century but by the second half of the nineteenth century steam threshing machines had been introduced and these trundled around farms until the 1950s when they were finally replaced by combine harvesters. The mechanisation of farming is almost complete and within the last few decades horse-drawn reapers and steam threshing machines have joined the flails, weyts, leys and sickles of previous generations in museums of agriculture.

Today, sheaves of corn are no longer a feature of the agricultural landscape and even children in rural areas know them only from television adverts for wholemeal bread!

Horse-operated threshing machines were introduced in the early decades of the last century, but the cost of a two-horse machine – £33 0s 0d in 1860 – made them prohibitive for most smaller Cumbrian farms, and flails continued to be used for threshing

Haymaking

Apart from wool, hay is probably the most important harvest in the Lake District but even haymaking has become mechanised and the ubiquitous black polythene silage bags have replaced hay stooks while the leys, rakes and *tumble toms* in use fifty or sixty years ago now collect dust and cobwebs in many Cumbrian

barns. Until the mid-nineteenth century grass was cut with a ley but, despite men like George Brownrigg of Troutbeck who in 1861 cut two acres of grass in eight hours and fifty-five minutes for a wager, the operation was a slow one. Ironically, in the same year George Brownrigg won his bet, one of the earliest two-horse mowing machines in Westmorland cut twenty-two acres in eighteen hours, just a few miles away at Low Wood. The speed and efficiency of these new machines, so important in the fickle weather conditions of the fells, was immediately appreciated. Soon one and two-horse mowing machines, many made by W and A Fell of Troutbeck Bridge, became common, several remaining in service until relatively recently.

With the introduction of mechanical baling and, more recently, polythene silage bags, much of the colour and atmosphere has been lost from haymaking – but so, too, has much of the sweat and back-ache! Fifty years ago things were certainly different; a preliminary task was *hacking out* with a ley the edges and corners of the meadow where the horse-drawn mower could not reach, after which the mower was set to work. The mown grass was then strewn and tossed or cocked, according to the weather conditions and eventually the meadow could be swept with a horse-drawn *gate-sweep* or *tumble tom*, which was basically a wooden beam with spikes projecting from it which slid underneath the hay and collected it. The driver lifted the sweep by the handles when full, so that the spikes dug into the ground, the horse continued forward and the sweep somersaulted, leaving the collected hay behind in a heap. Later, these heaps were collected into tall pikes which, when weighted down with stones, logs and binder twine, would withstand the weather until the hay could be led.

Like clipping, hay making was a communal effort, young and old lending a hand either to turn the hay, cock it, lead it to the barn or simply to provide the welcome refreshments for the workers. The late Tom

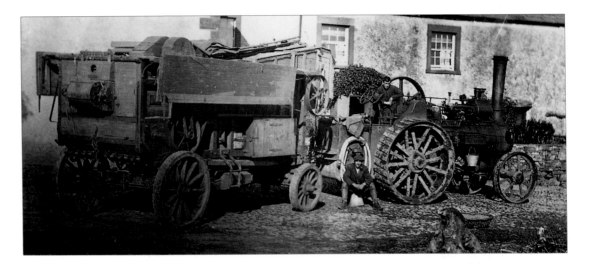

*Steam thrasher,
The Green, near Millom
in the 1920s.*

*Handbill advertising the
sale of a thrashing
machine in 1824.*

THRASHING
Machine,
TO BE SOLD
BY PRIVATE TREATY,

A Powerful and well Constructed Machine, with the Straps, Gears &c. belonging thereto; it is capable of Thrashing 20 Bushels of GRAIN in the hour, and may at a light expense be fitted up so as to be impelled either by Water or Horse power, as may best suit the convenience of a PURCHASER.

☞ To view the same and for other Particulars apply to Robert Askew, Mill-wright, at the Low-wood Gunpowder Works, near Cartmel, or to Mr Clarke, Auctioneer, Ulverston.

Low wood December 23rd, 1824. J. Soulby, Printer, Market Place Ulverston

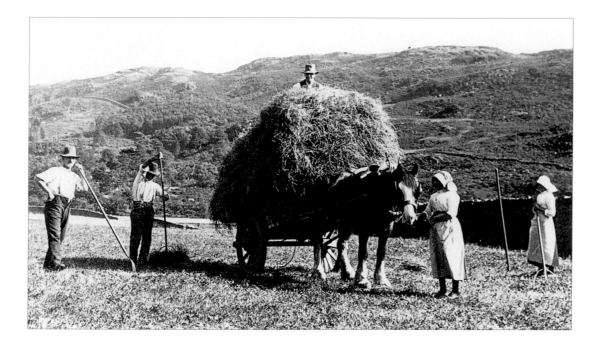

A haycart loaded high.

Fletcher Buntin has left an evocative description of hay making in Great Langdale in the early decades of this century:

It was lovely to see a row of people turning and scaling hay, and forking it into the horse drawn carts; it was a delight to see the women coming into the field at 3.30 p.m. with a basket of home-made fare and a large can of tea. Any tea left to go cold was a real pleasure to wash the dust away. Mother used to make a quantity of 'botanic beer' which was brought into the fields and left uder the hedge for the following day. It was all so enjoyable and I for one enjoyed my hay-making days. It was hard work especially if the weather was 'catchy'. It was a great joy to see the last load of hay being taken in. Often in a wet summer we were hay making in late September, and occasionally in October. There was no baling then. It was all led loose and put into the hay 'moo' in the barn. When it was being fed to the animals it was pulled out by hand using a 'hay puller' and shaken up thoroughly to get all the dust out – if it had been a bad summer and hard to dry it would be very dusty. For the Herdwicks it had to be the very best hay!'

Tom Fletcher Buntin, *Life in Langdale*, 1993.

Peat

Although not strictly a crop, the cutting of peat was certainly an activity which exploited the resources of the land. In flat-floored valleys such as the Winster and Lyth, as well as on the mosses which fringe the Leven, Kent and Duddon estuaries, the *graving* of peat was as much a part of the agricultural calendar as haytime and harvest. Even in the fells, when conditions were suitable, peat was cut for fuel; places such as Wythop Moss, west of Bassenthwaite Lake, Skiddaw Forest, and Flaskow Common to the north end of the Helvellyn range provided peat to fuel the smelting furnaces of Keswick in the sixteenth and seventeenth centuries, and continued to provide fuel for domestic purposes until the late nineteenth century.

Most fell farms owned a small peat working or *pot* and several peat spades. The 1710 schedule of farm implements left by the late William Hawkrigg of Grasmere is fairly typical; it lists a peat spade and three *flawing* or flaying spades used for paring off the top layer of peat. The peat spade had a small flange or wing at right angles which allowed two sides of the peat to be cut at a single stroke. Most peat and flawing spades were made by the local blacksmith and therefore the patterns differ from area to area.

A peat pot often produced two distinctive types of peat; the top layer to a depth of about two feet provided grey peat with a high percentage of fibrous material from the heather and ling which, when dried, made excellent kindling. Below this layer was the black peat which gave more heat and lasted longer in burning. Peats were usually transported in peat barrows, wooden hand carts which lacked sides but possessed a single broad iron wheel which prevented the barrow sinking in the soft ground; the peat cutters generally wore wooden pattens tied to their clogs for the same reason.

After *graving*, the peats were allowed to dry in *winrows*, lines of peats placed 'wig-wam' fashion to allow the wind to blow through them to hasten drying. The peats were later stacked in circular ricks or *mounts*,

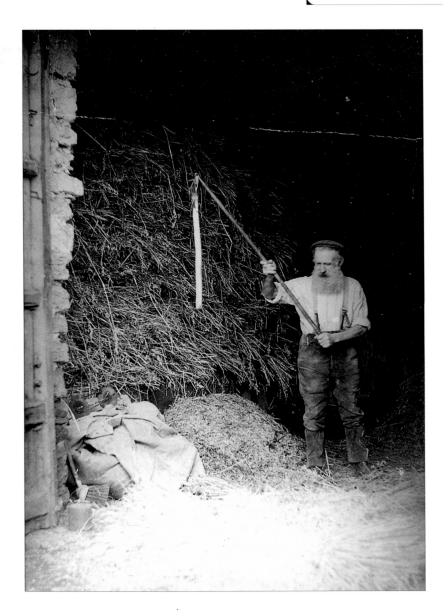

The flail, here still in use in the Lyth valley, is one of the oldest agricultural implements and was still used for threshing grain in the 1930s.

The man on the left, cutting peat at Witherslack, wears pattens strapped to his clogs to prevent him sinking.

again allowing air to circulate freely, before finally being brought in. Most 'peat houses' were near to the farmsteads but occasionally were located on the fell-sides close to the peat pots. Above the village of Boot, and in other parts of Eskdale, Dr Angus Winchester has identified no fewer than thirty-five of these peat *scales*. And there are other examples alongside the Burnmoor track connecting Eskdale with Wasdale Head.

In a dry summer a farmer might be able to *grave* sufficient peats for a year, or even two, but, as usual in the rural economy, no waste was tolerated. The *topping peats* or *flaughts* were dried for fuel and even the *comb* or *mull*, the fine peat dust, was carefully garnered – indeed, it was much prized on baking days when clap bread was made since it produced a hot fire.

Some farms still legally have *turbary* rights to cut peat for fuel, but few farmers now make the effort required to maintain their ancient traditional rights.

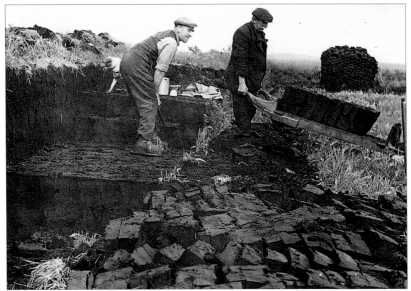

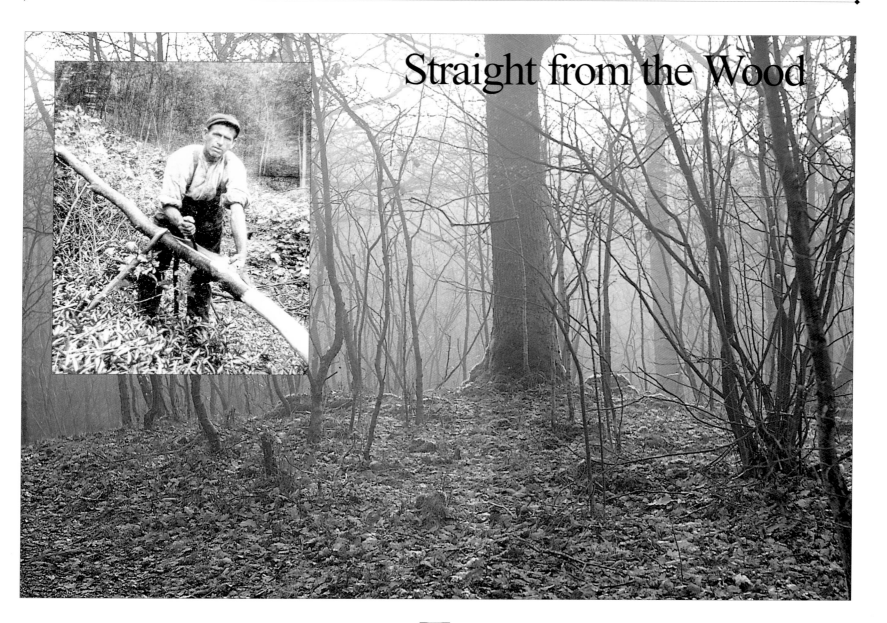

Straight from the Wood

The woodland industries of the Lake District are as ancient as any in the area and few can rival the tradition of craftsmanship which has lasted until today. Although many of these industries can be traced back at least to early mediaeval times, one of the earliest comprehensive accounts is contained in the certificate of revenues of Furness Abbey drawn up in 1537. In this we read that in the Furness Fells:

. . . there ys another yerely profytte commyng and growing of the said Woodes, called Grenehewe, Bastyng, Blecking, byndyng, making of sadeltrees, cartwheels, cuppes, disshes and many other things wrought by Cowpers and Turners, with makying of Coles, and pannage of Hogges, according as hath always been accustomed to be made in the said woodes, to the yerely valewe by estymacyon of xiii£ . vis . viiid.

Some of these terms such as the making of *cuppes* and *disshes* and the *pannage of Hogges*, here meaning pigs, are self-explanatory. Others require some elaboration: *grenehewe* was rent paid by the Abbey's tenants to lop off branches and leaves of ash, holly and other trees for sheep fodder in winter (see page 112); *bastyng* meant the manufacture of coarse matting from bark peelings and also the making of spelk or swill baskets; *blecking* signified the bleaching or drying of bark, or possibly the making of ashes from which soap was produced; and *byndyng* meant the making of barrels and hoops. *Sadeltrees* were the frames for panniers for pack horses – the most common form of bulk transport in Cumbria until the eighteenth century, while *'the makyng of Coles'* is a clear reference to the production of charcoal. Here, then, in spite of an apparently low

Page 135 shows a coppice woodland at Force Forge in the Furness Fells with [inset] a man bark peeling.

The Charcoal Burners

On the other side of the clearing they found the track again. The noise of the chopping was now close at hand. A keen smell of smouldering wood tickled their nostrils. Suddenly they came out of the trees again on the open hillside. There were still plenty of large trees, but the smaller ones and the undergrowth had been cut away. There were long piles of branches cut all of a length and neatly stacked, ready for the fire. There was one pile that made a complete circle with a hole in the middle of it. Forty or fifty yards away there was a great mound of earth with little jets of blue smoke spirting from it. A man with a spade was patting the mound and putting a spadeful of earth wherever the smoke showed. Sometimes he climbed on the mound itself to smother a jet of smoke near the top of it. As soon as he closed one hole another jet of smoke would show itself somewhere else. The noise of chopping had stopped just before the explorers came into the open. 'Look, look,' cried Titty.

At the edge of the wood, not far from the smoking mound, there was a hut shaped like a round tent, but not made of canvas but of larch poles set up on end and all sloping together so that the longer poles crossed each other at the top. On the side of it nearest to the mound there was a doorway covered with a hanging flap made of an old sack. The sack was pulled aside from within and a little, bent old man, as wrinkled as a walnut and as brown, with long bare arms covered with muscles, came out.

Arthur Ransome, *Swallows and Amazons*, 1930

value, is the first account of the woodland industries to indicate their range.

Sadly, many of these crafts have died but there are still echoes of the old traditions. Occasionally the Woodland Trust will organise charcoal burns in the old manner and a handful of people continue to make charcoal commercially, using large metal kilns. Arthur Barker of Kirkby-in-Furness continues to demonstrate the art of turning wooden objects on a foot-operated lathe, and one or two dedicated craftsmen – and one woman – keep alive that most ancient of woodland crafts, the making of woven oak swill baskets.

Charcoal Burning

The importance of charcoal to the mediaeval economy cannot be over-emphasised; it provided the only effective smelting agent for iron, copper, silver and lead. The Cistercian monks of Furness Abbey had their *colepittes* and *colepots* in the woods of Low Furness and these pitsteads or charcoal hearths supplied the abbey with sufficient charcoal to smelt the rich red haematite iron ores on which the monastic economy partly depended.

By the sixteenth century, however, much of this woodland had been depleted so the ore had to be transported to the still thickly-wooded fells of High Furness and there, dotted through the woods and along the shores of Coniston Lake and Windermere, small *bloomery hearths* began to smelt iron. Since five tons of wood were required to produce one ton of charcoal, and eleven hundredweights of charcoal were needed to make three hundredweights of iron, it was more cost-effective to carry the ore to the woodland for smelting than vice versa so the availability of charcoal became the main locating factor of the early iron industry. For several centuries the pale blue smoke from the pitsteads drifted through the coppice woodlands and on still overcast days hung like a veil over the calm sur-

Charcoal Burning and Bark Peeling at Troutbeck, 1770

This account mentions activities such as coaling, peeling bark, making pitsteads and 'cabbins', and the construction of 'hurdles', movable wind shields used to shelter pitsteads from the prevailing winds.

[handwritten eighteenth-century account ledger, largely illegible]

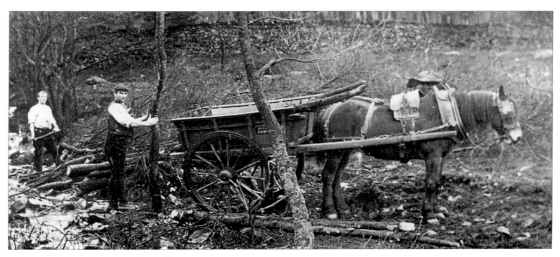

Coppice timber is being loaded onto a horse-drawn cart.

faces of the lakes, and the turf-built huts of the 'colliers', located close to the pitsteads, became a familiar part of the human landscape of southern Lakeland.

The term 'collier' has become associated with the mining of mineral coal from deep mines, but before the Industrial Revolution the word was almost entirely confined to those who made charcoal. Examples may be found in many south Cumbrian parish registers: the Ulverston records for 1598 mark the burial of *'a daughter of a collier of blawth'* [Blawith] and the Hawkshead register for 1701 mentions the death on 10 December of Clement Holm *'colier de Deal Park'*. And the name Colton, a small village near Greenodd, may be derived from Coleton or 'charcoal-town'.

The production of charcoal began with the coppicing of the woods and the felling of *standards*, or trees just above the ground. This left the stool or bole from which between ten or twenty new *poles* or shoots would eventually sprout, all fiercely competing for the available light. In effect, this was a crop which, rather than being harvested annually, was cut every fifteen or sixteen years. When the poles attained a diameter of about five or six inches, the wood was cut, usually *'at t'back end'*, between November and April when the sap in the timber was at a minimum. Oak trees, however, were allowed to remain until the spring when the rising sap allowed the valuable bark to be peeled more easily (see page 144). In the summer months the work of cutting, peeling and grading the wood was undertaken; larger timber was sent to the bobbin mills while smaller pieces, about an inch or two in diameter, were used by the colliers. Two sizes of wood were usually *coaled* – the *shanklings*, pieces about three feet long, and *coalwood*, approximately two feet in length.

The mechanics of traditional charcoal burning have changed little over the centuries; a circular platform about fifteen to thirty feet in diameter was prepared,

care being taken to fill in any rabbit or mole holes which might otherwise allow air into the stack of timber. These pitsteads were usually located on level sheltered ground with water close by but occasionally, when there was little available level land, a platform would be built out from the fellside. There are many examples of this type of pitstead in the upper part of the Troutbeck valley. In the centre of the pitstead floor a large single pole or *motty peg* was erected and around this the cut timber was stacked, forming a bee-hive pile about six feet in height. This was covered with bracken or grass, on top of which was placed a layer of turf or finely sifted marl to prevent any influx of air which might ignite the timber rather than *coal* it, so producing wood ash instead of charcoal. Further protection from draughts and wind was provided by movable windshields made of interlaced twigs, bracken and bark which could rapidly and easily be repositioned if the wind changed direction. To commence the burn, the central motty peg was removed and in its place a shovel of glowing charcoal was tipped so that coaling began in the centre of the stack. The hole at the top was sealed with a turf sod – and the waiting began.

Each pit – and there might be several at different stages of burn – required constant attention; parts of the stack might collapse and require rebuilding and any signs of a flame had to be smothered with wet turf or water. The coaling time depended on the size of the pitstead but anything between ones and three days was usual. It was said that many colliers knew instinctively when the burn was complete but others would take two pieces of charcoal from the base of the stack and strike them together; if the sound produced was that of a metal bell then the pitstead was ready for *saying*, quenching with water to produce steam which, in turn, cooled the stack. After an hour or so the charcoal was raked over in order to cool it further before being shovelled into sacks. The sacks were of a fairly standard size; when empty, each measured 2½ yards by 1 yard

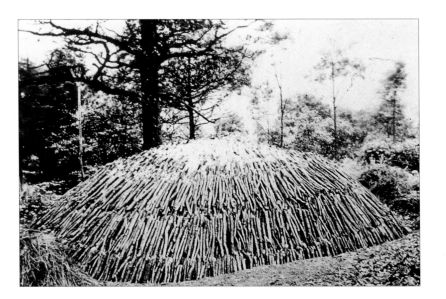

Coppice timber was stacked on the pitstead floor around a central stake, called a 'motty peg'. The timber stack was then turfed and the motty peg withdrawn. Glowing charcoal was placed in the centre of the stack and the coaling process began.

and when full they stood to a height of 4 feet 9 inches. In the 1880s it was estimated that an average pitstead produced two dozen and half sacks each coaling and these were worth £4 10s 0d.

In the early days of the iron industry in the Furness Fells, most of the charcoal produced in the coppice woods fed the *bloomeries* scattered through the woods, and the forges such as those at Cunsey, Force Forge, Hacket in Little Langdale and the delightfully-named Burblethwaite Forge on the River Winster. Later, much of the output from this area was used by the famous Backbarrow Furnace on the River Leven and boats carried charcoal the length of Windermere to a landing stage at Newby Bridge not far from the iron works. The furnace continued to produce high-quality charcoal iron until the 1920s but even then the demand for charcoal did not cease for it was one of the three vital ingredients of black powder – gunpowder – which continued to be made locally until 1937 (see page 143).

Apart from the meagre entries in parish registers, little is known of individual charcoal burners, but it requires only a little imagination to picture the tiring and dirty working conditions. Once a pit was fired, a second, third or fourth followed in succession, and during coaling, work went on day and night, seven days a week, without respite throughout the late summer and early autumn. During this period the pitsteads needed constant attention, which meant that the colliers remained in the woods and therefore built for themselves turf huts large enough to accommodate two people and these were used to snatch a cat-nap whenever possible. Basically, these crude shelters were made of a series of poles arranged rather like a native American wigwam, and this was then *thacked* with overlapping sods in order to keep out the rain. Standing about seven or eight feet high, they had no windows or openings other than a door of sacking. Similar huts built by bark peelers were rather more

substantial since they were intended to survive longer than the charcoal burners' huts, and therefore they often contained a crude stone-built hearth. Like the pit-steads themselves, traces of both types of huts can be found today if one knows how to read the landscape.

Spelk or swill basket making

The term *spelk* is derived from an Old Norse word *spelkr* meaning a shaving or splinter of wood and these baskets are quite literally woven from oak shavings. One of the earliest references to spelks is found in the Customs of the Manor of Windermere where in 1476 it was ordered that . . .

> . . . whoso felleth any wands of spelks [small sticks] in the dales of his neighbours without leave or any green wood forfeits 6s 8d.

It is likely that the term *bastyng* in the Furness Abbey document of 1537 included the making of spelk baskets. A little later, in 1563, an inventory of the goods of Matthew Dixon of Brantfell, Windermere, mentions *'iij spelks and iij corves xix d'* while the parish registers of Hawkshead record the burial in 1673 of *'John Harrison, swiller, who dyed at Grysdall'*. In 1691 the Reverend Thomas Machell noted that at Bowness:

> . . . a market was kept on Sundays – meat cockle[s], sheepskins, swills – on the South side of the Church under the Yew tree about fifty years ago.

Swill making remained important in Bowness until the nineteenth century but by that time other centres had emerged, including Lowick, Spark Bridge, Torver, Broughton, Haverthwaite and Backbarrow. By the end

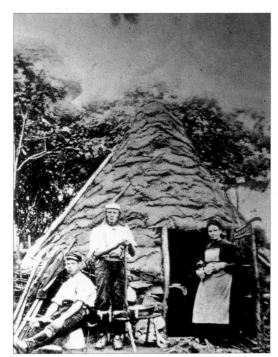

A charcoal burner's hut in the 1880s. The pitsteads needed constant attention so the colliers built themselves turf huts in which to snatch a brief rest. These crude shelters were like wigwams covered with overlapping sods to keep out the rain.

Making oak swill baskets, an ancient woodland craft.

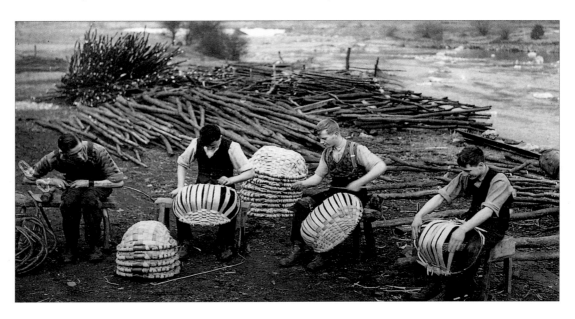

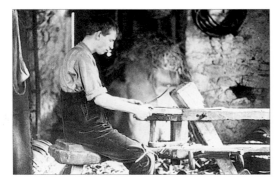

*Swiller sitting at
the mare.*

of the century, Broughton had no less that five swill-making firms which between them employed twenty-five men.

The raw material for swill-making was the straight-grained oak coppice poles about six inches thick; ash was occasionally used but oak was preferred. After felling, the timber was quartered, using a *lat axe*, and boiled in water for several hours. Each piece was then gripped between the knee of the swiller and a split initiated with a riving knife and a knocker and then riven or pulled apart by hand. The process continued until

each piece was about one quarter of an inch thick. While the oak was stewing, the *bools* or oval rims, were made from hazel or ash *withies* which had been boiled for a short period and then fastened with a single nail. As soon as possible after riving, the spelks were further trimmed on the *mare*, using a draw knife. Although crude and cumbersome in appearance, the mare was a very practical foot-operated vice. Sitting astride it, the swiller operated a pivoted arm with his feet, causing a heavy head to swing down on a wooden anvil, so gripping the spelk which was then shaved

*Cockler using a swill
basket. The workmanship
was so fine that the best
baskets could hold water.*

*Making the 'bool' or rim
of a swill basket.*

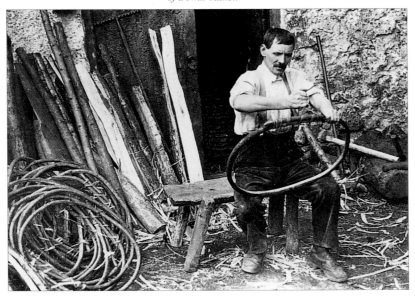

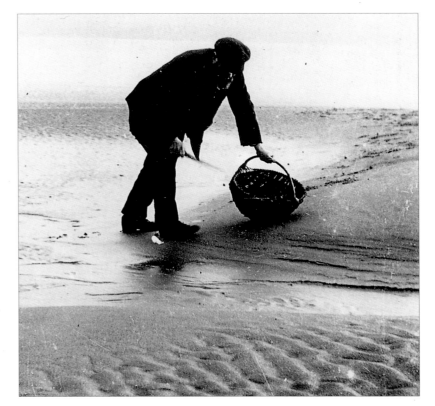

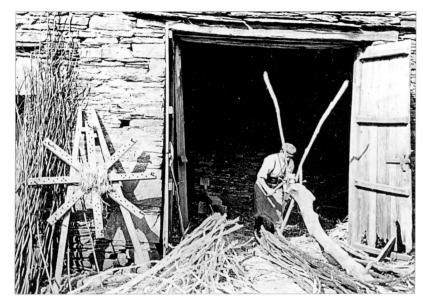

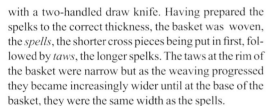

Making hoops at Hawkshead Field in about 1910. A coiling frame stands on the left.

Caldbeck bobbin mill with timber stacked outside waiting to be converted into bobbins.

with a two-handled draw knife. Having prepared the spelks to the correct thickness, the basket was woven, the *spells*, the shorter cross pieces being put in first, followed by *taws*, the longer spelks. The taws at the rim of the basket were narrow but as the weaving progressed they became increasingly wider until at the base of the basket, they were the same width as the spells.

A good swiller could make seven of these baskets a day and so fine was the workmanship that the best swills could hold water. The durability of swill baskets was legendary; they were used wherever a heavy-duty container was required – in farming, coal-mining, charcoal-burning, cockling and urban refuse collecting. One of the most important markets was Liverpool; thousands of baskets were sold for one shilling each and were used to carry coal on board steamships. And generations of young Cumbrians have been rocked to sleep in swill baskets used as make-shift cradles.

Closely allied to swill-making was the craft of hooping, the manufacture of hoops for barrels, kegs and casks. Sap-filled oak and hazel poles were split into three or four *smarts* which were then trimmed on a mare before being coiled onto a frame, an eight-armed cross which had pegs along each arm corresponding to the size of hoop being made. After seasoning, the hoops were exported in bundles of sixty known as 'half-a-hundred', mainly to Manchester and Liverpool where they were used in the coopering trade.

Liverpool provided the market for another off-shoot of the hooping industry – the production of ships' fenders from withies. One of the most important

centres of production was the water mill at Sunny Bank, Torver, which continued working until the early decades of the twentieth century but by that time discarded car tyres were proving to be cheaper and more effective than the products of Lakeland's woods.

Bobbin Making

The manufacture of bobbins or cotton reels was a cross between a skilled craft and an organised industry employing hundreds of men and boys. Just as dependent on the coppice woodlands as charcoal burning and basket making, bobbin mills were not conspicuous, being hidden away in the woodlands and, unlike the cotton mills of Lancashire, these water-powered mills did not smudge the landscape with smoke and grime. Of course, the prosperity of the bobbin industry was necessarily linked to that of cotton manufacturing

and during the American Civil War and the consequent cotton famine, many bobbin mills turned to the production of items such as tool handles, toggles, pill boxes, yo-yo's and mangle rollers. The decline of Lancashire cotton and foreign competition, together with the introduction of cheap plastic bobbins has meant the decline of a Lakeland industry which by the 1850s produced fifty per cent of all the bobbins used by British textile mills.

The history of the Stott Park Bobbin Mill at Finsthwaite neatly mirrors the fortunes of the entire industry. Originally built by John Harrison, a local landed farmer, the mill was powered by a waterwheel, later by turbines and a steam engine, and then, from 1941 until 1971 when it finally closed, by two electric motors. The larger coppice poles were used in bobbin production. After sawing into lengths slightly larger than the finished reels, the bobbins were *blocked out* and passed through a drying kiln, after which they were *rinced* with holes before the reels were turned by hand on a finishing lathe which could produce between 1,200 and 2,700 bobbins an hour. Finally, the bobbins were either dyed or waxed by tumbling them in a revolving drum containing pieces of wax. The Stott Park mill was not one of the largest in the Lake District but between the 1860s and the 1940s it provided employment for fifteen to twenty-five men and boys.

Working conditions in the mills were both arduous and hazardous; the constant frenetic flapping of the leather drive belts turning the lathes from the central line-shaft, and the unguarded machinery meant that accidents – especially amputated fingers – were common. Knots in the wood frequently sent the bobbins flying at great speed from the lathe, causing injury to the operatives, and windows were often shattered and seldom replaced so that in winter the temperatures inside the mills were as low as those outside.

Men and boys worked knee-deep in shavings which were not only a fire hazard but also provided admirable nesting sites for rats which abounded. The mills were usually badly ventilated and the dust resulted in respiratory problems.

In 1864 Mr J E White, the Parliamentary Child Employment Commissioner, took evidence of the working conditions in the bobbin mill at Staveley. The mill was one of the largest in the neighbourhood, employing fifty men and thirty-one boys, one of whom was William Philipson, aged seventeen:

Have worked here for 10 years. Am sure it is 10 because I know I was about 8 when I came, and I am now nearly 18. Our hours are from 6 am to 6 pm with half an hour for breakfast and the same for dinner. We used to have an hour for dinner when we left on Saturday at 4 pm, but since the hands wished to leave early on Saturdays, viz. at 12.30, as we do now, we have only half an hour for dinner every day, so as to make up the time. We never work after 6 pm in winter, or after dark in summer, but we have then sometimes worked longer, till 8 pm for a week together, perhaps. Have come a few times early in the morning, at 1, 4, 3, and so on, but only some of us that were at particular jobs that were wanted finished. One time a few of us worked all night as well as day; they wanted us to get some bobbins off . . . Don't like the work, it is so dusty and stuffs you up so, but it's different according to the kind of wood and the job. Alder and ash are very bad if dry. The dust chokes up your stomach, and you are

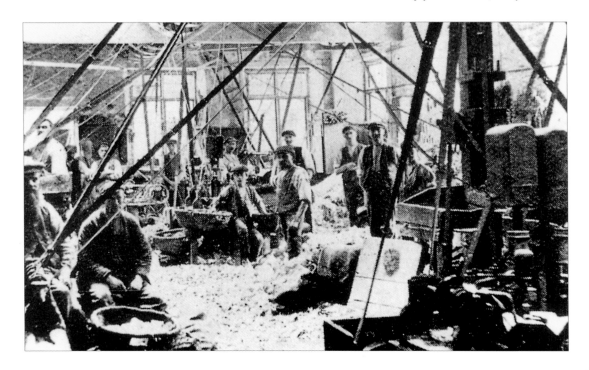

obliged to spit it up or you couldn't get on. It stops you breathing.

The Stott Park Mill was closed in 1971 but resurrected again as a working museum under the care of English Heritage and here visitors can see bobbins being turned by hand in the traditional manner. Ironically, all the working machinery has guards, the dust is extracted by ventilators, the cobwebs and the rats have gone – and all the windows have glass panes. Elsewhere, many of the mills have been converted to luxury holiday flats.

The Black Powder

Although not strictly a woodland industry, the making of Black Powder or gunpowder, was closely associated with the production of charcoal, one of the three essential ingredients. Consequently, the gunpowder plants were located in the main charcoal producing areas of the Lake District. Silver birch and alder char-

coal was particularly valued but best of all was *savin coal,* made from the juniper bushes which flourished on the lower slopes of the fells. This produced the highest quality charcoal which, in turn, made the finest gunpowder. The availability of water power to turn the heavy machinery used in the crushing and milling processes was an additional factor in the location of the industry. These advantages were initially appreciated by John Wakefield who opened the first plant at Sedgwick, south of Kendal, in 1764. Using the small port of Milnthorpe, he was able to import the two other vital ingredients, sulphur from Sicily and Italy, and saltpetre from India, which were landed at Liverpool and then transhipped to Milnthorpe. The same tiny port at the mouth of the River Bela was used to export the gunpowder to the great magazines on the Mersey.

At the end of the eighteenth century, the demand for Black Powder was increasing; the copper and lead mines and the growing number of slate quarries in the Lakeland fells all required blasting powder, but in addition there was a great demand for gunpowder from

West Africa, for it was one of the commodities most required in exchange for slaves.

The success of the Wakefield venture soon encouraged other entrepreneurs and by the end of the eighteenth century two more mills had been opened, one at Bassingill near the original Sedgwick works, and the other at Lowwood near Haverthwaite on the River Leven. In 1824 David Huddleston opened his works at Elterwater in Great Langdale; powered at first by the water of Langdale Beck. This proved to be inadequate so a dam was constructed to raise the level of Stickle Tarn below Pavey Arc on the Langdale Pikes and water was piped the four miles to Elterwater. Despite its comparative remoteness, the plant received its raw materials largely by water, boats bringing sulphur and saltpetre the length of Coniston Lake to Waterhead or along Windermere from Newby Bridge to a small pier at Brathay. During the second half of the nineteenth century, three other factories began manufacturing gunpowder – in 1852 the Gatebeck works, south-east of Kendal, was established, followed six years later by a new plant at Sedgwick, and finally, in 1860, the Blackbeck works at Bouth began production.

The manufacture of gunpowder involves the mixing of the three ingredients, charcoal, sulphur and saltpetre, in the correct proportions but the various processes are both complicated and dangerous and at every stage, from incorporating the ingredients to pressing and *corning* or granulating the powder, and finally packing it, great care was necessary. Even in the early days of the Sedgwick plant, protective leather skins and gloves were worn by the workers and special nail-less boots were provided to minimise accidental sparks. At Blackbeck, which had an unfortunate reputation for explosions, the workers were given overshoes and protective clothing without pockets – to discourage unnecessary metal objects on the person.

Horses, which hauled carts within the works, were shod with copper horseshoes, and later in the nine-

The interior of Stott Park Bobbin Mill in about 1912 [left] and today [right]

teenth century when horse-operated light tramways connected both Lowwood and Blackbeck works with the Ulverston to Lakeside railway, non-ferrous lines were used. Even the purchase of stone rollers used to press the powder were carefully selected – stone containing iron pyrites could produce sparks; the Lowwood company, after much deliberation, chose rollers made of the so-called Dent 'marble' and limestone from Birkrigg, near Ulverston.

Yet, despite all these precautions, explosions were not uncommon; in January 1863, six workers at Lowwood were killed in a blast which was clearly heard in Kendal, some thirteen miles away, and five years later five more men lost their lives in an explosion in the corning house. At Blackbeck between 1867 and 1911 there was a total of eight accidents in which twenty-seven people died. In September 1916, four men were killed at the Elterwater plant. Tom Fletcher Buntin remembers the tragedy as a boy:

I was in school at the time and the explosion shook
the school. Miss Gaskell, our teacher, said 'That's
the corning house'. I was sitting next to Joe Joiner
whose father was one of the men killed. The
explosion was very bad; it broke a lot of windows in
Elterwater village. I can remember my mother
taking us across the beck to view what had been the
corning house. The roof had been blown off, and
was resting in the top of a tree.

Tom Fletcher Buntin, *Life in Langdale*, 1993

By the late nineteenth century the total workforce in Lake District gunpowder mills probably numbered about five hundred but after World War 1 the demand for black powder decreased and mills began to close. In 1928-9 the Elterwater and Blackbeck plants closed, followed in 1934 by the Lowwood Company and finally, in 1937, the liquidation of the Gatebeck works ended another chapter in Lakeland industries.

Wages in this hazardous industry were not noticeably higher than in other local industries; in June, 1808, the Lowwood wage books record the following wages:

David Daw	3s 6d per day
Sam Daw	3s per day
Wm. Taylor	2s per day
'with an extra 1s 6d if he works nights'	

The same document records the wages paid to six 'gunpowder makers', Natty Bathrop, John Brockbank, John Harper, James Pearce, John Murphy and Henry Tyson, all of whom received between 2 shillings and 2s 4d per day. At the same time quarrymen could earn between 3s and 5s per day and farm labourers were paid 1s 6d per day in winter and 2s 6d in summer.

Today visitors to the Langdale Timeshare swimming pool can look out over a beautiful wooded landscape, unaware that in these same woods men and boys risked their lives to make black powder, while at Lowwood, overgrown by moss and partly obscured by ivy, lie the great stone wheels which once compressed the gunpowder.

Bark peeling

Inextricably linked with the coppice woodlands are several other activities which are now obsolete. One of these, bark peeling, usually carried out between May and early July, was once important. Most of the output from the oak coppices was used in the local tanpits of Ulverston, Spark Bridge, Barkhouse, and Nibthwaite.

By the late nineteenth century, however, many of these smaller pits had been abandoned and the bark

was sent instead to the tanning industries of Lancashire and Cheshire.

Brushmaking

Observant visitors to Kendal will have spotted the bristly beady-eyed 'Black Hog of Stricklandgate' protruding from the wall of an estate agent's office – and those with sharp eyes will have noticed that it is, in fact, a sow. This is the traditional sign of the brushmaking industry which once flourished in both Kendal and Ulverston. Using the local birch, ash, alder, sycamore and beech coppice timber for the handles and stocks, the bristles and other fibres were imported from South America, Africa, Mexico, Poland, Siberia and elsewhere. The building in Stricklandgate, known as Black Hall, began making brushes in 1869 and continued until 1922 when the firm moved to another site in the town where the industry lingered on in the face of competition from cheap plastic imports until its final demise in 1963. Apart from the 'Black Hog' and one or two exhibits in Kendal's Museum of Lakeland Life and Industry, there is now little tangible evidence of this craft which once had such close links with Lakeland's coppice woodlands.

The Black Hog of
Stricklandgate.

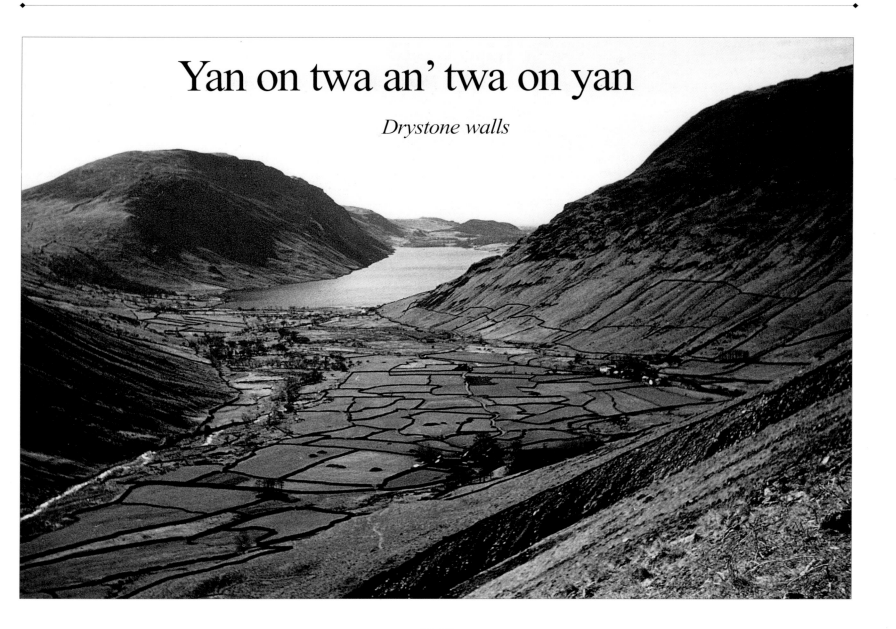

Yan on twa an' twa on yan

Drystone walls

For many visitors the drystone walls of the Cumbrian fells, snaking and winding over some of the highest summits, create an impression which lasts long after memories of postcard views and rum butter teas have faded. These drystone dikes which contain no mortar seem to grow out of the fellside like the rowans and blaeberries. They are an indomitable expression of man's effect on the environment, as much a part of the human landscape as the whitewashed farms, dripping copper adits, abandoned slate quarries, and hump-backed pack-horse bridges. Moss-cushioned and lichen-encrusted, they have a mysterious, almost timeless quality. But this is deceptive for they are a relatively recent addition to the Lakeland scene. Most of the fell walls were constructed between 1750 and 1850; within these hundred years the open unenclosed moorlands were enmeshed in a network of serpentine stone walls.

Although essentially field boundaries demarcating individual ownership, drystone walls have other functions; they afford shelter for sheep – and fell-walkers – in inclement weather and in some cases prevent animals from straying into gullies and onto precipices where they might become crag-fast. The now sadly-decayed wall on the crest of Dow Crags was built for precisely that reason, and in the nineteenth century Ennerdale shepherds collectively kept in good repair the wall which prevented sheep from wandering onto the front of Pillar Rock. Elsewhere, they provided *outgangs*, wide-mouthed funnels narrowing down to parallel walls culminating in sheep pens so that flocks may be gathered from the fells with relative ease. On some of the more level valley floors, notably Wasdale Head, Borrowdale and Great Langdale, the stone walls not only divide the available pasture into a jig-

Page 145
The pastures at Wasdale Head, enmeshed in a jigsaw
of drystone walls.

saw of irregular fields but they also act as stone dumps for the pasture has been created by the back-breaking process of clearing the land of boulders and stones and obviously the most convenient method of disposal was to build them into great bastion-like walls many feet thick. Often the stones cleared from the pastures were more than could be used in the building of the walls and so huge heaps of surplus stones or *clearance cairns* litter the landscape like some great unfinished cyclopean enterprise. Jonathan Otley, a nineteenth-century geologist and guide book writer, commented on these clearance cairns:

> Wasdale Head comprises a level area of 400 acres of land divided by stone walls into irregular fields which have been cleared with great industry and labour, as appears from the enormous heaps of stones, piled up from the surplus after completing the enclosure.

To the uninitiated eye, drystone walls are simply heaps of uncemented stones balanced precariously on top of each other. Nothing could be further from the truth. They are structures in equilibrium in which the main load is transmitted downwards through each carefully-laid stone course onto 'footing stone' foundations. Cohesion is achieved by placing one stone on two and

two stones on one to form a crude but effective bonding. *'Yan on twa an' twa on yan'* was a common and much-respected maxim. Whatever the slope of the land, the long axes of the stones remain in a horizontal plane rather than reflecting the slope for the wily old wallers knew that any departure from this would mean that the first frost and rain would lubricate the interfaces and their work would simply slide down the fell.

In cross section, many walls reveal further unsuspected secrets. Generally a single drystone wall is, in fact, two walls with a gap in the centre filled with smaller *hearting* stones, the two faces tied together, in Norman Nicholson's memorable phrase *'like Cumberland and Westmorland champion wrestlers'*, with *through stones* which project out from the wall on both sides. As the wall gains height, so the width decreases from about three feet at the base to perhaps one and a half to two feet at the top; this *batter* was achieved by gradually setting the stones into the wall slightly during the construction. Finally the wall is finished with a line of *cam* stones which present a rough and angular crenellation, originally designed to discourage the unwelcome attentions of *lish*, agile fell sheep but today equally effective in dissuading the clumsy clamberings of hoards of unthinking walkers.

Although the majority of Lakeland drystone walls date from the eighteenth and nineteenth centuries, a

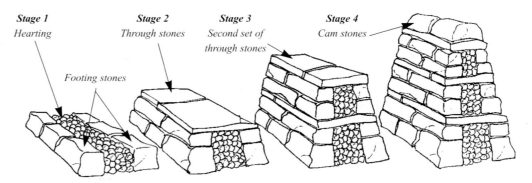

Stage 1
Hearting

Stage 2
Through stones

Stage 3
Second set of
through stones

Stage 4
Cam stones

Footing stones

few are considerably older. The turf and stone wall which crosses Lincove in upper Eskdale was built by the Cistercian monks of Furness Abbey between 1284 and 1290 for during that time John de Hudleston, Lord of Millom, granted the Abbey the right to enclose certain pasture land at *'Botherhulkil'* [Brotherilkeld] and *'Lincoue'* [Lincove] which adjoined the Forest of Egremont:

> . . . a dyke, wall or paling as the abbot and monks should think most convenient for them; but such . . . as harts and does and their fawns could leapt.

In other words, the wall was to be designed to prevent sheep from straying but not so high as to hinder the free movement of deer. More than two and a half centuries later, in 1551, the Forest of Troutbeck was divided between Ambleside and Troutbeck by a wall which straggled over the crags of Red Screes and then descended steeply to the summit of Kirkstone Pass. This wall, together with several others, was still being maintained by the Troutbeck tenants in 1680 when the Painable Fence Book was drawn up. This document recorded the names of tenants and the length of wall each was expected to keep in good repair. Dereliction of duty resulted in a fine of 6s 8d.

Without documentary evidence it is difficult to accurately date drystone walls. Recent field work by the National Trust in Borrowdale, the Langdale valleys and Wasdale Head has revealed the existence of ring garths, continuous stone walls which enclose the fertile bottom lands from the coarse grazing of the fellsides. Arguably, these were built in early mediaeval times to prevent animals from grazing on the cultivated land; other walls seem to abut these, indicating that the ring garth must have been built first but exact dating is impossible. However, in the case of dated gate stoups, some accuracy is possible. At Rosthwaite in Borrowdale, the date 1798 is found, at

Below Red Screes, Kirkstone Pass: a stretch of one of the Troutbeck 'painable' walls. In 1680 the Painable Fence Book recorded the names of tenants and the length of wall each had to keep in good repair or be fined.

Although this slate wall snakes over a steep outcrop, the long axes of the stones remain horizontal.

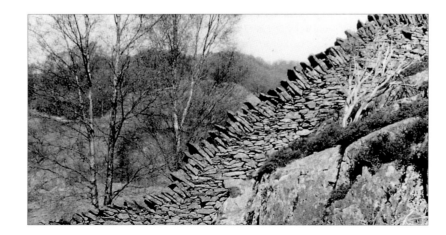

Ulpha in Dunnerdale, 1766 and the initials J G (probably John Gunson) may be identified, while near Taw House Farm in Eskdale, John Vicars Towers' initials and the date 1817 can be seen. But one of the earliest dated stoups is near Carter Ground in the Lickle valley where the name 'Carter' and 1663 can be clearly distinguished. However, such dated gate stoups are relatively rare – the exception rather than the rule.

Fell wanderers with a basic knowledge of the geology of the Lake District will readily be able to identify some of the primary types of rock which make up the fells. The builders of the drystone walls did not transport their raw materials from any great distance – they used what was available in the area – so the walls closely reflect local geology. In Eskdale, the pink crystalline granite is easily recognised; near St Bees the rose-red sandstone is the most common wall-building material, while in the carboniferous limestone country which forms a broken ring around the fells, the silver-grey walls reflect sunlight. In the Skiddaw and Blencathra area and also in the subdued well-wooded country between Coniston Water and Windermere, Skiddaw and Silurian slates and shales

A gatepost near Rosthwaite in Borrowdale dated 1798 and with the initials J B.

Wall builders used readily available local materials. Granite boulders rounded by ice or river action, used in a wall in Eskdale [left], contrast with fragile thin slate slabs used on a Troutbeck wall [right].

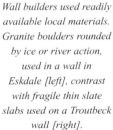

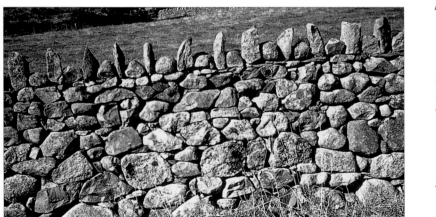

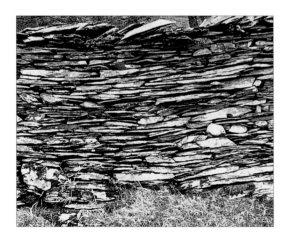

give rise to walls built of fissile platey layers, while in the heart of the fells the so-called 'Borrowdale Volcanic' group of rocks produce walls with coarse angular fragments. In certain locations, especially at the head of the Lickle valley, hexagonal volcanic columns, miniature versions of those at the Giant's Causeway in Antrim and Staffa's Fingal's Cave, occur naturally and the unknown but ingenious waller has used these in his work when bridging small becks.

Equally fascinating are the shape and variety of *hogg holes*, gaps left in the base of walls to allow free passage for *hoggs* or yearling sheep. Those with extra sharp eyes might identify *rabbit smouts*, small holes in the walls permitting unsuspecting rabbits to pass through to a slyly-concealed trapdoor and a stone-lined pit, so ensuring a ready supply of rabbit pies on the farmhouse table (page 149).

Of individual wallers, little is known; even in the eighteenth and nineteenth centuries, when most of the fellside walls were built under Enclosure Act legislation, wallers and walling gangs generally remained anonymous. Certainly their lives were harsh and arduous; often they bivouacked on the fell near to

their work, walling from sunrise to sunset and coming down to the valley settlements only at weekends. Small quarries were opened on the hillsides and care was taken in the choice of through-stones and cap stones as shown by a nineteenth-century walling account for Lanthwaite, near Crummock Water:

1837 January 6 To 1 Daye work for
Getting threwstones at 3s 3d per day 3s 3d
1837 April 10 To 3 Dayes Work for Getting top stones and undersetting at 3s 3d per day 9s 9d
1841 August 5 To 4 Dayes Work for
Getting settle stones and top stones 14s 0d

Wages were low and usually payment was by the rood of seven yards. In 1794 a rood of drystone wall $5\frac{1}{2}$ feet in height could be built for between 1s 6d and 1s 8d but by 1877 the rate had increased to 6s 6d per rood. These craftsmen who transformed the uplands were often illiterate and could sign their half-yearly wage receipts only with a cross. None the less, they have indelibly stamped their signatures on the fells.

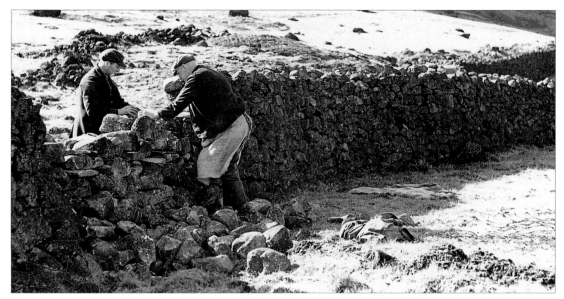

*Placing two stones on one
and one on two creates a
strong bond.*

*'Hogg holes' allow Sheep
access to both sides of the wall
[inset] a rabbit 'smout'.*

*Joseph Lancaster's wage
receipt signed with a
cross in 1841.*

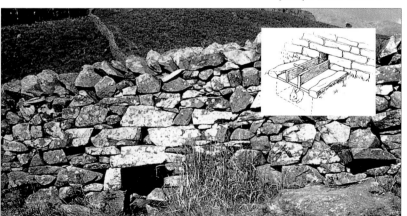

Quarries and Mines

Riving the slate and mining the ores

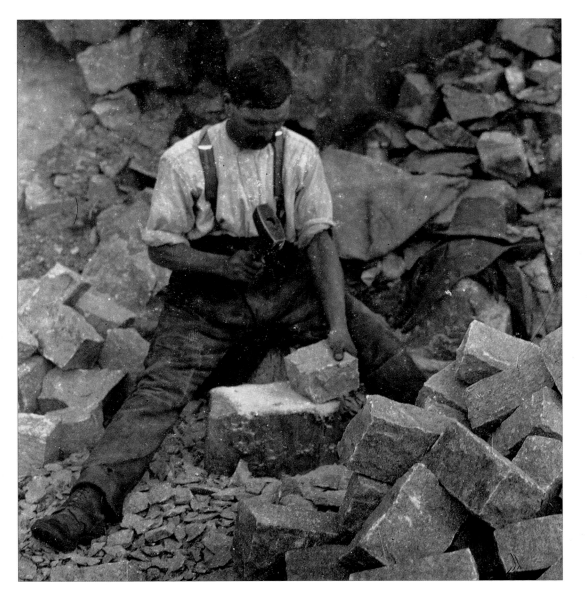

Making road 'setts' in a Cumbrian quarry.

O f all the traditional industries of the Lake District, the winning of blue-grey and sea-green slate from isolated fellside quarries is certainly one of the oldest. The Romans slated their granaries at the forts at Ambleside and Hardknott, and in mediaeval times, several monasteries were roofed with local slate. By the seventeenth century craftsmen describing themselves as 'slaters' begin to appear in parish registers and in 1693 the Hawkshead parish registers record the burial on 30th June of *'Michael Nolon, a workeman . . . [who] . . . was slayne when he was burstinge a cragg with gun powder'*. It seems probable that this was a quarry accident.

Sir Christopher Wren used Lakeland slate in the building of Chelsea Hospital and Kensington Palace but it was during the late eighteenth century that the

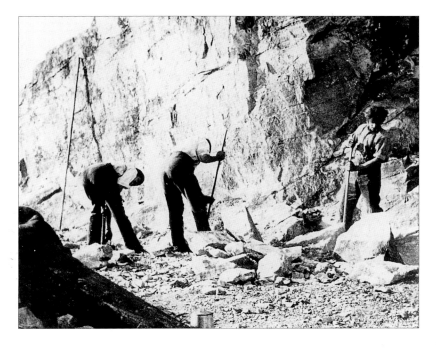

Riving stone and working the Cumbrian quarries was generally a back-breaking and hazardous occupation.

quarrying industry really developed, driven by a demand for slate from the growing industrial towns of the North and Midlands. Soon the fellsides became pock-marked with hundreds of slate quarries, large and small, wherever good slate could be worked.

Evidence suggests that the quarries at Honister Crag were being worked in 1643 but by 1753 the operation had expanded. Clearly the transport from such remote locations presented problems. Pack-horses carried the slate along the track known as Moses' Sled Gate from Honister, along the side of Great Gable to Wasdale Head and so to Drigg where it as finally loaded onto coastal vessels.

By 1774 Thomas West was able to report that *'the most considerable slate quarries in the Kingdom'* were in the Coniston fells and six years later artist and

writer William Green saw the quarries near the summit of Coniston Old Man *'in high working condition'*. Many of these quarries in the Coniston area were worked by the firm of William Rigge and Son, of Hawkshead who exported 1,100 tons a year at the end of the eighteenth century. Transport was easier here for the slate was shipped by water from the Kirkby Quay at the northern end of Coniston Water to Nibthwaite at the southern end where it was off-loaded for the ports of Greenodd and Ulverston and then shipped to Bristol, Chepstow, London and, during the early nineteenth century, to the West Indies. The great Kirkby slate quarries overlooking the Duddon estuary benefited from the proximity to tidal water and by the end of the eighteenth century small ports such as Angerton and Kirkby Pool were busily

engaged in the slate-shipping trade.

Small quarries employing a dozen or so men abounded. In the 1770s George Bownass, a Coniston blacksmith, was supplying and repairing quarrying tools and his accounts show that there were working quarries at Pennyrigg and Hodge in the Tilberthwaite valley and at Blind Tarn and Goatswater in the high fells, while other individuals were getting slate from Stang End and Bessy Crag in Little Langdale, from Ashgill near Torver, and other small quarries on the flanks of Coniston Old Man. About the same time a number of quarries had been opened at Troutbeck Park; these were managed by William Birkett of Troutbeck and his detailed accounts illuminate the state of the industry. Traditionally, Lakeland quarries produced four categories of slate according to fineness: *London, Country, Tom,* and the coarsest, *Peg*, mainly used for cladding walls. At the Troutbeck Park quarries, London slate formed the main output:

An Acct of what slate weighed since the 28th September 1754 until the 12th July 1755 at the slate quarries at Troutbeck Park.

London slate	897 Lds	}	Cash paid	£97.13.4
Country ditto	603		for getting	
Tom ditto	86		Do.	£3.7.4

[One load of slate = 16 stones (102 kg) weight]

The slate was transported by road from Troutbeck to Windermere, shipped down the lake, carted overland to Haverthwaite, and then transported by lighter to Ulverston and Greenodd where ships such as the *Hope*, the *Clifford* and the *Kendal Merchant* called to carry it to distant markets.

As the rash of redbrick building spread over the Lancashire plain so the demand for Lakeland slate increased. By 1792 *London* slates sold for between £3 and £4 per thousand, and even the poorer quality *Toms* sold at £1 10s 0d and £2 per thousand. In 1794

the government of the day, to raise revenue for the French War, imposed a tax of ten shillings on each ton of slate conveyed by sea. The outcome was a slump in trade and the redundancy of many quarry workers. In 1800 quarrymen from Coniston, Tilberthwaite, Torver, and Kirkby marched on Ulverston, laid siege to the flour mills and warehouses and distributed provisions amongst their families– an early attempt at 'self-help'! Encouraged by this success, they organised a second 'expedition' in 1802. This time they were hotly pursued by the local militia. The quarrymen withdrew to the maze of tunnels and galleries of their quarries, inaccessible to the soldiers, and eventually the insurrection petered out. By the beginning of the nineteenth century the industry had recovered and in 1805, 25,000 tons of slate were annually produced from the Coniston and Kirkby quarries alone, much of this was exported via the short deep Ulverston Canal, opened in 1796. But sterile statistics cannot convey the horror of the weekly toll of death, injury and dangers endured by the workforce. William Whellan highlighted the hazards in 1860:

When the slate is closely compacted, and offers a perpendicular surface, the quarryman goes to work as the shepherds do when they want to destroy eagles' eggs. His comrades let him down on a rope and he tries for a footing to rest on while he drives in his wedges. Seen from below, men thus employed look like summer spiders dangling from the eaves of a house. There are more measures and better roads than there used to be; and there is less breakage of men's bones, as well as of good slate, but between the needless risks they run, and the sudden storms they encounter, and the vast weights they carry or draw, and the slipping of the foot, and the dizzying of the head by drink, there are widows and orphans coming in almost every year from the quarries to live in the towns, and subscription lists going round

oftener than from any other local accident except drowning in the lakes

One of the most dangerous of all operations was the transport of the slate from the quarry face for this often involved a very steep descent. James Clarke observed (and tried) the process near Hartsop in 1787:

The slate is laid upon a barrow, which is called a 'trail-barrow'; it has two inclining handles or stangs between between which the man is placed, going, like a horse, before the weight, and has nothing more to do than keep it in the tract, and prevent it from running too fast. Those who are dextrous will not sometimes put a foot on the ground for ten or twelve yards together; but the barrow will often run away with an unskilful person, which was my case when I made an attempt.

Seventy-five years later Mrs Eliza Lynn Linton saw the same method employed at Honister Crag:

This slate quarrying is awful to look at, both in the giddy height at which men work, and in the terrible journeys which they make when bringing down the slate in their 'sleds'. It is simply appalling to see that small moving speck on the high crag, passing noiselessly along a narrow grey line that looks like a mere thread, and to know that it is a man with the chances of his life dangling in his hand. As we look, the speck moves; he first crosses the straight gallery leading out from the dark cavern where he emerged, and then he sets himself against the perpendicular descent, and comes down the face of the crag, carrying something behind him – at first slowly, and as it were, cautiously; then with a swifter step, but still evidently holding back; but at last with a wild haste that seems as if he must be overtaken, and crushed to pieces by the heavy sled grinding behind

him. The long swift steps seem almost to fly; the noise of the crashing slate comes nearer; now we see the man's eager face, and now we hear his panting breath, and now he draws up by the roadside – every muscle strained, every nerve alive, and every pulse throbbing with frightful force. It is a terrible trade – and the men employed in it look wan and worn, as if they were all consumptive or had heart disease. The average daily task is seven or eight of these journeys, carrying down about a quarter of a ton of slate each time; the downward run occupying only a few minutes, the return climb, by another path not quite so perpendicular, where they crawl with their empty sleds on their backs, like some strange sort of beetle or fly – half an hour.

Such feats were accepted by the quarrymen as part of working life but, like all working men, they had their folk heroes such as Samuel Trimmer who once made fifteen journeys in a single day for a bottle of rum and a small percentage of the slate he had sledged, and Joseph Clarke of Stonethwaite who travelled seventeen miles in seventeen trips and transported almost five tons of slate in a day – and then walked the three miles home!

Working conditions at the quarry face were just as dangerous. Most quarries were open to the elements but at Honister the workings were mainly underground. These 'closehead' quarries were lit by flickering tallow candles and accidents were common. This suggestion came from William Green in the early nineteenth century but his pleas went unheeded:

Slate rock, like the balls from cannon, have prostrated many a brave fellow . . . A club of all the northern slaters would prove greatly beneficial to widows and orphans, and a donation of even a farthing in the pound, from proprietors or renters, on the annual value of houses covered with slate from

the English Lakes, would produce a sum, the interest of which would be very considerable.

Wages were relatively low. In the 1830s the best workmen received 3s 6d per day or £1 1s 0d for a six-day week, and for this they were expected to quarry more than a ton of slate each day. Youngsters started at the quarry face for 6d per day but apprentice slate dressers earned more, usually between 1s and 1s 6d and this rose to 2s 6d before their apprenticeships were complete and they were *out of their time*.

Even by the late nineteenth century, wages were still low and hours excessively long. In 1878 Peter Hodgson of Little Langdale began work as a slate weigher in the Lingmoor quarries; aged fifteen, his hours were from 7 am to 5.30 pm and until 4 pm on Saturdays. For this he received 1s 2d per day. At sixteen he transferred to Chapel Stile to learn the craft of riving and dressing and his wage increased each year by 3d per day. By 1883 he was earning 3s 4d a day.

Transport and carrier pigeons

Transport by water, either by lake or sea, remained a critical factor in the industry until the development of railways. In 1846 the Furness Railway Company linked the great Burlington quarries at Kirkby with the tiny agricultural hamlet of Barrow on the shores of Barrow Channel, and a year later the line from Kendal to Windermere meant that slate from Great Langdale could be transported to the railhead by horse and cart and then distributed widely by rail.

The Buttermere Green Slate Company, which worked Honister Crag, had its offices in Keswick, six miles distant, so carrier pigeons were used to convey urgent messages to the quarries. This was tried in both Coniston and Langdale quarries but with disastrous results; the large number of hawks and falcons there meant that neither pigeons nor messages arrived!

Even as late as 1914, quarrymen who spent the working week living in bivouacs near to the Honister quarry, communicated with their wives in Borrowdale by carrier pigeon; a message could take anything from ten minutes (the record) to a day, according to wind, weather, and the inclination of the pigeon.

Quarrymen often acquired a reputation for 'hard living and hard drinking' – and were sometimes criticised for their life-style. James Clarke, writing of Great Langdale in 1787, noted that the valley was:

. . . as poor as any in these parts, except for the slate quarries and slaters . . . [who] . . . debauch the natives so far that even the poor Curate is obliged to sell ale to support himself and his family.

Drilling and riving

Before 1910 drilling onto the rock face to set the charge was undertaken by *rock hands* but in that year compressed air drills arrived and the old laborious method was made obsolete. Similarly, in the 1930s diamond-tipped saws which cut through the slate like a warm knife through butter, superseded the traditional reduction of large *clogs* or blocks of slate by sledge hammers and chisels. But riving and dressing have resisted the advance of mechanisation. Using a riving hammer, the river reduces a clog into a series of smooth slabs about two inches thick and from these he produces several slates. These are passed to the dresser who uses a brake, a long metal blade like an old-fashioned foot scraper, and the whittle, a long knife-like implement with a wooden handle. Seated on the ground with the brake between his outstretched legs and holding the slate with his left hand across the brake, the dresser deftly trims the edges and the slate is then classified according to grade. Today it is still possible to see the river and the dresser working side by side as they have done for centuries.

Mining

Unlike slate quarrying, the mining of minerals within the fells is a thing of the past, yet once the mining of lead, silver and copper was a major economic activity. In 1565 about fifty German miners were brought to Keswick area by the newly-formed Company of the Mines Royal to exploit the mineral wealth of the Derwent fells. This was a royal monopoly and Queen Elizabeth took her ten per cent. The Germans were the finest mining engineers in Europe at that time. On 1 April 1565, the company opened Goldscope Mine in the Newlands valley, thought to be a corruption of the German *Gottes Gab* or God's Gift and the working proved to be one of the most valuable in Lakeland.

Other mines followed at Stoneycroft and Barrow near Stair, Brandelgill on the side of Cat Bells, Ellers near Grange-in-Borrowdale and in the Caldbeck fells. By 1599 or 1600 the attention turned to the rich copper deposits of the Coniston and Tilberthwaite area. The small hamlet of Brigham, just outside Keswick, developed into the main smelting and ore-processing plant. In 1574 there was scarcely a single valley in the Lake District which was not represented in the lists of men employed either to work at Brigham or to cart wood, peat, ore and charcoal to the furnaces. By the seventeenth century it was reported that: *'above 500 persons dwelling near the works are enriched by this means to the great benefit of the country'*.

Despite sophisticated techniques to pump water from the mines, flooding was a problem, production costs rose and workings became less profitable. Closed by Parliamentary troops during the Civil War, the mines were later re-opened and some continued to work intermittently until the nineteenth century but never regained the output they had achieved during the period of the Mines Royal. However, one mine which continued to flourish in the eighteenth and early nineteenth century was the Black Lead mine

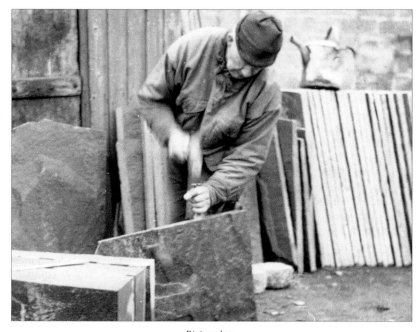

Riving slate

Circular saws can slice though slate like a warm knife through butter.

above Seathwaite in Borrowdale; first mentioned in a document dated 1555, the black lead, *wad* or plumbago was highly-prized in the eighteenth century – it was used in the casting of bomb shells, round-shot and cannon balls. It was also employed in the glazing of pottery, the fixing of blue dyes, the manufacture of pencils at Keswick, and as a cure for stomach ailments while local shepherds used it to smit-mark their sheep. Such a versatile and useful mineral commanded a high price on the open market and in the middle of the eighteenth century an Act of Parliament made it a felony to unlawfully enter *'any mine or wad hole of wad or black cawke, commonly called black lead, or unlawfully taking or carrying away any wad etc., therefrom, as also the buying or receiving the same,*

knowing it to be unlawfully taken.' The culprit was liable to be imprisoned with hard labour.

Yet, despite such dire penalties and the presence of armed guards who searched the miners as they left work, smuggling increased with the price of graphite. On one notorious occasion, armed men raided the offices of the mine superintendent but – in true Wild West style – they were driven off with musket fire!

During the early years of the nineteenth century several *pipes* or deposits were discovered but by the 1830s the output was in decline; in 1836 it was reported that twelve men had been regularly employed in the mines for fifteen months *'. . . without so much as falling in with even a single sop of the valuable material'* and the mines were closed.

Copper and other mines

It is probable that the copper of the Coniston fells was worked in mediaeval times but from about 1600 the enterprise of the German miners of the Company of the Mines Royal ensured expansion. The ore was not smelted at Coniston but taken by pack-horse to the company's furnaces near Keswick. The Coniston workings were closed by Parliamentary troops but by the early eighteenth century some of the adits were once again producing ore which was transported down the lake to Greenodd and shipped to Liverpool for smelting. By the end of that century the demand for copper cladding for Royal Navy vessels further stimulated output and by the mid-nineteenth century some

400 men were employed and an average of 250 tons of ore per month was mined. Later cheaper imported ores resulted in recession and, despite a short-lived resurgence during the First World War, the mines declined to the point of extinction, lingering on until the 1930s.

The Greenside lead mine above Glenridding was one of the few Lake District mines to be worked almost continuously from its opening in the sixteenth century to 1962 when it was finally closed. Since then, mining in the fells has been sporadic. The Nab Gill haematite mine above Boot in Eskdale, for which the Ravenglass and Eskdale Railway was built in 1875, lasted only a few years. Even the tungsten mine by Carrock Fell in Mosedale, opened in 1971, has closed. The small Florence iron mine at Egremont is the lone survivor of a once flourishing industry.

Like quarrymen, miners formed a closely-knit group which was often shunned by their neighbours. James Clarke, writing of Patterdale at the end of the eighteenth century, even went so far as to blame miners for the decay in rural society:

> Vice and poverty sit pictured in almost every countenance, and the rustic fireside is no longer the abode of peace and contentment. These fellows, who are in general the most abandoned, wicked and profligate part of mankind, no sooner settled here than they immediately began to propagate their vices among the innocent unsuspecting inhabitants. The farmer listened greedily to stories of places he had never seen . . . his daughters, allured by promises, were seduced; even those who withstood promises, and were actually married, were, upon the stopping of the mines, deserted by their husbands and left to all the horrors of poverty and shame.

Fortunately, such scurrilous and exaggerated rhetoric was countered some years later by A C Gibson, one time medical officer at the Coniston copper mines:

> They have, like the rest of us, their share of the failings of human nature, and may enjoy themselves rather freely at the month's end when they receive their pay, but open or obtrusive profligacy is very rare amongst them, whilst their ignorance is certainly not equal to that of the pastoral and agricultural population around them.

Working conditions were harsh and dangerous. *Levels* were cut by hand using picks, hammers and *stope and feather* wedges but the ancient method of fire setting was also employed. This involved kindling a fire or gorse, bracken and peats in a shallow trench which was allowed to burn for some time before it was dowsed with water in order to shatter the rock. Later, when blasting with gunpowder became common, the boring of holes to receive the charge was a skilled job, the tools used being a hammer and a *jumper*, a steel rod which was turned slightly after each blow. A C Gibson has recorded one of the few eye-witness accounts of blasting at Coniston:

> The attitudes of the men as they ply their melancholy toil are rather picturesque, holding up and turning the jumper with the left hand, whilst they keep driving it into the flinty rock with a hammer held in the right. Having bored the holes to a sufficient depth – say about eighteen or twenty inches – they clear out the borings or fragments; proceed to charge with gunpowder and then . . . they light the match and retire to await the results of the 'shots'. . . . After the explosion the men return to their working . . . breaking up the large fragments, and carefully beating down any loose pieces about the sides, select the most suitable 'lofe' and recommence

boring. Three of these borings and blasts are considered a fair day's work in this hard rock, the men working in three shifts of eight hours each.

Blasting was one of the most hazardous tasks, especially before the introduction of the safety fuse in the 1870s. The 'shot' was fired by fuses made from straws filled with fine gunpowder and ignited by touch-paper. Miners were responsible for providing their own straw fuses and great care was taken in their manufacture since lives depended on the 'running speed' of each fuse. Usually oat straw was preferred because the length from the ground to the first joint was longer than in either wheat or barley. Bundles of these carefully-prepared straws were a common feature of miners' kitchens in the nineteenth century.

Other hazards made working conditions difficult; ventilation of shafts was primitive. In some mines falling water created a current of air which was led to the workings through wooden tubes. Illumination was provided by tallow candles set in balls of soft clay; these were used until the First World War when acetylene lamps were introduced. In confined spaces miners attached tallow candles to the *nebs* of their caps. Until the twentieth century, protective helmets and clothing were virtually unknown though nineteenth-century miners wore thick woollen trousers and leather jackets. Clogs with iron caulkers were the preferred to boots which were difficult to dry. The clogs were often lined with soft straw for warmth, and old hands often wore footless stockings so that if their feet were wet, they merely tipped out the damp straw and re-lined the clogs with dry which they carried with them for this purpose.

Miners' wages were higher than those of agricultural workers but the harsh working conditions and heavy manual work these men endured brought premature old age and often appalling injuries for which such financial reward was no compensation.

GLOSSARY

Adits Horizontal mining tunnels cut into the hillside

Arles or Earnest money Money paid to farm servants on hiring as a token of their hire

Arvel or Arval bread Wheaten bread distributed to mourners at a funeral to be taken home with them

Bakstone Slate or iron plate on which oatbread was baked

Bears Crude matting made from the peelings of rushes

Beltane Fires Bonfires lit on the eve of May Day

Bink A narrow ledge used by foxes as a refuge from the hounds

Blenkard, Blenchard A one-eyed cock, veteran of several fights

Bloomery hearths Iron-ore smelting hearths

Borran A pile of stones

Bower, Chamber The bedroom of the master and mistress of a farm

Braffin Horse-collar

Brake and whittle Tools used in the dressing of roofing slate

Brandreth, Brandiron Iron tripod used in cooking

Brands, Brand ends Unburnt wood remaining after charcoal burning

Bread cupboards Carved oak cupboards, often forming part of a clam-staff-and daub partition separating the firehouse from the chamber and buttery. Many bear a seventeenth-century date and the initials of the owner and his wife. Traditionally, clap bread (q.v.) was stored in these cupboards, which were sometimes known as court cupboards

Brobbs Small branches of trees used to mark the fords across the Leven and Kent channels on the cross-sands route over Morecambe Bay

Cams Stones which surmount a drystone wall

Candle bark A cylindrical tin box used for the storage of candles and rushlights

Catmallison A recess shelf or carved cupboard, often over the fire window (q.v.), which contained the family Bible

Char-a-banc Originally a horse-drawn wagon with rows of bench seats used to carry groups of tourists, the term was later applied to luxury buses

Clap bread, Haver bread Oat bread

Clog-wheels Solid wooden cart wheels fixed to the axle which turned under the cart

Cockpenny Money contribution paid to the schoolmaster by his pupils partly towards the financing of a cockfight

Colliers Charcoal burners

Corpse ways Traditional routes along which funeral processions made their way to church

Crucks Pairs of naturally-arched timbers, pegged together at the apex to form a frame for a house of barn. Sometimes called 'siles'

Deeting Winnowing of grain in a through-draught of air

Dobbie stones Naturally-holed stones hung in byres to protect animals from 'the Evil Eye'

Down-house The service area of a farm

Elding Wood or peat fuel

Fire-house, House The living accommodation in a farmhouse

Fire window A small window which allowed light to fall on the hearth

Flean A blood-letting instrument used in veterinary medicine

Flourice Iron striker used with flint to ignite tinder

Gimmer A yearling ewe

To Grave To dig (usually peats)

'Gurning through a braffin' Grimacing through a horse collar

Hake Auld Wives' Hake Described by some authorities as 'an assembly of old dames' but by others as merely a rustic gathering

Hallan A passage running from the front to the back of a farmhouse

Hallan drop A black sooty liquid which fell down the open chimneys onto the heads of those seated around the fire below

Haver bread The same as clap bread (q.v.)

Heaf Sheep pasture

Hearting Small stones used as in-filling in a drystone wall

Hodden grey A grey woollen cloth made of a mixture of black and white wool

Hogg, Hogget Male or female sheep before clipping

Hogg holes Square holes left in the base of a drystone wall to allow sheep to pass through

Kern supper Harvest supper.

Kists, Arks Chests, usually made of oak

Lat-axe An axe used to split timber. Used in the making of swill baskets

Ley A scythe

Lish Agile

'London', 'country', 'tom', 'peg' Classification of roofing slates according to fineness; used in the eighteenth century

Mash vat Vessel for brewing ale

Mell Short passage leading from the hallan (q.v.) to the fire-house (q.v.)

Merry neet A social gathering with music, dancing and card playing

Motty-peg The stake around which a charcoal pitstead (q.v.) was built

Naffs Naves or hubs of a cart-wheel

Piggins Stave-built wooden vessels from which liquids were drunk

Pitstead, Pit-ring Circular charcoal burning floor

Push-plough, Breast-plough A cutting spade used to remove shallow turf and sods prior to cultivation

Rabbit smout A form of rabbit trap consisting of a small hole in a drystone wall and a stone-lined pit

Rannel balk, randle tree A wooden beam fixed positioned across the open hearth from which the ratten-crooks hung

Ratten-crooks, Racken-crooks Adjustable pot hangers suspended from the rannel balk or fire-crane

Ruddle Dye for marking sheep

Say A shallow dish used to hold water for quenching charcoal pitsteads (q.v.)

Sconce A fixed wooden bench under which kindling or elding (q.v.) was often stored

Scummer A long-handled spoon for skimming off the salt meat boiling in cauldrons

Seeves, Sieves Rushes, usually *Juncus conglomeratus*, from which rushlights were made

Shanklings Wood used in charcoal making, usually about three feet in length

Smart A thin oak lath used in the making of swill baskets (q.v.)

Smit books Books showing 'smits' or marks used to identify sheep

Sonks Green turf sods often used as a substitute for saddles

Souse tub Vessel holding brine or sour whey used for pickling

Stag A young fighting cock

Stang A pole or plank; the shaft of a cart

Strickle Instrument for sharpening a ley (q.v.)

Swill basket, Spelk basket An oval basket woven from oak smarts (q.v.)

Swiller's 'horse' or 'mare' A foot-operated vice and seat used by swill basket makers

Tatie-pot The traditional fare at hunts, merry neets and kern suppers. It consists of Herdwick mutton, black pudding, onions and potatoes and is regarded by many as food fit for the gods

Threshwood A wooden door step.

Thrinter, Thrunter A 'three-winter' sheep

Throughs Stones which help to tie the two faces of a drystone wall together. They usually project through the wall on both sides, hence the name

Trail barrow A sled with stangs or handles which was used to convey slate down a steep scree slope

Tummel cars Single-horse, two wheel carts made entirely of wood. The wheels were often clog-wheels (q.v.)

Tup A ram

Turnpike roads Improved toll roads with a barrier or gate across them. On payment of the required fee, the barrier would be turned, giving access to the traveller

Twinter A 'two-winter' sheep

Wall head A visible boundary built into a drystone wall to indicate ownership or responsibility for upkeep and repair

Wangs Leather thongs or bootlaces, hence 'wang' cheese, a tough blue milk cheese

Weyt A shallow sheepskin dish used in deeting (q.v.) or winnowing grain

BIBLIOGRAPHY

Abbreviations

CW1 Transactions of the Cumberland and Westmorland Antiquarian and Archaeological Society, Old Series, 1866 -1900.

CW2 Transactions of the Cumberland and Westmorland Antiquarian and Archaeological Society, New Series, 1901 to present.

T.H.S.L.C. Transactions of the Historic Society of Lancashire and Cheshire.

Allen, J. *The Early Registers and Parish Accounts of Hawkshead* CW1, vol. 4, 1880

Allen, P. *The Old Galleries of Cumbria and the Early Woollen Trade* Kendal, 1984

Armitt, M. L. *Ambleside Town and Chapel* CW2 vol. 6, 1906 • *The Church of Grasmere* Kendal, 1912 • *Rydal* Kendal, 1916

Bailey, J. and **Culley, G.** *A General View of the Agriculture of Cumberland* London, 1794

Barber, H. *Furness and Cartmel Notes* Ulverston, 1894

Bardsley, C. W. *Chronicles of the Town and Church of Ulverston* Ulverston, 1885

Bardsley, C. W. and **Ayre, L. R.** (eds.) *Ulverston Parish Registers,* Ulverston, 1886

Barnes, F. *Barrow and District, 1968* Barrow, 1968

Barnes, H. *On Touching for the King's Evil* CW1, vol. 13, 1895

Barret, M. *Oak Swill Basket Making in the Lake District* Kendal, 1984

Beaumont. T. *The Complete Cow Doctor* Halifax, 1863

Beck, T.A. *Annales Furnesienses* London, 1844

Bolton, J. *Geological Fragments* Ulverston, 1869

Bott, G. *Keswick: The Story of a Lake District Town* Keswick, 1994

Bouch, C. M. L. and **Jones, G. P.** *The Lake Counties, 1500-1830* Manchester, 1961

Bragg, M. *Land of the Lakes* London, 1983

Brunskill, R. W. *The Vernacular Architecture of the Lake Counties* London, 1974

Budworth. J. *A Fortnight's Ramble to the Lakes* 2nd edn., 1795 and 3rd edn., 1810

Buntin, T. F. *Life in Langdale* Kendal, 1993

Clapham, R. *Foxhunting on the Lakeland Fells* London, 1920

Clarke, J. *A Survey of the Lakes of Cumberland, Westmorland and Lancashire* London, 1787

Close, W. *Furness Agricultural Implements*, ms. Z229, Cumbria Record Office, Barrow

Collingwood, W. G. *Some Manx Names in Cumbria* CW1, vol. 13, 1895 • *The Book of Coniston*, Kendal, 1906. • *Elizabethan Keswick*, Kendal, 1912. • *Lake District History*, Kendal, 1925

Collins, E. J. T. *Sickle to Combine* Reading, 1969

Cooke, I. *A Hired Lass in Westmorland* Penrith, n.d.

Cowper, H. S. *The Domestic Candlestick of Iron in Cumberland, Westmorland and Furness* CW1, vol. 12, 1893 • *A Grasmere Farmer's Sale Schedule in 1710* CW1, vol.13, 1895a • ed. *On Some Obsolete and Semi-Obsolete Appliances* CW1, vol .13, 1895b • *The Oldest Register Book of the Parish of Hawkshead, Lancashire, 1568-1704* London, 1879 • *Hawkshead*, London, 1899a • *Illustrations of Old Fashions and Obsolete Contrivances in Lakeland* CW1, vol. 15, 1899b • *A Contrast in*

Architecture CW2, vol. 1, 1901

David, R. *The Quarrying Industry in Westmorland* Part 1, CW2, vol. 87, 1987 and Part 2, CW2, vol. 92, 1992

Dickenson, W. *Essay on the Agriculture of West Cumberland,* London, 1850

Eden, F.M., 1797. *The State of the Poor,* London.

Ellwood, T. *Lakeland and Iceland* London, 1895 • *The Mountain Sheep, their origin and marking* CW1, vol. 15, 1899

Evans, E. E. *Irish Folk Ways* London, 1957

Fair. M. C. *A Relic of Pack-horse Days in Eskdale* CW2, vol. 22, 1922

Fell, A. *The Early Iron Industry of Furness and District* Ulverston, 1908

Fell, J. *The Guides over the Kent and Leven Sands* CW1, vol. 7

Ferguson, R. S. *The Guides over the Kent and Leven Sands* CW1, vol. 9.

Fisher, W. *Manuscript Diary and Commonplace Book of William Fisher of Barrow* Barrow Public Library, 1811-1859

Fleming, W. *Manuscript Diary and Commonplace Book of William Fleming of Pennington* microfilm, Barrow Public Library, 1798-1819

Gambles, R. H. *The Spa Resorts and Mineral Springs of Cumbria* CW2, vol. 93, 1993

Garnett, F. W. *Westmorland Agriculture, 1800-1900* Kendal, 1912

Gell, W. *A Tour in the Lakes made in 1797* 1797, W. Rollinson, ed., Newcastle, 1968

Gibson, A. C. *The Old Man, Windermere* 1857 • *Ancient Customs and Superstitions in Cumberland,* T.H.S.L.C., vol. 10, Old Series, 1857-8 • *Hawkshead Parish* T.H.S.L.C., vol. 6, 2nd. series, 1865-6a. • *The Lakeland of Lancashire* T.H.S.L.C., vol. 6, 2nd. series, 1865-6 • *The Last Popular Uprising in the Lancashire Lake Country* T.H.S.L.C., vol. 9, 2nd. series, 1868-9

Gough, J. *The Manners and Customs of Westmorland and Adjoining parts of Cumberland, Lancashire and Yorkshire* Kendal, 1812, reprinted 1827

Green, W. *Guide to the Lakes* Kendal, 1819

Hall, J. *Manuscript commonplace book* Cumbria Record Office, Kendal, 1787

Hay, T. *The Goose Bield* CW2, vol. 43, 1943

Hindle, B. P. *Roads and Trackways of the Lake District* Ashbourne, 1984

Historic Manuscripts Commission *12th Report* Appendix, Part VII, Manuscripts of S. H. le Fleming Esq., London, 1890

Hobbs, J. L. *The Turnpike Roads of North Lonsdale* CW2, vol. 55, 1955 • *The Story of the Windermere Steamers* Cumbria, Jan.- Feb. 1957 • *The Story of the Coniston Steamers* Cumbria, Sept., 1960

Hodgson, J. *Westmorland As It Was* Reprinted in The Lonsdale Magazine, vol. 3, 1822 with additional notes by J. Briggs, 1822

Holland, E. *Coniston Copper* Milnthorpe, 1987

Jollie, F. *Sketch of Cumberland Manners and Customs* Carlisle, 1811

Kipling, C. *A Salt Spring in Borrowdale* CW2, vol. 61, 1961

Linton, E. Lynn *The Lake Country* London, 1864

Little, E. A. *The Chronicles of Patterdale* Penrith

Mackay, C. *Scenery and Poetry of the English Lakes* London, 1846

Macpherson, H. A. *Fauna of Lakeland* Edinburgh, 1892

Marshall, J. D. *Old Lakeland* Newton Abbot, 1971

Marshall, J. D. and **Davies-Shiel, M.** *The Industrial Archaeology of the Lake Counties* Newton Abbot, 1968

Marshall, J. D., and **Walton, J.K.**, *The Lake Counties from 1830 to the mid-twentieth century* Manchester

Mawman, J. *An Excursion to the Highlands of Scotland and the English Lakes* London, 1805

Melville, J. and **Hobbs, J. L.** *Furness Travelling and Postal Arrangements in the 18th and 19th Centuries* CW2, vol. 46, 1946

Morris, W. P. *Records of Patterdale*

Kendal, 1903

Nicholson, N. *The Lake District: An Anthology* London, 1977 • *Sea To The West* London, 1981

Otley, J. *A Descriptive Guide to the English Lakes and Adjacent Mountains* 8th edition, Keswick, 1850

Palmer, W.T. *Odd Corners in English Lakeland* London, 1937 • *Wanderings in Lakeland* London, 1946 • *More Odd Corners in English Lakeland* London, 1948

Pape, T. *The Sands of Morecambe Bay* Morecambe, n.d.

Parker, C.A. and **Collingwood, W.G.** *The Gosforth District* Kendal, 1926

Partington, J. E. *Rural House Types prior to the Early 19th Century in the English Lake District* Ph.D. thesis, Manchester University School of Architecture, 1960

Pattinson, G.H. *The Great Age of Steam on Windermere* Windermere, 1981

Peate, I. C. *Tradition in Folk Life, a Welsh View* London, 1972

Plint, R. G. *The Coniston Goose Bield* CW2, vol. 72, 1972

Postlethwaite, J. *Mines and Mining in the Lake District* Whitehaven, 1913

Price, N. *Vagabond's Way* London, 1914

Pringle, A. *A General View of the Agriculture of the County of Westmorland* London, 1794

Rawnsley, H. D. *Life and Nature at the English Lakes* Glasgow, 1902 • *By Fell and Dale at the English Lakes* Glasgow, 1911

Rice, H. A. L. *Where Rise the Mountains* Newcastle, 1969

Richardson, J., *Old Customs and Usages of the Lake District* Trans. of the Cumberland and Westmorland Association for the Advancement of Literature and Science, 1876

Robinson, J. *A Guide to the Lakes* London, 1819

Rollinson, W. *A History of Man in the Lake District* London, 1962 • *The Lake District: Landscape Heritage*

ed., Newton Abbot, 1989 • *Lakeland Walls*, Clapham, 1991

Rollinson, W. and **Twyman, M.** *John Soulby, Printer* Ulverston, Reading, 1966

Rowling, M. *The Folklore of the Lake District* London, 1976

Royal Commision on Historical Momuments *Westmorland* London, 1936

Scott, D. *Bygone Cumberland and Westmorland* London, 1899

Scott, S. H. *A Westmorland Village* London, 1904

Shaw, W. T. *Mining in the Lake Countie* Clapham, 1972

Stockdale, J. *Annals of Cartmel* Ulverston, 1872

Sullivan, J. *Cumberland and Westmorland, Ancient and Modern* Kendal, 1857

Sutton, S. *The Story of Borrowdale* Keswick, 1961

Taylor, S. *Cartmel, People and Priory* Kendal, 1955

Victoria County History of Cumberland 2 volumes, London, 1905

Walker, A. *A Tour from London to the Lakes* London, 1792

Ward, E. M. *Days in Lakeland* London, 1929

Watson, J. ed. *The Annals of a Quiet Valley* London, 1894

Webster, C. *On the Farming of Westmorland* Journal of the Royal Agricultural Society of England, vol. 6, 2nd. series, 1868

West, T. *Antiquities of Furness,* Ulverston 1774 4th edition with additions by W. Close 1805

Whellan, W. *History and Topography of Cumberland and Westmorland* London, 1860

White, W. *Furness Folk and Facts* Kendal, 1930

Wilson, W. *Coaching Past and Present* Windermere, 1885

Winchester, A. J. L. *Peat Storage Huts in Eskdale* CW2, vol. 84, 1984

Wright, P. *Cumbrian Dialect* Clapham, 1979

INDEX

A

Ague 39, 44
Alpine Trout (char) 13
Alston 41
Ambleside 37, 45, 49, 52, 53, 58, 85, 86, 88, 89, 91, 98, 125, 147, 150
Angerton 151
Animals, care of 38, 93-99
Appleby 61, 64
Arvel 17, 75
Asby 64
Ashburner, John 103
Ashgill 151
Askham 24, 31
Atkinson, Robert 62
Auld Wives' hakes 66

B

Backbarrow 79, 89, 139
Backbarrow Furnace 138
Bank barns 27-8, 31, 131
Bark peeling 135, 137, 144
Barkhouse 144
Barngates Inn 16
Barns 23, 27-8, 29, 31, 66, 69, 131
Barring out 48
Barrow 153
Barrow Channel 153
Barrow falls 122
Barrow in Furness 90, 92, 153
Bassenthwaite 58, 97
Bassenthwaite Lake 124, 133
Bassingill 143
Belle Grange 90
Belle Isle 90, 124
Beltane fires 48
Bessy Crag 151
Bidden weddings 46
Bigland Hall 83
Birkrigg 144
Birth 19
Birthwaite 88, 89
Black Combe 122

Black Lead mines 40, 105, 153
Blackbeck 143, 144
Blacksmith 30, 35, 129, 133, 151
Blea Water Crag 108
Bleaze Hall 49
Bleeding and blood letting 42, 94
Blencathra 107, 108, 122, 148
Blind Tarn 151
Bobbin mills 89, 137, 141-3
Boils 44
Bone setters 38
Boot 75, 88, 90, 134, 155
Borrowdale 13, 40, 41, 81, 85, 105, 107, 112-3, 122, 123, 125, 128, 146-7, 153-4
Bouth 89, 143
Bowick ground 36
Bowman, Joe 108
Bowness 58, 66, 69, 71, 76, 86, 88, 91, 124, 139
Bowness Bay 90
Braithwaite, Richard 91
Braithwaite, Thomas 90
Brandelgill 153
Brandelhow 122
Brathay 122, 143
Bread cupboards 25, 28, 34
Breast plough 127
Brigham (Keswick) 153
Bromfield 102
Brough 49
Broughton 30, 88, 89, 139, 140
Broughton Mills 27, 29, 114
Browne family 13, 25, 35
Brownrigg, George 132
Bruce, Robert 83
Brushmaking 144
Bull baiting 108
Burblethwaite Forge 138
Burgh-by-Sands 101-2
Burlington quarries 153
Burneside Hall 91
Burnmoor 75, 134
Burns 40
Buses 86
Butter Crag 61

Buttermere 81, 85, 105
Buttermere Green Slate Company 153
Buttery 36

C

Caldbeck 26, 62, 106
Caldbeck Bobbin Mill 141
Caldbeck fells 153
Candlemas 123
Candles 35, 155
Carlisle 56, 62, 79, 88
Carlisle, Bishops of 102
Carrier pigeons 153
Carrock Fell 155
Cars 86
Carter Ground 148
Cartmel 19, 24, 27, 82, 83, 98, 101, 104, 122, 127, 130
Cartmel priory 83, 104
Cartwheels 129
Castlehead 77
Cat Bells 153
Cattle 36, 37, 94, 95
Chapel Stile 153
Char 13
Charabancs 80, 89
Charcoal Black and the Bonnie Grey 103
Charcoal burning 136-9
Charles Edward Stuart, the Young Pretender 75
Charles II 69, 76
Children at work 79
Cholera 42
Christenings 19
Christmas 13, 27, 49, 56, 66, 68, 123
Civil War 153
Clap bread 9
Clogs 21, 62, 155
Cloth 20, 35
Clothing 20
Cock loaf 102

Cockermouth 6, 21, 30, 56, 82, 85, 88
Cockfighting 100-103
Cockley Beck 88
Company of the Mines Royal 153, 154
Conishead priory 83
Coniston 10, 13, 15, 22, 28, 75, 89-91, 104, 107, 152-3, 155
Coniston Fells 151, 154
Coniston Old Man 106, 151
Coniston Raiway Company 92
Coniston Water 13, 92, 121, 136, 143, 148, 151
Copper 154
Coppice wood 135-8
Cotton mills 79
Counting sheep 110
Cowmire Hall 27
Crakeplace Hall 28
Criffel 122
Cropple Howe Farm 25
Crosthwaite (Kendal) 99
Cruck frame buildings 23, 27, 29
Crummock Water 125, 149
Cunsey 138
Cures 39-44

D

Dairy 36-7
Dallam Tower 79
Dalston 48, 102
Dalton 17, 50, 75
Dances 66-8
Dated stones 28, 30
Dean 28
Deepdale 25
Dent 20-1
Dentist 42
Derwent Farm 27
Derwent Fells 153
Derwentwater 58, 107, 125
Dialect 6, 13, 34, 113, 118-20, 136, 139
Dickens, Charles 64

Dobbie stones 48, 49, 95
Dobson, Tommy 108
Douglas, Clementina Johannes Sobieski 75
Dove Cottage 18
Dow Crags 146
Down-house 24-5, 34, 36
Drigg 151
Drilling 153
Drink 16
Drystone walls 145-149
Duddon 133, 151
Dunmail Raise 81, 88, 97
Dunnerdale 88, 147

E

Eagles 104, 105
Easter 17
Eden Valley 23, 122, 130
Edward II 83
Edward the Confessor 39
Egremont 61, 155
Elizabeth I 153
Elizabeth II 10
Elleray 102
Ellers 153
Elterwater 143, 144
Ennerdale 90, 106, 108, 146
Epitaphs 73, 76-7
Eskdale 25, 75, 88, 90, 108, 110, 134, 146, 148, 155
Eskdale Green 30

F

Fairfield 122
Fairs 16, 54, 56, 61, 83
Falling sickness 39, 44
Far Easedale 30
Farm buildings 27-8, 31
Farm carts 128-30, 133
Farmer Dixon 108
Farming 109-117, 126-134
Farms and farmhouses 22-31
Fell running 61

Fig Sue 17
Finsthwaite 75, 79, 97, 142
Fire furnishings 32-3
Fire-house 24-5, 26, 37
Fish 13
Fisher, William 40, 42, 95
Flan How 62
Flaskow Common 133
Fleeces 28, 112, 115
Fleming, Sir Daniel 38, 42, 48, 68, 94, 98, 100, 105, 117
Fleming, William 16, 17, 19, 34, 37, 40, 42, 47, 66, 70, 75, 78, 79, 103
Florence iron mine 155
Folk cures 38-44
Folk dress 20-1
Food and diet 9-14, 17-19, 33, 34
Foot and mouth disease 97
Force Forge 136, 138
Fox traps 104
Foxfield 89
Foxhunting 104-8, 113
Funerals 17, 72-7
Furness 18, 24, 42, 47, 79, 83
Furness Abbey 111, 113, 136, 139, 147
Furness Fells 30, 135, 136, 138
Furness Railway Company 92, 153

G

Gatebeck 143
Gingerbread 52, 53, 55, 61
Glencoyne Farm 26, 27
Glenridding 155
Goatswater 151
Goldscope Mine 153
Gondola, the 92
Grange-in-Borrowdale 27, 153
Grange-over-Sands 79, 123
Grasmere 18, 30, 40, 49, 50, 51, 52, 53, 61, 64, 81, 85, 86, 88
Great Freeze, the 123

Great Gable 151
Great Howe Crags 106
Great Langdale 21, 29, 112, 122, 133, 143, 146, 153
Greenodd 151, 154
Greenside lead mine 155
Greystoke 62
Grizedale 71, 88
Groaning Cheese 19
Guides Race 61
Gunpowder 40, 89, 138, 143, 155
Gurning 61
Gutterby 41

H

Hacket 138
Hackthorpe Hall 130
Haemorrhage 38
Hardknott Pass 82, 87
Hare coursing 108
Harrison, Thomas 99
Hartsop 28, 113
Harvesting 130
Haver 9, 24
Haverigg 121
Haverthwaite 89, 139, 143
Haweswater 105
Hawkshead 16, 35, 36, 40, 82, 85, 86, 90, 91, 98, 102, 104, 125, 129, 139, 150, 151
Hawkshead Field 141
Hawkshead Hill 49
Haymaking 130, 131-3
Health 38-44
Hearths and fires 32-3
Helvellyn range 133
Hemans, Felicia 83
Herdwick sheep 10, 109-112, 113, 114
Heversham 102
Hewthwaite Hall 30
High Birk Howe 24
High Furness 18, 39, 47, 60, 112, 136
High Street range 108, 113
High Yewdale Farm 10, 15
Hird, Hugh 65
Hiring fairs 42, 55-6
Hodge 151
Hodge Hill 28
Hogg holes 148, 149
Hoggart, Thomas 68-9, 73

Hoggs 124, 148
Holker Hall 83
Holly 112, 136
Holme ground 31
Homelife 32-37
Honister 151-3
Honister Crag 151
Honister Pass 81, 85
Hooping 141
Horning 94
Horses 95, 126-7, 143, 153
Hound trailing 65-6, 114
Howgill 97
Humphrey Head 41
Hunting 104-8
Hutton Moor End 30

I

Iron industry 138

J

Jaundice 38
Jubilee 14, 15, 58

K

Keats, John 66
Kendal 9, 13, 18-21, 24, 42, 55, 56, 62, 69, 70, 71, 82, 85, 88, 90, 95, 101, 108, 122, 144, 153
Kendal Mint Cake 14, 19-20,
Kent Sands 83
Kent, river 122, 133
Kentmere 27, 82, 113
Kentmere Hall 27
Keswick 21, 30, 37, 42, 56, 58-60, 69, 71, 85, 86, 88, 89, 105, 108, 122, 125, 128, 133, 153, 154
Killington 97
Kilns 27, 28
King's Evil 39-40
Kirkby-in-Furness 151-3
Kirkby Pool 151
Kirkby Quay 151
Kirkby Stephen 49, 108
Kirkstone Pass 80, 147

L

Lady of the Lake 91, 92
Lake Bank 92
Lakeside 92, 144
Lambs 94, 95, 113-5
Lancaster 79, 83, 84, 88, 91
Langdale 82, 125, 153
Langdale Beck 143
Langdale Pikes 107, 125
Langwathby 62
Lanthwaite 149
Law and order 78-79
Lead mines 40, 41, 153-4, 155
Leaping contests 46, 47
Leven, river 83, 89, 138, 143
Levens Bridge 84
Levers Water 104, 106
Leys 130
Lickle valley 34, 148
Lighting 35
Lindale 77
Lingmell Gill 125
Lingmoor 153
Lintel stones 28, 30-1
Little Langdale 24, 90, 138, 151
Lodore falls 122
Longridge 56
Lonsdale 108
Loughrigg Fell 122
Low Furness 23, 76, 130, 136
Low Hartsop 28
Lowick 111, 139
Lowther 130
Lowwood 143, 144
Lug marks 113
Lyth valley 133, 134

M

Manesty 41
Mardale 113
Martindale 88, 113
Martineau, Harriet 89, 97
Martinmas 13, 123
Maryport 88
Maundy Thursday 49
May Day 48 -9
Medicine 38-44
Melmerby 62
Merry Neets 10, 66, 68, 108, 114
Messenger, Mary 81

Midsummer Day 44
Millbeck 30
Miller Ground 90
Millom 68, 121, 122
Mills 79
 see also Bobbin mills
Milnthorpe 143
Mines 150-5
Mines and mining 21, 40, 89, 90, 105, 113, 153-5
Monk Coniston 97
Morecambe 41, 42
Morecambe Bay 63, 77. 79, 83, 123, 124
Morris men 18-9
Mosedale 155
Moses' Sled Gate 151
Mummers play 18-9, 68
Murrain 97
Musgrave 49

N

Nab Gill mine 90, 155
Natland 102
Needfire 97
Nether Wasdale 112
Newby Bridge 91, 138, 143
Newlands 112
Newlands valley 153
Nibthwaite 92, 144
North, Christopher
 see Wilson, Professor John
Nosebleeds 44

O

Old Hutton 49
Optician 42
Orton 20, 102
Oxen Park 30, 102

P

Pace eggs 7, 17-8
Packhorse 30, 75, 81, 82, 154
Park End 106
Patterdale 28, 68, 85-6, 87, 88, 155
Pavey Arc 143
Peat 28, 32, 33, 133-4

Pedlars 21
Peel, John 20, 106-7
Pencils 154
Pennington 16
Pennyrigg 151
Penrith 6, 18, 42, 56, 69, 82, 85-6, 87-9, 102
Pillar Rock 146
Ploughing 5, 66, 126-8
Pool Bank 28
Portinscale 107
Potter, Beatrix 66, 109

Q

Quarries 21, 149, 150-5
Queen Anne 39

R

Rabbit smouts 148, 149
Races 46, 47, 59, 61
Railways 84, 85, 88-90, 92, 144, 153, 155
Rampside 76
Randle How 30
Rash Assault, the 88
Ravenglass 51, 88, 90
Ravenglass and Eskdale Railway 90, 155
Ravenstonedale 20
Reaping 130, 131
Red Screes 147
Regattas 58-60, 64
Rheumatism 42, 44
Richardson, 'Belted Will' 62
Riving 153, 154
Romans 150
Rose castle 102
Rosehill 71
Rosley 61
Rosthwaite 147, 148
Rowans 48, 75
Rowelling 94
Rum Butter 7, 19
Rushbearing 7, 45, 49-53
Rushlights 35
Ruskin, John 88, 121
Rydal Hall 13, 38, 41, 68, 94, 98, 113, 116
Rydal Mount 18

S

Sale of a wife 47-8
Salving sheep 98
'Sands, The' 83, 84
Satterthwaite 18, 49, 60
Sawrey 97
Saxoni, Mr 70
Schneider, Henry W 90
Seascale 12
Seat Sandal 122
Seathwaite 40, 113, 114, 125, 154
Seatoller 86
Sedgwick 143
Septic throats 41, 44
Shap 30
Shap Fell 88
Shap Wells 41
Sheep 94-9, 109-119
Sheep clipping 28, 114-7
Sheep dipping 96-8, 97, 114-6
Sheep scoring numerals 110
Sheep washing 96, 115
Sheepdog trials 65
Shepherds 7, 94, 110, 113-4, 112, 146, 154
Shepherds' meets 110, 113-4
Shrovetide 100, 102
Sickles 130
Skelwith Bridge 39, 44, 102
Skiddaw 107, 112, 122 148
Skiddaw Forest 133
Skirwith 97
Slate 7, 21, 24, 26, 150-3
Sleagill 62
Smit marks 61, 113, 154
Solway Marshes 117
Somervell, Robert 88
South End farm 28
Southey, Robert 60
Spark Bridge 139, 144
Spelk baskets 139-41
 (see swill baskets)
Spinning 21, 28, 30
Spinning galleries 23, 28
Sports 57-66
Sprinkling Tarn 122
St Bees 48, 61 148
Stage coaches 82-5
Stainton in Furness 102
Stair 153
Stang End 151
Stang riding 48
Statesman plan 23-6

Steadman, George 59, 64
Steam on the Lakes 91
Stickle Barn 27, 29
Stickle Tarn 107, 143
Stone walls 145-49
Stonethwaite 152
Stoneycroft 153
Stott Park Bobbin Mill 89, 142-3
Sturdy 94
Sty Head 122, 125
Sty Head Pass 107
Sunny Bank 141
Swan, the 90
Swarthbeck falls 122
Swill baskets 7, 139-41

T

Taking the waters 41
Tarn Hows 125
Tatie Pot 10, 66, 114
Tea 17
Theatre 68-71
Thirlmere 81, 104, 106
Thrashing 131-2, 134
Threlkeld 30
Tilberthwaite 31, 114, 151-3
Tooth pulling 41
Toothache 38, 39, 40, 44
Torver 114, 139, 141, 151, 152
Tourists 84, 85, 89
Townend 13, 25, 26, 27, 28
Transport 80-92, 153
Travel 80-92
Travelling treatments 42
Troutbeck 13, 17, 25, 26-8, 35, 65, 66, 68, 73, 75, 82, 97, 108, 113, 137, 138, 147, 148
Troutbeck Bridge 85
Troutbeck Forest 147
Troutbeck Giant, the 65
Troutbeck Park 65, 151
Tup shows 110
Tups 110-111
Turnpikes 82, 85

U

Ullswater 26, 62, 86, 87, 92, 108, 122-4
Ulpha 147

Ulverston 6, 18, 21, 26, 42, 55, 56, 69, 70, 71, 75, 82, 83, 84, 88, 91, 92, 102, 103. 144, 151, 152
Ulverston Canal 152
Urswick-in-Furness 49, 102

V

Vale of Lorton 125
Vale of St John 125
Vegetables 13
Veterinary skills 94-9
Victoria, Queen 15, 58

W

Wakes 73
Walkinshaw, Clementina 75
Wall End, Langdale 29
Wallow Crag 105
Walna Scar 114
Walney Island 28, 50, 117, 121-2
Walney Pot 121
Walpole, Sir Hugh 27
Wang Cheese 36
Wansfell 122
Warcrop 49
Warton 102
Warts 39, 44
Wasdale 63, 86,
Wasdale Head 62, 65, 75, 112, 125, 134, 146, 147, 151
Wastwater 125
Waterhead 88, 90, 91, 143
Waterhead Inn, Coniston 92
Watermillock 106, 123
Weather 7, 9, 58, 121-5
Weaving 20, 35
Weddings 46
Wesley, John 83
Wheel hooping 129
Wheelwrights 129
Whinlatter Pass 85
Whitehaven 47, 69, 71, 82, 85
Whitsun 56, 83
Whooping cough 39, 40, 44
Wigton 6
Wilhelm, Kaiser 92
Wilkinson, John 77
Wilson, Professor John, 60, 62, 102

Windermere 13, 37, 59, 60, 62, 64, 73, 85-6, 88-92, 102, 112, 124, 136, 138, 143, 148, 151, 153
Windermere Ferry 62, 86, 90-1
Windermere Regatta 58-9, 64
Windermere United Steam Boat Company 92
Windermere, Manor of 139
Winster Valley 27, 28, 35, 133
Winster, river 138
Wiper, Joseph 15, 19, 20
Witchcraft 95
Witherslack 41, 123, 134
Woodcock Graves, John 108
Wool 20, 35, 112-17
Woollen shrouds 76
Wordsworth, William and family 17, 21, 27, 53, 60, 81, 83, 85, 88, 90, 91, 121
Workington 88
Worms 40
Wounds 44
Wraysholme Tower 27
Wreay 101
Wren, Sir Christopher 150
Wrestling 46, 47, 59, 61-5, 113
Wrynose 82
Wythburn 111
Wythop Moss 133

Y

Yew Tree Farm 22, 28
Yewbarrow Hall 27
Yewdale Crags 89

Conversions (approximate)

Money Pre-decimal	Decimal
Farthing = quarter of a penny	*One tenth of one pence*
Halfpenny = $^1/_2$d	*One fifth of one pence*
Three farthings = $^3/_4$d	*Three tenths of one pence*
Penny = 1d	*0.42 of one pence*
Shilling = 1s = 12d	*5 pence = 5p*
£0 1s 6d = 1s 6d = 1/6 = 18d	*7.5 pence = 7.5p*
£0 2s 0d = 2s = 2/- = 24d	*10 pence = 10p*
£0 2s 6d = 2s 6d = 2/6	*12.5 pence = 12$^1/_2$ p*
10 shillings = 10s	*50 pence = 50p*
£1 = 20s = 240d	*£1 = 100 pence*

Numbers

Dozen	*12*

Measurement Imperial	Metric
$^1/_4$ inch = $^1/_4$ins	*6.35 mm = 0.635 cm*
$^1/_2$ inch = $^1/_2$ins	*12.7 mm = 1.27 cm*
One inch = 1 ins	*25 mm = 2.5 cm*
One foot = 12 ins	*300mm = 30 cm*
One yard = 3 feet – 36 ins	*0.914 metre = 91.44 cm*
One mile = 1,763 yards	*1.609 kilometres*

Weight Imperial	Metric
One ounce = 1 oz	*28.35 grams*
Half pound = $^1/_2$ lb	*226 grams*
One pound = 1 lb = 16 oz	*0.454 k'grams = 454 grams*
One stone = 1 st = 14 lbs	*6.35 k'grams*

And now you've a swatch o' them good oald days,
At fwoak brags on as hevvin lang sen;
And you know summat now o' their wark
and their ways;
Wad ye swap eb'm hands, good men?

William Dickinson, 1876